Princely Magnificence

COURT JEWELS OF THE RENAISSANCE, 1500~1630

15th October 1980~1st February 1981

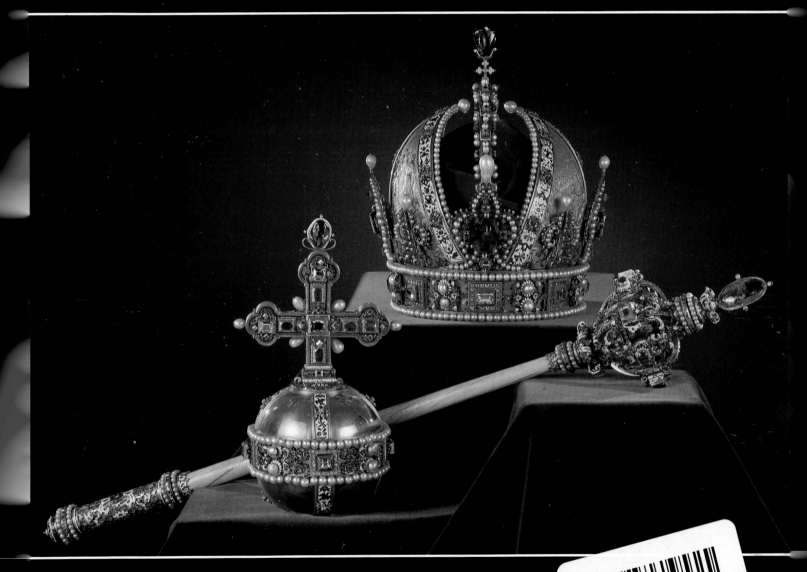

DEBRETT'S PEERAGE LIMITED

in association with the

VICTORIA AND ALBERT MUSEUM

Contributors

The entries in the catalogue section were written by the following, whose contributions are indicated by initials:

J.A. Janet Arnold
C.B. Claude Blair
S.B. Shirley Bury
R.D. Dr Rudolph Distelberger
C.G. Charlotte Gere
P.G. Philippa Glanville
I.H. Dr Irmtraud Himmelheber
K.H. Dr Kersti Holmquist
B.J. Barbara Januszkiewicz
R.M. Dr Rosalind Marshall
J.R. John Rowlands
A.SC. Anna Somers Cocks
M.S. Michael Snowdin
H.T. Hugh Tait
C.T. Charles Truman

Acknowledgements

The Museum's gratitude must go first of all to the lenders:

Her Majesty the Queen
H.R.H. Prinz Franz von Bayern
H.S.H. Franz Josef II, the Reigning Prince of Liechtenstein
The Duke of Buccleuch and Queensberry K.T.
The Duke of Hamilton
The Earl of Elgin
The Earl of Haddington
The Earl of Mar and Kellie
The Earl of Winchelsea
The Marquess of Bath
The Marquess of Tavistock
Lord Astor and Hever
The Prime Minister
R.J. Berkeley, Esq., and the Trustee of the Will of the 8th Earl of Berkeley
A.L. den Blaauwen, Director, Rijksmuseum, Amsterdam
P.L. Bradfer Lawrence, Esq., F.S.A.
Mr Breede, Kiel, West Germany
The Trustees of the Chatsworth Settlement
The Administrative Trustees of the Chequers Estate
Timothy Clifford, Esq., Director, City Art Gallery, Manchester
The Corporation of London
Professor Dr Franz-Adrian Dreier, Director, Kunstgewerbemuseum, West Berlin
Professor Dr Gerhart Egger, Director, Österreichisches Museum für angewandte Kunst Vienna
Wladyzlaw Filipowiak, Director, National Museum Szczecin, Poland
Dr Kenneth Garlick, Ashmolean Museum, Oxford
Jose Maria Garrut, Director, Museum d'Historia de la Ciudad, Barcelona
John Gere, Esq., British Museum
Charlotte Gere, British Museum
Professor Dr Horst Gronemeyer, Staats und Universitätsbibliothek, Hamburg

John Hayes, Esq., Director, National Portrait Gallery, London
E.W. Heaton, Esq., the Dean of Christ Church Oxford
Max Hebditch, Esq., Director, Museum of London
Dr Rudiger an der Heiden, Bayerische Staatsgemäldesammlung, Munich
Dr Georg Himmelheber, Bayerisches National-museum, Munich
Dr Kersti Holmquist, Director, Livrustkammaren, Stockholm
Professor Michael Jaffe, Director, Fitzwilliam Museum, Cambridge
Mme Genevieve Lassalle, Bibliothèque Nationale, Cabinet des Médailles, Paris

Michael Levey, Esq., Director, National Gallery, London
Dr Manfred Leithe-Jasper, Director, Kunsthistorisches Museum, Vienna
A.W. Mabbs, Esq., Keeper of Public Records, Public Record Office
The Lord Mayor of London
Lt Col Sir George Meyrick, Bart, M.C.
J.R. More-Molyneux, Esq.,
Dr Alessandra Mottola Molfino, Museo Poldi-Pezzoli, Milan
Major M. Munthe
David Pears, Esq., Curator of the Christ Church Library, Oxford
The Hon. Hugo Phillips
David Piper, Esq., Director, Ashmolean Museum, Oxford
Richard H. Randall Jr., Walters Art Gallery, Baltimore
Duncan Robinson, Esq., Fitzwilliam Museum, Cambridge
John Rowlands, Esq., British Museum
Mrs P.E. Scarisbrick
Mr and Mrs A. Kenneth Snowman
Hugh Tait, Esq., British Museum
C.E. Thompson, Esq., Director, Scottish National Portrait Gallery
Baron Thyssen-Bornemisza, Thyssen-Bornemisza Collection Lugano-Castagnola, Switzerland
Mr and Mrs P.E. Tritton
The Dean and Chapter of Westminster
Dr David M. Wilson, Director, British Museum, London

Many people have also helped generously with information and with smoothing the path generally:

Sir Anthony Acland K.C.V.O., H.M. Ambassador in Madrid
I. Aghion, Bibliotheque Nationale, Cabinet des Medailles, Paris
D.G. Banwell, Dulwich College
M. Barszczewski, Deputy Director, Polish Cultural Institute
Dr Reinhold Baumstark, Director der Fürstlichen Sammlungen
Mrs Joan Botfield, British Museum

Dr Terry Carlbom, Cultural Attaché, Swedish Embassy, London
Gudrun Ekstrand, Livrustkammaren, Stockholm
Dr Rudolph Distelberger, Kunsthistorisches Museum, Vienna
Rear Admiral E.W. Ellis, C.B., C.B.E.
Laurence Geddes, Esq.
Christopher Gibbs, Esq.
R.E. Hutchinson, Esq., Scottish National Portrait Gallery
Oscar and Peter Johnson Ltd.
Miss P. Latham, Courtauld Institute
Dr Rosalind K. Marshall, Scottish National Portrait Gallery
Ursula Mayerhofer, Österreichisches Museum für angewandte Kunst, Vienna
Lord Mowbray, Foreign Office
Hugh Murray Baillie, Esq.
Richard Parsons Esq., British Embassy, Madrid
Judith Prendergast, National Portrait Gallery
F.G. Reynolds, Esq., Exhibition of Treasures, Westminster Abbey
David Scrace, Esq., Fitzwilliam Museum, Cambridge
Dr Lorenz Seelig, Bayerisches Verwaltung der Staatlichen Schlösser, Gärten und Seen
Wing Commander Thomas, Chequers
Lavinia Wellicome, Curator, Woburn Abbey
Sarah Wimbush, National Portrait Gallery
Dr Christian Witt Doering, Österreichisches Museum für angewandte Kunst, Vienna
Anna Woodhouse
Adam Zamoyski, Esq.

I am also extremely grateful to all those who kindly wrote many of the catalogue entries (see separate list).

Within the Museum, Anne Hills of Exhibitions Section deserves loud praise for endless constructive help and for imposing order on chaos; the Director, Dr Roy Strong, was always accessible when his help was needed and gave much invaluable advice on the paintings section; Michael Darby, Garth Hall, Gillian Davies, Anne Seymour, Frances Newton, Mike Ford all lent a hand. As always, without Peter MacDonald, head of the Photographic Studio, most of the excellent photographs would not have been taken in time. Michael Martin is responsible for the stylish graphics of the exhibition, John Ronayne for the evocative display of the Szczecin jewels, the Swedish burial regalia and the Cheapside Hoard. Last, but not least, Paul Williams must be thanked for the overall design of the exhibition, which, apparently so elegantly simple, nonetheless conceals much meticulous research and experimentation.
A.S.C.

The Status and Making of Jewellery, 1500~1630

Enamelled gold case by François Dujardin with miniatures by Clouet of Charles IX and Catherine de Médicis. (23)

Philip Hainhofer, the famous Augsburg art dealer, indicated how a Renaissance prince might spend his leisure, when he wrote with evident approval that Duke Maximilian I of Bavaria enjoyed breeding beautiful horses, hawking, and collecting jewels and jewelled works of art (*Kleinod*), art and painting, and turned work (*Drehwerk*). Hawking and breeding horses were conventional enough activities and would have been favoured by most medieval princes. The possession of objects in precious metals and of great jewels had also always been a vital aspect of princeliness, but during the 16th century princes, for the first time, made a formal association between certain specific jewels and their own dynasty, declaring them to be inalienable heirlooms. Theoretically they could then no longer be given away or sold in times of financial stringency, and, although this stipulation was often flouted, a number, astonishingly large by comparison with the previous centuries, survive, often in their original collections.

The first prince to pass such a decree was Francis I of France. On 15th June 1530 he established by letters patent that eight pieces of jewellery consisting of especially fine gemstones should henceforth be called the 'Jewels of the Crown'. This group was to be separate from his own personal jewels, and the personal jewels of his wife Eleonor of Austria, although she might wear them as long as she was Queen of France.

However, it is clear from the way the decree is phrased that Francis was only concerned with the gemstones themselves, as it allows the form of the jewels to be changed so long as the number and weight of the stones remains the same.[1] Indeed the eight pieces of jewellery were completely refashioned on Francis II's accession in 1559, by the Court goldsmith François Dujardin the elder (*see* cat. no. 23)[2] and we have only the verbal descriptions of what they looked like. In the case of the French Crown, objects in precious materials such as cameos in enamelled and jewelled

Elephant pendant from the Bavarian Ducal treasury, part of Duke Albrecht's Disposition of 1565. (27)

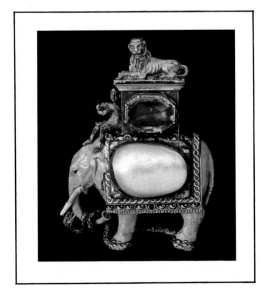

Right:
Another pendant from the 1565 Disposition. (28)

mounts were collected as works of art and did not go into the *Trésor* where the jewellery was kept, but into the *Cabinet du Roi*; there they were not protected by decree, but, at least after the accession of Henri IV in 1589, they were carefully organised and inventoried.

The Duke of Bavaria, Albrecht V, the first great Wittelsbach patron of art and an enthusiastic lover of goldsmiths' work, also distinguished between works of art and his jewellery. When he made his Disposition of 19th March 1565, he referred to his jewels under the general term of *Kleinod* for which there is no exact translation, but which approximates to *objets de vertu* and jewellery combined, thus suggesting that he meant the objects in their actual state, not merely the gems set in them. Like Francis I, he also declared them to be inalienable heirlooms of his princely house, and although two centuries later in the mid 18th century, penurious dukes disposed of a large number of them, nonetheless seven of the original pieces have survived. These are a heavy gem-set, enamelled gold chain, three pendants, a gem-set and enamelled gold cup by Hans Reimer and two exquisite caskets. For the first time we have proof that workmanship and historical association were valued above mere intrinsic worth and changing fashion. Thus, when the wife of Duke Maximilian I of Bavaria, Archduchess Maria Anna, wore the great old-fashioned chain, and one of the three pendants over her delicate lace and ropes of pearls in 1640, she was demonstrating her dynastic pride.[3] This Disposition was crucially important and much copied, if not actually by decree at least in practice, by other German rulers. It was part of the tendency which made the possession of an art collection with aspirations to total comprehensiveness, including ethnographica, zoological rarities, scientific instruments, complicated turned ivory cups and small intrinsically precious works of art, an almost essential part of the 16th-century prince's role.

These collections did not just reflect the individual's prestige: when Emperor Rudolph II began to build up his vast collection of sculpture, of paintings, of hardstone cups in gold mounts, of automata, of cameos and of gemstones in the palace at Prague where he had decided to make his residence, it was not merely for his own sake, but for the glory of all the many branches of the Austrian House of Hapsburg. Gemstones and jewellery were especially important in these collections because they illustrated the natural marvels of the universe and they were regarded as having supernatural properties. They gave an opportunity for the display of great virtuosity of craftsmanship, both on the part of the goldsmith, and of the gemcutter, who had to conquer these hard materials. They were expensive, therefore inherently princely, and they satisfied the craving of the later mannerist phase of the Renaissance for rare and exotic materials.

Carved gems in particular were an essential ingredient of these collections. The Renaissance, with its intensified and more accurate appreciation of the world of classical antiquity had brought these tiny and imperishable works of Greek and Roman art to the fore. Lorenzo de Medici was just one of the more famous collectors of them. Contemporary craftsmen began to copy them, originally with intent to deceive, but soon to make new works of art. As the 16th century wore on, cameos became more popular than intaglios, perhaps because they were easier to take in at a glance and they were put in magnificent settings to give them further importance and luxury. Cat. nos. 70 and 86 are examples from Rudolph II's and Henri IV's collections respectively. These jewels were not, as before, kept locked away in strong rooms, but displayed in specially organised rooms, often in chests of expensive ebony, and honoured guests of the prince would be taken to admire them.

Of course, not all the jewellery was for this purpose: a great deal was for wearing, or for giving away (*see* next section), and Rudolph would place his commissions quite differently according to the purpose for which he was acquiring the pieces. If they were for his personal collections they were made by his Court goldsmiths, if merely for the ritual court present-giving, then they might come from Nuremburg, Augsburg, Munich or Vienna[4]. Jewellery travelled fast across Europe and even

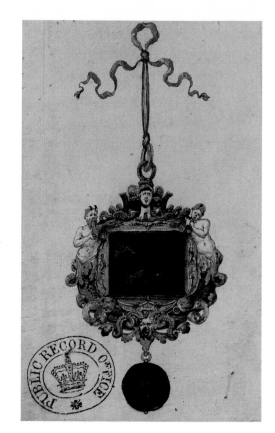

Watercolour of a pendant offered to Henry VIII in 1546. (G48)

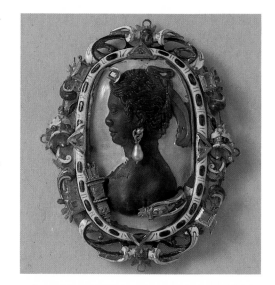

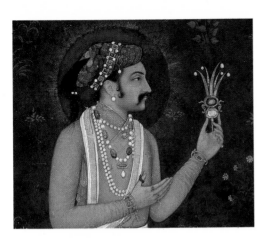

Detail of Mughal miniature, 1616-17, of Shah Jehan holding a jewelled aigrette. (G45)

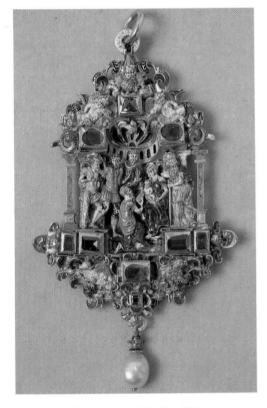

'Tabernacle' pendant, *c*1560-70. (29)

Left:
Cameo in an enamelled and gem-set mounting, almost certainly from the collection of Emperor Rudolph II. (70)

Left:
Cameo of Silenus in an enamelled gold frame, almost certainly from the collection of Henri IV. (86)

further afield through this obligatory present-giving. Shah Jehan was painted holding what is clearly a Western aigrette (cat. no. G45) which was almost certainly a present from an envoy. Every triumphal progress of a prince through the country, every diplomatic mission, every New Year, and all major events in the life of a princely family were marked by the giving of jewellery.

A bride would bring jewels with her from her own Court quite apart from what she was given when the marriage took place—Anna of Denmark arrived for her marriage to Augustus of Saxony in 1548 with fifteen important pieces of jewellery[5] along with her brocades, damasks and velvets. The Hapsburgs, who married into every Catholic royal family quickly spread a dynastic network all over Europe which tended to unify styles.

But the diffusion of jewellery through present-giving and marriages was as nothing compared to its circulation as security for loans. If it was a time of unprecedented splendour at Court, it was also politically very troubled. Long, draining military campaigns meant that nearly every European prince was short of money. Even Rudolph II, who loved his collections and refused to use them as security, began his reign by putting 308 items of plate, jewellery, (mostly, one suspects, rather outmoded pieces), in pawn to Queen Elizabeth of England. It was a very large loan, and prominent courtiers, Walsingham, Cobham and Davison negotiated it on 27th September 1578 at Antwerp, the major centre both for finance and for jewels[6]. The pledge was never redeemed and the items have now disappeared. It is debatable whether they ever moved from Antwerp to England; they probably stayed there as abstract 'commodities' until they were eventually broken up.

The close involvement of the goldsmiths' trade with finance is shown by a curious transaction between Henry VIII and Antwerp agents in January, February and March of 1546. Henry needed 100,000 crowns for his campaign against the Scots, but could only persuade the Antwerp merchants to lend 50,000 in cash, and the rest in jewellery, on both of which he had to pay interest. One of the pieces of jewellery is illustrated in the correspondence (cat. no. G48) and its setting is extremely fine and completely up-to-date: nonetheless it is clear that the artistic quality of the jewel was of minor importance in this transaction.

What becomes clear from all this, then, is that, although there may have been minor inclinations towards local fashions, every court would have been exposed to large quantities of jewellery from other centres, and to try to define national styles precisely is foolhardy and irrelevant.

Occasionally a contemporary inventory gives a tantalising glimpse of how this question was regarded at the time: 'Paris work', at least in Saxony, seems to have meant hollow, pierced work and filigree[7], not work made in Paris. Similarly 'Spanish work' appears frequently in the inventory made after Emperor Matthias's death in 1619, always applied to work clearly of Prague origin, and seems to have meant heavy enamelled gold with a scrolling pattern in reserve (*see* cat. no. 68). The French may have meant those tiny sculptural tabernacle jewels (cat. no. 29) when they referred to pieces as being in 'the German manner'. The inventory of the jewels belonging to Madame Claude of France, Henri IV's sister, describes two figurative pendants thus, one with the Resurrection, the other with Pyramus and Thisbe.

Considering the high cost of the materials and the consequent capital risk involved, a surprising amount of jewellery was ready-made in the major centres of production. These pieces changed hands at the big fairs such as the one at Saint-Germain.[8] The Frankfurt-am-Main goldsmith Leonard Zaerle, who supplied the Medici Court in Florence from 1591 onwards, used to send jewellery and unset gemstones on a sale or return basis. For example, in 1593 he despatched two pendants, a diamond parrot and a pelican respectively; if they were not wanted they were to be sent back separately wrapped to look like a letter so as not to arouse suspicion[9].

It was, however, more usual to commission the more expensive pieces of jewellery from a member of the goldsmiths' guild in one of the important centres (which were

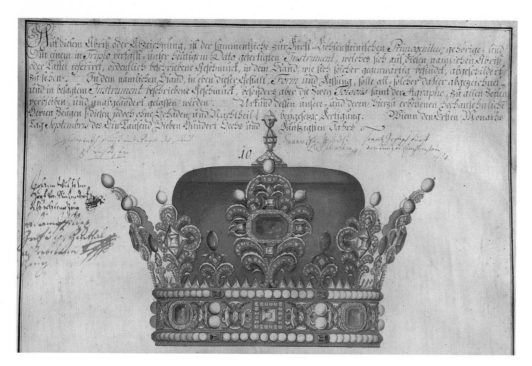

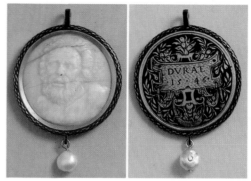

18th century watercolour of the Liechtenstein ducal crown. (G46)

Pendant, dated 1546, set with an alabaster cameo and hung with a pearl. The great majority of Renaissance pendants have pearls hanging from them. (15)

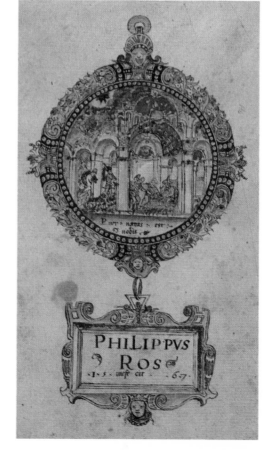

Watercolour design for a pendant by Felip Ros, 1567, from the *Llibres de Passanties II*, folio 225. (G1)

Augsburg, Nuremberg, Munich, Frankfurt, Hamburg, Antwerp, Paris and Barcelona,) or to have them made to order by a Court goldsmith.

Emperors Ferdinand I and Maximilian II, for example, did not have their own court goldsmiths and commissioned work principally from the South German centres but also from a Niklas Muller in Prague, and a Viennese goldsmith called Niklas Gattermair. It was usual to send a wax or lead model of a piece of jewellery for approval before the piece was finally completed.

Many of the successful goldsmiths played a role similar to that of the French *marchand orfevre* in the 18th century, dealing in ready-made pieces and subcontracting orders. Jacob Mores in Hamburg (*see* cat. G35) certainly did this and when the contract for the making of the Abbot of Averbode's pectoral cross (cat. no. 19) was given to the Antwerp goldsmith Reynere von Jaersvelt on 15th September 1562, he passed it to a younger colleague, merely supplying the stones. The making of the Liechtenstein Ducal crown was an even less straightfoward process. Prince Karl ordered it in 1623 from Daniel de Briers, the Frankfurt goldsmith and merchant, who supplied some of the stones. Three craftsmen worked on it, Briers's brother-in-law Jost of Brussels, the jeweller Gottfried Nick, a goldsmith, and Hans Berckman, also a jeweller. The crown was partly made in Frankfurt, then sent to Prague for completion by Jost who was one of the imperial goldsmiths there. Thus the crown was made partly by ordinary guild craftsmen and partly by a craftsman affiliated to the Court.

The growing number of middlemen obviously added to the cost and a court goldsmith who worked directly for the prince at a yearly stipend made jewellery cheaper and allowed the prince greater involvement in the production of the pieces. Some princes took an intense interest in the process of manufacture: the case of Rudolph II is well known, and the Imperial Crown, made for him in 1602 by his Court goldsmith Jan Vermeyen almost certainly reflects his own tastes and historical preoccupations. Catherine de Médicis would also write letters to her goldsmiths in which she described exactly what she wanted (cat. nos. 23 and 26).

Because they were under the protection and patronage of the prince, court goldsmiths did not need to belong to a goldsmiths' guild. The town guilds usually limited membership to citizens of that town while court patronage encouraged cosmopolitanism. Grand Duke Ferdinand I of Florence, for example, took Jaques Bylivelt of Delft into his service from 1573 until he died in 1623. Bylivelt had

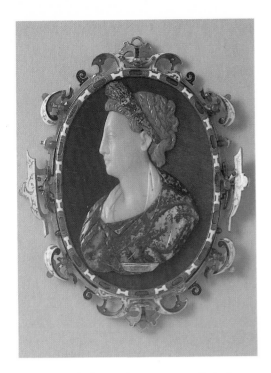

Commesso of Ceres in an enamelled frame, described in 1619 as 'Spanish work'. (68)

lodgings in his Galleria, and goldsmiths from the Netherlands, France, Sweden, Germany and Italy worked for him. He made both the enamelled gold mounts on the semi-precious stone vases for the Grand Duke's collection and jewellery for wearing. His skill, and the high esteem in which his art form was held, is reflected in his very privileged position at Court, where he was treated much more as a courtier than as an artisan. He was given an estate and the Grand Duke even sent him on a diplomatic mission to Queen Elizabeth early in 1597 and he had three audiences with her.[10] Henry VIII employed a goldsmith called Hans of Antwerp who executed the designs of Hans Holbein; among the Flemings and Germans at the Munich Court in the 1570s there was a Giovanni Battista Scolari from Trieste[11], and furthest afield of all, the jeweller and goldsmith Augustin Hiriarte of Bordeaux was taken on by the Mughal Emperor, Jahangir, in 1612[12].

Thus, throughout this whole period, the craft of the goldsmith was one of the most international because so directly under princely patronage. This internationalism of the craftsmen was reinforced by the circulation of published designs. The invention of printing in the previous century led to designs being engraved and etched, and the number of them proliferated with the 16th century. Their title pages proclaim their prospective usefulness to the goldsmith, and the *Llibres de Passanties*, the book of designs submitted by aspirant masters to the Barcelona goldsmiths' guild, shows how they were indeed used: folio 199 in volume 2 shows a pendant drawn by a certain Juan Ximenis in 1561 which is copied from the designs of the Frenchman Pierre Woeriot; folio 353 shows a sphinx-mermonster pendant hanging from fluttering ribbons which derives from the jewellery prints made twenty years earlier by the Collaert family of Antwerp (cat. no. GI).

Care must be exercised when dating and attributing surviving objects on the basis of these published designs because they need not necessarily have been ahead of, or even abreast of, fashion, when they were produced; for example, the book of arabesque designs published in 1548 by Thomas Geminus of London was at least ten years behind the adoption of these motifs by English goldsmiths.

Neither were the people whose names appear on the frontispieces of these design books necessarily the inventors of the designs: Virgil Solis, who was once thought to be an immensely inventive and active Nuremberg designer must, in fact, have borrowed substantially, from other artists such as Cornelis Floris and Peter Flötner because of the implausible eclecticism of the designs attributed to him (cat. nos. G13-15). Thus the design books help to confuse an already confused scene.

The aim here has been to juxtapose as many items of jewellery as possible which are documented, whether externally, by their provenance or appearance in an inventory or a portrait, or internally, with an inscription or a miniature which can be localised. The catalogue entries purposely avoid attributing a country of origin or date where neither emerges clearly from what is known about the piece, in the hope that this will encourage a more flexible and realistic approach towards the whole subject. The jewels should be looked at in relationship to the portraits, which not only bring them to life and show how they were worn, but fill in the gaps in the surviving material—although many pieces still survive, whole categories of objects such as aglets, have disappeared, or, like the large jewel-studded chains, are exceedingly rare.

A. G. Somers Cocks
Assistant Keeper
Metalwork Department
V & A.

1 G. Bapst, *Les Joyaux de la Couronne de France* (Paris, 1889) p. 3

2 Bapst, p. 56

3 Kunsthistorisches Museum, Vienna. Inv. no. 8034

4 Lhotsky, p. 270. He had a strong connection with the Augsburg mercantile house of Warnberger where he bought most of his plate and jewellery for giving away.

5 E. v. Watzdorf, 'Fürstlicher Schmuck der Renaissance aus dem Besitz der Kurfürstin Anna von Sachsen', *Münchener Jahrbuch der Bildenden Künste* XI (1934) p. 50

6 Lhotzky, p. 289 and *Jahrbuch der Kunsthistorischen Sammlungen XIII*, Re. no. 9118

7 Watzdorf, p. 61 The inventory made in 1583 of Duchess Anna of Saxony's jewels lists 'Three chains of hollow pretty Paris work: also a similar belt with a gold button of pretty pierced work.'

8 A. C. Willemijn Fock, 'Der Goldschmied Jaques Bylivelt aus Delft und sein Wirken in der Mediceischen Hofwerkstatt in Florenz', *Jahrbuch der Kunsthistorischen Sammlungen* LXX (1974) p. 126 and note 169. The Frankfurt goldsmith, Zaerle mentions this fair in a letter dated 26th November 1605; apparently the Medici family often bought jewellery at fairs, but this may have been as part of their financial activities rather than as part of their art collecting.

9 Fock, p. 126

10 Fock, pp. 87-178

11 M. Frankenburger, *Die Alt-Münchner Goldschmiede und ihre Kunst* (Munich, 1912) pp. 304-5

12 'Four letters by Austin of Bordeaux', *Journal of the Punjab Historical Society* IV, 1 (1916) pp. 3-17

13 G. Heinz, 'Studien zur Porträtmalerei an den Höfen der Österreichischen Erblande', *Jahrbuch der Kunsthistorischen Sammlungen* LIX (1963) cat. no. 126. pl. 207

Renaissance Jewels in their Social Setting

Renaissance jewels are interesting historical objects as well as exquisite natural phenomena and impressive works of art. The problem faced in any modern appraisal of them, however, is that they are rarely seen in a suitable context. Discovering the significance these jewels held for their original owners and how they were used is a task which demands substantial historical research and a certain amount of imagination. Work in this area has scarcely begun and the generalisations put forward in this essay should therefore be treated with some care.

It is clear enough, however, that in the late Middle Ages and the Renaissance, jewels were appreciated for more than their beauty and rarity. They were believed to have many 'virtues', including the power to protect their wearers, to improve their health and even to increase their mental powers. The diamond, for example, was supposed to be 'good against enemies, wild beasts, venomous beasts and cruel men'; the amethyst was 'good against drunkenness'; the emerald 'maketh a man to understand well and giveth to him a good memory.'[1] Some people were sceptical, like the Elizabethan squire Reginald Scot, who wrote off many of these claims as examples of 'the abundance of humane superstitions and follies', not to mention 'common cousenage', but he too was prepared to admit that 'God hath bestowed upon these stones, and such other like bodies' most excellent and wonderful virtues.'[2] Pulverised pearls and other precious stones were used as medicine for such patients as could afford them.

Jewels were also loved as though they were individuals, and many of them were known to their owners by name. The Duc de Berry, for example, had a ruby known as 'Heart of France'. Lodovico Sforza, the ruler of Milan, had a jewel called 'the Wolf'. Charles the Bold, Duke of Burgundy, owned three rubies called 'The Three Brothers', and James I of England, 'three great pearles fixed, with a faire great pearl pendant, called The Brethren.'[3] Jewels, like relics (themselves sometimes kept in jewelled reliquaries), had what the Polynesians call *mana*, a term perhaps best translated as 'glamour', in its medieval (magical) as well as its modern sense. The crown jewels of different kingdoms, with their rich historical, not to mention mythological associations, possessed this glamour to a supreme degree; the sacred crowns associated with St. Wenceslas, St. Stephen, St. Edward the Confessor, for example.

Like other jewels, the crown jewels were meant for use. Their *mana* rubbed off on the rulers who wore them. They had a political function. Hence Sir John Fortescue's remark about the king's special need for 'rich stones' and 'other jewels and ornaments convenyent to his estate roiall.'[4] Their best-known use was in the ritual of the coronation, which made a man a king rather than simply showing that he was one, but needed the regalia to be efficacious. When Albert II of Hungary died in 1440, and the Estates elected his successor, Albert's widow, Queen Elizabeth, had the sacred crown of St. Stephen stolen and her baby son crowned Ladislaus V. In the Middle Ages, kings wore their crowns for major festivals; William the Conqueror wore his for Christmas, Easter and Pentecost. The Doge wore his crown on the Thursday before Lent, when he sat at the window of the Doge's Palace to watch the festivities of the Carnival.

It is obvious from the portraits of the period that for private individuals as for rulers, one of the main functions of jewels was display. They were a particularly conspicuous sign of status. Men as well as women wore jewels to mark special occasions. They wore jewelled collars, like the collars of the Order of the Garter or the Burgundian-Hapsburg Order of the Golden Fleece, or at the least golden chains. Isabella d'Este, a Renaissance woman with a taste for expensive jewellery and an eye for its value, noted that when Lucrezia Borgia came to Ferrara, seventy-five of the Duke of Ferrara's gentlemen wore golden chains, 'none of which cost less than 500 ducats, while many were worth 800, 1000 and even 1200 ducats.'⁵ Men as well as women wore bracelets, like the 'Bracelet of precyouse stone' which Francis I gave Henry VIII at the Field of Cloth of Gold.⁶ They wore jewelled armour. They wore jewels in their hats: James I sometimes wore in his hat a diamond 'of wonderful great value', and Charles the Bold a jewelled feather composed of five rubies, four diamonds and 73 pearls.⁷ Jewels were among the most splendid of the status symbols of the period. The noble monopoly of these symbols was protected by sumptuary laws. Wearing jewels was part of what was meant by the contemporary phrase 'living nobly'. Indeed, the Renaissance architect Antonio Filarete once compared the nobles to precious stones, citizens to semi-precious stones and peasants to common stones.

Jewels and plate were also put on display at the meals of great men on great occasions. At a banquet of the Order of the Golden Fleece at the Hague in 1456, there were three dressers full of plate, one filled with jewelled articles 'for display' (*de parement*), the others with gold and silver plate for the use of the guests.⁸ Golden ships were a not uncommon form of table decoration, like the ship pulled by a silver swan displayed at the Feast of the Pheasant at Lille in 1454. It was for such settings of ritualised feasting that artists of the calibre of Cellini and Jamnitzer created their famous salt-cellar and ewer.

At other times, plate and jewels were kept in the treasury or 'jewel-house'. However, visitors might be allowed to see them, although the exhibition as an institution did not yet exist. Leo of Rozmital, a Bohemian nobleman who was in Brussels over the winter of 1465-6, went to see the treasury of the Duke of Burgundy, though he was unable to see everything, 'for the keeper of the jewels said that he could not show them in three days. He told us that his lord has so many jewels that he had not seen them all in many years and indeed did not know where they were.'⁹ Claims like these were naturally good for the duke's prestige. A treasury of this kind was a political asset.

In case of need, that asset might be realised—the plate melted down and the jewels pledged as security for loans. In 1561, Philip II of Spain sold three of the Hapsburg crowns to raise cash. A generation later, Sigismund Vasa, King of Sweden, pawned the crown jewels to raise an army, though this did not prevent him from being deposed by Duke Karl, later Karl IX. But a much more important function of treasure, second only to display, and as useful politically, was for it to be given away—to the right people on the right occasions.

Historians are indebted to anthropologists for their exploration of the social functions and meanings of gifts. The pioneer in this area was Bronislaw Malinowski in his study of the Kula, a form of exchange carried on by the inhabitants of a group of islands in the Western Pacific, near New Guinea. These islands 'form a closed circuit . . . along this route, articles of two kinds, and these two kinds only, are constantly travelling in opposite directions.' Red shell necklaces always move clockwise, while white shell bracelets go the other way. Like the Crown Jewels (the comparison is Malinowski's), these bracelets and necklaces are objects of 'parade', and also objects of sentiment. 'Every really good Kula article has its individual name.' The exchange of these ornaments was accompanied by rituals, such as blasts of the conch-shell, and it was regulated by convention. The 'opening gift' (*vata'i*) was distinguished from the more valuable parting gift (*talo'i*). Each gift had to be repaid by an equivalent counter-gift, but only after a certain amount of time had elapsed. In

the long term, no one accumulated ornaments and no one lost them, making it obvious that the function of the Kula system was not economic but social; it was to maintain good social relations between different groups.[10]

The Kula ring involved communities rather than individuals and the exchanges took place between equals. In late medieval and Renaissance Europe, on the other hand, gifts of plate and jewels tended to involve individuals and often took place between unequals. The value of this brief reference to the Western Pacific does not lie in any precise analogy between the two situations, but in the more general conclusions about the social functions of the gift and the conventions surrounding it, notably the obligation to give, the obligation to receive, and the obligation to repay.[11] Let us return to the fifteenth and sixteenth centuries and look at who gave what to whom, on what occasions, for what purposes, and with what returns.

Gifts tended to flow downwards because giving, as Aristotle put it in a passage well known at this period, is better than receiving. Giving to the proper recipients was a manifestation of liberality or *largesse*, a virtue located between the extremes of meanness and prodigality.[12] Like display, liberality was part of the princely or noble style of life. There was also a movement of gifts upwards. Nobles and cities presented their rulers with gold and jewels, while at a humbler level Queen Elizabeth's laundress offered her an embroidered handkerchief on New Year's Day, and the Earl of Northumberland's footmen offered him gloves on the same occasion.

What was given by princes and nobles included land, money (cash or pensions), titles, horses and other animals, and of course hospitality. However, as in the days of *Beowulf*, when a king could be described by the epithet 'giver of rings', gold and jewels were the basic currency of *largesse*.

The recipients of gifts included the poor, who received their maundy money from the sovereign on Maundy Thursday. However, the recipients of large gifts, as opposed to alms, were the magnates, those who had the duty of giving in turn. In contrast to the simple circuit described by Malinowski, we find the prince making large gifts to his nobles, who made smaller gifts to their subordinates, and so on down the social hierarchy. It is taxation, which in this period is becoming more and more distant from the idea of a 'free gift' from subjects to ruler, which completes the circuit and replenishes the royal treasury. Only between princes does a simple exchange operate.

Gifts were handed over in public, in special places and at special times. In *Beowulf*, which presumably represents the social conventions prevailing at some point in Anglo-Saxon times, the king made his distribution of rings at a feast in hall, and the recipient drank to him. In the fifteenth and sixteenth centuries, a favourite time for the presentation of gifts was the New Year, a traditional occasion of crown-wearing in 'full court', and a time of ritual exchange which had its legendary reflection in the story of the Magi, kings bearing gifts, including gold, to a still greater king. Charles VII of France, for example, gave *grosses étrennes* of diamonds and rubies to René of Anjou and the lords of Clermont, Armagnac and Vendôme, and *menues étrennes* to his physicians, astrologers and other servants.[13]

At the English court, in the reign of James I, New Year gifts had become standardised, and the ritual of giving bureaucratised. Gifts to the king were made in gold pieces; gifts from the king came in gold plate. The procedure was recorded by the Earl of Huntingdon. 'You must buy a new purse of about v s. price, and put thereinto xx peeces of new gold of xx s. a piece, and go to the Presence-Chamber, where the Court is, upon New-Yere's day, in the morninge about 8 o'clocke, and deliver the purse and the gold unto my Lord Chamberlin, then you must go down to the Jewell-house for a ticket to receive xviii s. vii. d. as a gift to your paines, and give vi d. there to the boy for your ticket; then go to Sir William Veall's office, and shew your ticket, and receive your xviii s. vi d. Then go to the Jewell-house again, and take a peece of plate of xxx ounces weight, and marke it, and then in the afternoone you may go and fetch it away, and then give the Gentleman who delivers it you xl s. in

gold, and give to the box ii s. and to the porter vi d.'

Queen Elizabeth, by contrast, had received more splendid gifts than gold pieces on her birthday and coronation day, as part of the process by which she was courted by Leicester, Burghley, Hatton, Sidney and the rest. They said it with jewels in the form of frogs and phoenixes, squirrels and salamanders. Elizabeth was less generous in return, though she did pass on some of the gifts as wedding presents, and gave Sir Thomas Heneage the jewel which bears his name. By Aristotle's standards, she erred on the side of meanness, as James erred on the side of prodigality. He once gave the Duchess of Lennox 'a fair chain of diamonds with his picture on it, valued by the jewellers at £8,600', for looking after the Marchioness of Buckingham.[15]

Other occasions of public gift-givings to and from princes included rites of passage like weddings, christenings, and coronations. In England, it was customary for the newly-crowned king to give the Lord Mayor of London a golden cup. State visits were also occasions for an exchange of gifts. When Philip the Good of Burgundy met Louis of Bavaria in 1454, the Bavarians gave each of Philip's courtiers a jewelled clasp. Henry VIII and Francis I exchanged gifts 'for remembrabrunce' at their leave-taking at the Field of Cloth of Gold. Royal visits to subjects were favourite occasions for the upward movement of gifts. When Queen Elizabeth did a subject the favour of staying in his house, she expected a present on her departure, and when rulers entered cities in their kingdom, this state 'entry' would be marked by a gift, often a gold or at least a silver gilt cup, like the one Elizabeth received at Sandwich in 1573 or James at Lincoln in 1617. Each prince had his own occasions for giving and receiving. The pope, for example, sent a golden rose to a ruler of his choice every year on the fourth Sunday in Lent.

These gifts were given because it was customary to give them, because the roles of liberal prince and loyal subject required them. Big men knew that this was the way to build up a political following. John the Fearless, Duke of Burgundy, gave jewels to some of the prelates at the Council of Constance, doubtless for services to be rendered. Small men knew that (as a correspondent of the Paston family once put it), 'Men do not lure hawks with empty hands'. The world turned upside-down image of the poor giving presents to the rich underlines the fact that European society in the fifteenth and sixteenth centuries was divided into patrons and clients.

However, the upward movement of gifts also needs to be seen as a kind of democracy, a way in which the relatively powerless could exert pressure on the powerful. When Louis XI entered his city of Tournai in 1464, the town council decided to give him a jewel worth a thousand francs. The next resolution recorded was to ask the king for a favour.[16] Rulers were not exempt from the obligation to repay. To give and to receive were political acts. To give was a declaration of intent to ask for a favour. To refuse was difficult because of the obligation to receive. To accept was, however, to expose oneself to requests which could not easily be denied. This process of giving and requesting went on at different social levels. The Paston Letters are full of technical terms referring to this process, to the need to 'labour' someone to get something done, to the importance of 'well willers' and of 'good lordship'. A certain Sir William Oldhall was offered over £2,000 for his good lordship in 1450.

Historians have sometimes spoken a little glibly of the 'bribery' and 'corruption' prevalent in this period. No doubt there were occasions when individuals overstepped the limits of the permissible. There are famous stories about the gifts which Thomas More refused ('forty pounds in angels . . . for a New Year's gift'), and those which Francis Bacon accepted. However, it is somewhat ethnocentric to condemn bribery and corruption without making a study of the conventions regulating gifts in this period. Such a study has not yet been made. The social history of the gift remains to be written.

Dr. Peter Burke,
Emmanuel College,
Cambridge.

1 *The Book of Secrets of Albertus Magnus*, ed. M. R. Best and F. H. Brightman (Oxford, 1973) pp. 31, 34, 44.

2 R. Scot, *The Discovery of Witchcraft* (1584) Book 13, ch. 6: (London, 1886 ed.) p. 239.

3 *The Progresses of King James I*, ed. J. Nichols (London, 1828) vol. 2, p. 544.

4 J. Fortescue, *The Governance of England* (Oxford, 1885) p. 125.

5 J. Cartwright, *Isabella d' Este* (London, 1903) vol. 1, p. 203.

6 E. Hall, *The Triumphant Reign of Henry VIII* (London, 1904) p. 218.

7 F. Deuchler, *Die Burgunderbeute* (Bern, 1963) p. 121.

8 G. Chastellain, *Oeuvres*, 8 vols (Brussels, 1863-6) vol. 3, p. 91.

9 Leo of Rozmital, *Travels* (Cambridge, 1957) p. 28.

10 B. Malinowski, *Argonauts of the Western Pacific* (London, 1922) 81 f.

11 M. Mauss, *Essai sur le don* (1923-4), trans. as *The Gift* (London, 1954).

12 Aristotle, *Ethics*, Book 4, ch. 1; *see* D. Bell, *L'Idéal ethnique de la royauté en France au Moyen Age* (Geneva and Paris, 1962).

13 M. Vale, *Charles VII* (London, 1974) pp. 218-27.

14 *Progresses of James I*, vol. 2, p. 471 n.

15 *Progresses of James I*, vol. 4, p. 756.

16 *Les entrées royales francaises 1328-1515*, ed. B. Guénée and F. Lehoux (Paris, 1968) p. 188.

Sources of Gemstones in the Renaissance

For two thousand years or more India was the only major source of diamonds, although an unknown but probably small quantity emanated from Borneo. Following the discovery of diamonds in Brazil in 1725, the Indian output declined considerably and, in turn, Brazilian production was surpassed by the prolific South African mines after the discovery in 1867 of diamond among the pebbles along the Orange river. Most diamonds used in Renaissance jewellery were undoubtedly of Indian origin.

The widespread but now largely derelict diamond deposits in India may be divided into five main groups. Traced northwards these are:

1) The Cuddepah group along the Penner river, which rises in the Mysore highlands and flows into the Bay of Bengal north of Madras. Deposits at Jennoor and at Bellary are included.

2) The Nandyal group between the Penner and Kistna rivers including those at Nandyal, Baganapalle, Ramulkota (probably the *Ralconda* of Tavernier, the 17th century French traveller), Kurnool (Karnul) and Wajrah Karur which became famous for the number of stones exceeding 60 carats in weight which were found there.

3) The Elure group on the lower Kistna river. This includes the important mines at Kollur (Tavernier's *Geni Coulour*) and Parteal. It is the Golconda group of some authors, although Golconda is really the name of a fortress near Hyderabad formerly used as a diamond store to the north west of the Golconda group. The mines of Chota Nagpar are also included.

4) The Sambalpur group on the Mahanadi river. These are said to have been the richest deposits in India and included a mine on the island of Hirakhund in the Mahanadi near Ihunan. Mines at Wairagah have been included in this group and were probably the Beiragah mines recorded by Tavernier.

5) The northern Panna group (not mentioned by Tavernier but one of the few still worked in 1980) is interesting geologically, since three types of deposits are found there—in pipes (as in South Africa), in conglomerates (ancient compacted river gravels) and present-day alluvial or river deposits.

From a study of the ancient Indian lapidaries and the writings of Tavernier (*c*1660) and later authors, it appears that the general grouping described above was well known by the 6th century AD. According to C. W. King[1], the Portuguese writer Garcia ab Horto was among the first to publish (*c*1563) authentic accounts of Indian diamond mining, but Eudoxus Cyzici[2], who visited India about 120 BC specifically mentions in his report sites next to river alluvions as being places of diamond production. Marco Polo also gave many details of Indian riches at the end of the 13th century. It appears that the occurrences of diamond in river gravels and in conglomerates were known from antiquity, as were methods of extraction such as surface working and mining from pits up to 15 metres (50 feet) deep. When the rock overburden was sufficiently firm, short tunnels were driven from the pits into the diamond bearing conglomerate layer, but mining techniques did not develop further.

The exact dates of working of Indian mines are generally uncertain, but not all are of great antiquity, as is often supposed; many began after AD 1000. It has been asserted that diamonds were in production in India as early as 600 BC, but

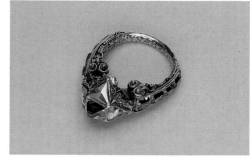

Diamond ring of Queen Isabella of Hungary, between 1539 and 1569. (16)

Pendant set with diamonds making up the sacred monogram IHS. (56)

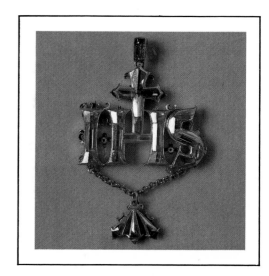

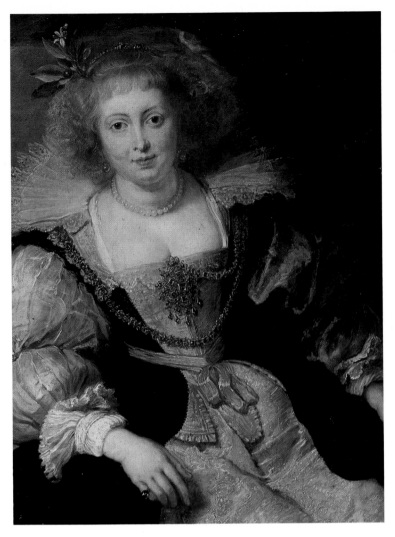

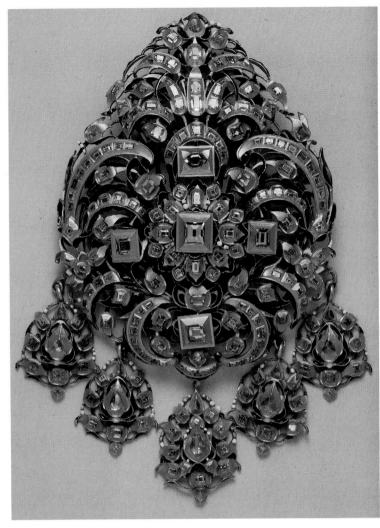

Portrait by Peter Paul Rubens of his second wife, Hélène Fourment, whom he married in December 1630. The breast ornament she is wearing is very similar to that shown on the right.

Right:
Breast ornament, *c*1630, set with table-cut and facetted point-cut diamonds. (114)

documentation of the ancient Indian lapidaries is lacking before the 3rd century BC. Laufer's[3] study of Chinese manuscripts suggests that there was a trade in diamond engraving tools between Rome and China from AD 168, or even earlier; these diamonds almost certainly derived originally from India and the tools were fabricated in Rome. The wider spread of diamonds into western Europe possibly coincides with the beginning of Islamic invasions into India (AD 1001). The Persian historian, Firishta, writing about 1600, tells of the Ghorid invader, Ghijas-ed-Din Mohammed ibn Sam, who is reported to have left 500 muns (400 pounds or 180 kg) of diamonds at his death in 1203 after some 32 years of plundering India coupled with control of the Panna mines.

Before Vasco da Gama's discovery in 1498 of the sea passage to India via the Cape, there had been two main routes to Venice, the principal centre for the luxury trade with the East, since as early as the 8th century. The trading centres in India had included ports on the Kalinga coast (west of the Bay of Bengal), Bihar, Oudh in the Ganges plain—the diamond production areas—and ports on the Gulf of Cambay and Gujarat (Kathiawar)—the export centres. The northern route passed through Hormuz (Ormus), the Persian Gulf, Aleppo and Constantinople, while the southern route went by sea past the Hadhramaut to Aden and thence to Cairo and Alexandria either overland or through the Red Sea. There was, of course, filtering of the good stones *en route* by the merchants acting for the gem-conscious rulers of Egypt and Ethiopia, and it appears that better stones arrived in Venice by the northern route. Following the opening of the Cape route, the Portuguese established trading centres at Goa (1510),

13

but continued using other west and east coast ports such as Madras. Bartholomeo de
Pasi, writing on Venetian commerce around 1490, records regular shipments of
diamonds from Venice (then approaching its heyday) to Lisbon, Antwerp and Paris.
He distinguished between *diamanti* (rough diamonds), sent to Antwerp for finishing,
and *diamanti in punta* (natural crystals with polished faces, effectively the point cut),
which went to Lisbon and Paris. The discovery of the Cape route had resulted in the
expansion of Antwerp (supplied through Lisbon) as the diamond market and

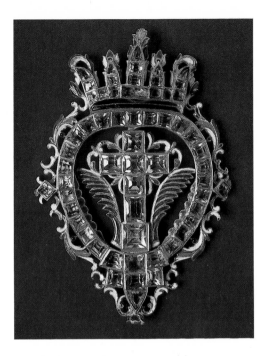

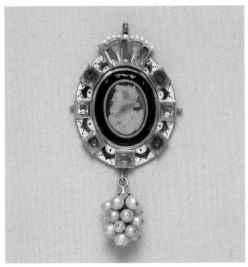

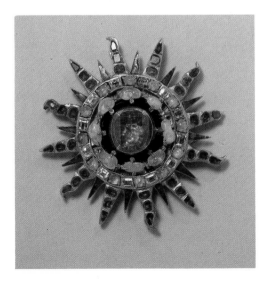

finishing centre during the first half of the 16th century, and the blossoming of Augsburg and Nuremberg and the gradual eclipse of Venice by the end of the 17th century. As a result of the Wars of Liberation (1568-1648), with the curtailment of religious freedom, and because of insistence on workers belonging to a guild, Antwerp lost many of its cutters to Amsterdam. Frankfurt also gained from this emigration and its prosperous Fair became a focal point for the gem trade, commercial and money markets. Wars in the 1630s resulted in the decline of Frankfurt and the rise to major importance of Amsterdam early in the 18th century. This had been helped by the activities of the Dutch East India Company in the Far East. As early as 1609, this company had sought to establish a monopoly to ship diamonds from Borneo and to supplant earlier traders on the ancient diamond trade routes between Java and China via Thailand.

The name diamond is derived from the popular Latin form, *adimantem*, itself derived from the Greek meaning unconquerable, in allusion to its supreme hardness and the mistaken idea that it would resist hammer-blows. In Pliny's time as many as six types of 'adamas' were recognised, but since medieval times the name has been restricted. The French form *diamant* and the earlier English forms *dyamaund*, *daimounde* and *adamaund* were replaced by the modern spelling during the mid-16th century.

In Renaissance jewellery examined by the author and his colleagues, many stones formerly described as diamonds have been proved to be rock-crystal (colourless quartz), but paste (glass) is common, and topaz and beryl have also been identified. The name diamond with a locality prefix, e.g. 'Bristol diamond', is commonly used, but the stones are usually rock-crystal; among similar prefixes are 'Alencon', 'Brazilian', 'Buxton', 'Cornish', 'German' and 'Bohemian'. 'Saxony diamonds' are colourless topaz. However, 'Matara' and 'Ceylon' diamonds are near colourless zircons (sometimes termed jargoons) which have usually been heat-treated; they are often very slightly milky. Jewellery set with these stones (including Renaissance pieces) first originated during the Portuguese occupation of Sri Lanka (Ceylon), some four centuries ago, when impressed lapidaries in garrisons there used the local zircons which vied with diamonds in their brilliance. However, the term 'Laxey diamond' refers to shallow tablet-like Indian stones known as *lasques* and probably cut from cleavage pieces. It has no connection with the lead/zinc mines at Laxey in the Isle of Man.

Ruby and sapphire, the principal gemstone varieties of the mineral corundum, have attracted man since earliest times on account of their hardness and the glorious colours they display when at their finest. The name ruby, from the Latin *ruber* (red) was used loosely in medieval times for all red stones, but was eventually restricted to the hardest. Sapphire, possibly derived from the Sanskrit, was in Greek and Roman times used for lapis-lazuli and possibly other opaque blue minerals. Today (and probably in Renaissance times also) the term is restricted to the blue variety of the mineral corundum, other colours being specifically described, e.g. green, yellow or purple sapphire; red corundum is, of course, ruby.

The varieties of corundum occur in a number of different geological environments, and their origins are often reflected in the microscopic inclusions which they contain. These inclusions may help in deciding the area from which a particular stone originated. Rubies from Burma may be identified with some degree of confidence if they contain rounded crystals of zircon or if characteristically arranged needles of ruttle or minute crystals of calcite are observed. The colour of Burma rubies is often a very pure purplish-red, whereas stones from Thailand and Cambodia may have a slightly brownish tinge caused by small amounts of iron replacing the aluminium in the mineral lattice. Burmese rubies actually fluoresce bright red in daylight and this is strikingly reinforced under ultra-violet radiation. The iron in the Indo-Chinese stones often inhibits fluorescence.

The rubies (mostly table-cut) examined by the author in Renaissance jewels from the collections in the British and Victoria and Albert Museums show by their colours

and inclusions that a very high proportion are almost certainly of Burmese origin. Ceylon rubies are more commonly paler in colour, and stones from India are of poorer quality. Rubies from Afghanistan are reported in the older literature, and a study was made therefore of rubies from Jagdallak in the British Museum (Natural History) collections. These proved to have almost as good colours as the Burmese stones and occurred in a similar limestone matrix. Thus an Afghan source for some early rubies cannot be excluded, but any such material it totally subordinate to that from the major Burmese source. Continental African deposits were unknown in Renaissance times.

It is less easy to be sure of the source of sapphires seen in Renaissance jewels. The prolific gem deposits in the ancient province of Sabaragamuwa, south-east of Colombo in Sri Lanka have been known for thousands of years and Sinbad's 'Valley of Gems' in 'A Thousand and One Nights' could well be in the neighbourhood of Ratnapura, the gem centre of the province. Sri Lanka is virtually certainly the source of many sapphires, and feather-like inclusions typical of this locality have been seen in Renaissance jewels. The discovery of a finger ring with a large pale blue sapphire containing typical 'Ceylon' inclusions in the tomb of Archbishop de Gray during reconstructions in York Minster affords proof that this locality provided sapphires as early as the mid-12th century when the prelate died. Burma, too, has produced magnificent stones and cannot be ruled out as a source, unlike Australian and African deposits which are prominent today but were then unknown. The beautiful stones from Cambodia were discovered in the 1870s, but those from Thailand were known earlier. It is very doubtful if the superb sapphires from Kashmir were being mined in Renaissance times.

Emerald and aquamarine are varieties of the mineral beryl; both are used in Renaissance jewellery but emerald is of far greater importance. Emeralds were well known to the ancient Egyptians; their sources were probably Jebel Zubara and Jebel Sikait, the so-called Cleopatra's Mines, some 25 km inland from the Red Sea in Upper Egypt. These mines were abandoned at some point and not re-discovered until 1818 by the French explorer Cailliaud. The Romans certainly knew emeralds, possibly from Egyptian sources but also from Habachtal in the Salzburg Alps, and stones from the latter locality have been noted in Renaissance jewellery. Localities in the Urals have been suggested as early sources for emeralds, but the major source on the Takovaya river near Sverdlovsk was not discovered until 1830. Emeralds from these localities, all formed in a mica-schist matrix (often with quartz), sometimes attain good colours but generally tend to be pale and often turbid. They do not compare in colour with the glorious Colombian emeralds which became available in Europe after the voyage of Colombus in 1492 and the subsequent exploration of Central and northern South America. These superb stones were first discovered by the Spaniards in temples and graves in Peru and Mexico and were sent back to Spain soon after the initial voyage. In fact, Muller[4] records that Spanish silversmiths were active in the West Indies by 1495 and a Spanish jeweller was active in Hispaniola by 1512. The actual sources[5] of the emeralds are in Colombia. The Spanish possibly knew about them first in 1537, and by 1558 they were working the mines in the Muzo area despite the hostility of the Indians.

The Colombian emeralds are found in a matrix of shale or calcite (or both) and this contrasting mode of occurrence is reflected in the minute internal inclusions when viewed under the microscope. Whereas stones formed in mica-schist often contain flakes of mica and other metamorphic minerals, the Colombian stones often contain tiny spiky cavities filled with liquid, a bubble of gas and a cube of salt. These inclusions are so characteristic of the locality that it is possible to identify the provenance of a stone with considerable certainty, and many of the emeralds examined in the Renaissance collections of the Victoria and Albert and British Museums are of Colombian origin.

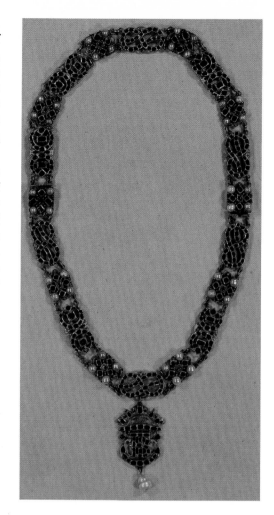

Necklace, set with table-cut rubies, diamonds and pearls, c1610. (119)

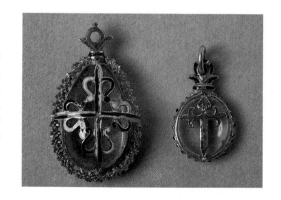

Pendants of the Spanish Inquisition (111) and the Order of Santiago (112), the former set with a large Colombian emerald.

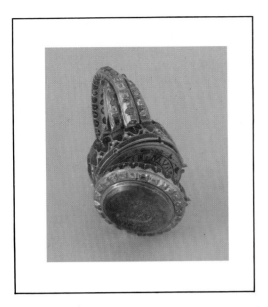

Watch seal ring, *c*1610-20, set with a large emerald carved with the imperial arms. (84)

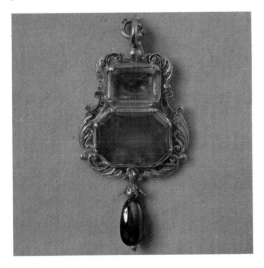

Prophylactic pendant hung with a polished sapphire and set with a hessonite garnet and a peridot. (8)

During the early searches for emeralds in Central and South America, Brazil was thought to be a source for emeralds, but early finds proved to be green tourmaline, and emeralds proper do not appear to have been discovered there until 1913 at Bom Jesus in Bahia state. Sri Lanka is not a source for emeralds, but fine aquamarines have been found there as well as in India, and the island possibly provided stones during Renaissance times; Russia was another possible source. Emeralds have been found in India since 1943 near Udi apur and Ajmer and more recently in Pakistan in Swat state. These are modern discoveries, however, and it seems uncertain whether India was a source in Renaissance and earlier times; the possibility that stones from Egypt reached Europe via India cannot be excluded.

Spinel is not very well known in jewellery, but it does merit attention as the gem mineral forming the 'Black Prince's Ruby' and the 'Timur Ruby' of the British Crown Jewels, and the prominent stones in the former Russian and French Crown Jewels. These fine red spinels vie with ruby in the superb colours they attain and Burma is almost certainly the source of these large gems and of smaller stones set (knowingly or not) alongside rubies in the Renaissance jewels and their later imitations in the London collections. They were collected by Marco Polo as early as the 13th century in the province of Balascia (the present day Badakshan of Afghanistan), and the area cannot be discounted as a source in Renaissance times. The old name for spinel, balas-ruby, probably derives from Balascia, where spinels are found with rubies in white limestone—as they are in Burma and in the recently discovered deposits in the Hunsa Valley in Pakistan. Sri Lanka is another ancient source for spinels, but blues and purples predominate and these colours were little used in early jewellery. The older names balas-ruby, and rubicelle for orange spinel, should be dropped, as should the term hyacinth which has been variously applied to reddish-brown spinels, zircons and hessonite garnets.

The name chrysoberyl is derived from the Greek for golden beryl and it is possible that the term was originally applied to such stones. In some Renaissance jewellery, but more commonly in later Spanish and Portuguese jewellery, the mineral is best known for the very bright pale greenish-yellow stones it provides which look so attractive when set in groups. These stones were recovered from alluvial deposits in Brazil following the Iberian conquest. Sri Lanka provides a wide colour range of chrysoberyl from pale yellow through green to brown, including the now highly prized cat's-eye variety, but these stones are not commonly encountered in Renaissance jewellery. Russia is another source of chrysoberyl, especially for the colour-change variety alexandrite, which was not discovered until 1830 on the birthday of Czar Alexander II—hence the name.

At this point it may be prudent to examine some nomenclature problems. The term chrysolite (golden stone) has been applied to pale yellow chrysoberyls and also to leek green peridot (the mineral olivine). To complicate matters still further it seems that the term chrysolite as used by ancient writers probably applied to topaz, and that the green peridot from St John's Island (Zebirget) in the Red Sea (probably the only source of gem quality peridot in Renaissance times) was known as topaz to Pliny. Confusion is avoided if the modern, mineralogically-based, terms are used.

Garnets of the slightly yellowish red pyrope variety have long been known from Bohemia ('Bohemian rubies'), and Bauer[6] quotes Boetius de Boot, who published a historical lapidary in 1609 in which he describes a pyrope the size of a hen's egg in the possession of Kaiser Rudolph II. The Bohemian pyropes are found in near-surface gravels, and their presence led to the development of a local cutting industry. Pyrope-almandine garnets are very widely distributed in India and Sri Lanka and these countries were the source of many of the purplish-red stones (sometimes resembling ruby) seen in Renaissance jewellery. However, it must be mentioned that both varieties of garnet may vary in colour, although this is no guide to mineralogical composition. The orange-red to orange-brown hessonite garnet is also encountered in

Renaissance jewels; the stones often have a granular appearance under the hand lens, very characteristic of material from Sri Lanka, which was almost certainly their source. Garnets are widespread in distribution and gem quality deposits are now known in many countries.

In the past, the term topaz denoted a yellow stone to many people and for others all yellow stones were called topaz. Confusion was eased but little by the use of the term 'Brazilian topaz' for true topaz. Other misleading terms included 'Spanish topaz' and 'topaz quartz' for yellow quartz (citrine). All such terms should be discontinued. The term topaz as used in old inventories is therefore suspect and many of the stones thus described may be yellow quartz. Yellow topaz has been known from Schneckenstein in Saxony since at least the end of the 18th century and possibly earlier. Colourless topaz from the old tin-mining districts of Central Europe possibly provided much material which passed as rock crystal when cut. Russia was a source of fine topaz but the principal localities were not discovered until the 18th or even 19th centuries. The fine yellow topaz from Ouro Preto in Brazil was found about 1760, but stones of paler colour could have been obtained from river gravels considerably earlier. Thus the sources of topaz in Renaissance jewellery remain uncertain.

Precious opal was known to the Romans and opals were included in the parure given to Elizabeth I by Sir Christopher Hatton[7] on New Year's Day 1584. These opals came from the deposits in volcanic lava near Czerwenitza, formerly in Hungary but now in Czechoslavakia. These stones were originally marketed via Constantinople and this gave credence to the idea that they came from the East, but in fact precious opal is not known in India. These opals were supplanted by the magnificent stones which were discovered in Australia in the 1870s. Central America, including Honduras, Guatemala and Mexico, also provides precious opal, including the red and orange-red fire opal. The latter was known to the Indians and the Spanish possibly obtained it in Renaissance times. However, some Central American fire opal deposits were only discovered in the 1830s and fire opals in some jewellery could be later substitutions, or the whole object could be of later manufacture.

The mineral quartz in its various forms was extensively used in Renaissance objects. The transparent crystalline varieties include rock crystal (colourless), citrine (yellow), amethyst and smoky quartz. Jasper is a coloured, impure and relatively finely crystalline variety and includes the 'oriental jaspers' and 'Bohemian jaspers' mentioned in the inventory of the Prague treasury of Emperor Rudolph II. Chalcedony is the very fine-grained or cryptocrystalline variety of quartz. Chalcedony (cawesdon of Tudor times) is broadly divided into two groups by colour and by structure. Coloured varieties include carnelian (red), sard (brown), chrysoprase (light green), prase and plasma (dark green). Structured varieties include agate (bands of various colours), onyx (black/white bands) used for cameos, sardonyx (brown or red and white bands), bloodstone (green with red spots), moss agate and other types.

Quartz or silica is among the most widely distributed of minerals at or near the Earth's surface and small crystals and masses are easily obtained. Larger masses of rock crystal and amethyst may be found in veins, and the chalcedony minerals are often characteristic as cavity infillings in volcanic lavas. All are of widespread occurrence in Europe, especially the Alpine regions, Bohemia and near Idar Oberstein in Germany where a lapidary industry was started with local stones in Roman times and has continued to the present day, but with Brazil now providing much of the material. India has abundant supplies of practically the whole range of silica minerals and undoubtedly many of these were available to the Renaissance jeweller. Supplies of rock crystal and the chalcedony group were also available in Madagascar and were probably traded by the Arab seafarers, and later by the Portuguese on the supply routes from India via the Cape. Principal modern sources for quartz family minerals are Brazil and Uruguay; the former was probably also available during later Renaissance times.

Pendant, c1610, set with an opal cameo of Louis XIII of France. (87)

The lapis-lazuli deposits on the Kokcha river in Badakshan, north-east Afghanistan have been worked intermittently for 6000 years or more and this was undoubtedly the source of most or all the material up to the Renaissance period or later. It reached Europe by several routes, this giving rise to the belief that it derived from various localities en route. Bauer[8] has suggested that the material carved by the ancient Egyptians probably came from Afghanistan. Lapis-lazuli is a rock composed of the blue mineral lazurite, whitish calcite and sporadic brassy pyrite, the proportion of lazurite determining the intensity of the blue colour. It also occurs near Lake Baikal (doubtfully a source in the 16th century) and in Chile, Burma and Colorado. The name is probably derived from an Arabic word for the sky or more generally for anything blue. In Pliny's time lapis-lazuli was known as sapphire.

Turquoise of the Renaissance period probably came from two major localities (1) near Nishapur, Khorassan province, Persia, and (2) in the Sinai Penninsula at Serabit el Khadem and the Wadi Moghara. The Persian mines have been in continuous production for many hundreds of years; the Sinai mines provided material for the ancient Egyptians, but they were abandoned for some time and not rediscovered until the mid 19th century by Major C. K. Macdonald. Nowadays the Persian mines still operate and the Sinai area is insignificant, but much turquoise comes from Nevada, New Mexico and Arizona in the United States, where it is currently used in jewellery by the local Indians. The name derives from the French *pierre turquoise* (Turkish stone), possibly since much of it first appeared through Turkish (Constantinople) markets. Turquoise is commonly imitated today, but ceramic imitations may date back for some centuries.

Pearls ('margarettes') were extensively used in Renaissance jewellery and the majority seen in the London collections are derived from the marine pearl oyster; a few are from the freshwater or river mussel. Systematic pearl fisheries existing in the 16th century included those of the Persian Gulf, controlled by the Arabs, and those of the Gulf of Manaar, off the northeast coast of Sri Lanka. Madras and (later) Bombay were marketing centres, and the distribution routes to Europe were similar to those for other gems. Fisheries in the Red Sea used Alexandria as a market centre. Pearls were fished along the coasts of Venezuela, especially near Trinidad, before the Spanish conquest. They were sent back to Spain for some years, but the shipments ceased because of oppression of the native fishermen. River pearls were fished in Roman times and were subsequently obtained from Scottish and Irish waters and from various rivers in Germany, especially Bavaria. River pearls do not possess the same superb 'orient' (pearly lustre) as the marine type and some modern Scottish river pearls have a delicate pinkish-violet colour. Perfectly spherical pearls are relatively uncommon and most pearls seen in Renaissance jewellery are somewhat irregular. Doubts have often been raised on the ageing qualities of pearls but the orient still apparent in some Renaissance jewels is evidence that it can last for some centuries. However, some pearls seen in recent examinations have taken on a porcellanous look and many of the pendent pearls seen in 16th century jewellery could easily have been replaced later.

In conclusion, it may be noted that the sources of fine emeralds, rubies and sapphires during Renaissance times were not so different from those available during the era of 19th century imitation. The diamond sources may be different but diamonds from different provenances are less easy to pinpoint than coloured stones. The use of gemstones such as demantoid garnet (not discovered until 1868) by unscrupulous jewellers imitating genuine Renaissaince jewellery could easily be detected, but these operators generally used material from traditional sources, and the detection of fakes may require the services of experts in several fields.

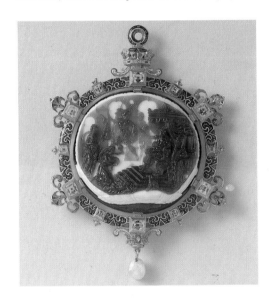

Onyx cameo, *c*1550, of the Judgement of Solomon, from the Imperial Collection. (65)

1 C. W. King, *The Natural History of Precious Stones and of the Precious Metals* (London, 1870) p. 53.

2 G. Lenzen, *The History of Diamond Production and of the Diamond Trade* (English translation, London, 1970) p. 33.

3 B. Laufer, *The Diamond, a study in Chinese and Hellenistic folklore* (Chicago, 1915).

4 Priscilla E. Muller, *Jewels in Spain 1500-1800* (New York, 1972) p. 28.

5 M. Bauer, *Precious Stones* (translation by L. J. Spencer, London, 1904). p. 313.

6 Bauer, p. 358.

7 Joan Evans, *A History of Jewellery 1100-1870* (London, 1970, 2nd Ed.) p. 108.

8 Bauer, p. 442.

E. A. Jobbins,
Institute of Geological Sciences,
(The Geological Museum),
London.

Published by permission of
the Director, I. G. S., London.

The Cutting and Setting of Gems in the 15th and 16th Centuries

During the whole of the High Middle Ages the usual form of gems was the cabochon, that is a stone polished on the curved upper surface, but with the colour, lustre and fire unrevealed. From the 14th century onwards archival, and later, pictorial sources, reveal that gemstones were being cut and provided with facets which fundamentally changed their form.

Since the history of gem cutting is also the history of the diamond, the first part of this essay will deal, necessarily briefly, with the diamond in its most important early forms—using only sources from North of the Alps. The second part deals with the setting of gems in the 15th and 16th centuries, while the third concerns itself with gems grouped together, and their settings.[1]

To discover the early history of gem working (especially of diamonds), it is essential to refer to contemporary French sources. In his description of Paris in 1407, Guillebert de Metz makes an important reference to '*plusieurs artificieux ouvriers comme Herman, qui polissoient dyamans de diverse formes*'. As early as 1381, a report of the '*Corporation des Orfevres de Paris*' names an '*alemant nomine Jean Boule*', who testified before the prefect of the city of Paris that he cut diamonds ('*qu'il tailloit dyamans*'). This introduces two terms, which are of fundamental significance in judging the early working of diamonds and other gem-stones: *polir* and *tailler*. While *polir* is the final touching up of a previously worked gem, the word *tailler* signifies the shaping of a gem, a process during which parts of the original and natural gem-stone are removed, leading to a new and artificially created form.

A note in the 1406 inventory of the Duc de Berry (as well as many other sources of the 14th and 15th centuries) serves as unequivocal proof: '*item un petit relequiere d'or pour porter au col, ou quel a d'une de costes une croix que Monseigneur a faicte faire et tailler d'un balay . . . et ladicte croix a couste a tailler et pollir XXCI escus.*'

A further word appears in this text, which is frequently used in such sources to describe a worked gem-stone: *faire*. Stones are described as '*fait*' (plural '*fais*' or '*faiz*') or as '*non-fait*', which shows clearly whether the gem in question is cut or uncut. An even more evolved stage is reflected in the words '*quarre-equarrir*' which refers to the process by which rectangular gems—including diamonds— are produced: '*Pour avoir faire equarrir in diamant*'.

In the 14th and 15th centuries the predominant shape of diamonds was the *pointed stone*, a four-sided double pyramid (octahedron), which is described in old French sources as '*dyamant a poincte*'. This is the natural crystal form of the diamond which needs to be worked very little, if at all. In the 14th century the decription '*dyamant plat*' does not give certain proof that such a gem has been worked, since a flat crystalline form of diamond also occurs naturally. The '*dyamant quarre*', on the other hand—which is frequently mentioned in the last two decades of the 14th century—is a diamond whose form has been changed, the so-called 'table-cut' obtained by cutting off the apices of an octahedron (pointed stone). Another form of 14th century diamond, first mentioned in the Will of King Jean le Bon in 1364, is the '*dyamant plat en guise d'ecusson*', respectively '*en façon d'eseu*'. This shield-shaped diamond is presumably the natural form (a *macle*,) which can be used for jewellery without much further work.

1 This essay is a condensed version from the book by the same author, *Edelsteinschliff und Fassungsformen im späten Mittelalter und im 16. Jahrhundert: Studien zur Geschichte der Edelsteine und des Schmuckes* (Ulm 1975), and the references for the various points made can be found there.

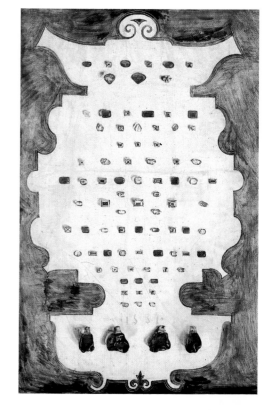

Miniature painting by Hans Mielich, dated 1551, showing unmounted stones in the Duke of Bavaria's collection. (G18a)

From what has been said up to now it can be established, therefore, that at least three basic shapes were known in the second half of the 14th century: the pointed stone (as a largely natural form), the table stone (a flat diamond cut from an octahedron) and the shield-shaped diamond (which is found with an equilaterally triangular shape, and requires little change).

In the early 15th century both inventories of Duc Jean de Berry mention hexagonal diamonds such as one shown by the Brothers van Eyck in the crown of the Madonna in the Ghent altarpiece. Also mentioned is a '*dyamant fait a petits losanges*' which probably corresponds to a gem with lozenge-shaped facets on the stone on the rim of the foot of the rock-crystal goblet of Philip the Good of Burgundy (made between 1453 and 1467) and now displayed in the Kunsthistorisches Museum, Vienna. The second of these inventories (1413-1416) mentions some diamonds described as: '*fait en maniere de losange*'. This form of diamond is also derived from the octahedral shape in that two opposite corners (not the apices) of a pointed stone are cut parallel to each other, creating a lozenge-shaped stone, as seen in the diamond lily on the lid of the rock-crystal goblet of Philip the Good. The '*dyamans plaz, tout rond, en facon d'un mirouer*', also recorded in the inventories, probably had eight sides and a nearly circular table surface which made it appear round and mirror-like. Diamonds cut into the shape of a heart '*cuer de dyamant*' and '*dyamant en façon d'un cueur*' are also mentioned in the second de Berry inventory. An original example of this type of cutting is also preserved on the rock-crystal goblet at Vienna.

The study of further 15th century inventories from France, Germany and England reveals no further new forms or descriptions. The term '*dyamant quarre*', however, has now been replaced by the term '*table de dyamant*'. A note in the 1467 inventory of Charles the Bold, '*dix dyamans, des pluseurs tables*' suggests that by then the square shape of table stones could be extended to elongated rectangles. This inventory includes two terms which presumably have the same meaning: '*freste de dyamant*' and '*doz d'asne*': these are long rectangular diamonds without a table. They are the so-called split pieces with facets angled towards each other in the shape of a roof and described as 'hog-back' cut in the catalogue entries. These forms of diamonds were primarily used to create diamond letters (*see* cat. no. 55). Many pieces of jewellery containing '*doz d'asne*' diamonds are recorded in the inventories of the 16th century Kings of France.

The forms of cut gems mentioned in 14th and 15th century inventories can all be seen in contemporary pictorial representations and on surviving original pieces. Especially valuable evidence is provided by the parchment miniatures of the so-called Basle jewels, (Historical Museum, Basle Inv. no. 1916¹/475-478), in which many of the gem forms are represented very clearly. With the aid of these illustrations, and other pictorial evidence, such as cat. no. G18a, it is possible to understand, and interpret correctly, the knowledge gained by the study of inventories and other literary sources.

Gem-stones cut into the shapes developed in the 14th and 15th centuries found various uses in jewellery and other forms of the goldsmith's craft. Besides the relatively few surviving pieces of goldsmiths' work of around 1400, contemporary paintings are the main sources for demonstrating not only the gems themselves, but also the shape and form of their settings. Artists like the van Eyck brothers (Jan van Eyck was court painter to the Burgundian Duke Philip the Good from 1425), the master of Flémalle, and the German painter, Stephan Lochner, clearly depict gems and gem settings in their paintings.

Around 1400 the '*diamans poinctus*' appear set in simple square gold box settings which, like the octahedral shape of the stone itself, were strongly tapered underneath. The gold sheet of the settings grips the upper pyramid of the pointed stone above the widest part of the box covering up to a quarter of it, and holding it firmly. Comparatively numerous examples of this type of setting have survived.

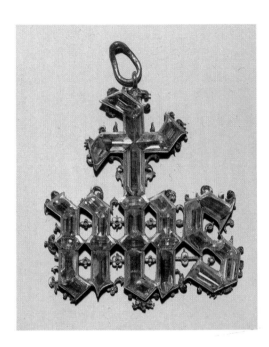

IHS pendant of hog-back cut diamonds. (55)

The commonest gem-setting from about 1420 to circa 1530 was the so-called 'bowl setting', which was used for mounting all types of gems, including the increasingly rare cabochons. The bowl setting originated as a basic, simple technique of the goldsmith's craft: it consisted of a small golden bowl which received the gem, usually of rectangular cut; after the rim of the bowl had been fitted along the edges of the stone, the rim was then pressed laterally to produce small, semicircular hollows on the bowl. Later a conscious creative process produced sharply defined depressions with a semicircular closure below. The depressions could be worked as simple, smooth planes, or as concave troughs. Diamonds on the lid and the rim of the foot of the rock-crystal goblet of Philip the Good of Burgundy are held in such bowl settings, some already in six or eight-sided arrangements, and on the cameo given by Charles V to Pope Clement VII (cat. no. 6).

As this setting developed, the planes or troughs at the sides were given sharply accentuated edges, or a second, purely decorative, curved area was chased on the planes: what had started as practical technique of goldsmithing was being used as an opportunity for embellishment. As early as the first half of the 15th century the simple bowl setting with three, four or more side planes or troughs developed into a new form of setting. It became extensively used, with many different enrichments, particularly in the 16th century, and especially by the goldsmiths of Southern Germany. The basic form of this new setting probably arose around 1440, and was called the 'quatrefoil setting'. The semicircular side planes, (see cat. no. G25b), which had been an integral part of the bowl setting, became independent lobes. The term 'quatrefoil' must be changed to 'trefoil' or 'multifoil' according to the number of individual bodies and their 'shields' (this term describes the side plates of this form of setting). The quatrefoil setting remained virtually unchanged, until almost the middle of the 16th century, as the sole method for setting gems in metal.

Anonymous design of c1550, showing the use of a pointed diamond (above), two table-cut stones (left and right) and a cabochon (below). The settings of the table-cut stones are elaborately decorated with strapwork. (G26)

The Jewel book of the Duchess Anna, painted by Hans Mielich, between 1552 and 1555 as an inventory of the jewellery of the Bavarian princess, (see also cat. no. G18) shows simple quatrefoil settings, with only minor variations, used for pointed stones, table stones and cabochons. A pendant made around 1532 (probably at Augsburg and illustrated on folio 27 r of the Jewel book) shows an important development of the quatrefoil setting (cat. no. G24d): the four 'shields' of the setting have been changed by subdividing the area of each plane with a double-arch.

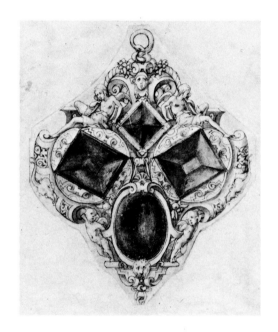

It is important to stress the fact that enamel was not used for the colourful decoration of gem settings during the 15th century, or the first four decades of the 16th. It can therefore be deduced that the pendant of the Duchess Anna illustrated on folio 35 r of her jewel book was one of the first pieces of jewellery employing an enamelled gem setting. The three quatrefoil settings of this pendant (relatively broad 'shields' subdivided with double arches) are filled with black enamel in the lower fields of the 'shields', and also had fine tendrils of gold wire set inside the enamelled double arch area. (See cat. no. 19).

Further variations and developments after 1540 are displayed in the wedding bracelet of the Duchess (1545/6): the 'shields' of the gem setting are completely enamelled, except for a narrow gold border along the edges of the stones. Some of the settings show a further, important innovation, with white enamelled ribbon ornament rimming the 'shields', and spanning them. The numerous pendants of the Duchess display a series of such decoration (folio 43 r depicts a particularly beautiful example), with the variation that the black of the shield and the white band ornaments are sometimes reversed. The ribbon-ornament moresque which after about 1540 had begun by decorating the backs of jewellery appears on the front of Duchess Anna's pendant by 1545. Quatrefoil settings with enamelled ribbon-ornament moresques on the 'shield' continued to appear until about 1570.

By 1550, at the latest, a further enrichment of the enamelled quatrefoil setting had taken place. As in the case of ribbon-ornament moresques only a short time before, strapwork now appeared on the shields of gem settings (see cat. no. G26). This can

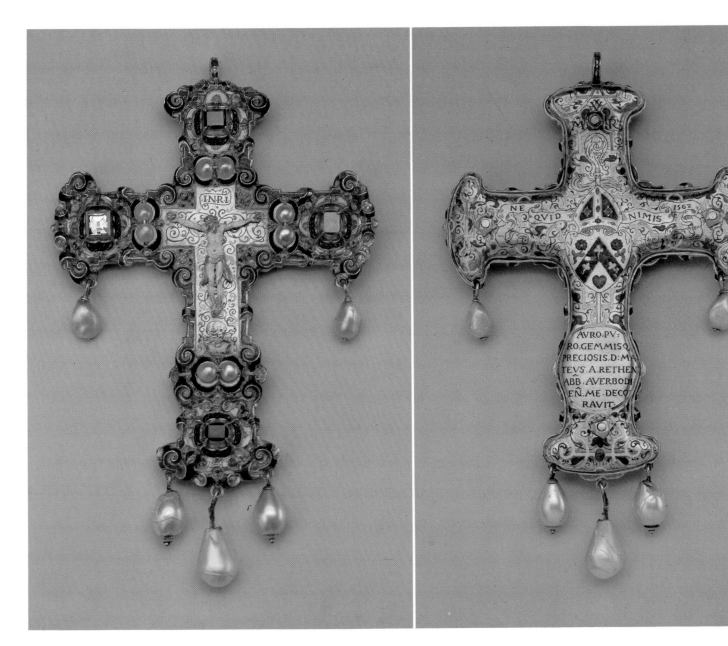

Pectoral Cross of the Abbot of Averbode, 1562, showing octofoil settings, the 'shields' subdivided with double arches and decorated with black enamel. (19)

Left:
Designs by Etienne Delaune for chain links; the top left-hand link illustrates the quartrefoil setting. (G25a, b)

also be seen on Duchess Anna's pendants. Strapwork had previously ornamented the fronts of many pieces of jewellery, but now it invaded the 'shields' of gem settings, changing what were originally flat areas into scrolling forms. This variation seems to have originated in the designs for jewellery by Virgil Solis, the Nuremberg engraver.

Rectangular settings, as well as bowl and quatrefoil ones, were also used in the 15th and 16th centuries but the simple, rectangular setting of pointed stones of the early 15th century showed little change apart from occasionally being stepped, and it disappeared almost completely after 1500, only to reappear at the end of the 16th century. The rectangular 'shield' setting, with vertical side areas divided into double arches, was developed around 1490. It appears to have been used only rarely during the first half of the 16th century and cannot be found on any of Duchess Anna's jewels.

Goldsmiths' work and jewellery created after 1565 however, quite often include a number of examples which have rectangular settings, a further development of the earlier rectangular 'shield' setting. These settings consist of rectangular gold boxes, the four side walls of which have a slightly trapezoid form and drop unusually steeply,

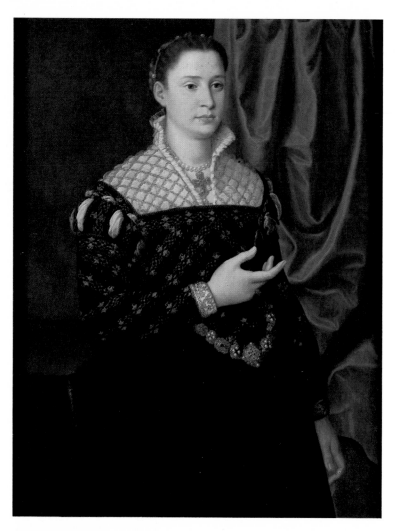

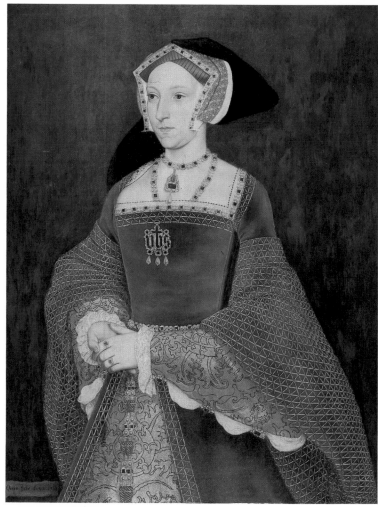

Portrait after Holbein of Jane Seymour with an IHS pendant. (P5)

Top left:
A Florentine lady of *c*1555-65 wearing a belt with a double diamond rosette on its clasp. (P8)

Right:
Pieces of *c*1630 from the Cheapside hoard, showing the predominance of gems over settings. (120)

Thirteen hat jewels belonging to Duke Francis I of West Pomerania and Szczecin, some of which illustrate the square setting with enamelled border and leafy edges. (1251,m)

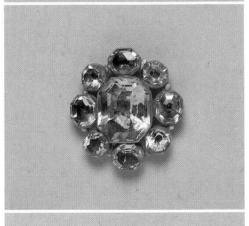

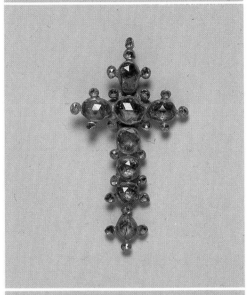

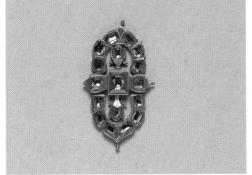

almost vertically. The side walls are subdivided, with black and white enamel decorations which create the characteristic fields with double arches. There is often a step in the moulding surrounding the whole setting, usually decorated with *champlevé* black enamel. This type of enamelled rectangular setting evolved in South Germany, and was further enriched slightly before 1570. A band of small enamelled and golden leaves was placed below the moulding and merged into lily-like shapes at the corners of the setting. The enamelled state chain (dated about 1560) from the Schatzkammer of the Munich Residenz has such a setting and seven of the hat jewels in the Stettin hoard (cat. no. 125m) are also examples of it.

During the last two decades of the 16th century a change took place: the goldsmiths' work depicted in the design book of Jacob Mores (cat. no. G35) already shows a different character. The gems themselves begin to be of greater importance than the work of the goldsmith. The settings, which had previously been of independent importance as a consciously created element of the whole piece of jewellery, are now replaced by small, simple settings, grouped together to carry to gem-stones. The goldsmith's art of setting gems becomes the new 'art of the jeweller', which was to predominate in the 17th century. (*See*, for example, some of the later items in the Cheapside Hoard cat. no. 120.)

This short description of some of the most important forms of gem settings in the 15th and 16th centuries has shown that some of them recur in almost identical form in various centres of goldsmithing. They were used for long periods without significant change and cannot, therefore, be employed for dating or places of origin. Some settings, on the other hand, because of a particular characteristic, can help give the date and origin of various pieces of goldsmiths' work, when the external evidence to answer these questions is lacking.

Certain special groupings of gem-stones occur during the 15th and 16th centuries as a result of the development of certain skills of the gem cutters and goldsmiths. Some of these groupings will be discussed here.

Surviving pieces, and many illustrations (*see*, for example, the portrait of a Florentine woman, cat. no. P8), display the so-called 'gem rosette' in its simple and double form. Early forms of this flower-like grouping of stones, usually diamonds, can be recognised in French inventories of the first half of the 15th century. There is mention of '*diamans fais en maniere de fleurs de quatre pierres de dyamans*'. The oldest surviving examples of five-part simple rosettes can be found on the presumably Burgundian crown of Margaret (sic) of York, now in the cathedral Treasury of Aachen (circa 1468). The simple diamond rosette is often found up to the middle of the 16th century, as for instance on the St Michael Beaker in Vienna (presumably made in France about 1530/40) and on the Holbein Bowl of the Schatzkammer of the Residenz in Munich (made after 1540).

The double rosette is an extremely complicated arrangement of gem-stones: the centre consists of five to ten precisely cut gem lozenges (most of the surviving double rosettes are made of diamonds) which are arranged in a star-like shape around a gold focal point. Triangular diamonds are placed at the tips of these diamond stars in such a manner that the whole unit has a circular shape. The gold mountings of the rosettes are extensively based on variations of the bowl-setting. The evidence of paintings proves that diamond double-rosettes were first made in 1483. The oldest surviving specimen is on the cross of St Ulrich, made in Augsburg in 1494. In the first half of the 16th century Hans Mielich painted many simple and double rosettes (diamonds and rubies) for the jewel book of Duchess Anna, and the double rosette was still used in the second half of the century. It is very probable that the most important centres of rosette manufacture and use in Germany were Augsburg and Nuremberg.

The 'diamond lily' pieced together from four to seven gems of different cut, is already mentioned in French inventories of the early 15th century: '*un diamant fais en maniere d'une fleur de lis*'; and the oldest surviving examples are on the rock-crystal goblet of Philip the Good. In Italy the diamond lily was mentioned by Benvenuto

Cellini, and in 1586 Queen Elizabeth I was presented with a 'juell of golde, being a flower-de-luce of dyamondes'.

In the 15th and 16th centuries gems were often combined to form letters, words and even whole sentences. The IHS jewel is of a religious character, and appears also with the letters: YHS and YHC. The earliest ones had already made an appearance by the second half of the 15th century. One of the most beautiful IHS pendants was worn by Jane Seymour (cat. no. P5). It is assumed that this jewel (no longer in existence) came from a South German workshop. The 1519 list of the jewels of King Henry VIII mentions an: 'IHS of diamonds with 3 hanging pearls', and the jewel book of Duchess Anna (folio 29 r) depicts an IHS pendant made up, for the first time, of Roman letters: this may have originated in Nuremburg around 1547. The IHS jewel in the Cabinet des Médailles of the Bibliotheque National, in Paris, cat. no. 55, is closely related to a piucture by Arnold Lulls in his jewel book (cat. no. G44); there are sources which suggest that it originated in a Nuremberg workshop. IHS jewels still occur in the early 17th century; Duke Francis of Stettin (d. 1620) had one (cat. no. 125), and the design book of Jacob Mores also depicts some IHS pendants.

Initial jewels, with or without gem-set crowns above the jewelled letters, appear in the archival sources from the 15th century onwards: 'une P de cinq gros dyamans' and 'une M de sept bonnes dyamans' are mentioned in the 1493 inventory of Margaret of Austria.

In 1552/3 the Nuremberg workshop of Wenzel Jamnitzer created the AA jewel, (probably designed by Mathias Zündt) still in the Green Vaults at Dresden, for Augustus, Elector of Saxony, and his wife Anna. There is also the jewel in the shape of a C in the Cathedral Treasury at Uppsala, which was found in the grave of the Swedish-Polish Queen Catharina, who died in 1583.

The 1528 and 1530 treasury inventories of King Henry VIII mention an M of diamonds (perhaps for Mary Tudor) and a finger ring with an A of diamonds (perhaps for Anne Boleyn). *See also* the ring with portraits of Queen Elizabeth and Anne Boleyn and an E of diamonds on the bezel (cat. no. 37).

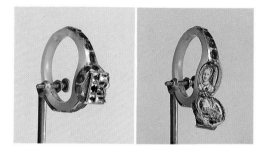

English ring *c*1575, with an E of diamonds on the bezel and containing portraits of Queen Elizabeth I and Anne Boleyn. (37)

The Garter of Charles the Bold, Duke of Burgundy, carried the following inscription in hog-back cut diamonds: '*honny soyt qui mal y pense*'. (He was granted the insignia of the Order of the Garter in 1469.) Such diamond studded Garters were made throughout the 16th century, and the Schatzkammer of the Residenz in Munich has an English example of the early 17th century. In this instance the motto is in Roman letters.

Small human figures were also made of gems (usually diamonds) in the 16th century. Emperor Maximilian I, for instance, owned a '*Jörgen*(St George) *von diamant*' in 1509. An inventory of 1524 mentions a '*Jörgenbild mit dreyunddreyssig diamanten*'. The jewel book of Duchess Anna shows two small figures of St Michael on folio 2 r and 3 r. and two small figures of St Michael, set in diamonds, have survived in the Green Vaults at Dresden.

Finally one must draw attention to the diamond cross crosslets of the 15th and 16th centuries. Probably the oldest of these crosses, composed of several smaller diamond crosses, can be found in the crown of Margaret of York in Aachen (around 1468). In her portrait of around 1495, Bianca Maria Sforza, second wife of Emperor Maximilian, wears a diamond cross crosslet as a pendant. The inventory of the estate of the Emperor describes this cross crosslet as a '*croix d'or a quatre croix et une au milieu de dyamant*'. The Hans Mielich miniatures of Duchess Anna of Bavaria's jewels show numerous diamond cross crosslets (e.g. folio 16r, 26r, 28r, and 30r and cat. no. G18), an indication of the great popularity of this type of cross during the first half of the 16th century.

Dr Fritz Falk,
Director of the Jewellery Museum,
Pforzheim, West Germany.

Dress in Western Europe 1500~1630

During the 16th century there were marked changes in the economy of Western Europe and a general increase in wealth due in part to the discovery of the New World. There was a consolidating of kingdoms and states, improvement of contacts and greater harmony and understanding between nations, which the religious troubles of the Reformation did not greatly disrupt. Trade increased, even with the East, and above all the craftsmen, gold and silversmiths, metal workers, sculptors, weavers, glassmakers and potters established themselves more firmly in their guilds, improved their skills, and earned reputations outside their own cities and countries. There was a growing interest in people's appearance, particularly in their clothes. The loosely fitting garments of the Middle Ages were gradually succeeded by the tailored clothes of the Renaissance. The process had started in Burgundy and in the cities of Italy in the 15th century, but now rapidly spread throughout Europe.

Portraits now showed not only the individual likeness but also the exact dress of the sitter, (see, for example, cat. no. P4) features which previously had been only summarily recorded in the kneeling figures of donors in votive pictures and on recumbent funeral effigies. Next, at the foot of printed maps it became customary to show a small group of the nationals of the country or of citizens of the town concerned, and their servants. In 1586 Sigismund Feyerabend of Frankfurt-am-Main found a market for his studies of the women's dress of Europe, entitled *Theatrum Mulierum*, illustrating the clothes worn not only by different nations but also by the different ranks of society and occupations. Strict accuracy was not at first achieved and a degree of fantasy prevailed, but by the 1590s Cesare Vecellio of Venice was employing a German wood-engraver (Krieger, or, in Italian, Guerra) to illustrate what he had observed or heard from his correspondents in other cities[1]. Naturally his pictures of noble English ladies and their daughters were not as true to life and reliable as those of the English merchants and sailors whom he had seen in Venice. During the earlier part of the 16th century the men wore as many jewels as the ladies (see, for example, the portrait of Henry VIII cat. no. P4) but from the middle of the century onwards women definitely began to outshine the men. From the beginning of the century the medieval hood was drawn further and further back from the face. For a time, the hair, possibly out of deference to St Paul's teaching, was still concealed under the coif, but the ladies of Italy began to display their carefully combed hair under light network with jewels at the intersections: for the unmarried in Castile, long beribboned plaits were a distinctive fashion. The English, if we may trust the drawings of Hans Holbein, were more conservative; only the younger ones showed a few strands of hair under their coifs or the cauls, which were worn beneath the gabled hood, whilst the older ladies concealed their hair as carefully as they did their ears. Hair-pins and jewels were worn on their hair, fringes and coifs. Their foreheads and bare necks gave them an opportunity to display jewelled carcanets, circlets, or necklaces with pendants.

Holbein's portraits of Queen Jane Seymour show how the tight-fitting bodices had receded from the neck, leaving a very wide square opening, which could be edged with jewels called, appropriately, 'the square', (see Janet Arnold, *Sweet England's Jewels*). This fashion continued more modestly for young girls who would have the

1 C. Vecillio, *Degli abiti antichi e moderni* (Venice , 1590) (2nd ed. Venice, 1598).

neck opening filled by their shift or a partlet. By the end of Henry VIII's reign the bodices began to have a pointed opening in front, revealing the embroidered collar of the shift. On the continent and especially in Spain, the tight collars of the bodices rose high on the neck, almost to the ears, under which the pleated collar of the shift, soon to became the ruff, was just visible. Necklaces were becoming very much longer, and were worn over the bodices or gowns.

Portraits in the last half of the century show the ruff developing from a pleated collar to a gigantic cart-wheel of starched linen (*see* cat. no. P10) sometimes supported by wires or under-proppers. The ruff was normally circular, but in England, where there was still a preference for the bare neck, the ruff might be divided and secured to the corners of the bodice (*see* cat. no. P14). This display was not universal and the false shift-collar (called the partlet) of embroidered linen with a little neck-band (rather like the masculine 'dickey-shirt' of the early 20th century) was worn for modesty's sake, and examples have survived with embroidered fore-sleeves to match.

At their waists ladies might also wear, suspended from hooks or fastened to chains, toilet accessories, such as small looking-glasses, knives and forks for the table, scent bottles (*see* cat. no. 110), small books for their devotions (*see* cat. no. P17), as well as fans. Since jewelled objects of this type were treasured family possessions, they tended to be of different styles and date, and even from different countries of origin. Magical properties were attached to particular stones, and the talisman element was still present though the cross was less frequently worn in England after the Reformation (cat. no. 120r is an exception). In Spain (cat. no. P11) the princely child with his hobby horse might wear all manner of charms and inherited jewels (cat. no. 58) but in England one doubts if all the festoons of jewellery worn by the children of the Cobham family (cat. no. P9) really existed in such identical multiplicity; perhaps only one set existed, and was reproduced on each child.

Towards the end of the 16th and in the early years of the 17th century ear-rings, sometimes worn singly, seem to have been more popular and were often tied by a ribbon to the ear or to the biliment (cat. no. P25). Another feature was the larger jewel pinned to one side of the corsage or else to the padded sleeve (cat. no. P16). Rings, whether worn singly on the finger, or about the neck, presumably as a token of remembrance, were often secured by a single black silk cord threaded through them.

The waist-line was lowered as the century advanced, and the pointed front, emphasised by a rigid corset masked by an embroidered stomacher, gave an opportunity for displaying jewelled girdles or bands, from which could hang pomanders, miniatures in gold or silver cases, or the thick watches which were coming into fashion. Fans, gloves, and, later, handkerchieves with tassels ('buttons') at their corners, were also hung from the girdle.

Women's skirts were at all times heavily pleated and gathered to the waist. In Germany and the north several petticoats could be worn for the sake of warmth and without too much discomfort. All the grander dresses had padded hems or fur trimmings even if they did not sweep the ground. In the 15th century there had been a remarkable development in Spain, which in due course spread across Europe. Court etiquette insisted that a Spanish lady's dress must reach to the ground (hence it was said 'The Queen of Spain has no feet') but the warmth of the climate led to the invention of the hooped petticoat, the skirts of which were held out by horizontal hoops usually of willow-shoots, carefully seamed in fabric. These shoots (*verdugo*) gave their name to the *verdugado* petticoat which later became the verdingale, and thence farthingale, as its derivation was lost, and the shoots replaced by whale-bone. By the mid-16th century the *verdugado* in Spain (as also in Milan and Naples, which were under Spanish rule) had taken a stiff cone-shaped form over which the brocade or silk petticoat could be tightly stretched and appear between the skirts of the open gown, as an inverted 'V' in a contrasting colour (*see* cat. no. P26). In northern Europe the advantages of coolness and freedom for the legs came to be realised, and this was achieved by wearing a thick padded hip-roll, shown in Dutch caricature engravings.

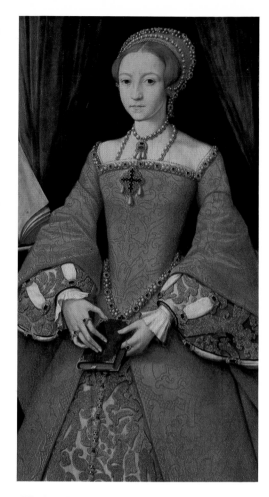

Elizabeth I, when Princess, painted in 1547. (*see* cat. no. P5).

The alternative was a metal frame-work from which the skirt hung vertically, not necessarily reaching the ground or hiding the feet. This drum-shaped farthingale was especially favoured by Queen Elizabeth I, and carried on into the 17th century by James I's Queen, Anne of Denmark. With it were worn the pointed bodice and the large open-necked wired collar, which had replaced the ruff. This was stiff so that it could bear the weight of numerous jewels sprinkled all over it (cat. no. P21).

As weaving techniques improved, the ground materials for dress tended to become more rich and varied. Sumptuary laws had been passed in most countries, but even in Italian cities they were seldom observed or enforced. The wearing of figured velvets and brocades became more common. The richest embroidery—the *opus anglicanum* for which England had a European fame—had died out, but there was much enrichment of the seams of clothes with silver and silver-gilt thread. In memory of the open seams and hems of the past, pairs of short cords with metal aglets, tied in bows, were often added to seams, but served no useful purpose, since they had been replaced by buttons fastening through worked buttonholes (*see* the Cobham portrait cat. no. P9). In Spain especially, the close-fronted gowns often have pairs of aglets from waist to hem (*see* cat. no. P26). The button of course, as its name implies, had originally been a decorative bud or rosette with a jewel in the centre. Rosettes of this type with starched borders persisted until Queen Elizabeth's time. They were sewn on in geometrical patterns, and were unstitched and washed when they got dirty. Metal thread buttons in the form of small acorns or knots were still sewn in rows along the edges of false sleeves, which hung from the shoulders. Applied fabrics commonly used for furnishings are occasionally shown as borders for petticoats.

Men's dress at the beginning of the century was characterised by the breadth at the shoulders of doublets and gowns, exaggerated by the collars of the short cloaks. Doublets and breeches were often cut with vertical slits showing contrasted linings or the shirts beneath them. These panes, as they were called, could be linked together with small brooches or ties. The men's wide chests encouraged the display of gold chains, and the collars and insignia of the orders of knighthood and of the liveries which continued to increase in number (cat. no. P3). To the up-turned brims of hats were attached jewels, badges and medallions (cat. no. 9), survivals of the medieval emblem showing that a pilgrimage had been successfully made.

Then, by the middle of the century the doublets, following French and Italian rather than German styles, became narrower, and were padded and laced to give a beaked front. Sleeves were slit open from shoulder to wrist or hung loose showing tight-fitting inner sleeves in contrasting material. Breeches laced inconspicuously to the inside of the doublet were also padded, but when they hung loose in panes gave increased prominence to the cod-piece. The long stockings, at first cloth or linen, and later, occasionally, of Italian knitted silk, had showy lace-trimmed garters. In England they were covered on the thigh by embroidered or brocaded silk canons (canions), the part between the trunk hose and the knee. Cloaks hanging from both shoulders continued to be worn, especially in Spain, but elsewhere they were draped or slung so as to keep the sword-arm free. Swords were worn out of doors by all members of the upper classes, their embroidered sheaths and trappings attached to low-hung waist belts.

For men as for women, the most conspicuous feature in the latter part of the century was the ruff, which at first had been the neck-fill of the shirt, and had then become a separate item of dress, increasing rapidly in width and depth. The wide hat was replaced by various types with high crowns and narrow brims (cat. no. P27) about which ran the metal or braid cords which could support badges or large jewels (cat. no. 125p).

The study of dress becomes easier from the end of the 16th century onwards, since actual garments have been preserved, some amongst collections of armour, others hung as relics, such as the Sture doublets in the Cathedral of Uppsala, Sweden or the clothes removed from the Wittelsbach vaults at Lauingen, Germany. Spain was the

only place where a tailoring book (J. de Alecega, *Geometria y traca . . .* 1589) was published. It gave instructions and diagrams of how to cut clothes and dresses of all sorts from the lengths of cloth. Doublets were generally still stiffened in front and had inner lacing; waistlines, however, became higher and were edged with eight, or after 1600, six overlapping skirts. The ruff continued in favour in the Low Countries, for the merchant classes, but then gave place to the falling collar, lace trimmed and spreading over the shoulders (cat. no. P29). In England, breeches were full and padded in the German fashion, till the narrower French style came in with Charles I.

Women's dresses of the period are less frequently preserved; those made of velvet, silk, or linen were no doubt cut up and remade. It is, however, remarkable that a number of English linen jackets, thickly embroidered with floral patterns in coloured or black silk and metal thread have been preserved (cat. no. P18). A large number of linen coifs in the same style of embroidery made from a single piece of material seamed along the crown of the head with side flaps to cover the ears and the plaited hair have been found. With these coifs are sometimes found matching triangular pieces, to be tied over the crown of the head with the long side over the forehead and the point backwards. These may have been a middle-class fashion but it is also evident that both they and men's round night caps were treasured by those who possessed no jewellery apart from rings and perhaps a necklace. They can be compared with the dress of burghers' wives on the Continent, who might copy the upper classes in some details and even wear ruffs (cat. no. P23) but whose caps are only enriched versions of those worn by peasants.

The period ends with dress of what we may call the Rubens and later the Van Dyck style. The ladies had high-waisted bodices, with contrasting sleeves padded and all with a profusion of lace on collars and at wrists. Hair was curled, dressed out with pins, under wide felt hats. For men the 16th century stiff doublet persisted, though it was now cut with a higher waist and longer skirts; breeches were tighter with garters at the knee. Elaborate roses now covered the ties of shoes which had square toes and low heels. Among the men's clothes preserved are silk dressing gowns, with night caps and slippers to match. These are decorated with metal braid, but the only jewellery worn with the more formal dress would have been rings, chains and badges of the Orders of knighthood (cat. no. 125a, b, c) and miniatures worn as a memorial to a deceased wife or friend.

John Nevinson.

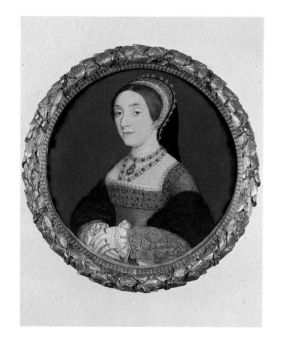

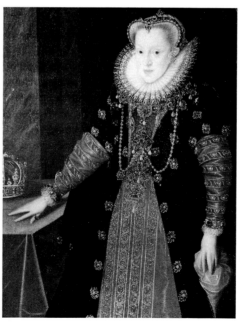

Margaret of Austria, with jewelled 'aglets' down the front of her dress. (P25)

Left:
Portrait of a woman, formerly thought to be Catherine Howard, illustrating the 'biliments' which decorated a gable headdress and the 'square' of jewels around the neckline. (P6)

Sweet England's Jewels

Portraits show only a small selection of the rich profusion of rings, chains, pomanders, brooches, aglets, buttons and other items worn by those resplendidly bejewelled monarchs of the Renaissance, Henry VIII and his daughter, Elizabeth I. Lists and inventories, prepared by the Clerk of the Jewel House[1] when jewels were delivered into the charge of various courtiers for the Sovereign's use, give an insight into the careful organisation which ensured the safety of this royal treasure[2]. In some cases they also describe jewels to which dates may be given, as the same descriptions appear in jewellers' bills, or with the names of donors in New Year's Gift Rolls during Elizabeth's reign[3]. Although strictly relating to the English Court, these documentary sources cast some light on jewellery worn in other Courts all over Europe during the sixteenth century.

Storing and recording royal jewels

Part of an inventory made during the third year of Edward VI's reign records the way in which some items in the vast array of Henry VIII's jewels were stored in the 'Secret Juelhous in the Tower of London'[4]. It lists those jewels and other items, including plate and books, which were in 'the Kinges removing cofers late in the charge and custody of Sir John Gates'. More jewels and plate were stored at the Tower and in another repository, the Secret Jewel-house at the Palace of Westminster[5], but this section of the 1550 inventory is a record of some of the quantities of valuables transported when King and Court moved between royal residences at regular intervals.

Copies of inventories were made for different departments; this particular copy of the 1550 inventory was used as a check list by the Clerk of the Jewel-House to record the dates when items were removed from his custody. For example, 'a paier of bracellettes of stele set in golde enamuled blacke garnished eche with ix small Diamountes and iij greate' was delivered to Queen Mary on 4th June 1556 and 'a litle Cheyne of flatte litle hoopes doble set and linked together' to Queen Elizabeth on 11th June 158[0][6]. Other lists were made, sometimes in abbreviated form, for the courtiers into whose charge jewels were delivered. It is, therefore, not always easy to identify items recorded in different inventories, often with a passage of several years between. One such abbreviated list[7], undated, which appears to have been made in c1536-7, records two strings of lapis lazuli beads thus: 'Item a paire of lapid lazeris dressed with golde with small pearles at them' and 'Item A nother paire of Lapid Lazeris lyke pottes dressed with golde with a piller at thende . . .[8]' These appear in the inventory of jewels given by Henry VIII to Katherine Howard on their marriage in 1540, in reversed sequence, with 'pottes' now described as 'spottes' and 'dressed with golde' as 'garnesshed with golde'. These descriptions are far more detailed, for example: 'Item oone other peir of Beades of blewestones lykewyse called Lapis Lazarnes garnesshed with golde and every of theym havyng peerlls being of that sorte· xxx/and xxx beades of goldesmytheswercke of an other sorte ennamuled white/havyng a pillor of golde ennamuled blewe and wrethed and vij very small peerlls at the same with these wordes Spes mea with also a tassell of venice golde garnesshed with verey small peerll'[9].

1 Nicholas Bristowe, father (d. 1584) and son (d. 1616) held this office under Henry VIII and succeeding monarchs. A. J. Collins, *Inventory of the Jewels and Plate of Queen Elizabeth I* (London, 1955) p. 5.

2 This organisation is discussed further in Collins, op. cit. and Janet Arnold, *Queen Elizabeth's Wardrobe Unlock'd* (to be published by Macmillan).

3 Listed in Collins, op. cit., pp. 249-252.

4 British Library, Add. 46,348, f.145.

5 A. J. Taylor, *The Jewel Tower, Westminster*, (London, 1965) pp. 10-14.

6 B.L. Add. 46,348, f.145.

7 B.L. Royal C7 xvi f.18.

8 Ibid.

9 B.L., Stowe 559, f.63v.

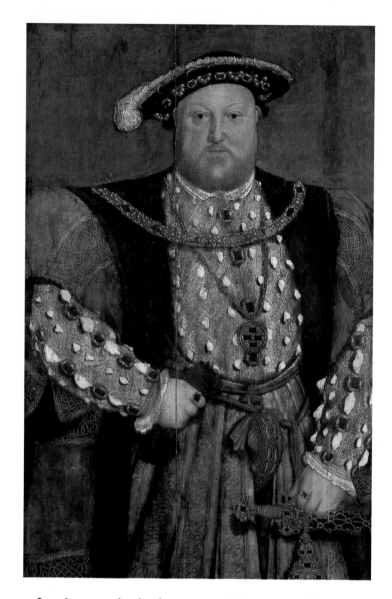
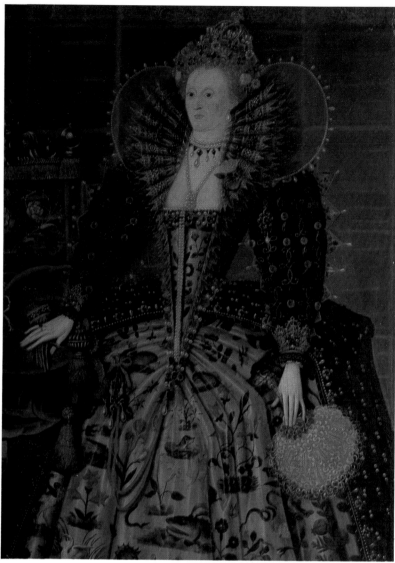

Jewels were also broken up and pieces moved from one garment to another, thus making them difficult to identify. In May 1550, four caps were 'new made' for King Edward VI at the 'commyng in of Mounsieur Chatilion the frenche Ambassador, the furnyture whereof was taken from other cappes of the kinges and his graces fathers . . .' This description shows how many pieces were used in just one cap: 'Item a blacke velvet Capp newe made having viij Diamountes abowte the crowne taken of an olde blacke velvet capp and xvij trewe loves of iiij perles whereof one borowed of Robert of the roobes (which is redelivered to hym) the rest taken of an olde cappe sett with ballaces Nyne smale Diamountes sett in collettes of golde taken of an olde white capp and lxiiij beades of golde and lxiiij perles taken of the black capp sett with Diamountes with a brouche of a crosse of Diamountes taken of the same Cappe'[10].

Some of the jewels were given names and can be more easily identified even when the descriptions are brief. One of the best known, the Three Brethren, appears in the 'Ermine' portrait of Elizabeth. This jewel was carried by Charles the Bold on his expedition against the Swiss and captured by the latter at Grandson on 1st March 1476. With some other pieces, the jewel came into the hands of members of the Basle municipality, to be sold to Jacob Fugger in Augsburg for 40,200 gulden[11]. At this time a water-colour sketch was made of it[12]. The Three Brethren apparently came into the possession of Henry VIII in 1543[13]. Whether the piece was later pawned and then sold

Portraits of Henry VIII (P4) and Elizabeth I (P14), both by unknown artists.

is uncertain, but 'a Jewell bought by the Kinges Majestie of Anthony Fulker and his company of Antwarpe in May 1551 and delivered to thandes of the Erle of Willteshere lorde treasorer of England by the Kinges Majestie the vij[th] day of June 1551, and put into the coffre marked with the lettre H(?) in the Towre of London'[14] fits the description of the Three Brethren. It is 'a fayer flower of golde havinge sett in the same three table ballaces sett without foyle and betwene every ballace a perle and in the myddes betwene the three ballaces a large pointed Dyamounte and a perle pendaunte at one of the ballaces'. After Edward's death the jewel was delivered to Queen Mary, in October 1553. It is described as 'The Brethren' in a list of Elizabeth's jewels made in 1587: 'Item a faier flower with three great ballaces and in the middes a great pointed diamond and three great pearles sett with a faier great pendaunt pearle, Called the brethren'[15]. James I wore it and then had it 'newlie sette' for Prince Charles to wear in Spain in 1623[16]. In 1631 it was in pawn at Amsterdam, 'One Jewel called the 3 Brethren conteyning 3 Great Rubies Balasses'[17], still recognisable, although it had been reset. A note in 1633 recorded that it had been 'pawned first at £5000 and after upon redemption of other jewels pawned with it, repawned at £7,000 & valued in the Inventory at £9,400'[18].

Individual jewels are described quite carefully in the inventories, but lengths of strings of beads, girdles and chains are usually only indicated by the number of component pieces. However, one item in the 1587 inventory of Elizabeth's jewels gives a little more detail: 'Item a longe small Chayne of golde of diverse sortes ennameled black with pearles in linkes of golde contayninge six yardes iij quarters by estimation'[19].

A number of removing coffers in the Secret Jewel-house at the Tower of London in 1550 were each marked with a letter, from A to V. Others were numbered from 1 to 11. There were also 'The Quenes Jewelles in A Cofer havinge written upon it the Quenes Juelles'. An indication of the size of each coffer is given by the contents. For example, in the first one, marked A, jewels were packed in several separate containers. There was a little coffer with 'tilles', or drawers, and a square box, both covered with crimson velvet; a little coffer 'casket fashion' of copper and gilt; a little coffer of iron 'of Morisco Worke'; a small coffer of silver gilt 'garnished with Counterfet stones with a white Antique hed in the Toppe'; a little white coffer 'parcell guilte plated'; a little white coffer 'copper and guilte parcell' and a square black leather box.

The first of these little coffers was large enough to hold three square boxes. Their contents comprised eighteen pairs of bracelets, and twenty-one ropes of pearls, while the drawers of the coffer were filled with twenty-one items including 'one small Cheyne golde wyer woven hollow hanginge to the same Cheyne A Unicornes horne closed in golde with a Whistell and instrumentes for teth and Eares and a Diall in the toppe all golde'[20]. Some of the ropes of 'grete perles' had ten on a string, others, of 'meane perles,' had as many as a hundred. These smaller pearls and those used for embroidery seem to have been counted out on pins: 'Item a Ringe with viij pynnes of Silver for mesure of perles'[21]. They were graded into various sizes usually described as great, mean, ragged and seed. One note of pearls delivered to an embroiderer for 'the Quenes hindre part of a kirtell' included 140 'of the bigger sorte', 80 'of the seconde sorte' and 357 'of the small sorte'[22].

The white coffer plated with silver gilt had nine carcanets in it, each described in a similar way: 'Item a pasted paper covered with yelowe cloth sett with vj diamountes iij Emerodes ix Rubies x grete perles all set in golde. viij peces set everie of them with iiij perles, iij peces in everie of them ij perles, iij peces in everie of them ij perles and a rubie, ij peces set with flower de luces of diamountes one other pece garnished fullie with diamountes Emerodes and Rubies with a perle pendaunt'[23]. These carcanets may have been made with a fabric base but the description probably means that sheets of stiffened paper covered with yellow cloth were used as trays to keep the jewelled necklaces apart. Another entry seems to support this second theory: 'Item

10 B.L., Add. 46,348, f.217.

11 Erich Steingräber, *Antique Jewellery: Its history in Europe from 800 to 1900*, (London, 1957) p. 62.

12 Ibid., fig. 98.

13 Ibid., p. 62.

14 B.L. Add. 46,348, f.221.

15 B.L. Royal App. 68, f.2.

16 John Nichols, *Progresses and Public Processions of King James the First*, IV (London, 1828) p. 832.

17 B.L., Stowe 560, f.53.

18 Ibid., f.63.

19 B.L., Royal App. 68, f.11.

20 B.L., Add. 46,348, f.146.

21 Ibid., f.155.

22 B.L. Royal C7 xvi f.33. Further details about pearls used for embroidery are given in Arnold op. cit.

23 B.L., Add. 46,348, f.148.

two yelowe clothes havinge sewn upon them Ciiij×× [180] Diamountes of sondrie sortes set in Collettes of golde And lv Rubies of sondrie sortes set likewise in golde all whiche were taken from garmentes'[24]. The sewing was probably a security precaution; the jewels could not be removed without clipping the threads holding them in position and any missing items would have been spotted immediately. Several of these carcanets were delivered to Queen Mary in 1554 and 1556, and were no doubt used by Elizabeth in her turn.

Eleven groups of rings were kept on rolls in the little white copper and gilt coffer: 'Item a Rolle with vj Ringes wherof three Amatistes one Eye and ij Saphires'[25]. Here, again, it would have been very easy to see if any were missing. Four batches of buttons and clasps were kept in the little copper and gilt coffer made like a casket and another seven ropes of pearls in the iron coffer of Moorish work, with 'Cxxx trueloves of golde everie of them having iiij pearles taken from garmentes of the kinge that dead'[26] in the 'little white plated cofer parcel guilte.' Sixty-two 'knottes of pearls' and seventy 'pescoddes of pearles' were in the square black leather box, and these had also been taken from Henry VIII's garments.

All these, and several other items, apparently packed loose, were in Coffer A. In Coffer B there were thirty-nine gold collars and chains, numerous buttons and jewels, with eleven batches of rings, five of them arranged 'in a boxe, booke fashion, of silver guilte with a Diall on the toppe garnished with Counterfait stones'[27]. Rings are not usually described in very much detail, but one was 'a Rubie that the kinge wore at the heling of pore people'[28].

Henry VIII seems to have had poor sight. Several pairs of spectacles and cases are listed in the inventories, and other members of the family may have used them. Mary suffered from headaches which may have been caused partly by eyestrain and Elizabeth was short-sighted. One case was undoubtedly Henry's: 'Item a spectacle Case of golde engraven with Tharmes of Englande with ij Spectacles'[29]. He probably also used 'one broode glasse to looke uppon a booke garnished with golde weying iiij oz di [4½ ounces]'[30]. Another spectacle case was of 'Morisco work' and there were two 'of Silver gilte with spectacles silver guilte enameled'[31].

It must have been difficult to remember exactly what the various jewels were like, with so many at the monarch's disposal. In coffer A there was 'a paper booke conteyninge diverse paternes for Jewelles[32]. This may have been prepared by Hans Holbein[33], a visual record of Henry VIII's jewels, including new designs when gems were reset. Edward probably used it as a guide to his father's jewels when choosing some for his own use. The drawings would also have helped the King's servants to trace jewels, if any were mislaid or stolen.

The cut of stones and types of jewels
The most popular stones were diamonds, rubies, emeralds and then sapphires but many semi-precious stones were used, in addition to numerous pearls. One chain in the 1587 inventory included a mixture of amber beads with flies in them, small rubies and diamonds: 'Item a Chayne of golde contayninge viij knobbs fower with two small diamondes in a peece iiij with two small Rubies with viij antique pillors xvjtene amber beads with flies in them, and small links of golde enameled white and red betwene them. A ringe with a diamond and xxtie small rubies about it hanginge at the same chayne'[34].

Glass was also used (see cat. no. 57). One of the prettiest double strings of beads given to Katherine Howard in 1540 was: 'one peir of Beades of grene glasse garnesshed with golde being of that sorte xxix and betwixt every of them oone perle and one peece of goldsmytheswerke the same beades being garnesshed with red stones and x other stones of goldesmytheswerke ennamuled grene and garnesshed with rubyes havyng also a pillor made of two grenestones and two peces of goldesmytheswercke and iiij peerlls garnesshed also with stones with also a feir Tassell of golde and red Sylke garnesshed with a ca[w]ll of peerle'[35]. It was not always easy to

24 Ibid., f.149v.

25 Ibid., f.149.

26 Ibid., f.149v.

27 Ibid., f.152.

28 Ibid., f.162v.

29 Ibid., f.147.

30 Ibid., f.8.

31 Ibid., f.154v, 155.

32 Ibid., f.149v.

33 Some of Holbein's ornamental drawings which have been preserved (B.M., Dept. of Prints and Drawings, Sloane Coll. E.C.M. 4-188) are designs, but others, at least nine, appear to be accurate drawings of jewels already in existence. This 'paper booke' may have been similar to Hans Mielich's *Kleinodienbuch* of 1551, prepared for Duchess Anna, wife of Albrecht V of Bavaria (Bavarian State Library, Munich, Cod. Icon. 429), *see* cat. no. G18.

34 B.L., Royal App. 68, f.12.

35 B.L., Stowe 559, f.64.

distinguish stones from glass. One 'garnet cut table wise set in open golde worke without foile' worn by Elizabeth, listed in an inventory of 1600, had 'or glasse' written over it by one of the clerks checking the entries[36].

Stones were cut in simple shapes, usually backed with foil to make them sparkle. In the sixteenth century diamonds were mainly 'pointed,' when they stood like tiny pyramids, or 'tabled', when they showed a flat surface. They might be 'square,' 'lozenged' or 'triangle' diamonds, terms which refer to their shape. An early description of what seems to be a facetted diamond appears in the 1587 inventory: 'Item one ringe of golde with a diamonde without foyle cutt with diverse triangles and garnished with sparckes of diamondes called a Sepulchre'[37]. The word 'facet' apears early in the seventeenth century[38]. By the time of Charles I, one jewel was described as 'An olde Crosse of golde sett with six Diamondes of an olde cutt'[39], obviously out of fashion. Rubies might be left uncut, referred to as 'rocke rubies' in the inventories, as an alternative to being table cut.

The word 'rose' was used to describe an arrangement of gems, not the cut of single stones. They were apparently placed petal fashion round a central stone: 'Item one Whistell with a small doble and longe flagon cheyne being A grete square whistell set with vj Rubies and vj diamountes havinge in thende A flower of Diamountes Rose fashion on thone side and on thother side A flower of Rubies Rose fashion the same Whistell being fastened to A Dragon set with small Emerodes on the backe thereof'[40] (see G23b). This was delivered to Queen Mary on 3rd December 1554, and Elizabeth may well have worn it a few years later.

The names of different pieces of jewellery can be confusing. They vary from inventory to inventory, with the passage of time and changing fashions. Habilliments, or biliments, were the bands of jewels used to decorate gable headdresses (cat. no. P5) and French hoods (cat. no. P6)[41]. They were often made to match girdles and a broken girdle might easily be confused with a biliment. 'Item Twelve peeces of a girdle or habilliament having in every peece one meane diamonde'[42]. There were usually two pieces, an upper and a nether biliment, which could be worn together or separately. There might sometimes be three pieces, as the description of a New Year's Gift from Henry VIII to Katherine Howard in 1540 indicates: 'Item one upper habulyment conteignyng viij Diamondes and vij Rubyes. Item a turnyng up of the same habulyment conteynyng xij Diamondes and lv Rubyes. Item a nether habulyment conteignyng ix Diamondes ix rubyes and xix peerlls and also iiij Diamondes and xij rubyes in the Chekes of the same habulyment'[43].

Carcans and carcanets were bands of jewels worn as necklaces. Sometimes the description specified where they should be worn: 'Item one other Carcane for the necke conteignynge thre verey Feire Diamondes thre verey feire Rubyes and thre verey feire Emeraldes all set in Goldesmytheswerke with xx feire perles in the same by two peerlls betwixt every stone'[44]. Carcanets might also, apparently, be worn in the hair: 'A carcanett or atyer for the head of goulde, contayning 34 peeces fullie garnished with smale diamondes, at every second peece a pearle' was presented to Elizabeth as a New Year's gift in 1581, by Sir Christopher Hatton. The decorative bands of pearls and jewels strung on laces and woven into patterns were, quite literally, neck laces: 'Item a lace for the necke conteyninge xxiij Diamoundes and Cxlvj perles'[45].

A square was the band of jewels outlining the square neckline of a woman's gown (cat. no. P5). Several were listed in the 1540 inventory among the carcans, and were similar in design, as for example 'one Square of Goldesmytheswerke conteignynge xxvij table Diamondes and xxvj Cluster of peerlls being vj in every Cluster'[46]. No squares are listed in the 1587 inventory, as by that time the fashion had changed. The jewels would have been used for girdles and other ornaments.

There are examples of both single and pairs of borders in the 1536-7 inventory. In pairs they were decorations for sleeves, as 'Item ij borders of golde enameled with

36 This complete inventory of the Wardrobe of Robes, from an MS which formerly belonged to Mr Craven Ord and from which an extract was printed in J. Nichols, *Progresses and Public Processions of Queen Elizabeth*, (London, 1823) Vol. III, will be printed with other MSS and a commentary in my forthcoming book *Queen Elizabeth's Wardrobe Unlock'd*.

37 B.L. Royal App. 68, f.24v.

38 Oxford English Dictionary.

39 B.L., Stowe 560, f.45.

40 B.L., Add. 46,348, f.145v.

41 'The attire or ornaments of a woman's head or neck' according to Baret's *Alvearie*, 1580. However, the term seems to have been used most often for the jewelled decorations on gable headdress and French hoods.

42 B.L.; Royal App. 68, f.25v.

43 B.L., Stowe 559, f.55v.

44 Ibid., f.56.

45 B.L., Add. 46,348, f.170v.

46 B.L., Stowe 559, f.56.

redd And white sett Apon a payre of blacke velvet sleves'[47]. Single borders, for example 'a border of goldesmithsworke enameled with white and black geven to Mrs Littester (?) ageynst her mariege'[48] were presumably for mounting either on the hem of a forepart or across the neckline of a gown, but no lengths are given. Borders were apparently made of separate links and might be taken to pieces: 'Item iij litle borders of golde broken by the Quenes comaundement And putt into dressing of cappes Agaynst newers daie'[49]. None are listed in the 1587 inventory, probably because borders, or guards as they were then called, were embroidered rather than of goldsmith's work, although pearls and gems might still be set into them.

Buttons were not only functional but were used increasingly for decoration all over a gown or doublet[50]. They were round, square or oblong and would have had some kind of shank at the back to enable them to be stitched to material. Some of the buttons given to Elizabeth were very pretty: among them were stars, tortoises set with pearls, and others enamelled with ragged staves among them; these described in the 1540 inventory are just as attractive: 'Item xij buttons lyke faces enameled—the whiche are sett upon a gowne of carnation caffa'[51].

Aglets were attached to ribbons and tied to the gown for decoration. Originally they were the metal tags for laces or points which enabled them to be passed through eyelet holes. Gradually they grew larger until they were purely decorative features. Sometimes the ribbons attaching them to the gown were very short and the aglets stand on end (cat. no. P9). These ribbons became a prominent feature of Spanish dress and are seen in many paintings of the late sixteenth and early seventeenth centuries (cat. no. P25). Aglets are always listed in pairs, one for each end of the ribbon ties, as in the 1587 inventory: 'Item aglettes ennameled white like crosses vij paier'[52].

Single jewels are listed under a variety of names in the inventories: crosses, hachis, tablets, pendants, brooches, ooches and flowers. The crosses are self-explaratory and the 'hachis' simply the initial letter of Henry. However, some other items may need further clarification.

Tablets are listed with books in the 1536-7, 1540 and 1550 inventories; the books were miniature ones, to hang at the girdle (cat. no. 11). In the 1587 inventory, tablets are listed together with pendants, so it would seem that these were all types of hanging jewels. An entry in the 1550 inventory would seem to confirm this impression: 'Item vij small Tablettes golde enameled with ij hartes golde enameled to hange at ladies girdelles'[53]. One tablet which appears in the 1550 inventory was still in Elizabeth's list of jewels in 1587: 'Item a Tablett of golde being a Whistle beinge Cleopatra the upper parte golde enameled white & the lower parte of mother of pearle and one faier Rubie and a lesse Rubie a large diamonde two other meane diamondes thone pointed and three very small Chaines of golde to hange it by wantinge a diamonde'[54]. Tablets appear to have come in many sizes. Some opened to reveal a miniature, others had enamelled or other decorations of naturalistic, historical, biblical or classical inspiration. Towards the end of the sixteenth century, they were also decorated with motifs taken from emblem book.

Brooches were jewels with a pin and a clasp at the back. They are listed by themselves in the 1536-7 inventory. They are grouped with 'ooches, crosses and hachis' in the 1540 inventory and with 'crosses and Jhsus' in that of 1587. These other jewels were fixed with one or more separate pins and sometimes lost if a pin worked loose[55]. Towards the end of the century ribbons were tied over the pins for extra security (cat. no. 16).

The word 'flower' appears in the 1540 inventory under the section of 'brooches, ooches, crosses and hachis'. It is used much more in the section 'Flowers or Ooches' in the 1587 inventory, the word 'ooch' being almost obsolete by this time. The term 'flower' does not necessarily describe a jewel with a floral motif. It is simply a word for a jewel, as in this example: 'Item one flower or Juell of golde like an ancor with a woman holding thone end and the topp garnished with small diamondes and

47 B.L., Royal C7 xvi, f.26.

48 Ibid., f.25.

49 Ibid., f.26.

50 The knob of a tassel was also described as a button in accounts of Garter and other ceremonial robes, see Janet Arnold, 'The ''Coronation'' Portrait of Queen Elizabeth I,' *The Burlington Magazine*, CXX, 1978, p. 730.

51 B.L.,Royal C7 xvi, f.29.

52 B.L., Royal App. 68, f.25v.

53 B.L., Add. 46,348, f.161.

54 B.L., Royal App. 68, f.7.

55 Further information about the loss of jewels is given in Janet Arnold, '*Lost from Her Majesties Back*' (London, 1980) pp. p, 10, 14, 87.

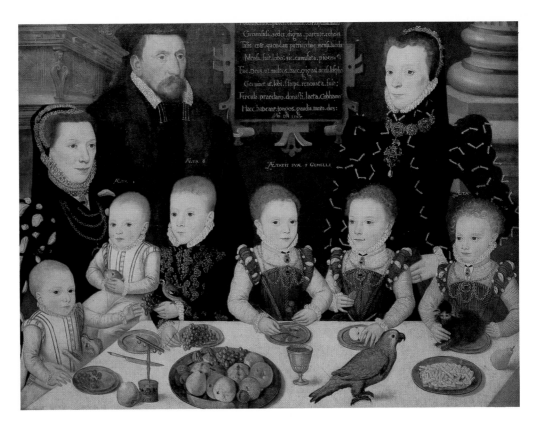

The Cobham family. Lady Cobham's dress is profusely decorated with shot 'aglets'. (P6)

Rubies'[56]. 'Flower' probably has some connection with 'flourished'—a word used at that period to describe the adorning of textiles with decorative designs.

Pomander was a mixture of aromatic substances rolled into a ball and its containers were known by the same name. Pomanders were of open work, to allow the perfume to scent the air, and were often jewelled. The word was also used for buttons, as in 'small buttons of pomaunder netted with damaske golde made peare facion with a pearle at thend of every button'[57]. Small pieces of scented cotton-wool might have been used instead of pomander, tucked inside filigree beads and buttons. Pomander chains were hung at the neck and round the waist: 'Item a Chayne of pomander netted with golde every longe knobb havinge a triangle of goldsmiths worke in the middest conteyning by estimation two ells longe[58].

Designs and Symbolism

The portraits of Queen Elizabeth conjure up the poet's words: 'when she came in like starlight, thick with jewels'[59], and suggest the wildest extravagance. However, this impression is quite unjustified. As the Chancellor of the Exchequer told the Commons in 1573: 'As for her apparel, it is royal and princely, beseeming her calling, but not sumptuous nor excessive'[60]. Many of the jewels were from her father's coffers and had been worn both by him and his six wives and, in turn, by her brother and sister. In addition to this, the New Year's Gift Rolls record a large number of jewels presented to her by members of the nobility, courtiers and their wives. Many were of most imaginative design, and would have given Elizabeth far more pleasure than purses of angels. The numbers fluctuated from year to year with a grand total of eighty on 1 January 1587, the twenty-ninth year of her reign. At this time one danger was past: Mary, Queen of Scots, had been executed on 8th February 1586. However, there were now threats of a Spanish invasion and the gifts symbolise the loyalty of the Queen's subjects, and often held hidden messages (*see* cat. no. 31). One, for example, was 'a Jewell of gold having two hands, the one holding a sworde, the other a Trowell, both garnished with sparcks of diamondes and between the hands a garnishment of opalls'[61]. This device, dedicated to Sir John Payton, appears in

56 B.L., Royal App. 68, f.4v.

57 Ibid., f.25v.

58 Ibid., f.13v.

59 Quoted in Elizabeth Jenkins, *Elizabeth the Great* (London, 1972 edn.) p. 317.

60 Sir Simonds D'Ewes, *Journals* (1963) p. 473.

61 Arnold, *Queen Elizabeth's Wardrobe Unlock'd*, op. cit.

Geoffrey Whitney's *Choice of Emblems*, printed in 1586. It may have been he who gave the jewel to Elizabeth, conveying the message 'That to defend our country dear from harm/For war or work we either hand should arm.'

Other jewels were presented on Progresses and many of these too were designed to remind the Queen of the donors and their good wishes, as, for example, these given by Sir Henry Norris's family, when Elizabeth visited Rycote in 1592[62]. One son, who was in Ireland, sent the Queen an Irish dart of gold set with diamonds, delivered by an Irish lackey. With it was a letter saying 'I desire this Dart to be delivered, an Irish weapon,' with the motto in Irish 'I flye only for my Soveraigne.' Another son, in Flanders, sent a gold key set with diamonds, with the motto in Dutch 'I onlie open to you,' a letter explaining that this was the key of Ostend, and Ostend the key of Flanders: 'The wards are made of true hearts; Treachery cannot counterfeit the Key, nor Treason herselfe picke the locke.' A third son, in France, sent a gold sword set with diamonds and rubies with the motto in French 'Drawen onlie in your defence.' His letter proclaimed that in the Queen's service 'I will spende the blood of my heart . . . what my words cannot effect, my sworde shall.'

The fourth son sent a truncheon, with the motto in Spanish 'I do not commaunde but under you,' and a letter explaining that, as he had to be obedient to the winds in his ship and could not visit Cheapside, he had nothing to offer but his truncheon. It was, however, a little jewel set with diamonds. Finally sir Henry's daughter sent a daisy of gold set with rubies from Jersey, the messenger delivering it to the Queen with a speech to say that 'it hath no sweetnes, yet manie vertues; her heart no tongue, but infinite affections: in you, she saieth, are all vertues, and towards you all her affections.' Although jewels similar in design dating from 1583 have been described

Left:
The Darnley Jewel with its complex emblems and devices. (31)

The Ermine Portrait of Queen Elizabeth I.

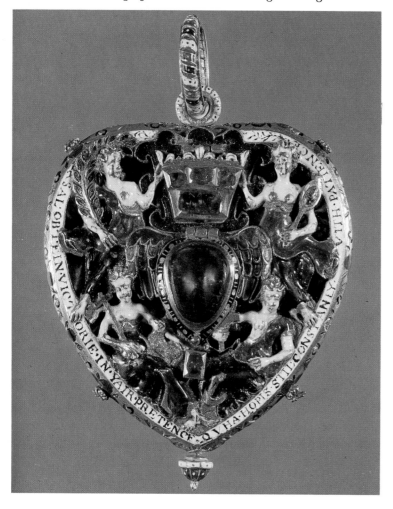

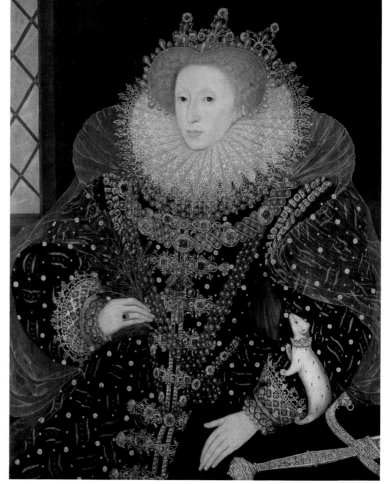

as stupid and ugly, and it has been said that by 1586 Elizabethan emblems were lapsing into petty and purposeless naturalism[63], these and other examples show that this was not so.

Jewels formed from initial letters also made attractive gifts. Henry VIII presented one to Katherine Howard in 1540: 'Item oone other hache of golde wherin is vj feir diamondes wherof iiij be table diamondes and two be poynted & a feir Emeralde in the myddes therof with also thre feir peerlls hanging at the same'[64]. The same jewel seems to be listed in the 1587 inventory, the single emerald being replaced by a diamond, 'Item an H with seaven diamondes wherof two pointed and five tabled with three pearles pendaunte'[65]. Another gift from Henry 'unto Quene Katheryne his most derest wif' in 1540 was 'one Tablet of golde on thonesyde thereof is set a litle Roose of Diamondes being vj small Diamondes with H.K. of Diamondes being xiij Diamondes in them bothe and an E of Diamondes being v Diamondes And on thothersyde one greate Table Diamonde with ij lettres in the Foyle and iiij other Diamondes in the same with certayne persones'[66]. As this jewel also appears in the 1550 inventory[67], it was probably worn by Katherine Parr as well, and may originally have been given to Catherine of Aragon. A 'grete pomander of golde with H and J and a crowne'[68] was presumably a gift to Jane Seymour from Henry. Elizabeth had a jewelled initial of a more complicated design, probably containing some secret message from the donor: 'Item one flower of golde with cloudes of Opalls an arme with diamondes a speare garnished with sparckes of Rubies and an E of diamondes pendaunt. And an helmett in the topp garnished under it with diamondes'[69].

The letter S was also used by goldsmiths for royal jewellery. Two examples worn by Henry's Queens: 'xxxij buttons of golde lyke eeses enameled with white and redd'[70] and 'a paire of beydes with eeses dressed with golde'[71], as well as the esses used for Elizabeth's jewels and lace and embroidery motifs on her gowns[72], suggest that Purey-Cust's theory that S in the Collars of SS stands for 'Soverayne' may well be correct (cat. nos. 18 and P3)[73].

Some jewels told a story. One given to Katherine Howard as a New Year's gift by Henry VIII in 1540 reflects the anti-papal campaigns of the 1530s: 'Item one Tablet of Golde conteignyng on thoneside a goodlye diamonde lozenged with divers other small rubyes and diamondes two naked boyes and a litle boy with a crosse in his hande and divers other persones one with a sawe/and scripture under the said diamonde. And on thotherside a Feyer ballas and the pycture of the busshopp of Rome ronnyng away Lamentyng/and divers persones one settyng his fote upon the busshop overthrowen'[74].

The description of another jewel, in the 1587 inventory, mentions that it contained a miniature of Philip of Spain. It seems likely that it was a gift from him, although whether to Elizabeth or to her sister Mary is uncertain. On her accession, De Feria, the Spanish Ambassador, had sent Elizabeth, in Philip's name, two valuable rings that Philip had originally given to Mary. He also took it upon himself to tell her that the King would be pleased if she would accept a box of Spanish jewels left in Whitehall 'as a good brother should'[75]. This jewel may have been among them: 'Item a Tablett with a storye on thone side and a table Ballace in the middes and on thother side a cittye havinge in the toppe thereof five litle diamondes and nynetene litle Rubies and a great square diamonde underneath and within the tablett is the picture of Kinge Phillipp'[76].

Some of the stories represented in these jewels were chosen specially to please the recipient. In 1571, De Spes, the Spanish Ambassador told Zayas, the Duke of Alva's Secretary, that Leicester had given the Queen a jewel in which she was represented as seated on a throne with the Queen of Scots in chains at her feet and France and Spain submerged by waves 'with Neptune and the rest of them bowing to this Queen'[77].

Other jewels showed mythological subjects. The Queen had a jewel showing on one side Ixion being broken on the wheel and on the other Diana, the chaste huntress: 'Item one faier flower of golde with a man lieing upon a whele garnished with sparcks

62 John Nichols, *Progresses and Public Processions of Queen Elizabeth* (London, 1823) III, pp. 169-172:

63 Joan Evans, *A History of Jewellery 1100-1870* (London, 2nd edn. 1970) p. 117.

64 B.L., Stowe 559, f.21.

65 B.L., Royal App. 68, f.6.

66 B.L., Stowe 559, f.68.

67 B.L., Add. 46,348, f.168v., with the additional information that there were diamond ostrich feathers in the design.

68 B.L., Royal C7 xvi, f.21.

69 B.L., Royal App. 68, f.4v.

70 B.L., Royal C7 xvi, f.29.

71 Ibid., f.18.

72 Arnold, '*Lost from Her Majesties Back*,' op. cit., nos. 161, 174 and 312, and Arnold, *Queen Elizabeth's Wardrobe Unlock'd*, op. cit.

73 A. P. Purey-Cust, *The Collar of SS*, (Leeds, 1910) p. 55.

74 B.L., Stowe 559, f.14.

75 Quoted in Elizabeth Jenkins, *Elizabeth the Great*, op. cit., p. 70.

76 B.L., Royal App. 68, f.7.

77 Quoted in Elizabeth Jenkins, *Elizabeth and Leicester*, (London, 1972) edn., p. 200.

of diamondes and fullye garnished with diamondes rubies and Emerodes on both sides having a diale therein and a Scottishe pearle pendaunte. On the back side a woman shootinge at a Hinde'[78]. Another jewel illustrated the story of Prometheus: 'Item one flower of golde with a naked man and an Eagle sitting on him garnished with sparckes of diamondes rubies and Emerodes pearle and mother of pearle having a small pearle pendaunt'[79]. These jewels would have been similar to that depicting Orpheus with his lute taming wild animals, worn by Mrs Sheldon (cat. no. P15).

Elizabeth was fond of giving her courtiers and suitors nicknames. Walter Raleigh was 'Water'; Hatton, jealous of him, sent the Queen a gold bodkin and a gold charm made like a little bucket, with a letter saying he knew she would need the latter as 'Water' was sure to be near her[80]. This may be the jewel entered in the 1587 list: 'Item a watche of golde sett with small Rubies small diamondes and small Emerodes with a pearle in the topp called a Buckett wantinge two Rubies'[81].

Elizabeth's nickname for her suitor François, Duke of Alençon, was 'frog'. Many enchanting little jewels with gold and enamelled frogs were given to her during the time of his courtship, but one of them was obviously a gift from François himself, containing his picture. A pair of bracelets bore his name. Both gilts are listed in the 1587 inventory of jewels: 'Item one litle flower of golde with a frogge thereon and therein Mounsier his phisnamye and a litle pearle pendaunt'[82] and 'Item one paire of Bracelettes of golde ennameled sett with lettres of sparckes of diamondes with this name Francos de Valos contayninge viij peeces'[83].

Leicester's gifts often incorporated his badge of a bear and ragged staff, sometimes just the latter, into the design. On New Year's Day 1580 he gave her, among other presents, a black velvet cap with 'a bande abowte it with 14 buttons of golde garnished with dyamonds, being raged staves and true-love knotts, garnished with rubyes and dyamondes and 36 smale buttons, being true-love knotts and raged staves.' The design of a chain in the 1587 list suggests that it too may have been a gift from Leicester: 'Item a Chayne of golde contayninge xxiiij[te] peeces whereof twelve peeces being longe peeces ennameled white and blacke and thother twelve round peeces ennameled grene like flowers. And three small links betwene every peece with blacke men clyminge upon ragged staves'[84].

It is not possible to tell exactly where all of Elizabeth's jewels were designed and made. Some of them were sent from abroad by ambassadors, agents and friends, some were captured from Spanish ships, and some were made in England. Others were brought into the country by foreign goldsmiths and merchants, sometimes at the Queen's behest. In May 1561 Sir William Cecil finished a letter to Sir Nicholas Throckmorton, Ambassador in France, with a plea for a goldsmith: 'To end; the Queen's Majesty . . . willed me to require you that some goldsmith there might be induced indirectly to come hither with furniture of aglets, chains, bracelets etc: to be bought both by herself and by the ladies here to be gay in this Court towards the progress'[85]. Perhaps this item in Elizabeth's inventory was purchased at this time: 'a Chayne of parris worke beinge white & Tawnye bugle slightlye garnished with golde'[86], although it is possible that 'paris work' simply refers to a particular type of design.

The goldsmith requested by the Queen need not necessarily have been of French origin. Later in the same year two merchants from Antwerp brought some beautiful jewels to London, where they were unfortunately stolen. A printed sheet offering a reward for help in tracing the thieves is dated 23rd October 1561. From the descriptions and value of the jewels it seems likely that they were intended for Elizabeth: 'Ye shall enquier for a fanne of golde of a verie faire fassion with figures of divers beastes, having on either side iij great Diamounds and a great table Rubie . . . The fethers are black and white. And the said fanne may be worth xv or xvj C crowns'[87].

Janet Arnold.

78 B.L., Royal App. 68, f.3v.

79 Ibid., f.4v.

80 Quoted in Jenkins, *Elizabeth the Great*, op. cit., p. 315.

81 B.L., Royal App. 68, f.9.

82 Ibid., f.35v.

83 Ibid., f.15v.

84 Nicols, *Progresses . . . Elizabeth*, op. cit., II, p. 289 and B.L., Royal App. 68, f.13v.

85 *Miscellaneous State Papers from 1501 to 1726*, (London, 1778) p. 172.

86 B.L., Royal App. 68, f.15.

87 B.L., Harl. 286, f3.

The Renaissance
in the 19th Century

In the late 1820s two remarkable costume balls took place, one in London and the other in Paris. The great heiress Lady Londonderry[1] held the first at Holdernesse House, her London home, in 1828. Elaborately dressed as Queen Elizabeth, her necklace and earrings made no concessions to sixteenth century design, and her curious two-tiered crown sprouted two aigrettes, one trailing a feather. But the front of her bodice, to judge from an engraving published in the *Belle Assemblée* in 1830, was garnished with rows of strapwork enclosing stones[2]. These ornaments many have been embroidered, but they do show some awareness of historic forms. In January 1829, the Duchesse de Berri[3], the daughter-in-law of Charles X and a well-known patroness of the arts, took part in a Marie Stuart quadrille at the Tuileries. Bapst, the Royal Jewellers, were called in for the occasion and re-set some three million francs' worth of the Crown Jewels for her. Some, at least, of this jewellery will probably have been in the Renaissance taste. The Duchesse patronised the silversmith Fauconnier, who is reputed to have revived the Renaissance style in France around 1827; moreover, for a painting by Dubois-Drahonnet she wore an immense jewelled girdle which appears to owe something to sixteenth century motifs[4].

Costume balls, already popular in the eighteenth century, lost none of their appeal in the nineteenth. They were often held for charitable purposes. Queen Victoria and Prince Albert organised a ball at Buckingham Palace on 12th May 1842 in aid of the unemployed silk weavers of Spitalfields. The Queen went as Queen Philippa and the Prince as Edward III, and Victoria was so delighted with their costumes that she sketched them in her Journal. Her crown and the jewellery on her costume, namely brooch clasps and a girdle, were specially made[5], but her necklace, a triple row of pearls, was chosen from her own jewellery. It is clearly visible in Landseer's painting of the royal couple in costume, painted in 1843[6], and also in the chromolithographed souvenir volume of the ball, published in the same year. In 1920 Victoria's granddaughter, the Marchioness of Milford Haven[7], gave the London Museum a necklace, earrings, girdle and pendant which were described in the accessions register as the set worn by the Queen at the ball. In fact, the pieces, which appear to range in date from the seventeenth to the nineteenth century, were given to Victoria by Albert as 'a complete antique *parure*' for Christmas 1842, some seven months after the date of the ball[8].

The pendant, in the shape of a mermaid with a baroque pearl forming the upper part of her torso, has been included here, because it is substantially nineteenth century in date (cat. no. H1). The deception practised on Albert, who was passionately keen on the Italian Renaissance[9], demonstrates that the interest of collectors in sixteenth century artefacts was already encouraging the production of forgeries. The Prince cannot be blamed for failing to spot the crude enamel colours and the anomalies that identify the piece as an imitation. Even antiquaries were somewhat hazy about the qualities that distinguished the Renaissance from the Middle Ages; indeed, it was customary at the time to regard the medieval period as extending into the seventeenth century. This is not to say that research had not already begun. Plate in the Renaissance manner was executed for William Beckford, the great collector and antiquary[10], as early as 1812[11]. The Royal Goldsmiths

Rundell, Bridge & Rundell started to produce silverwork in the Gothic style for George IV in about 1819[12]. The same firm also copied the Holbein drawings of jewellery in the British Museum in the 1820s: whether they reproduced them, in whole or in part, is unknown. If they did so, they were, as usual, exceptional. In general, the antiquarian movement brushed the jewellery trade only lightly in England. The great moral imperative of the antiquaries, fidelity to historic originals, was little regarded.

In the 1830s and 40s the Renaissance style was expressed by English jewellers in the form of moresques and Renaissance scrolls engraved on pieces made in the currently fashionable shapes. One form alone, the lozenge, widespread in the early seventeenth century, was equally popular in the first fifty years of the nineteenth, but it has to be admitted that this useful geometric device also did sterling service in Neo-classical design. What was true of the Renaissance style also applied to the Gothic manner, which was only redeemed from what he regarded as cynical frivolity by the earnest work of the antiquary and designer A. W. N. Pugin.

The reasons for the somewhat cavalier behaviour of most English jewellers in the face of mounting intellectual pressure are hard to explain, but they probably had to do with the fact that women wore their productions to enhance their own appearance; architecture and the other decorative arts did not have the same personal application, and could therefore reflect contemporary aesthetic views in purer form. Thus many of the leading firms in London, who made both silverwork and jewellery, employed sculptors to design and model important pieces of plate in which the human figure was used, but rarely produced jewellery which was figurative. There was no insuperable technical difficulty about reducing models to a size appropriate for jewellery. Pantographs were probably used for the purpose of making the dog and fox head stock pins so popular with sporting gentlemen from the 1820s onwards. We must conclude that the decision not to represent the human figure as frequently as in silverwork was taken deliberately as a concession to the conservatism of purchasers.

French goldsmiths had fewer inhibitions about introducing the human figure in their jewellery, and their prestige was such that they carried their customers with them. Apart from Fauconnier, there were other craftsmen such as Charles (Carl) Wagner, a German who settled in Paris in the 1820s, who were instrumental in resuscitating old techniques to match the styles in which they worked. Wagner's speciality was *niello* decoration, which disappeared from Western European metalwork in the sixteenth century[13]. Fauconnier was succeeded by his two nephews, the Fannière brothers, who produced plate and some handsome jewellery in the Renaissance style[14]. Wagner died some time after the French National Exhibition of 1839. His pupil F. J. Rudolphi, a Dane by birth, succeeded to the business and achieved a reputation for articles in the Gothic and Renaissance style[15]. But the towering figure of the time was Francois-Désiré Froment-Meurice, a silversmith and jeweller of such fame that the title of 'Orfevre-joaillier de la ville de Paris', abolished in 1793, was revived for him[16]. The son of a silversmith, Francois Froment, and trained in his father's workshop, Froment-Meurice took the additional name of his stepfather, who directed the business for a time after Froment's death and married the latter's widow. Early on, Froment-Meurice proved to be a skilled chaser, but he extended his education much further by studying drawing and sculpture[17]. He himself took over the management of the workshops in 1832, and contributed for the first time to one of the periodic exhibitions of French manufactures in 1839. Throughout his working life, Froment-Meurice continued to produce plate, for which he used the services of outstanding artists and craftsmen. His jewellery likewise merited the help of sculptors. Pradier designed and modelled a bracelet for him in the Renaissance style in 1841, with a *vinaigrette* in the centre flanked by two female figures. One of these bracelets is in the collections of the *Musée des Arts Décoratifs*, Paris[18]. Another sculptor, Jules Klagman, was responsible for a group of rings incorporating human figures in 1844[19].

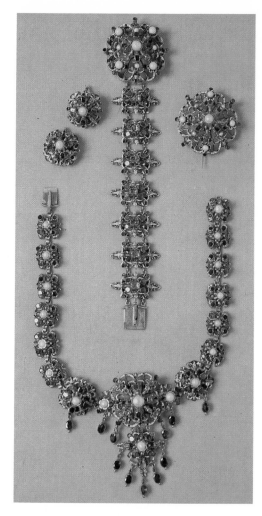

Parure imitating the style of *c*1600, made in Vienna and shown at the Paris Universal Exhibition of 1855. (H3)

Commesso of Queen Victoria based on Thomas Sully's portrait of 1838. (H2)

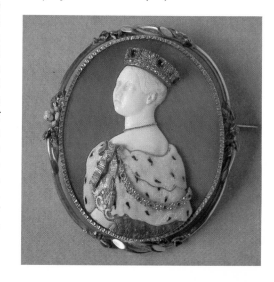

St George and the Dragon from a brooch or pin by F. D. Froment-Meurice. (H4)

Below:
Coral pendant and pair of brooches by Froment-Meurice, *c*1855. (H5)

Bottom:
'Holbein' pendant, set with a cabochon garnet, *c*1860. (H12)

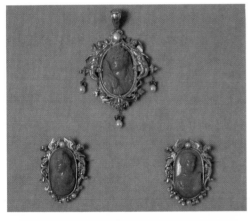

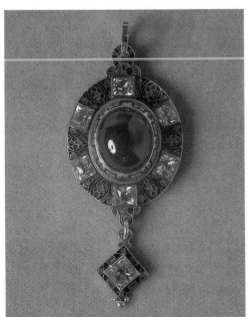

Froment-Meurice's reputation preceded him to the Great Exhibition of 1851, where the Jury cited 'two elegant brooches in the Renaissance style, in rubies and opals, with brilliants arranged in the form of a fringe . . .' among the pieces in his display which were thought to merit the highest award, the Council Medal[20]. A naturalistic bracelet incorporating *putti* was one of several works by Froment-Meurice to be chosen for the new Museum of Manufactures, the ancestor of the Victoria & Albert Museum, by a committee consisting of Pugin, Henry Cole, the first Director of the Museum, Richard Redgrave, the painter, and Owen Jones, the architect. Cole had served in the 1851 Commission as a member of the Executive Committee, and though he and Redgrave were thereafter engaged in running the Museum, they continued to be involved in subsequent international exhibitions, always contriving to purchase items for the collections. Thus the Museum came to acquire, from the Paris exhibition of 1855, several further works by Froment-Meurice, including the sculptural jewel representing St. George and the Dragon (cat. no. H4), a beautifully-modelled example of French goldsmithing, while at the other end of the scale it purchsed a complete *parure* in silver-gilt by Schlichtegroll of Vienna, which, despite being set with precious and semi-precious stones, was regarded as an enterprising example of mass-production (cat. no. H3).

Froment-Meurice died shortly before the opening of the 1855 exhibition, and his detractors were quick to allege that he had often put his name to work that he had neither designed nor executed. Two of his jewels shown here (cat. nos. H4, H7) bear the marks of unidentified goldsmiths, and so we have to recognise that there were grounds for the allegation. On the other hand, there were few jewellers anywhere who did not use the service of outworkers, at least on one occasion. Froment-Meurice's real crime was to be successful, for his work was so much in demand that he was forced to sub-contract commissions on a large scale.

Froment-Meurice's set of a pendant and two brooches with coral cameos (cat. no. H5) demonstrates the continuance of the old practice of pinning brooches to sleeves. This was not a revival: the tradition had persisted, and sleeve brooches were still being made in the late nineteenth century. But one of Froment-Meurice's contemporaries, Felix Dafrique, won a Prize Medal at the 1851 Exhibition for a display including a group of cameos which deliberately emulated a rare class of Renaissance jewel, the *commesso* cameo. These pieces were usually assembled from gold, sometimes enamelled, and cameo components. The specimen shown here (cat. no. H2), makes no pretence to Renaissance design: the subject, the young Queen Victoria after a portrait by Sully[21], was plainly chosen as a compliment to the sovereign of the country staging the exhibition.

To the distress of Henry Cole and his friends, most of the English jewellery shown at the Great Exhibition was naturalistic in character (which they considered decadent) and they thereafter exerted themselves to persuade designers and manufacturers to turn to the Classical and Renaissance styles. To judge by the British contributions to the International Exhibition, their efforts met with spectacular success, though we must not underestimate the part they played in selecting what they regarded as suitable exhibits. Nevertheless, signs that their ideal was gaining acceptance were apparent at least by 1856. In that year, C. F. Hancock made a magnificent enamelled gold *parure* to contain the Devonshire collection of historic gems[22]. Commissioned by the 6th Duke of Devonshire, the *parure* was intended to be worn in Russia by Lady Granville, whose husband, the 2nd Earl, the Duke's nephew[23], was appointed Ambassador Extraordinary to the Court of St. Petersburg for the coronation of Tsar Alexander II in 1856[24]. The Crimean War was an all too recent memory, and it was considered a matter of some moment that the English and French delegations should make an impression both for diplomatic and trade purposes. (Regrettably, the *parure* could not be lent to the Museum for showing here, as it is included in an exhibition of treasures from Chatsworth, which concludes its tour at the Royal Academy. Similar enamelled gold settings, however, appeared in a quanitity of so-called Holbein jewels

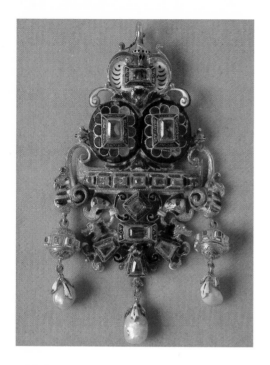

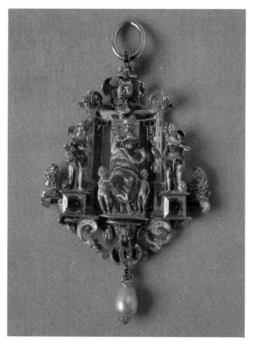

Left:
Pendant, very similar to H10 and probably also by Castellani. (H11)

Centre:
Pendant by the German goldsmith and faker, Reinhold Vasters, before 1890. (H17)

Below:
Ring, set with a cabochon garnet, German, late 19th century. (H16)

Bottom:
Pendant for which two drawings (*see* cat. no. HG3) by Reinhold Vasters exist. (H19)

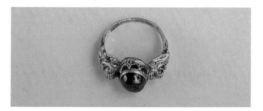

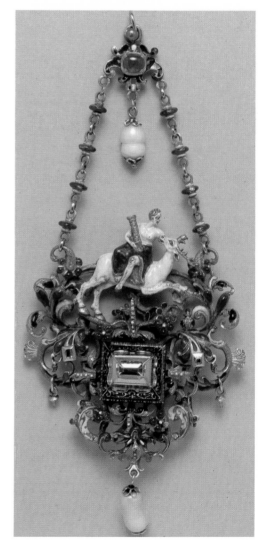

which were shown by at least three firms at the 1862 exhibition. The example included in this exhibition (cat. no. H12) is typical of the genre, its centre formed of a cabochon garnet, a polished, unfacetted stone already popular in Gothic Revival jewellery.)

The literal interpretation of historic styles favoured in the early Victorian era was gradually superseded during the 1850s by creative eclecticism. To be successful, this had to be based on a thorough knowledge of the history of design. The new mood did not affect the firm of Castellani of Rome, which continued to turn out the faithful renderings of Classical jewellery for which they were already famous. As one of their side-lines, the firm produced versions of Renaissance jewellery. Two pendants are shown here; one, set with a sapphire intaglio of a contemporary battle scene (cat. no. H10) is signed with the firm's monogram. The other, unsigned but attributed to Castellani on the grounds of its remarkable similarity of structure to the first piece, entered the collection of Dame Joan Evans as a specimen of early seventeenth century design, and came to the Museum with the rest of her collection in 1975 (cat. no. H11). It is impossible to say whether it was made with intent to deceive: all that can be said at this stage is that the Castellani concern sometimes tinkered with old pieces that it acquired[25], and may therefore have pushed deception further.

Many German firms also disregarded the fashion for eclecticism. The Renaissance manner, treated with a high degree of exactitude, became a symbol of an emergent nation after the unification of the country in 1865[26], a visible reminder of German might restored after centuries of divided existence. Von Angeli's portrait in the Wallace Collection of the Crown Princess Frederick William, dated 1882, shows her wearing a magnificent necklace and pendant in the style[27]. Renaissance jewellery was studied in Germany in the approved antiquarian fashion with the aid of surviving examples of old pieces, portraits and other records. German publications on the subject were consulted everywhere, even in England, where an altogether more relaxed attitude obtained. To cite one example, Ferdinand Luthmer's *Goldschmuck der Renaissance*, published in Berlin in 1880, appeared in London two years later as *Ornamental Jewellery of the Renaissance*. The thoroughness of the German research bore ultimate fruit in the work of Reinhold Vasters of Aachen (cat. nos. H17 & H23).

Carlo Giuliano, a Neapolitan craftsman who had assisted Alessandro Castellani in his efforts to revive the ancient technique of granulation, was set up by his employer

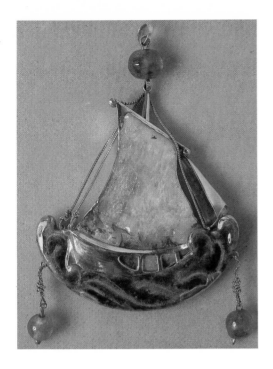

Ship pendant made by the Guild of Handicraft Ltd, c1903. (H15)

in Frith Street, Soho in about 1860, thus enabling the Castellani firm to advertise themselves as of London and Rome at the International Exhibition of 1862[28]. After a few years working as a manufacturing jeweller to the English trade, Giuliano severed his connection with Castellani completely and established himself in Piccadilly in 1874. Giuliano had already begun to free himself from the shackles of antiquarianism, developing a distinctive style based, though not dominated, both Classical and Renaissance motifs (cat. no. H8).

The diluted treatment of the style in England did not prevent it from influencing the metalwork of the Arts and Crafts Movement towards the end of the century, while Lalique himself showed a Renaissance brooch at the Paris Salon of 1895[29], designed before he developed his mature version of the Art Nouveau manner. The last phase of Renaissance inspiration is represented here by a single piece (cat. no. H15), a ship pendant by C. R. Ashbee which derives, in simplified form, from the fully-rigged pieces of sixteenth century date, one of which appears in the portrait of Lady Cobham (cat. no. P9). The Ashbee pendant, dating from about 1903, has several layers of meaning. Its Renaissance derivation has already been cited; it is also the Craft of the Guild—the Guild of Handicraft was founded by Ashbee in 1888. Moreover, the opal forming the sail incarnates all Ruskin's views about the desirability of interfering with stones as little as possible, and Ashbee owned Ruskin as a mentor. Such complexity would have delighted the Elizabethans, and Ashbee, architect, designer and writer, was a Victorian version of the Renaissance man.

Shirley Bury,
Deputy Keeper,
Metalwork Department,
V & A.

1 Frances Anne (1800-1865), daughter of Sir Henry Vane Tempest, married Lord Charles Stewart as his second wife in 1819. She succeeded his brother as 3rd Marquess of Londonderry in 1822.

2 Belle Assemblée, 3 series, XI, pp. 256-7.

3 Caroline Ferdinande Louise (1798-1870), eldest daughter of Francis I of the Two Sicilies; married in 1816 Charles, Duc de Berri, son of the Comte d'Artois (later Charles X).

4 Henri Vever, La Bijouterie Francoise au XIXe Siecle, I, 1906, pp. 111, 127 (ill.) The portrait was acquired by the Musee d'Amiens.

5 Souvenir of the Bal Costumé, 54 plates with descriptive letterpress by J. R. Planché (1843). Planché's Preface refers to the fabrics, arms and 'jewelry modelled and manufactured on purpose', for which, as for other items, 'The Antiquary and the Herald are courted for their information'.

6 In the Royal Collection, Buckingham Palace; J. Harris, G. de Bellaigue and O. Millar, Buckingham Palace (1968) p. 306 (ill.)

7 Victoria (1854-1921), the eldest child of Alice (1843-1878), the second daughter of Victoria and Albert, married Prince Louis of Battenburg (1854-1921). In 1917 Prince Louis assumed the surname Mountbatten and was created Marquess of Milford Haven.

8 I am very grateful to Miss Jane Langton, Registrar of the Royal Archives, Windsor Castle, for her help in unravelling this mystery.

9 Albert toured Italy in 1839, the year before his marriage to Queen Victoria. He designed a silver centrepiece in the Renaissance manner which was made for him by Garrard's in 1842 and is now on show in Kensington Palace. S. Bury, 'The Prince Consort and the Royal Plate Collections', Burlington magazine, CIV (1962) fig. 42.

10 William Beckford (1761-1844), the son of Alderman Beckford of the City of London; spent extravagantly on various building projects, especially Fonthill Abbey, which he was forced to sell in 1822.

11 M. Baker and M. Snodin, 'William Beckford's silver', I, Burlington magazine, Autumn 1980.

12 S. Bury, A. Wedgwood, M. Snodin, 'The Antiquarian Plate of George IV', Burlington magazine, CXXI (1979) pp. 343-53.

13 Vever, op. cit., I, p. 164. In about 1825 Wagner began importing articles decorated with niello (presumably originating in Russia): he then progressed to working with the technique himself.

14 Vever, op. cit., I, pp. 114-5, 190.

15 Rudolphi won a Council Medal at the Great Exhibition. Reports by the Juries, 1852, Class XXIII, p. 513.

16 Vever, op. cit., I, p. 171.

17 Id., p. 169.

18 Id., p. 166 (ill.) Another of these bracelets is in the collection of the Musée National de Compiègne.

19 Id., p. 180 (ill.)

20 Reports by the Juries, 1852, Class XXIII, p. 514.

21 A. Ten Eyck Gardner, 'Queen Victoria and Mr. Sully', Metropolitan Museum of Art Bulletin, n.s. V (1946) pp. 144-148.

22 D. Scarisbrick, 'Classic Gems in an English Masterpiece', Country Life, CLXV (1979) pp. 1796-98.

23 Granville George Leveson Gower (1815-1891), 2nd Earl Granville, whose mother, Harriet, was the Duke's sister. The 2nd Earl's wife was Marie Louise, daughter of the Duc de Dalberg and widow of Sir Richard Acton.

24 The coronation took place in Moscow; the receptions, balls and other festivities were held in both St Petersburg and Moscow.

25 S. Bury, 'Alessandro Castellani and the Revival of Granulation', Burlington Magazine, CXVII (1975) pp. 664-668, figs. 53, 54.

26 Information kindly supplied by Brigitte Marquardt.

27 G. Gregorietti, Jewellery through the Ages (1969) p. 267 (ill.)

28 See fn. 25.

29 S. Barten, René Lalique, Schmuck und Objets d'art, 1890-1910 (1977) p. 381, nos. 903, 904 (ill.)

CATALOGUE

1 Pendant

Silver, parcel-gilt. Height including rings: 9 cm.

A number of examples of this pendant exist; there is one, for instance, in the Cloisters Collection, New York. It derives from a design by Albrecht Dürer, dates from about 1510 and may have been part of the chain worn by members of the Order of the Swan, founded in 1443 by Elector Frederick II of Brandenburg. In this case the swan would have hung from the lower ring. [A.SC.]

Provenance: Gustav von Benda collection.
Literature: E. Steingräber, *Alter Schmuck* p. 76; *Katalog der Sammlung für Plastik und Kunstgewerbe II*, Kunsthistorisches Museum, Vienna (1966) no. 306; Y. Hackenbroch, *Renaissance Jewellery*, p. 112.
Collection: Kunsthistorisches Museum, Vienna. Inv. no. 9024.

2 Pendent Cross

Enamelled gold, set with rubies, pearls and a table-cut colourless stone. Height: 2.7 cm.
Condition: very worn. A pendent jewel missing from the base.

Outline-enamelled on the reverse in black against a hatched ground with the Man of Sorrow emerging from the tomb, waist-high in the centre, and the Evangelists around him. The sides are plain.

The solidity of this small Greek cross, the plain scalloped settings round the stones and the Gothic attitudes of the figures on the back all suggest that it dates from the first quarter of the sixteenth century. A painting of Johannes Pfalzgraf bei Rhein and his family (Bavarian National Museum, R.685) dated 1534 but based on individual portraits made in 1532, shows his daughters, Elizabeth and Sabina, wearing almost identical small crosses. [A.SC.]

Provenance: given by Dame Joan Evans PPSA.
Collection: V&A. Inv. no. M74—1975.

3 Ring

Gold, set with a ruby and diamond. The ring is cast and chased. Diameter: 2.2 cm.

This woman's ring combines a ruby which has simply been polished, with a diamond that has been given the quite complicated hog-back cut also seen in the IHS pendant (cat. no. 55) dating from about seventy-five years later. The scalloped settings are still plain in the 15th century manner, a style which evolved after about 1520 into the double-scalloped form with enamel decoration on the sides as worn by the Bavarian patrician lady (cat. no. P23). The foliage is still Gothic in its naturalism, and the ring must come from Northern Europe, probably Germany, c1500. [A.SC.]

Provenance: Guilhou Collection: sold Sotheby's 12 November 1937, part lot of 734. Given by Miss Joan Evans.
Collection: V&A. Inv. no. M1—1959.

4 Seal Ring of Hans Burgkmair (1473-1531?)

Enamelled gold, with painted foil red, black and bold under rock-crystal. Diameter: 2.1 cm.
Condition: slightly scratched.

The setting of the bezel is engraved with the black enamelled inscription MORS VINCIT (Death triumphs). Cut in the rock-crystal are Burgkmair's coat of arms, a foiled black bear's head to the right, and the same head to the left foiled gold. The background is foiled red.

The ring is depicted in the double portrait of Hans Burgkmair and his wife (1529) found in the Kunsthistorisches Museum, Vienna, (*Katalog der Gemäldegalerie II*, 1963, no. 167.) [I.H.]
Provenance: bought in 1909 from Johann Renning of Augsburg.
Literature: Muller, *Die Malerfamilie Burgkmair; Das Malerwerk Hans Burgkmairs von Augsburg*, (Exhibition, June-July 1931) cat. p. 26. *Lebensbilder aus dem bayerischen Schwaben, IV*, (Munich 1955), p. 44 ff; A. V. Reitzenstein, *Zum Burkmairschen Doppelbildnis von 1529; Pantheon XXXIII*, no. II, 1975, note 28.
Collection: Bayerisches Nationalmuseum. Inv. no. R 8735.

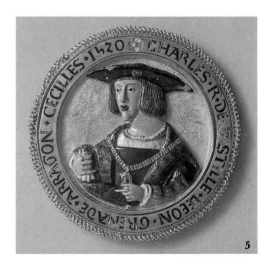

5 Hat Badge with a portrait of Charles V, 1520

Gold enamelled in white, black, flesh-coloured, translucent red, green, purple and colourless enamel. Diameter: 5.72 cm.
Condition: enamel very slightly damaged.

The bust of Charles V is separately embossed and attached by butterfly clips to the matted ground. Rope mouldings and a spiked wire moulding are soldered to it. The border is *champlevé* enamelled with the inscription CHARLES.R.DE.CASTILE.LEON. GRENADE.ARRAGON.CECILLES. 1520.

The inscription lists only Charles's Spanish territories despite the fact that he was elected Emperor on 29th October 1519. Muller (*see* cat. no. 4) suggests that it was therefore made during his passage through the Burgundian territories on the way to his coronation at Aachen on 23rd October 1520. The French spelling of the inscription, as well as the combination of old-fashioned uncial letters with Roman capitals, also point to an origin in the French-speaking Netherlands.

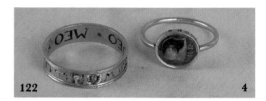

There is another hat badge with an enamelled bust of Charles V from the same workshop, also in the Kunsthistorisches Museum, Vienna, (Inv. no. 1612). They would have been worn on the brim of the hat as Charles is wearing one in this portrait. [A.SC.]

Provenance: The Imperial Collections.
Literature: Steingräber, *Alter Schmuck*, p. 91, pl. 148; *Karl V* Exhibition, Kunsthistorisches Museum, Vienna, 1958, cat. no. 50; *La Toison d'Or* Exhibition, Musée Communal des Beaux-Arts, Bruges, 1962, cat. no. 160; Hugh Tait, 'Historiated Tudor Jewellery', *The Antiquaries Journal* XLII-ÏI (1962) p. 227; Evans (1970) p. 96, pl. IV; Y. Hackenbroch, *Renaissance Jewellery* pp. 229-230.
Collection: Kunsthistorisches Museum, Vienna Inv. no. 1610.

6 Pendant

Opaque black enamel on gold; table-cut diamonds and rubies, set with a double cameo of Hercules and Omphale. Width (with frame): 4.5 cm.
Condition: very slight damage to enamel and some loss of gold *appliqué*-work.

Onyx cameo. Obverse: bust of Hercules, frontal, with head turning slightly to the left, lion's skin covering shoulders and tied below neck; cut entirely in dark blue stratum. Reverse: bust of Omphale in profile to right wearing lion's skin on head and tied round the neck; cut in creamy-white and brown strata.

Gold pendant frame. Obverse and reverse both encrusted with four diamonds and four rubies alternating with *appliqué* gold vine-leaves and bunches of grapes arranged in the traditional fleur-de-lis form. The narrow side or band of the frame is enamelled in black with running foliate scroll pattern. Gold pins fasten the frame together and the small gold pendant loop at the top has a thick, larger gold ring through it.

The army of his Imperial Majesty, Charles V, was responsible for the Sack of Rome in 1527, an event that shocked the whole of Christendom. In 1529-30, Charles V came to Italy for the first time and in Rome, where he was crowned by the Pope after his triumphal entry, he was particularly anxious to make amends for the Sack and offered the Pope many gifts, of which this pendant was one.

For an Italian gem engraver of the first quarter of the 16th century, this double cameo is a fine achievement. The pendant setting is probably by an Italian goldsmith, perhaps working in Rome itself. [H.T.]

Provenance: given by the Emperor Charles V (1519-1556) to Pope Clement VII (1523-1534), who presented it to the Piccolomini family; in the Piccolomini cabinet in Rome; subsequently, in the Medina, Bessborough and Marlborough collections; purchased, 1899.
Literature: Borioni, *Museum Piccolomini, Collect. ant.*, pl. iii, no. 45; Montfaucon, *L'antiquité expliquée et représentée en figures, Supplément*, 1, p. 141, pl. liii, fig. i; M. H. N. Story-Maskelyne, *The Marlborough Gems* (London, 1870) no. 309, and the original *Marlborough Gems* (1791) vol. ii, no. 18; S. Reinach, *Pierres gravées* (1895) pl. 114, no. 18; O. M. Dalton, *Catalogue of the Engraved Gems of the Post-Classical Periods in the British Museum* (London, 1915) nos. 109-110, p. 18, pl. VI; Hugh Tait in *Jewellery through 7000 Years*, (British Museum, 1976) no. 387, p. 233; Y. Hackenbroch, *Renaissance Jewellery* (London, 1979) p. 23, fig. 38A, B, colour pl. 1.
Collection: The British Museum, London. Inv. no. M&LA, 99, 7-18,2.

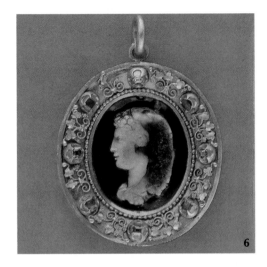

6

7 Seal Ring

Gold, light red cold enamel and crystal, with white, red, green and blue colours behind the crystal. Diameter: 2.8 cm.
Condition: much of the cold enamel, and the colour under the crystal lacking.

The style of the acanthus decoration suggests a date around 1520 for the ring, and it may have been made in Nuremberg. The hoop is decorated on the outside with acanthus in relief on a matted ground. Acanthus masks are finely chased on the underside of the large, shallow, oval bezel. Traces of cold enamel are visible on them. The inside of the ring works as a sundial and displays the curved lines of a summer and winter clock. In the middle of the base lines of the two curves, at the bottom of the ring, there are two small holes which pierce through the acanthus leaves on the other side. If the ring is held vertical to the sun,

50 7

the light shines through the holes on the dial opposite and so registers the time.

The crystal in the bezel is engraved with an archducal coat-of-arms which has not been blazoned, so has still not been precisely identified. The stone has either been painted on its underside, or a painted foil lies beneath it. The coat of arms is surrounded by an order of the Golden Fleece.

Until now, this ring was supposed to have belonged to Archduke Ferdinand II of Tyrol but this is definitely wrong as the heraldry makes too many allusions to Spain, and Bohemia and Hungary are not included. The owner of the ring may have been Ferdinand I, the brother of Emperor Charles V and may date from before the Jagellonian inheritance (Bohemia and Hungary) of 1527. Ferdinand became a knight in the Order of the Golden Fleece in 1516, married Anne of Hungary in 1521 at Linz, and was elected King of Bohemia on 2nd October 1526 (crowned 24th February 1527). [R.D.]

Provenance: The Imperial Treasury.
Collection: Kunsthistorisches Museum, Vienna. Inv. no. 2183.

8 Prophylactic Pendant (*see* p. 17)

Black and translucent blue enamel on gold, set with a hessonite garnet, a peridot and hung with a sapphire. The garnet is fancy cut and the peridot has a facetted point-cut. Both stones are in cut-down settings partially open at the back, scalloped and clawed. On the reverse, the garnet is surrounded by the inscription ANNANISAPTA + DEI and the peridot by DETRAGRAMMATA IHS MARIA in *champlevé* enamel. The sapphire is polished. Height: 5.9 cm.
Condition: only traces of enamel remain on the scroll work.

It is worth noting that the settings of these jewels are open at the back rather than closed as is normal at this date. This was so that the magical power of the jewels might be transmitted more easily to the skin of the bearer. Belief in the healing power of precious stones is very ancient, dating back to classical times and giving rise to numerous treatises on the subject, one of which is close to the date of this jewel, the *Speculum Lapidum clarissimi doctoris Camilli Leonardi Pisaurensis* (1592) maintains, for example, that garnets 'strengthen natural vigour, especially the heart. They drive out sadness and imaginary suspicions. They increase genius, glory and wealth . . .' The peridot, which, like all pale green stones at this date, would have been called a beryl, 'makes those who wear it happy; it preserves and increases conjugal love; hung around the neck it dispels bad dreams; it cures diseases of the throat and mouth' and much more besides. The sapphire, on the other hand, 'refreshes the body and improves the skin; it represses the ardours of desire and makes man chaste and virtuous . . .'

The power of these stones is reinforced by potent magical words on the back. Despite the

Church's disapproval of belief in the mystical and magical power of words and numbers, it flourished throughout the Middle Ages and well into the 17th century. ANNANISAPTA DEI is a very common invocation, frequently engraved on 15th century rings for example, and it was generally believed to ward off epilepsy. DETRAGRAMMATA, a version of TETRAGRAMMATON, refers to the four letters with which the name of God, Jahweh, is written in Hebrew. IHS, the abbreviation of the name Jesus (*see* cat. no. 55), and less often MARIA, were used with similar amuletic intention.

It is certainly true that this pendant resembles a number of designs by Holbein, and in particular the pendant worn by Jane Seymour (cat. no. P5) but this resemblance is only approximate, and when one sees a portrait such as the 1567 group study of the Cobham family (*see* cat. no. P9) with no less than four very similar pendants depicted, it is clear that such jewels were quite common and widespread and the relationship to Holbein's designs is merely generic. [A.SC.]

Provenance: Cook Collection (sold 8th July 1925). Given by Dame Joan Evans P.P.S.A.
Literature: Evans, 'Un bijou magique dessiné par Hans Holbein', *Gazette des Beaux Arts* (1926) pp. 357-361.
Collection: V&A. Inv. no. M.242—1975.

9 Hat Badge

Gold, enamelled in opaque white and black, translucent green, golden brown, and dark blue.
Diameter: 5.7 cm.
Condition: slight damage to the enamel on the rim and on the red drapery.

A gold enamelled roundel, with four projecting pointed loops for attachment to the cloth of the hat, decorated with an applied relief of true embossed work representing Christ talking to the Woman of Samaria at Jacob's Well (St. John, iv, 4-42). Applied to the side of the Well, a separate sheet of burnished gold bearing a black enamelled inscription + OF.A.TREWTHE + THOW. ART.THE TREW MESSIAS: Christ's robe is dark blue; the dress of the Woman is red below the apron and the bodice is finely painted in black over white enamel; the ground in front of the Well is a mixture of golden browns and green; the convex circular frame with its gold foliate running enriched with green, white and red enamel, is seen against a background of black enamel.

The back consists of a thin, circular disc of gold, with ten narrow short slits cut in it, through which pass the butterfly-winged clips that fasten the various elements of the roundel to the back or 'base-plate'. Four clips fasten the figural scene at the Well and two clips in the centre secure the inscribed sheet to the side of the Well; the remaining four clips are located at the cardinal points of the roundel and secure the convex frame. The 'back-plate' has a finely punched surface in all those areas which remain visible after the figural relief scene is attached—and even in some adjacent areas covered by parts of the figures. The reverse of the figural relief has

patches of gold where in the embossing and chasing processes the goldsmith has so worked the thin gold sheet that it developed a hole.

Tudor jewellery with inscriptions in English is extremely rare, though a roundel depicted in a Holbein portrait shows a 'Gentlewoman Luting' and the legend: PRAISE THE LORDE FOR EVERMORE. Similarly, in the 1530 Inventory of Royal Jewels is listed: 'a brooch with a gentlewoman luting and a scripture about it.' The subject is rare in jewellery, though another gold enamelled Hat-badge with this scene exists (formerly in the collection of Lord Wharton); it is smaller and less confident in its use of Renaissance architectural detail. It has no inscription but appears to be of English origin, perhaps a product of the same workshop at a slightly earlier date. From both internal and external evidence, the two hat jewels seem to have been made in England between *c*1530-1540.

The technique of engraving and enamelling the inscription on a separate sheet of gold and attaching it to the gold base-plate is extravagant and contrary to the normal practice of these Renaissance goldsmiths who tended to work the gold as thinly and as economically as possible. However, this technique may be seen on the famous 1520 Charles V Hat-Badges now in the Kunsthistorisches Museum, Vienna (cat. no. 5), which were probably made in the Southern Netherlands. From this area strong artistic

influences and craftsmen came into England in the sixteenth century. [H.T.]

Provenance: unrecorded; purchased in 1955, with the aid of the National Art Collections fund and the Christy Trustees.
Literature: Hugh Tait, 'Tudor Hat-Badges', *The British Museum Quarterly*, vol. 20 (1955-6), p. 37; Eric Mercer, *The Oxford History of English Art, 1553-1625* (Oxford, 1962) p. 216, pl. 75a; Hugh Tait, 'Historiated Tudor Jewellery', *The Antiquaries Journal*, vol. XLII, pt. 2 (1962) pp. 228-9, pl. XXXIX a-c; Hugh Tait, *Jewellery through 7000 Years* (British Museum, 1976) no. 288, illustrated on p. 176; Y. Hackenbroch, *Renaissance Jewellery*, p. 278, fig. 746, colour pl. XXXIV.
Collection: The British Museum, London. Inv. no. M&LA, 1955, 5-7, 1.

10 Hat Badge

Gold enamelled in black, white, translucent blue and green. The construction cannot be described as the reverse is covered by a wooden plate.
Diameter: 3.5 cm.

Item 8 in the 1561 inventory of the Cabinet du Roi is an oval gold hat badge on which there is a battle with small figures mounted on small horses, enamelled white, and around it a border *champlevé* enamelled black. The description is of a hat badge very similar to this one, but it is too hopeful to equate this badge with the 'gold image on which there is an enamelled battle scene' for which a payment was made from the *Dépenses Secrètes* to a Simon Gardyn, 27th September 1538. Battle scenes of this sort can be traced back through numerous Italian examples to classical sources. [A.SC.]

Provenance: bequeathed to the Cabinet des Médailles by J. H. Beck in 1846.
Literature: *L'Ecole de Fontainebleau*, Grand Palais, (Paris, 1972) cat. no. 659; *Revue Archéologique VI*, (1849) p. 350-351; Chabouillet, no. 2721; Evans (1970) p. 85, pl. 460; Y. Hackenbroch, *Renaissance Jewellery*, pp. 60-61, ill. 131.
Collection: Cabinet des Médailles, Paris.

11 Girdle Prayer Book

Gold binding enamelled in opaque white, black, dark blue, light blue, translucent brown, green and turquoise. This encloses a printed devotional book including *Morning and Evening Praiers with divers Psalmes, himnes and Meditations. Made by the Lady Elizabeth Tirwit* and the only known example of the 1574 edition of a set of prayers printed by Henrie Middleton for Christopher Barker.
Height (of the spine): 6.4 cm.
Condition: The losses of enamel on the two figural scenes correspond with the pictorial record of 1791 published in the Gentleman's Magazine, vol. IV, pl. III.

The spine and the two hinged clasps are decorated with arabesque designs in black enamel and the

two small suspension rings are enamelled in light blue. On the front cover, there is a scene in relief representing the Brazen Serpent (Numbers xxi 8) surrounded by the black enamelled inscription: + MAKE . THE . AFYRYE . SERPENT . AÑ . SETITVP. FORA. SYGNE: THATAS. MANY. ASARE. BYTTĒ. MAYELOKE.VPONIT.AÑ.LYVE. On the back, in relief, the Judgement of Solomon (3 Kings, iii, 27) surrounded by the black enamelled inscription: + THEN.THE.KYNG.ANSVERED.AÑ.SAYD.GYVE. HER.THE.LYVYNG.CHILD.AÑ.SLAYETNOT.FOR SHEIS. THEMOT.HER.THEROE.3к3с.

The two figural scenes are true embossed work, modelled from thin rectangular sheets of gold, which were subsequently enamelled and hinged to the spine. There are many small patches of gold on the reverse where the goldsmith worked the gold too thin during the embossing process. The letters of the inscription are often plainly visible on the reverse because of the thinness of the gold but the punched background between the figures is apparently more delicately executed and rarely shows on the reverse. An inner frame of gold creates a double thickness to surround the scenes, and offers a surprising strength and sturdiness to the covers, which move smoothly on a simple hinge. The damaged areas of enamel reveal, especially on the figures, the technique of pitting the surface of the gold in order to key the enamel onto the gold.

The enamelling on the Brazen Serpent panel differs from that on the Judgement of Solomon panel, both in the use of a wider range of colours and in the introduction of translucent enamels, which are used to give a far greater sense of realism, as, for example, where the engraved markings on the body of the Brazen Serpent itself show through the turquoise-green translucent enamel. The more sophisticated technique of enamelling combined with the different scale of the figures within the panel indicates that the Brazen Serpent panel may be the work of a different goldsmith, who did not adapt his foreign prototype to conform to the Judgement of Solomon panel, (*see below* in cat. no. 12).

The contents of this Girdle Prayer Book have no bearing on the date of the covers. They now contain a collection of printed devotional pieces bound together with many pages extracted in order to reduce the thickness to the width of the unyielding gold spine. Furthermore, the pages have been trimmed down around the edges to fit the covers, and, as one of the collections bears the colophon at the end: 'imprinted at London by Henrie Middleton, for Christopher Barker, 1574' —the only known example of this edition—it is probable that about 1575-1580 the original devotional manuscript was removed and a printed, and more Protestant, set of devotions inserted.

According to Nichols in 1788, the Girdle Prayer-Book contained 'on a blank leaf at the beginning this memorandum: *This Book of Private Prayer was presented by the Lady Eliz. Tirwitt to Queen Eliz. during her confinement in the Tower; and the Queen generally wore it hanging by a Gold Chaine to her Girdle; and at her death left it by will to one of her Women of her Bed-Chamber.*' This page, if it ever existed in the book, is now missing, though as there is no sign of the page having been removed, it was probably a later insertion. If there was any truth in this memorandum, the reference must have been to the gold binding, for the earliest of the printed prayers in the Girdle book were published in 1574, later than the event referred to. Admittedly the Lady Elizabeth Tirwit was appointed governess to the Princess Elizabeth in place of Katherine Ashley in 1548, but if it was ever her gift to the Princess Elizabeth in the mid-fifties, then its contents were different at that time. This tradition may, however, arise out of the fact that the first set of prayers in it are entitled: *Morning and Evening Praiers with divers Psalmes, himnes, and Meditations. Made by the Lady Elizabeth Tirwit* (1574). At this stage, therefore, the conclusion can only be that the tradition that it belonged to Queen Elizabeth I cannot be proved.

The precise form of words in the two Biblical texts surrounding the scenes on the covers occurs in only two of the printed English translations of the Bible, namely, the famous Cromwell Bible or 'First Great Bible' (as it is often called) printed in Paris in 1539 and, again, in the Cranmer Bible of 1540, which was published in England by Edward Whytechurche. Most significantly, a very different set of words and phrases were used in the first printed English translation of the Bible by Miles Coverdale in 1535, for which Holbein designed the woodcut on the title-page. Similarly, the next Bible in English—the Thomas Matthew translation of 1537—uses different phrases, perhaps the most significant different phrase being 'brazen serpent'; however, the text for the Judgement of Solomon scene does appear verbatim.

Whereas the spelling of 'BYTTĒ' is identical with that in the 1539 Cromwell Bible and the 1540 Cranmer Bible (including the abbreviation sign above it), the Sixth Great Bible (as it is called) in 1541 prints the word in full, 'BYTTEN'. Subsequent printed translations of the Bible introduce other variations, as in the 1568 first edition of the Bishops' Bible where the text reads: 'Make the a fyrie serpent and set it upon a pole, that as many as are bytten . . .'. It is, therefore, possible for the goldsmith to have made the covers at any time after 1539 but it is highly probable that they were made soon after the Cromwell and Cranmer Bibles appeared in 1539 and 1540, respectively.

Confirmation of this dating emerged during my recent researches into the Continental links with the work of English Renaissance goldsmiths. The scene of the Brazen Serpent on the front of the Girdle Prayer Book is closely related to a fully documented and securely dated masterpiece by the leading Antwerp goldsmith of the High Renaissance, Hieronymus Mamacker. His greatest extant work is the large and especially splendid silver-gilt book-cover (38.5 cm. × 29 cm.) which he made in 1543 for the Abbey of Tongerlo, where it is still preserved. It is, in fact, the earliest Flemish goldsmithswork in the Renaissance style to have survived and, in design, resembles a Renaissance classical triumphal arch or gateway, with the Crucifixion, St. John and the Virgin dominating the centre, supported by the Four Fathers of the Church (below) and the Four Evangelists (above). In the two rectangular panels on either side of the central niche are two small scenes in relief, the Brazen Serpent (on the left) and the Sacrifice of Isaac (on the right). The dimensions of both reliefs are almost identical to those on the Girdle Prayer Book and a close comparison of the two versions of the Brazen Serpent scene reveals that the compositions are extremely similar, though the modelling of the figures in the silver-gilt version by Hieronymus Mamacker appears to be superior. Furthermore, Mamacker has introduced a number of serpents

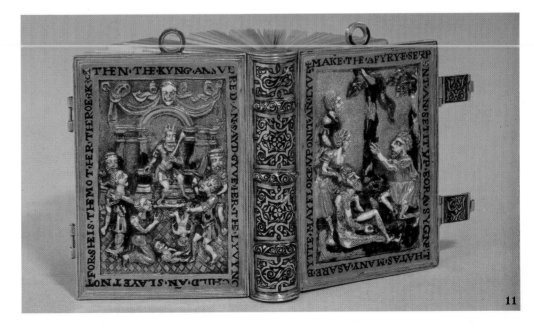

11

49

into the foreground with horrifying effect whereas the English goldsmith, not understanding, has omitted them and, for example, has replaced the snake coiled between the legs of the reclining nude in the foreground by a rather long and large hand. Similarly, the semi-nude female figure seated on the rocks to the left and behind the male nude, is depicted by the English goldsmith as a standing figure, fully-clothed. Nevertheless, most details are faithfully repeated in both versions, even to the tree on the right and the classical style of short sleeve worn on the right shoulder and arm of the figure in profile on the extreme left. Perhaps the most striking repetition is in the kneeling figure grasping the pole on which the 'fyrie serpent' has been set.

The Tongerlo book-cover bears the hall-marks for Antwerp and the maker's mark (a small orb and cross, for Hieronymus Mamacker). It was commissioned by one of the most famous of the Abbots of Tongerlo, Arnoldus Streyters (or Arnoldus de Dyest) 1494-1560. His enamelled coat of arms is to be seen on the silver-gilt book-cover, just to the right of the inscription: ME . FECIT . FIERI . R . P . D . ARNOLDVS . DIEST . ABTS . TONGERLEN . ANO . 1543.

This great patron of the arts, Arnoldus Streyters, turned to Antwerp when he wanted goldsmithswork of high quality in the latest fashion embellished with Mannerist ornament. According to Guicciardini, the city of Antwerp in 1557 had '124 goldsmiths and cutters of diamonds and other precious stones; these produce works of beauty and marvellous quality . . .' Hans von Antwerpen or John of Antwerp (as he is more usually called in England) was a Flemish goldsmith who came to England, probably as early as 1511, married an Englishwoman, had a large family and, according to the last known reference to him, had yet another son baptised at the parish church of St. Nicholas Acon, London, in 1550. His workshop in London was already quite large by 1528 when four of his apprentices were admitted to the Goldsmiths' Company. Holbein, who died in London in 1543, named him as one of the witnesses to his Will and, undoubtedly, had helped him as a friend to obtain the patronage of Henry VIII's court. Holbein, who had returned from Basle in 1532, received his first payment from the English court in 1534 and, by 1536 at the latest, John of Antwerp was receiving commissions from Thomas Cromwell and his name appears for the first time in 1536 in the Privy Purse Expenses of Henry VIII's daughter, Mary. Indeed, without the intervention of Thomas Cromwell, John of Antwerp's activities might have been severely curtailed by the Goldsmiths' Company, who in 1536 had found him guilty of employing without the necessary testimonial a foreigner, probably the Flemish craftsman named Andrew Pomert; in fact, conflict was suddenly avoided and John of Antwerp was admitted a Freeman of the Company in 1537. He clearly kept up his close contacts with the Continent and is described in 1539 in the Royal Accounts as

carrying dispatches for the King to Germany. As nearly all the royal and official payments he received mention not only the quantity of gold but also the gem-stones to be used, it would seem that his workshop was as concerned with the jewelled arts as with silver plate.

No extant piece of jewellery or plate has been identified as a product of his workshop. However, this Girdle Prayerbook, with its scene of the Brazen Serpent so similar to that created by the Antwerp goldsmith, Hieronymus Mamacker, and finished no later than 1543, may be presumed to have originated in the London workshop of John of Antwerp. It is not known whether he obtained access to the original in Antwerp during his travels to Germany in 1539 or whether he may have gained a knowledge of it from one of his 'foreign' assistants. At the time when this Girdle Prayer-book was made, soon after 1540, John of Antwerp was undoubtedly in high favour at Henry VIII's court and this object was certainly designed to be worn by a lady of the court.

Finally, the nonsensical errors in the spelling of the English inscriptions, such as THEMOT . HER . THEREOE, are more understandable if the goldsmith was a Flemish goldsmith, whose native tongue was not English.

The fashion for the ladies of high estate at court to wear tiny prayer-books in richly ornamented gold bindings suspended from the waist on a long and elaborately designed chain, often reaching almost to the ground, dates from Henry VIII's reign. Indeed, his court painter, Hans Holbein, produced at least two alternative designs (in the British Museum) for an English patron, probably for Thomas and Jane Wyatt when they were married in 1537. A devotional illuminated manuscript of miniature proportions with a portrait of an ageing Henry VIII c1545, still survives in its contemporary gold enamelled binding with two panels of openwork leaves and flowers (discussed and illustrated in *Antiquaries Journal*, XLII (1962) pl. XLIc). *See* portrait of Lady Speke (cat. no. P17) painted about 1592 which shows how these girdle prayer-books became a prominent item of jewellery. [H.T.]

Provenance: by 1788 in the possession of Revd. Mr. Ashby, of Barrow, Suffolk, whose family (according to John Nichols) had long treasured it as an heirloom and whose mother received it soon after her marriage in 1720 from her husband's father, George Ashby, M.P., of Quenby, Leicestershire. Subsequently, in the collections of Sir John Cullum, Mr. Farrer (in 1872), and the Duke of Sussex; acquired at the sale of George Field's collection in the early eighteen-nineties by Charles Wertheimer, it was sold to Sir Augustus Wollaston Franks, Keeper at the British Museum, who in 1894 presented it to the Museum.
Literature: John Nichols, *Progresses of the Court of Elizabeth*, vol. I, p. xxxvii; *Notices and Remains of the Family of Tyrwhitt* (reprinted 1872), p. 25; *The Gentleman's Magazine*, vol. V (1791), p. 27, pl. 111; Evans (1970) pp. 101-2, pl. 70; Hugh Tait,

Historiated Tudor Jewellery', *The Antiquaries Journal*, vol. XLII, part 2 (1962), pp. 232-5, pl. XLI a-b; Hugh Tait, *Jewellery through 7000 Years*, (British Museum 1976), no. 286, colour pl. 24; Y. Hackenbroch, *Renaissance Jewellery*, p. 281, figs. 748 A-B.
Collection: The British Museum, London. Inv. no. M&LA, 94, 7-29 1.

12 Pair of Book Covers—Panels
Gold enamelled in opaque white, black, light blue and a translucent darker blue. Height: 6.6 cm.
Condition: almost total loss of enamel, probably mainly translucent, from both the draperies and parts of the foreground; possibly carefully removed in modern times to give the panels a more attractive appearance.

Embossed work, modelled from two thin rectangular sheets of gold: a) the Judgement of Solomon, surrounded by black enamelled inscription: + SOLOMONIS IVDITIO PVERI MATER DINOSSETVR VERA; b) Susanna accused by the Elders and the judgement of the young Daniel, surrounded by black enamelled inscription: + REDITE. IN. IVDITVM QUIA ISTI FALSVM IN ANC TESTIMONIVM.DIX.ERVNT. (Book of Daniel, xiii, 49—'Return to the place of judgement, for they have given false testimony against her'.)

Parts of the background which are finely engraved with foliate scroll motifs, were probably not enamelled; similarly, parts of the draperies decorated with finely punched scrollwork would probably not have been enamelled since there is no sign of any roughening of the surface for keying the enamel.

Until 1962, these two panels were described as a pair of scenes from the story of the Judgement of Solomon—a subject that was popular with the Tudors, several of whose portraits show jewellery depicting this scene. Although representations of the Judgement of Daniel are considerably rarer, the combination of these two scenes would have been a highly suitable choice for the Girdle Prayer Book of the Queen or a Royal Princess since both exemplify the virtue of administering justice after, but not before, the truth has been successfully elicited. The lesson is particularly demonstrated by the story of the young Daniel, who had appeared in the crowd as Susanna was being led to her executioner; she had been found guilty of adultery with a young man on the evidence of the two lustful elders who were robbed of their prize. The scene therefore represents the return to the seat of justice: the goldsmith has represented a king-like figure seated in judgement on a throne, with Susanna standing in the foreground and the young Daniel about to mount the steps of the throne. In the story Daniel keeps the two elders apart and questions them separately, so here the goldsmith places one on the extreme left and the other on the extreme right.

The Gothic training and tradition come out in the use of a distinctive headgear for the two elders, in the foliate design engraved on the gold

ground, and the complete lack of space or perspective. The new Renaissance style, hopelessly misunderstood, creeps into the architecture and the throne with its misinterpreted *baldacchino*.

The quality and range of the enamelling as well as the figure style of these two crowded scenes correspond closely with that of the Judgement of Solomon panel on the Girdle Prayer Book of *c*1540, (cat. no. 11) though there is a slightly more primitive quality about the compositions and little attempt to create a sense of spatial depth. Similarly, the goldsmith of the two loose panels had less awareness of the repertoire of Renaissance ornament and architectural styles. Consequently, it may be assumed that these two panels represent the products of a London workshop in the period immediately prior to the Girdle Prayer Book of *c*1540, and are therefore tentatively dated 1525-1535.

In a portrait of Lady Speke dated 1592 (cat. no. P17) there is depicted a Girdle Prayer Book, which in its design appears to have been some 50-60 years earlier. Furthermore, it is most exceptionally shown fastened by a short red ribbon to the base of the pointed 'V' shaped stiff bodice just below the waist, rather than suspended in the normal way from a chain attached to a girdle around the waist but this deviation may be due to a change in fashion towards the end of the century.

The black enamelled arabesque patterns on the spine and general construction of Lady Speke's prayer-book are immediately reminiscent of the British Museum's Brazen Serpent Girdle Prayer Book (cat. no. 11), but the scene depicted on Lady Speke's book is almost identical to this loose panel representing the Judgement of Daniel. Indeed, the Latin text surrounding the scene is repeated verbatim although the spacing and positioning of the words is at variance. However, many details, such as the misunderstood *baldacchino* and the flanking towers are remarkably similar, although some minor variations can be detected. The

artist's rendering of the scene is in gold relief with only a very little black and white enamel, though the British Museum's loose panel still bears the remains of other coloured enamels.

Whilst it is tempting, therefore, to see in the Lady Speke portrait of 1592 a pictorial representation of the British Museum's loose panel still intact within its original gold enamelled binding, a final conclusion must await the discovery of supporting archival evidence, perhaps in the Will of Lady Speke or some family papers. At present, the records offer no more than a most convincing picture of loyal service at the Court by this prominent Somerset family. In about 1528, Sir George Speke was succeeded by his grandson, Thomas, who married the daughter of Sir Richard Berkeley and held various offices at Henry VIII's court, becoming a Privy Councillor under Edward VI. He died in 1551 and it would seem most likely that it was through him or his wife that this court object, a gold Girdle Prayer Book entered the family and became a treasured heirloom. [H.T.]

Provenance: unrecorded; bequeathed by Sir Augustus Wollaston Franks in 1897.
Literature: Evans (1921) p. 83; Hugh Tait, 'Historiated Tudor Jewellery', *The Antiquaries Journal*, vol. XLII, pt. 2 (1962) pp. 235-6, pl. XLIId; Hugh Tait in *Jewellery Through 7000 Years*, (British Museum 1976) no. 285, illustrated on p. 175; Y. Hackenbroch, *Renaissance Jewellery*, p. 281, figs. 749 A-B.
Collection: The British Museum, London. Inv. no. M&LA, AF 2852-3.

13 Memento Mori Pendant ('Tor Abbey Jewel')

Gold enamelled in white, black, opaque pale blue and white, translucent green and dark blue, decorated with *champlevé* enamel. Height: 7.2 cm.
Condition: considerable enamel loss.

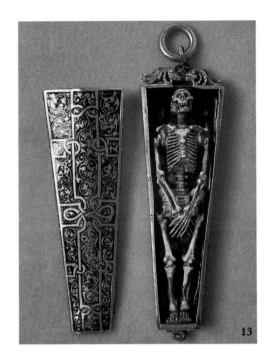

13

The lid is detachable with an enamelled gold skeleton inside.

The inscription round the sides reads: THROUGH. THE. RESVRRTION. OF. CHRISTE. WE. BE. ALL. SANCTIFIED.

The Museum owns another enamelled skeleton of identical dimensions so at least one other similar jewel must have existed. The inscription makes it certain that this is English, although the style is international, with its use of *moresques* which was widely diffused by the engravings of, among others, Virgil Solis and numerous anonymous books of design such as the *Livre de Moresques tres utile et necessaire à tous orfevres, tailleurs, graveurs, painctres, tapissiers, brodeurs, lingières et femmes qui besognent de l'esguille* (Paris: Gormont 1546). The first published English source for *moresques* was Thomas Geminus's *Morysse and Damashin renewed and increased, very profitable for Goldsmythes and Embroderers* (1548) although it is clear from its widespread use on surviving church plate that this form of decoration was already well known in the 1530s. This jewel probably dates from 1540-50. [A.SC.]

Provenance: found at the site of Tor Abbey, Devonshire.
Literature: Clifford Smith, p. 365; J. Evans, p. 142.
Collection: V&A. Inv. no. 3581-1856.

14 Necklace

Gold with black, white and painted enamel. Length of chain: 59.8 cm.
Condition: some of the enamel is missing from the oblong links.

Rosette-shaped links filled with black enamel between cloisons on both sides. There are seven rectangular oblong links enamelled white and painted in Roman capitals with the words VBI

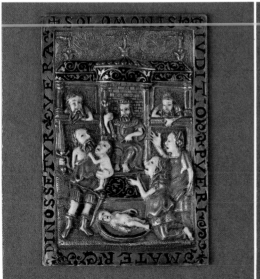

12

AMOR IBI FIDES (where is Love, there also is Faith). The same inscription on the cross.

An identical chain, lacking only the pendent cross, appears in a portrait probably of Renée of France, Duchess of Ferrara, by the Ferrarese artist Girolamo de Carpi, 1501—after 1556 (Städelsches Kunstinstitut Frankfurt a.M.) and a chain made of the same rosette-shaped links enamelled black is worn by the woman in a painting by Agnolo Bronzino, 1502-1572 (Washington National Gallery of Art, Widener Coll.) On this basis, one can with reasonable assurance call this chain Italian. [A.SC.]

Provenance: given by Dame Joan Evans P.P.S.A.
Collection: V&A. Inv. no. M117—1975.

15 Pendant, dated 1546 (*see* p. 6)
Gold enamelled in black, set with an alabaster cameo and hung with a pearl. Diameter: 3.3 cm.

The relief, which is probably Italian, copies the head of the Laocoon, the main figure in the famous sculpture in the Vatican. The inscription on the reverse DOVRATE (*et vosmet rebus servate secundis, Virgil, Aeneid* I 207) was the motto of Antoine Perrenot, Cardinal Granvella (1517-1586) and appears on numerous medals of him. Granvella was a key figure in the imperial administration: he was made Chancellor of the Empire by Charles V in 1550. In 1570 he became Viceroy of Naples, and his last position was as President of the Council of Italy and Castile. He had also been a considerable patron of the arts and collector, and Rudolph went to a great deal of trouble to acquire a number of paintings, sculptures and cameos from his collection. This

pendant is not on the list of desiderata which the Emperor sent with his envoy Karl Billeus, in 1600 to Granvella's heir in Besançon, but may well not have been considered important enough to be mentioned. It remains most probable that the pendant entered the Imperial Collections then. (*See* Lhotsky, pp. 283-4). [A.SC.]

Provenance: no. 2359 in Emperor Matthias inventory of 1619: 'An agate which is carved in relief with an old Hercules; mounted in gold. Durate 1546'.
Literature: Matthias Inv. 2359; Kenner, *Jahrbuch der Kunsthistorischen Sammlungen*, XIII, p. 93; Eichler-Kriss, *Die Kameen*, no. 337.
Collection: Kunsthistorisches Museum. Inv. no. XII 787.

16 Ring of Isabella of Hungary (*see* p. 12)
Gold enamelled in black, white, opaque mid-blue, translucent red and green. The ring is set with a pointed diamond and four triangular facetted diamonds, with four more table-cut diamonds on each shoulder. Height from point of diamond: 3.2 cm.
Condition: The ring shows signs of wear, the inscriptions being abraded and the enamel lacking from the base of the hoop. There is slight enamel loss on the shoulders and bezel.

The ring is cast and chased in high relief with strapwork scrolls and moresques in the interstices. The decoration goes inside the bezel and the shoulders. The outside of the hoop is chiselled with the initials in roundels S F V, and the inside is engraved YSAB-R-VG.
Isabella, Queen of Hungary, was the daughter of Sigismund I of Poland and Bona Sforza of Milan. She married John Szapolya (d. 1540), King of Hungary in 1539, and died herself in 1559. The ring must therefore date from between 1539 and 1559. The S.F.V. stands for 'Sic Fata Volunt' (As the fates wish), the motto of her husband.
It may have been made in Central Europe, but Italy is equally possible because of the Italian connection through Isabella's mother. [A.SC.]

Provenance: the collection of Isabella, Queen of Hungary; in the collection of Andrássy Manó 1884.
Literature: *Catalogue of the Budapest Exhibition of 1884*, p. 139, no. 66. C. Pulsky, E. Radisics, E. Molinier, *Chef d'oeuvre d'orfèverie ayant figuré à l'exposition de Budapest* (Paris, 1884-88) I p. 100, ill. p. 98.
Lent by Diana Scarisbrick.

17 Seal Ring
Gold set with a chalcedony intaglio of Henry VIII. Diameter: 2.6 cm.

Henry is shown full face with a fur-trimmed coat and flat cap on his head. H and R are engraved on either side of him. It is known that rings set with intaglios of Henry VIII did originate from his

court; for example in the *Life of Cardinal Wolsey* George Cavendish relates that at Christmas, 1529, Henry sent his fallen minister a ring 'which was engraved with the King's visage within a ruby, as lively counterfeit as possible to be devised. This ring he knoweth well; for he gave me the same.' This intaglio must be considerably later in Henry's reign because of the portrait type and is certainly not of the quality of the cameo of Henry at Windsor, so may well not be by one of the gem-engravers working directly for Henry. It must predate 1576 when an impression of it appears attached to a deed dated 31st October 18 Elizabeth (1576) as the seal of Dorothy, wife of John Abington. The document (PRO. Ancient Deed pp/103) is a lease from the crown of the Manors of Hallow and Blockley.

Another ring set with a sardonyx intaglio of a profile portrait of Henry was formerly in the possession of Lady Mary Wortley Montague but is known only from a drawing of it by Vertue in *Notebook IV* (Walpole Society, 1936) p. 84. [A.SC.]

Provenance: in 1576 the property of Dorothy Abington of Hindlip, Worcs. Ex. C. J. Fellons Collection (sold Sotheby's 18th December 1930, Lot 28) P. Webster Collection; Holbrooke Collection; bequeathed to the Museum by Frank Ward.
Literature: Oman, *British Rings*, pp. 31, 106, pl. 466.
Collection: V&A. Inv. no. M5 1960.

18 Collar of SS
Gold enamelled in opaque white, green and red.
Condition: enamel renewed. The collar was extended in 1567, and has been frequently repaired and reset e.g. in 1716, 1747.
Cast gold links comprising pairs of letters (28) with an enamelled Tudor rose (14) and a knot alternately between each pair; central link a portcullis.
A rare survivor of the gold livery collars of SS and badges granted as a sign of favour at the Tudor Court (*see* cat. no. P3) incorporating the Tudor rose and knots and the Beaufort portcullis. The significance of the letter 'S' is disputed; it stands most probably either for 'sovereign' or '*souviens de moi*'. Livery or service collars incorporating the device or badge of the lord had been in use at least since the late fourteenth century; the city waits or musicians each had, in 1475, a silver collar of SS and the arms of London.

Sir John Alen, citizen, mercer and twice Lord Mayor, was active at court and as member of the King's Council from at least 1532. His second mayoralty (1535/6) was engineered by Thomas Cromwell 'to have in the said office a well-disposed man, of influence and experience' (Chapuys to Charles V, October 1535). He retired in 1541/2. The King presumably presented the collar to him as a member of the Council. Alen's gift to the Lord Mayor and his successors 'to use and occupy yearly at and upon principal and festival days' reflected the increasing status of the mayoralty in the early sixteenth century. The prefix 'lord' only became permanently attached to the title from about 1534. [P.G.]

Provenance: Bequeathed in 1545 (delivered in October) to the Lord Mayor of London by Sir John Alen.
Literature: L. Jewitt, ed. W. H. St John Hope, *Corporation Plate and Insignia . . . of England and Wales* (1895) p. 111-116; B. R. Masters, 'The History of the Civic Plate' in *Collectanea Londiniensis* (London and Middlesex Archaeological Society, 1978) p. 308-309; A. P. Cust, *The Collar of SS* (1910) p. 30-36 ff.; 'Alen, Sir John', *Letters and Papers Henry VIII 1524-1546*.
Lent by the Lord Mayor and Corporation of London.

19 Pectoral Cross of the Abbot of Averbode, 1562 (*see* p. 23)

Gold enamelled in white, black, opaque pale blue, translucent green, royal blue and dark red; set with precious stones and pearls. Height without pearls: 11.6 cm.

Made in two halves to contain a relic. The front and back held together by four screws. The back decorated in *champlevé* enamel with green predominating in scrolling patterns beneath white bandwork. At the crossing, the coat-of-arms of the owner, together with the mitre, abbots' staff and motto: NE QVID NIMIS (everything in moderation), 1562. On the lower limb is the dedicatory inscription: AVRO PVRO GEMMISQ(UE) PRECIOSIS D(OMINUS) MATEVS A RETHEN ABB(AS) AVERBODIEN(SIS) ME DECORAVIT (Sir Mathew van Rethen, Abbot of Averbode decorated me with pure gold and precious stones).

This is one of the best documented surviving jewels of the 16th century. A contemporary entry in the records of the Premonstratensian monastery of Averbode outside Malines records that the Abbot, Mathew van Rethen (1546-1565), gave the Antwerp goldsmith, Reynere van Jaesvelt, the contract to make a pectoral cross on 15th September, 1562. As in the case of the Liechtenstein crown (*see* cat. no. G46), however, this jeweller was only the middleman, and the actual execution was by a younger Antwerp colleague 'Jherominus Jacobi', although Jaesvelt may have supplied the jewels. The records show that the design was by the famous Hans Collaert the older (*see* cat. nos. G29-31) for which he was paid a very small sum, no more than the cost of

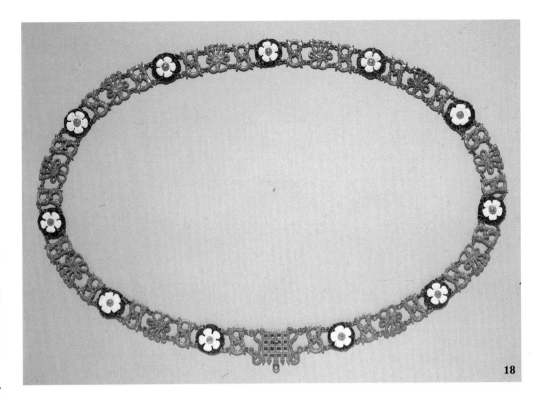

18

the case for the cross. The use of a diamond, emerald and ruby on the front of the cross probably alludes to the different colours of the liturgical year. The blue of the sapphire is not properly a liturgical colour, but that stone may have been used in the absence at this date of amethysts for violet. [A.SC.]

Provenance: the Abbey of Averbode. Figdor collection. Bought 1934 by the Kunstgewerbemuseum, Berlin.
Literature: M. Rosenberg, 'Studien über Goldschmiedekunst in der Slg. Figdor—Wien', *Kunst und Kunsthandwerk* (1911) 329 ff.; exhibited 'Drei Jahre nationalsozialistische Museumsarbeit'. *Acquisitions 1933-1935* (Berlin, 1936) no. 169; H. J. Heuser, 'Drei unbekannte Risse Hans Collaerts des Älteren,' *Jb. d. Hamburger Kunstsammlungen* VI (1961) p. 50 ff.; *Ausgewählte Werke,* Catalogue of the Kunstgewerbemuseum, Berlin, I (Berlin 1963) no. 111; H. Brunner, 'Kunsthandwerk', *Das 16. Jahrhundert, Propylaen-Kunstgeschichte VIII,* (Berlin, 1970), p. 303, no. LVa; H. Appuhn, *Renaissance Anhänger* (Schmuckmuseum Pforzheim, 1970), p. 16, pl. 16.; K. Pechstein, *Goldschmiedewerke der Renaissance* (Kunstgewerbemuseum, Berlin, 1971) cat. no. 92.
Collection: Kunstgewerbemuseum, Berlin. Inv. no. F. 3783.

20 Memento Mori Ring

Gold enamelled in black and white. Diameter: 2.3 cm.
Condition: considerable loss of black enamel.

Cast in one piece, the bezel hexagonal with two scrolled shoulders is chased with moresques inlaid with black enamel. The bezel is enamelled with a

death's head and the words: BE HOLD THE END. Around the edge of the bezel: RATHER DEATH THAN FALS FAYTH. Reverse of bezel has initials ML connected by a true lovers knot.

This is closely related to another ring in the V& A's collection (Inv. no. 920—1871) which has the same death's head on a bezel with incurved sides, but NOSSE TE IPSVM (know thyself) as an inscription. There is a portrait in the Scottish National Portrait Gallery of Mark Ker, Commendator of Newbattle, dated 1551 in which Ker, aged 40, is wearing one of these rings on the forefinger of his left hand. Another portrait (sold Christie's, May 8th 1964, lot 103) dated 1607, shows an unknown man aged 75 also wearing such a death's head ring but on the third finger of his left hand. It is possible therefore that these rings were made throughout the second half of the 16th century. This one may have combined the melancholy qualities of a memento mori jewel with those of a love ring because of the second inscription and the initials united by a lover's knot. [A.SC.]

Provenance: said to have been given by King Charles I on the day of his execution. Bequeathed by Miss Charlotte Frances Gerard.
Literature: Clifford Smith, pl. XXVI no. 12; Oman, 740.
Collection: V&A. Inv. no. 13—1888.

21 Bezoar Pendant

Gold with black enamel. Length: 16.2 cm.

A large bezoar encased in filigree with four plaques on the side with black *champlevé* enamel repeating the same coat-of-arms: chequy of fifteen, argent and azure (arranged in five

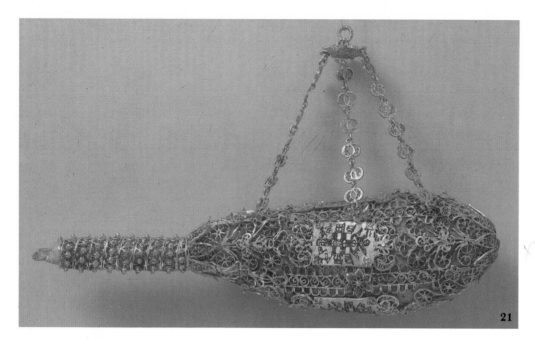

21

horizontal and three vertical rows), the shield in pretence with eighteen roundels; the whole surrounded by moorish standards and surmounted by a ducal coronet.

A bezoar is a concretion found in the stomach or intestines of some animals formed of layers of animal matter deposited around some foreign substance. Elaborate distinctions were made by lapidaries of the time between bezoars of western and of oriental origin, the latter being considered the more efficacious and in consequence, more expensive. In 1609, for example, Kurfürst Christian II of Saxony spent the large sum of 200 thalers buying four bezoars from Joel Haneman of Amsterdam. All were thought to protect against illness, in particular jaundice, dysentery and fevers, and so were worn on the person like many prophylactic gemstones (*see* cat. no. 8). The coat-of-arms shows that this pendant belonged to the famous Duke of Alva (1508-1583), one of Emperor Charles V's most successful generals, and King Philip II of Spain's envoy to the Netherlands, where he crushed the Protestant revolt with great cruelty and thoroughness.

Filigree is notoriously difficult to date and to attribute to a place of origin because of its rather abstract decorative nature. It was popular in many areas of Europe, including Spain, Italy and the German towns. In the estate of Maria Luisa of Orleans there were two bezoars set in filigree gold, but Kurfürstin Anna of Saxony, at her death in 1585, also owned a bezoar in 'a little gold wire basket of fine work'—quoted by E. van Watzdorf, 'Fürstlicher Schmuck der Renaissance,' *Münchener Jahrbuch der bildenden Künste*, XI (1934) p. 62. Thus one cannot be certain that Alva's pendant was made in Spain. [A.SC.]

Provenance: The Imperial Treasury, Vienna, where it is mentioned in the Inventory of 1750, f. 139, no. 38.
Literature: E. Kris, *Goldschmiedearbeiten des Mittel-*

alters, der Renaissance und der Barock, I (Vienna,1932) no. 31; Muller, ill. 218.
Collection: Kunsthistorisches Museum, Vienna. Inv. no. 998.

22 Miniature Case

Gold enamelled in black, white, opaque pale blue, translucent red, blue, green and yellow; set with table-cut rubies and diamonds and an onyx cameo of Emperor Claudius (?), and hung with a pearl. The reverse opens to reveal the densely enamelled interior. Height: 8 cm.
Condition: considerable damage to the enamel.

Originally in the Imperial Collections, Matthias Inventory of 1619 no. 2193: 'In a completely golden portrait box decorated with 5 rubies and 4 diamonds of French work, finely enamelled, is a portrait or miniature of the King of England. Outside the box a pagan emperor, carved in agate, the laurel wreaths and his garb brown in colour, in a black velvet case.'

The epithet 'French work' raises the usual problems as to what is meant by these national attributions in the inventories. Does it refer to the country of origin, or merely to some peculiarity of style regarded as characteristically French, or Spanish? The closest parallel with the black, blue and white enamelling on the rims are the mounts by the Delft goldsmith, Jacques Bylivelt, on a lapislazuli bowl, 1575 (Museo degli Argenti, Florence). The interior of the case is, however, closely related to the decoration on a case containing an English miniature in the British Museum (C. H. Read, *Catalogue of the works of Art bequeathed by Baron Ferdinand de Rothschild* (1902) no. 168). The inside of the lid, with its geometrical, multicoloured patterns outlined in white is like the settings on the cameo with the Judgement of Solomon (cat. no. 65), and another cameo, a 15th century Crucifixion (Eichler-Kris, *Die Kameen*, no. 145), also in Vienna. The front cover, with its

matted gold background, and enamelled relief decoration is however very similar in its treatment and colouring to the case with the miniature of Catherine de Médicis and Charles IX, and this is definitely French (*see* cat. no. 23) so perhaps 'French work' in the case of this cameo can after all be taken to mean work from France. The date is about 1575-90. [A.SC.]

Provenance: The Imperial Collections.
Literature: Matthias Inv. 2193; Arneth, *A.C.* p. 27, pl. XV.7; Sacken-Kenner, 425-38; J. J. Bernoulli, *Römische Ikonographie* II (Stuttgart, 1882) p. 157; Eichler-Kris, *Die Kameen*, no. 21.
Collection: Kunsthistorisches Museum, Vienna Inv. no. IXa98.

23 Miniature case with portraits of Charles IX of France and Catherine de Médicis (*see* p. 3)

Gold enamelled in white, black, opaque pale blue and mid blue, a variety of greens, translucent red, dark blue, turquoise and emerald green. Height: 6.1 cm.
Condition: heavy loss of enamel from the reverse, paint peeled off from the background of Catherine de Médicis's portrait.

Reverse: crowned double Cs which stand for Charles and his mother, Catherine, who governed through him. Obverse: crowned columns on pedestals with the tablets of Mosaic laws and the numeral XII; the inscription: PIETATE ET IVSTITIA (By piety and justice), with the female personifications of these virtues on either side. The insides of the two lids are engraved with a sunburst.

The miniatures of Charles IX (1550-74) and his mother, the formidable Catherine de Médicis (1519-81) are definitely by François Clouet the Younger (d. 1572). The emblem of good government on the front was composed by Michel de l'Hospital, the King's Chancellor. The French royal crown is supported on columns which have the Mosaic laws and the *Lex XII Tabularum*, the civil laws of ancient Rome, as their bases. The twin columns allude to the pillars of Hercules, the device of Emperor Charles V, godfather of Charles IX; the figures of Piety and Justice are united by an olive branch which they hold over the royal crown, thus symbolising peace.

The documentary evidence suggests two possible origins for this pendant. Von Schlosser refers to a document dated 1572 which records that Charles sent a '*pourtraict de la Royne*' to Anna Maria of Austria; it was painted by Clouet, the goldsmith was François Dujardin, and a certain Erondelle was responsible for the King's monogram and device on the case (perhaps the enamelling). On the other hand, Hackenbroch quotes another document in which Catherine addresses herself to Dujardin and François Clouet to commission a medallion, '*pour M. de Savoye*.' It is to be 'A pair of tablets of the same size as the picture that the Queen Mother had shown him, and there will be on one side that above mentioned painting, and on the other side also one of identical size, and device which Monsieur

de Roysi will indicate.' This theory has the advantage that it does mention both portraits, and the double Cs are enamelled red-and-white, the colours of Savoy. The important thing, however, is that Francois Dujardin who is mentioned in both, obviously operated jointly with Clouet in the miniature making business, and almost certainly is the maker of this case. In 1570 Charles IX gave valuable presents to Archduke Ferdinand II which by 1619 were in the Imperial Collections, as was this, so this is in all probability yet another miniature case made by Dujardin. [A.SC.]

Provenance: The Imperial Collections; Matthias Inv. of 1619, no. 2907: 'A portrait box, very neatly enamelled with the portrait of King Charles of France and his lady mother's portrait therein'. 1750 inv. fol. 141, 51.

Literature: J. v. Schlosser, *Album ausgewählter Gegenstände der Kunstindustriellen Sammlung des Allerhöchsten Kaiserhauses* (Vienna, 1901) p. 21 and pl. XXXIC/1-4; *I'École de Fontainebleau* (Paris, 1972) Exhibition cat. no. 671; Y. Hackenbroch, *Renaissance Jewels* pp. 95-7.
Collection: Kunsthistorisches Museum, Vienna. Inv. No. 1601.

24 Posy Holder
Gold enamelled with white, black, opaque pale blue and mid blue, green, translucent red and green; set with table-cut rubies and diamonds. Height: 17.5 cm.
Condition: one flower holder missing; heavy damage to the *champlevé* enamelling on the upper stem.

24

This is probably the only surviving posy holder from this period. It may well be French on the basis of a strong similarity between its moresque enamelling and that on the mounts of a splendid onyx ewer dating from the 1560s given in 1570 by Charles IX of France to Archduke Ferdinand II. [A.SC.]

Provenance: The Imperial Collections.
Collection: Kunsthistorisches Museum, Vienna. Inv. no. 3205.

25 Pendant
Gold enamelled in white, black, translucent green, royal blue and red, set with a sardonyx cameo of Emperor Charles V and Archduke Ferdinand I. The reverse is a plain gold plate. Height: 6.1 cm.
Condition: the gemstones and dependent pearls are missing.

This fine cameo is related to a circular boxwood carving in the Kunsthistorisches Museum, Vienna (*see* Arneth, *C.C.*) which shows Charles V and Ferdinand in an expanded composition which includes Emperor Maximilian opposite them. The portrait of Charles V shows him aged about thirty (*see* Habich, *Die deutschen Schaumünzen des XVI Jahrhunderts* (Munich, 1930) I, CXXII no. 1, dated 1530, by Matthew Gebel.) The setting however, is considerably later, *c*1575. [A.SC.]

Provenance: acquired by the Cabinet des Médailles in 1896.
Literature: Babelon, 977.
Collection: Cabinet des Médailles, Paris.

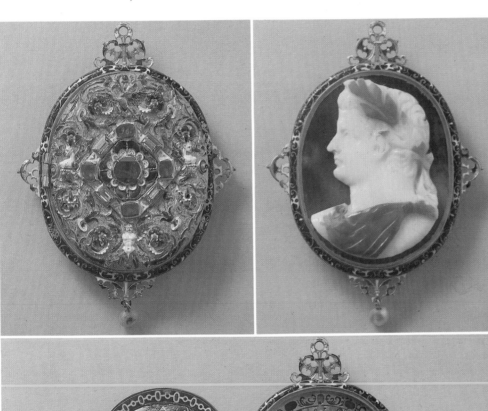

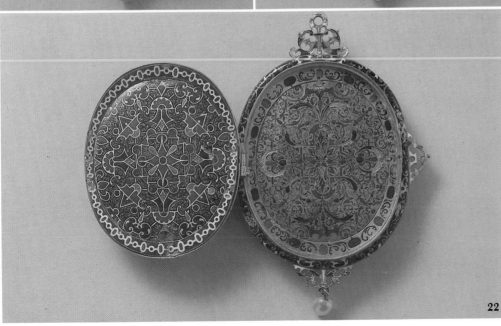

22

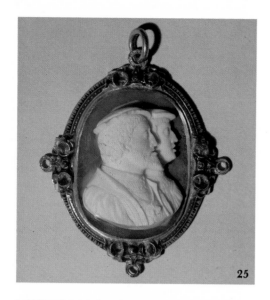

25

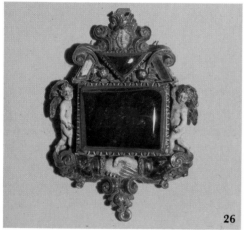

26

26 Pendant

Gold enamelled in black, white, opaque greyish blue and red, translucent red, green, blue and yellow, set with hog-back cut diamonds and cushion-cut emeralds. Height: 5.7 cm.
Condition: the pendent jewel missing from the bottom. Heavy enamel loss from the back. The suspension ring broken off.

The reverse *champlevé*, enamelled with an interlacing pattern of quatrefoils, octofoils, and circles in red, green, blue and yellow against a black ground with a repeated gold feather motif.

This pendant has traditionally been associated with Marie de Médicis (1573-1647) because of the monogram MA formed by the triangular emerald and the diamonds. The style of the setting tends to discredit this legend as it suggests a date not later than about 1575, with its chunky strapwork, realistic clusters of fruit, cupids and female mask. A letter of November 16th, 1571 from Catherine de Médicis to the court jeweller Francois Dujardin says, 'The emerald is a brittle stone which breaks easily, and there are two hands symbolising faith which enclose the emerald; there must be a motto saying that fidelity and friendship which are the desire of the one who

presents this jewel are not like stone, but like the two hands which are inseparable and the colour of enamel on the jewel which is yellow and lasting without growing pale . . .' It is possible that this is the jewel mentioned because the stone is indeed an emerald; there are two clasped hands, and yellow enamel is used on the back. On the other hand, there is no motto as specified in the letter, there are two emeralds not one, and the upper part of the jewel forms the monogram MA which does not fit in with Catherine. The attribution to Francois Dujardin (*orfevre de la Reine* in 1560 and *orfevre et Lapidaire du Roi* in 1570, died 1575) therefore remains tentative. In its bold architectural construction, with heavy strapwork combining with sculptural figures it is, however, reminiscent of the Fontainebleau style, so a French origin for this pendant does seem very likely.

The heavy, rather coarse appearance of the gold, the style of the scrolls, fruit and foliage, and the shades of the enamel colours are similar to the strapwork frame of the cameo of a young woman (cat. no. 53) [A.SC.]

Literature: Chabouillet, no. 223; Y. Hackenbroch, *Connoisseur* (1966) pp. 28-33; *L'École de Fontainebleau* (Paris, 1972) exhibition cat. no. 672.
Collection: Cabinet des Médailles, Paris.

27 Pendant (*see* p. 3)

Gold enamelled in black, white, opaque grey and blue, translucent green, facetted point-cut diamonds, a baroque pearl and spinel. Height: 5.6 cm.

The reverse enamelled with the Bavarian coat-of-arms. The pearl and spinel are not original to the piece; the pearl replaces a large table-cut diamond which the mid 17th-century inventory records as missing. The inventory of 1795 records the spinel instead of the ruby which was then in its place.

This, like cat. no. 28, formed part of the group of jewellery declared to be inalienable heirlooms of the Bavarian ducal house by Albrecht V of Bavaria. It appears in a portrait of Duchess Anna in the miniatures painted by Hans Mielich between 1557 and 1559 for the Motets of Cyprian de Rore. The pendant must, therefore date from before 1559. It has been attributed to Hans Reimer who supplied the Bavarian court with many pieces between 1557 and 1598. There are, however, fewer grounds for suggesting this than for cat. no. 28, although the moresques on its saddle do occur on the white enamelled sapphire-set standing cups (Schatzkammer cat. 562). [A.SC.]

Provenance: the collection of Duke Albrecht V of Bavaria (1550-1579); described in the Disposition of 1565 as 'an elephant with a tower on it in which there is a highly coloured ruby, and below, between the feet, a large oblong diamond, with a fine big pendant pearl'; described in the Munich inventory of the mid 17th-century.
Literature: E. von Schauss, *Historischer und*

beschreibender Catalog der Königlich Bayerischen Schatzkammer zu München (Munich, 1879) B46; Lord Twining, *A History of the Crown Jewels of Europe* (London, 1960) p. 40; U. Krempel 'Augsburger und Münchner Emailarbeiten des Manierismus aus dem Besitz der bayerischen Herzöge Albrecht V, Wilhelm V, und Maximilian I,' *Münchner Jahrbuch der bildenden Künste XVIII* (1967) p. 131, cat. no. 1; E. Steingräber, *Schatzkammern Europas* (Munich, 1968) I, pl. 20; H. Tillander, 'Die Tafeldiamanten der Schatzkammer in München', *Gold und Silber* (April 1969) pp. 96-101; *Official Guide to the Schatzkammer of the Residenz I* (Munich, 1938) 593; *idem II*, (Munich, 1958) 577; *idem III* (Munich, 1970) 636.
Collection: Bayerische Verwaltung der Staatlichen Schlösser, Gärten und Seen.

28 Pendant (*see* p. 3)

Gold enamelled in black, white, opaque pale blue, green, translucent red, blue and green; set with a rock crystal and four table-cut diamonds. Height: 6.5 cm.
Condition: the pearl is now missing.

Cast and chased with two putti below the stone which originally was a 118 carat ruby, removed *c*1760-70, and set in an Order of the Golden Fleece, still in the Schatzkammer (cat. no. 309). A red paste stone was put in its place, and the present rock crystal added after 1785.

This is one of the foundation pieces of the Munich Schatzkammer. It dates from around 1560-65 and may have been made by Hans Reimer, the Munich goldsmith who supplied the Court with numerous pieces from 1557 to 1598, because of the similarity between its dense strapwork and clusters of fruit, and the similar features on the great enamelled standing cup set with sapphires, signed by him (Schatzkammer cat. 562). However, this remains conjectural.

Electress Maria Anna, the second wife of Maximilian I, was painted in 1640 wearing two of the jewels mentioned in the Disposition of 1565, the chain of state and this jewel in her hair (Kunsthistorisches Museum, Vienna). By this time of course, the two pieces were completely out-of-fashion, but she was demonstrating her dynastic pride by wearing the jewels which, as heirlooms, were associated with the ducal house. [A.SC.]

Provenance: the collection of Duke Albrecht V of Bavaria (1550-1579) and part of his Disposition of 19th March 1565 where it is described as 'Item a very fine large brightly coloured balas ruby, mounted *à jour* in a small wreath, with a fine pendent pearl.'
Literature: E. von Schauss, *Historischer und beschreibender Catalog der Königlich Bayerischen Schatzkammer zu München* (Munich, 1879) B 47; E. v. Watzdorf, 'Mielich und die bayerischen Goldschmiedewerke der Renaissance,' *Münchner Jahrbuch der bildenden Künste XII* (1937) pp. 78-79 ill. 9; Lord Twining, *A History of the Crown-Jewels of Europe* (London, 1960) p. 40; U. Krempel,

'Augsburger and Münchner Emailarbeiten des Manierismus aus dem Besitz der bayerischen Herzöge Albrecht V, Wilhelm V und Maximilian I,' *Münchner Jahrbuch der bildenden Künste* XVIII (1967) p. 131 cat. no. 2; H. Tillander, 'Die Tafeldiamanten der Schatzkammer in München,' *Gold und Silber* (April 1969) pp. 96-101; Y. Hackenbroch, *Renaissance Jewellery*, p. 144, ill. 367 a & b; *Official Guide to the Schatzkammer of the Munich Residenz I* (Munich, 1931 and 1937) 591, *II* (Munich, 1958) 579, *III* (Munich, 1970) 638.

Collection: Bayerische Verwaltung der Staatlichen Schlösser, Gärten und Seen.

29 Pendant (*see* p. 5)
Gold enamelled in white, black, opaque pale blue, and mid-blue, mottled green, flesh colour, lilac, translucent red, pale green, mid-green, dark blue, mid-blue, yellow, orange, brown and tawny, set with one point-cut and three table-cut diamonds, five table-cut rubies and with a pendant pearl. Height: 9.5 cm.

Condition: minor loss of enamel from the figures and the back.

The architectural frame is cast and chased with a front and back layer soldered together; the outside columns, box settings of the stones, vault and columns behind the figures separately soldered in. The principal figures, the dove and cherubs' trumpets separately attached. The back plate, which is screwed on by means of nuts and bolts is enamelled *en basse-taille* with the Nativity beneath a ruined classical arch, and, in tiny figures above, the appearance of the Angel to the shepherds. On the left and right are clusters of fruit. The enamelling throughout is a combination of *basse-taille* and *ronde-bosse*.

This large pendant is of very fine quality, chased and matted with great subtelty, and with an especially wide palette of enamel colours. Viewed as an altarpiece in miniature, this invites comparison with the enamelled and bejewelled ebony altarpiece, made for Albrecht V of Bavaria shortly after 1570, and now in the Residenz Schatzkammer Munich, probably by the Augsburg goldsmith Abraham Lotter. Analysis of the ornament with its tight strapwork and clusters of fruit shows that it is more precisely in the tradition of, for example, Virgil Solis's jewellery designs of the 1550s—*see* Ilse O'Dell Franke, K43 and other illustrations. However, it is a more developed form of these ideas, with its architectural 'tabernacle' composition such as one finds in the designs for pendants produced by the Fleming

Erasmus Hornick in Nuremberg (1565). These 'tabernacle' pendants were to become very popular during the last third of the 16th century, and were made all over Germany and Central Europe. This is, however, an early example of the type, from c1560-70 and may well, therefore, also because of its quality, derive from one of the centres in South Germany, Augsburg, Nuremberg or Munich, where the type originated.

Provenance: A. Lopez Willshaw Collection (sold Sotheby's, 13th October 1970, Lot 11).
Literature: *5000 years of Gold Jewellery* (Goldsmiths' Company, London 1972) cat. no. 65; Y. Hackenbroch, *Renaissance Jewellery*, p. 161, ills. 432 a + b pl. XIV.
Lent anonymously.

30 Seal ring, dated 1575
Enamelled gold set with rock crystal over painted foil. Diameter: 2.4 cm.

The crystal is engraved with the arms of Robert Taylor. The inside of the bevel is enamelled with a grasshopper in *basse-taille* green enamel.

The grasshopper was the canting device (*graes & ham*, Anglo Saxon for grass and home) of Sir Thomas Gresham (1579-71), the great financier. A number of rings survive, all with this grasshopper inside the bezel, and one theory was put forward that they were presents at the banquet given in January 1570-71 to mark the opening of the Royal Exchange by Queen Elizabeth. This is not possible however because of the dates of some of these rings. This one is dated 1575. In 1740 the Society of Antiquaries was shown a grasshopper ring dated 1557 which had been found on the Gresham estate in Suffolk (*see* Egerton MS 1041, p. 513[1]) and the V&A has one which belonged to Sir Richard Lee and may have been made at any time between 1551 and 1575, (Inv. no. M249—1928). It seems more likely that these rings were simply presents from Gresham to his friends and to those who had done him some service. Taylor worked in the Exchequer, so they would have known each other there. [A.SC.]

Provenance: sold at Christie's, 9th May, 1978.
Literature: W. T. Hemp, F.S.A., 'The Goodman & other Grasshopper rings' *Antiquaries Journal V* (1925) p. 403; D. Scarisbrick, 'Sir Thomas Gresham & the Grasshopper Rings', *Christie's Review of the Season* (London, 1918) p. 300.
Lent by Diana Scarisbrick.
[1]Information gratefully received from C. L. Oman.

31 The Lennox or Darnley Jewel, *c*1571-1578
(*see* p. 38)
Gold with white, black, translucent red, blue, turquoise, green, brown and yellow enamel. Set with a cabochon sapphire, table-cut rubies and an emerald. Height: 12.5 cm.

Around the face of the heart is the Scottish in-

scription in Roman capitals: QVHA HOPIS.STIL. CONSTANLY.WITH PATIENCE SAL OBTAIN VICTORIE IN YAIR PRETENCE (Who hopes still constantly with patience shall obtain victory in their claim.) In the centre is a winged heart surmounted by a crown with fleurs de lis on an azure shield. Four allegorical figures surround it: bottom left, Faith with the Cross and Lamb; top left, Victory with the Olive branch; top right, Truth with a mirror, and below, Faith with the Cross.

The crown opens to reveal two hearts united by a blue buckle and a golden true love knot, pierced with arrows, feathered with white enamel and barbed with gold. Above is the motto QVAT VE RESOLVE (what we resolve), and below, MSL in monogram crowned by a wreath.

The heart also opens to show two hands clasped together holding a green hunting horn by a red band with, below, a skull and cross bones, and around them, the inscription DEATHE SAL DESOLVE (Death shall dissolve).

Reverse, the inscription MY STAIT TO YIR I MAY COMPAER FOR ZOW QVHA IS OF BONTES RAIR (My state to these I may compare for you who are of rare goodness). The emblems in *basse-taille* enamel are: the sun in splendour, amid blue clouds, studded with stars, opposite, the crescent moon with a man's face in it; below, a crowned salamander, and below that, a Pelican in her piety, a Phoenix in flames and a man lying in the grass with a royal crown beside him, out of which grows a sunflower, with a lizard in its leaves. Behind him is a laurel tree with a bird.

Interior, also in *basse-taille* enamel—a stake surrounded by flames with small crosses in them; a crowned woman on a throne and above her, GAR TEL MY RELEAS (Cause tell of my release); a double figure, being Time on one side and a Demon with cloven feet standing on a celestial sphere on the other. Time is pulling a naked woman symbolising Truth out of a well; opposite Truth is the mouth of Hell and above TYM GARES AL LEIR (Time causes all to learn). Below time is ZE SEIM AL MY PLESUR (You seem all my pleasure). On the lower part of the heart are two groups: a soldier who has thrown down another warrior who points at a crowned red shield; and a crowned warrior holding a woman by her hair.

Emblems and devices were a natural part of people's thinking during the period (*see* cat. no. G49) so, although complex, this would not have been impossibly obscure to a contemporary viewer. The jewel was made for Margaret Douglas, Countess of Lennox in memory of her husband, the Regent Lennox (d. 1571). M.S.L.are the initials of both of them—Mathew and Margaret Stewart Lennox. The salamander is the crest of the house of Douglas, the three fleurs-de-lis on an azure field the first quarter of the Lennox arms, being the royal arms of France granted to his ancestor Sir John Stewart by Charles VII of France. The heart is the Douglas device. The motto around the front refers to Margaret and the Regent Lennox's ambition to see James, the offspring of their son, Lord Henry Darnley and

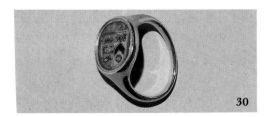

30

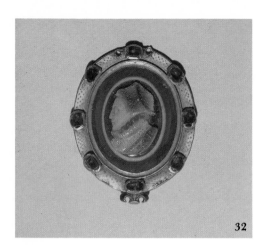

32

Mary Queen of Scots as successor of Queen Elizabeth I of England. The pendant can therefore be seen not only as a memorial to the Regent Lennox, but as a series of admonitions to the little grandson, James VI of Scotland, who was indeed, eventually, to become King of England, in 1603, as James I.

The Pelican in her Piety alludes to Margaret's and the Regent's great care and tenderness for their grandson; the salamander, the Douglas crest, refers to the afflictions which Margaret suffered; the recumbent figure on the grass, with a sunflower growing out of the royal crown in his side is Darnley, for although not a king himself, a King, James VI, was his son. The sun in splendour and the Phoenix are both devices of Queen Elizabeth herself, and the sunflower (James VI) turns in response to the rays of this sun.

The most secret parts of this emblematic message are contained in the interior of the jewel.. The fallen warrior pointing at a crowned shield is the Regent Lennox himself who fell in battle in 1572. The shield refers to the little King, the crowned warrior dragging a woman by the hair refers to the temporary triumph of the Scottish Queen's party over the fortunes of the Countess of Lennox and of James VI who were temporarily ruined after 1572.

The stake symbolises the religious persecution which Margaret suffered on suspicion of being a Catholic. The enthroned and crowned woman refers to her happy state once her honours were restored. The emblems in the group of Time and Truth refer to her being slandered as illegitimate while Time pulls Truth out of the well.

This complex jewel partly looks back over the events of Margaret Douglas's life and partly looks forward to the pretensions of the young James VI to the throne of England. If one accepts that it was made on Margaret's order the jewel must have been made between 1571—when the Regent was killed—and 1578 when she herself died. [A.SC.]

Provenance: Horace Walpole Collection. Sold at Strawberry Hill, 11th May 1842, lot no. 60, where it was bought for Queen Victoria.
Literature: *Horace Walpole's Correspondence*, ed. by

W. S. Lewis (London, 1951) XV, p. 233; P. Fraser Tytler, *Historical notes on the Darnley Jewel* (London, 1843); A. Way, *Catalogue of Antiquities and Historical Scottish Relics* (1859) p. 163; Evans, (1921) p. 188; Evans, p. 116, pls. Vb VIa; Tait (1962) p. 241; Y. Hackenbroch, *Renaissance Jewellery* pp. 292-3.

32 Pendant
Gold with black, white, translucent blue and green enamel. Set with table-cut rubies and a sardonyx cameo of Queen Elizabeth. Height: 4.2 cm.
Condition: two later holes bored into the top of the frame, a truncated suspension scroll at the base.

Open setting, the frame with a thin rim of gold leaf-and-dart, then white with ovals of translucent blue enamel.

This is one of three cameos of Queen Elizabeth in the Cabinet. The setting with its table-cut rubies set in a broad white enamelled border is similar to that on another pendant set with a cameo of Queen Elizabeth (cat. no. 33) which is generally regarded as being English. Because of the style of the ruff this cameo and therefore also the setting cannot date from before c1570. Babelon tentatively attributed all the Cabinet cameos of Elizabeth to Julian de Fontenay who was summoned to England to engrave the Queen's portrait but he he was unaware of the very large number of cameos of Elizabeth, good, mediocre, and bad, in existence which make it clear that there must have been almost an industry producing them, (*see* cat. no. 120 found amongst the Cheapside Hoard.) [A.SC.]

Provenance: possibly from the Cabinet du Roi.
Literature: Chabouillet, no. 372; E. Babelon, *Le Cabinet des Antiques* p. 70, pl. XXIII, fig. 5; O'Donoghue, *Gems* 8; Babelon, no. 968; E. Babelon, *Histoire de la Gravure sur Gemmes* (Paris, 1902), pl. X (7); R. Strong, 'Cameos', *Portraits* 13.
Collection: Cabinet des Médailles, Paris.

33 Pendant
Gold enamelled in opaque white and translucent red; set with eight table-cut rubies, one being of triangular form, and a cameo of Queen Elizabeth. Width: 2.4 cm.
Condition: slight loss of red enamel on reverse.

Onyx cameo bust of Queen Elizabeth I, in profile to left, wearing high ruff, set in the centre of a gold pendant of radiate openwork design. Set with eight garnets (on the obverse) alternating with white enamelled scrollwork. On the reverse, decorated with eight squares of red enamel alternating with white enamel scrolls.

Openwork pendants with a wheel-like or radiate design are exceptional; this example set with a cameo portrait of Queen Elizabeth I is unique and was probably made in England about 1570-90. A pendant of similar radiate open-work design with the arms of Mary Queen of Scots in the centre was purchased in 1939 by the National Museum of Antiquities, Edinburgh—*see Proc. Ant. Scot.*, vol. LXXIV, p. 137-8, pl. liv. [H.T.]

Provenance: unrecorded; bequeathed by Sir Augustus Wollaston Franks in 1897.
Literature: Dalton, *Engraved Gems*, no. 379, p. 51, pl. XV; R. Strong, *Portraits*, p. 132, no. 19; Hugh Tait, *Jewellery Through 7000 Years*, (British Museum, 1976) no. 391, ill. p. 236.
Collection: The British Museum, London. Inv. no. M&LA, AF2654.

34 Pendant
Gold enamelled with black and white, set with table-cut diamonds and an onyx cameo of Queen Elizabeth I and hung with a pearl. Height: 6.5 cm.

The back of the onyx is uncovered. The frame has an inner border, red and blue enamelled egg and dart ornament.

This is one of the best surviving cameo portraits of Queen Elizabeth, comparable with that in the Royal Collection at Windsor. Like all the cameo portraits of her, it cannot date from before about

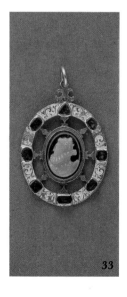

33

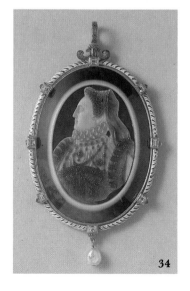

34

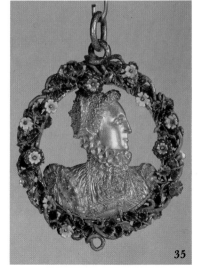

35

1575 because of the style of the costume. Its presence in the Imperial Collections cannot therefore have anything to do with the abortive marriage negotiations conducted in 1567 between Elizabeth and Archduke Charles. It may well, however, have arrived as part of some other diplomatic mission. The border with its red and blue spirals on white enamel is the same as on a cameo of a Roman emperor (Eichler-Kris, *Die Kameen* no. 344) in the collection, also mentioned in Matthias's inventory, the handle on a narwhal horn cup (Leitner, *Die hervorragendsten Kunstwerke der Schatzkammer* (Vienna, 1870-73) p. 12) and two mounted cameos in the Cabinet des Médailles, Bibl. Nat. Paris (Babelon nos. 684 and 778). The setting is therefore one which can be connected definitely with the imperial court. In the case of the cameo of the Roman Emperor, the 1619 inventory describes the jewel as 'Spanish work,' for which *see* cat. no. 69. [A.SC.]

Provenance: Rudolph II's collection(?); no. 2238 in Matthias Inv. of 1619.
Literature: Matthias Inv. 2238; Arneth, *C.C.*, p. 102, pl. II, 22 and pl. XIV; Sacken-Kenner, 477/22; Fr. Kenner, *Jahrbuch der Kunsthistorischen Sammlungen*, IV p. 23 ff; C. D. Fortnum, 'Gems and Jewels at Windsor Castle', *Archaeologia* XLV, 1880, p. 18; Dalton, *Engraved Gems*, p. 378a; Earl of Ilchester, 'Cameos of Queen Elizabeth', *Connoisseur* LXIII (1922), p. 65; R. Strong, *Portraits of Queen Elizabeth I* (Oxford, 1963) p. 128, no. 1.
Collection: Kunsthistorisches Museum, Vienna XII 116.

35 The 'Phoenix Jewel'

Gold enamelled in opaque white, green and yellow; translucent red, brown and green. Width: 4.6 cm.
Condition: slight loss of enamel on the wreath.

Gold, bust of Queen Elizabeth I cut out in silhouette; on reverse, in relief, the device of a phoenix in flames under the royal monogram, crown and heavenly rays; enclosed within an enamelled wreath of red and white Tudor roses with green leaves, buds and intertwined stalks. Some of the roses are single blooms; others are double with white centres and red outer petals. The petals of Tudor roses are formed out of a tiny disc of gold, with a hole pierced in the centre, through which a gold pin is passed, thus attaching them to the wreath and yet still allowing the petals to revolve freely on the pin.

This jewel is a unique survival and bears every indication of having been freely and individually tooled, engraved and chased. Although said to be cut from a medal, no other matching example is known. Neither the front nor the back corresponds with the surviving examples of the famous medal known as the 'Phoenix Badge' (*Medallic Illustrations*, Elizabeth, no. 70), which was also engraved and published in 1620 by John Luckius in *Sylloge Numismatum Elegantiorum*, where it is dated 'about 1574' but without any justification; a silver impression in the British Museum

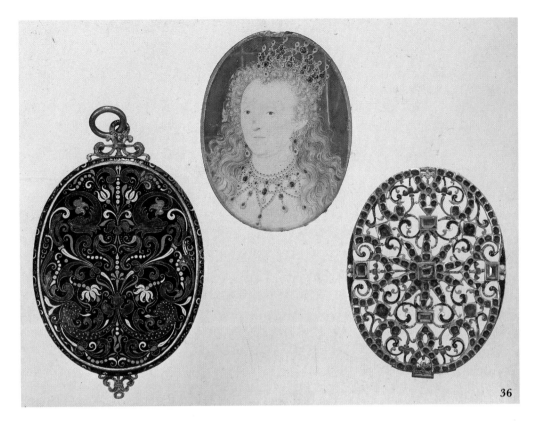

36

bears the engraved date '1574', but this has almost certainly been added more recently. The medals, unlike this gold version, bear an encircling legend expressing grief over the celibacy of the Queen.

Elizabeth I is said to have adopted the phoenix as an emblem of herself—in one painting, the Queen is portrayed wearing a pendent jewel in the form of a phoenix (*see* R. Strong, *Portraits*, p. 60, pl. VII)—but firm documentary evidence concerning the use of this emblem is lacking, and Miss Farquhar's reference to the use of the phoenix as 'her Highnesses badge' at Norwich in 1578 seems to be inaccurate and misleading.

At present, this jewel can only be dated tentatively to the decade 1570-80, partly because of the similarities between this gold bust of the Queen and Nicholas Hilliard's miniature of her dated 1572 (in the National Portrait Gallery). However, Dr Auerbach's recent attribution of this gold jewel to the hand of Hilliard has yet to be proved. [H.T.]

Provenance: collection of Sir Hans Sloane; acquired in 1753 as part of the foundation collections of the British Museum.
Literature: Evans, (1921) p. 91, pl. XIX; Helen Farquhar, 'John Ruttinger and the Phoenix Badge of Queen Elizabeth', *Numismatic Chronicle* 5th Series, 111 (1923), p. 270f. pl. XIII; Evans (1971) p. 120; E. Auerbach, *Nicholas Hilliard* (1961) p. 179f., pl. 174 a-b; R. Strong, *Portraits*, p. 149; Hugh Tait in *The Great Book of Jewels*, edited by Ernst and Jean Heiniger (Lausanne, 1974) p. 229; Hugh Tait in *Jewellery through 7000 Years* (British Museum, 1976) no.

294, colour pl. 26; Y. Hackenbroch, *Renaissance Jewellery*, p. 295, figs. 790 A-B, Colour pl. XXXV.
Collection: The British Museum, London. Inv. no. S1.

36 Miniature Case

Gold enamelled in white, black, opaque yellow, pale green and pale blue, translucent red, blue, green and yellow, set with table-cut diamonds and rubies and enclosing a miniature of Queen Elizabeth.

The openwork front is cast and chiselled with scrolling tendrils behind the main pattern and the star; the back and sides are densely enamelled with a combination of *champlevé* and *cloisonné* enamelling. The background is entirely covered with black enamel, and the dense scrolling design of stylised foliage around a central axis with dolphins above and below is executed in a wide range of enamel colours within fine gold cloisons. Part of the design is achieved through broader areas of gold left in reserve against the black background. The dolphins at the base are enamelled blue, with green collars, yellow spots and white eyes.

The portrait, which is by Nicholas Hilliard, must date from after 1600 and depicts the by now aged Queen in an idealised form. Her hair is loose, symbolising her virginity and she is shown as *Stella Britannis*, an image repeated by the starburst on the front cover.

Open-work fronts occur on other English miniature cases, for example, on the miniature by

the school of Hilliard of Anne of Denmark (cat. no. 118). The openwork front of the Lyte jewel (*c*1620) in the British Museum resembles this one particularly closely in its combination of a gem-set letter on the front with enamelled tendrils curling out behind.

The design on the reverse has been called 'after Daniel Mignot,' the French designer, who engraved numerous prints in Augsburg between 1593 and 1596 (*see* cat. nos. 932-34) but the similarity is only general, not specific. [A.SC.]

Provenance: bought in 1857.
Literature: O'Donoghue, *Miniatures* (32); C. Winter, *Elizabethan Miniatures* (London, 1943) p. 24, pl. IV (a); Evans (1921) p. 10, pl. XX; *N. Hilliard and Isaac Oliver*, V&A Exhibition (London 1947), cat. no. 79; Auerbach, *Hilliard*, p. 146; R. Strong, *Portraits*, p. 97, no. 921; R. Strong, *N. Hilliard* (London, 1975) p. 31, pl. 13.
Collection: V&A. Inv. no. 4404—1857.

37 Locket Ring (*see* p. 26)
Mother-of-pearl, enamelled gold set with table cut rubies, diamonds and a pearl and containing portraits of Anne Boleyn(?) and Queen Elizabeth. Diameter: 1.75 cm.

The bezel bears the monogram ER in diamonds on translucent blue enamel. It is hinged and opens to reveal portraits of Anne Boleyn(?) and Elizabeth, the former set with a diamond, the latter with a ruby. Beneath the bezel is an oval medallion over a device in translucent enamel of a phoenix rising from a flaming crown.

This is said to have been given to the first Lord Home by King James I. The portrait of Queen Elizabeth suggests a date of manufacture of around 1575. Elizabeth was devoted to her mother and treasured any objects associated with her. Although this ring cannot be found in the inventories of her jewels it is very possible, nonetheless, that it did belong to her.

The device of a phoenix rising from a flaming crown is that of the Seymour family so it is possible that the ring originated with Edward Seymour, Earl of Hertford, who, although out of favour in the 1560s because of his marriage to Lady Jane Grey, was sufficiently forgiven by 1576 to be carrying the sword of State before Elizabeth at the St. George's day procession through Whitehall. [A.SC.]

Provenance: The Earl of Home Collection, Viscount Lee of Fareham's Collection.
Literature: Evans, (1921) p. 91, pl. XIX, 2 & 3; *A Catalogue of the Principal Works of Art at Chequers* (H.M.S.O. 1923) no. 507.
Lent by the Administrative Trustees of the Chequers Estate.

38 The Armada Jewel
Gold enamelled in white, black, opaque pale blue, green, translucent red, green, blue, grey, orange and yellow; set with diamonds and rubies and enclosing a miniature of Queen Elizabeth I. The diamonds are facetted joint-cut and table-

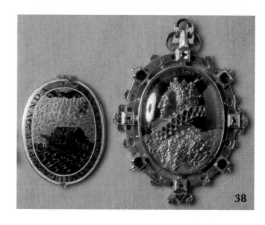

38

cut, Burmese rubies also table-cut. Height: 7 cm. Condition: a small amount of enamel loss. The date 1580 on the miniature not contemporary.

The reverse of the locket opens to reveal the miniature of Queen Elizabeth. The profile bust on the front is surrounded by an inscription painted in Roman capitals on the blue enamel ground ELIZABETHA D.G.ANG.FRA.ET.HIB.REGINA (Elizabeth, by the grace of God Queen of England, France and Ireland). The outside of the lid with the inscription in Roman capitals SAEVAS TRANQVILLA.PER.VNDAS (peaceful through the storm waves). The inside of the lid with the inscription in italic '*Hei mihi quod tanto virtus perfusa decore non habet eternos inviolata dies*' (Alas, that so much virtue suffused with beauty should not last forever inviolate) around a Tudor rose encircled by leaves.

The exchange of portraits by 16th-century princes and rules of Europe was a well-established diplomatic gesture of friendship and the giving and wearing of miniatures was a shade more fervent in its implications; it partook of the chivalric practice of wearing a token of one's lady into the tourney. This was especially true of Queen Elizabeth who, as the Virgin Queen, had become a cult figure at court, and noblemen proclaimed their devotion and loyalty by having themselves painted with her portrait about their person (*see* the portrait by Ketel of Sir Christopher Hatton, cat. no. P13). This fashion for wearing miniatures in jewelled lockets dated from the 1570s and this pendant must date from around 1585-90.

The front bears a version of what was probably the Garter badge of *c*1585 known from a medal in the British Museum and is dated 1574. The text, by Walter Haddon, the Queen's Master of Requests is printed in his *Poemata* (London, 1567) lib. II.

The miniature is by Nicholas Hilliard. The outside of the lid depicts the Ark of the English Church tossed on a stormy sea and the inscription alludes to her safeguarding of it. This also appears on a medal associated with the defeat of the Spanish Armada, and engraved on mother-of-pearl in a miniature case (*see* cat. no. 39). The inscription on the inside of the lid appears on the reverse of the Phoenix medal, an impression of which is in the British Museum and is dated 1574.

Provenance: according to tradition, given by Elizabeth I to Sir Thomas Heneage (d. 1595) a Privy Counsellor and Vice Chamberlain of the Royal Household on the defeat of the Spanish Armada. Kept by the Heneage family until 1902; sold at Christie's, 18th July 1902, lot 99; J. Pierpont Morgan Collection; Sotheby's 24th June 1935, lot 99; presented by Lord Wakefield through the N.A.C.F.
Literature: G. C. Williamson, *Catalogue of the Miniatures in the possession of J. Pierpont Morgan*, (1906), I p. 138; Clifford Smith, pp. 255-6; Evans (1921) p. 91, pl. 17; Auerbach, *Hilliard*, p. 324; R. Strong, *Portraits*, p. 97, pl. 19; Evans (1970) pp. 120, 125, pl. 93.
Collection: V&A. Inv. no. M81—1935.

39 Locket
Gold enamelled in white, opaque mid-blue, yellow and pale green, translucent dark green and red; set with a mother-of-pearl relief and table-cut rubies. Height: 5.9 cm.

Condition: the portrait, whether a cameo or miniature, is lacking from the front.

Around the gaps where the portrait would be, the inscription PER-TOT. DISCRIMINA.RERVM. ('Through so many crises of events', a phrase which recurs in the *Aeneid*). Reverse: a mother-of-pearl relief of the Ark on a stormy sea and the inscription: SEVAS. TRANQVILLA.PER.VNDAS. A circle of rubies around the inscription.

The device of the Ark on a stormy sea, together with this motto, appears on the reverse of a medal of Queen Elizabeth dating from around 1585, and on the Armada jewel (*see* cat. no. 38). The same emblem was used by James I (1603-25) (*see* cat. no. 117), but the style of the locket precludes its dating from his reign.

It is most likely, then, that this locket once contained a portrait, whether a cameo, or miniature, or gold relief like the Armada jewel, of Queen Elizabeth. For example, in his will of 11th August 1607, Thomas Sackville, Earl of Dorset, bequeathed 'one picture of our late famous Queen

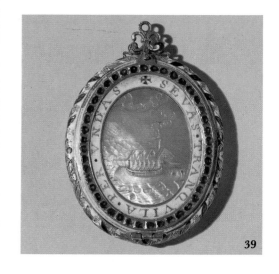

39

Elizabeth, being cut out of an agate, with excellent similitude, oval fashion and set in gold, with 26 rubyes about the circle of it, and one orient pearle pendant to the same,' (quoted in R. Strong, *Portraits*, p. 29, note 1).

Provenance: bought by G. G. Poldi-Pezzoli before his death in 1879.
Literature: G. Bertini, *Fondazione Artistica Poldi Pezzoli, catalogo generale* (Milan, 1881) no. 78; Clifford Smith, p. 256, pl. XXXV, 3; R. Strong, *Portraits*, p. 136.
Collection: Museo Poldi-Pezzoli, Milan. Inv. no. 733.

40 The Drake Jewel

Gold enamelled in white, opaque pale blue, pale green, mid-blue, translucent red, blue and green; set with a sardonyx cameo and table-cut rubies and diamonds containing a miniature of Queen Elizabeth I, and hung with pearls. Height: 11.7 cm.
Condition: slight loss of enamel. The inscription on the miniature damaged and overpainted.

The cameo is set into the front while the reverse, which is enamelled simply with translucent blue, opens to reveal a miniature of Queen Elizabeth with the inscription '*Ano Dm 1575 Regni 20*.' The inside of the lid contains a parchment lining painted with a phoenix.

This exceptionally fine jewel, with its miniature by Nicholas Hilliard, and two-layer sardonyx cameo, dates from 1588, the twenty ninth year of Elizabeth's reign: careful examination of the miniature has shown that the inscription once recorded this and this compatible with the style of the portrait. The painting of the phoenix is very damaged, but probably original, and is of the same type as appears on the Phoenix medal of the Queen, one example of which, (in the British Museum) is dated 1574.

The case is presumably contemporary with the miniature, and it is worth remarking on the fact that the Gresley Jewel (cat. no. 46), which also contains a miniature by Hilliard, is also set with a sardonyx cameo of a blackamoor, although the goldsmiths' work of one does not otherwise bear any resemblance to that of the other.

This jewel was given to Sir Francis Drake (c.1540-1595) the naval hero and freebooter, and it is tempting to think that it was on the occasion of the defeat of the Spanish Armada in 1588, when he commanded a ship under Lord Howard. In any case, it must have been given to him before 1591 because in the National Maritime Museum, Greenwich, there is a portrait of him wearing it painted in that year. The owner of the jewel also owns a portrait of Sir. Francis wearing this pendant and dated 1594 (see cat. no. P15). [A.SC.]

Provenance: the Drake family; thence by descent.
Literature: Ill. in *The Illustrated London News XXVIII*, (1856) p. 163; O'Donoghue, *Miniatures* (12); Lady Eliott Drake, *The Family and Heirs of Sir Francis Drake* (London, 1911); Clifford Smith, pl.

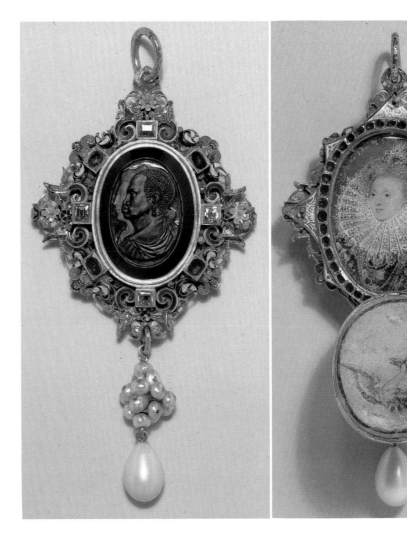

40

34; *Nicholas Hilliard & Isaac Oliver Exhibition*, (Victoria & Albert Museum 1947) cat. no. 102; Evans (1970) pl. 14; Auerbach, *Hilliard*, p. 324 (209); Strong, *Portraits*, p. 92; *A Kind of Gentle Painting Exhibition* (Scottish Arts Council Gallery, 1975).
Lent by Lt. Col. Sir George Meyrick Bart., M.C.

41 The Barbor Jewel (*see* p. 15)
Gold enamelled in white, black, opaque pale blue and pale green, translucent green, blue and brown; set with diamonds and rubies, and an onyx cameo, hung with a cluster of pearls; the stones are table cut. Height: 6 cm.

Reverse: the enamelled crown pale blue and brown; the border enamelled in the pea-pod style, royal blue and white. In the middle an oak tree.

According to tradition, made for Richard Barbor (d. 1586) to commemorate his delivery from the stake by the timely death of Queen Mary. This tradition can hardly be true, as Mary died in 1558, and by the style of her dress the cameo of Queen Elizabeth cannot date from before 1580. The setting, with its 'pea-pod' style reverse and points of black enamel on white, must be even later, around 1600 at the earliest. [A.SC.]

Provenance: in the possession of the Blencowe family who inherited it in marriage some time after 1757. Given by Miss M. Blencowe.
Literature: O'Donoghue, *Gems*, no. 13; *Gentleman's Magazine* N.S. XVI (December 1840) 613; *The Portfolio*, (1900) pl. VIII; Clifford Smith, p. 254; Auerbach, *Hilliard*, p. 324.
Collection: V&A. Inv. no. 889—1904.

42 Ring (the 'Essex')
Enamelled gold, set with an onyx cameo of Queen Elizabeth I. The reverse of the bezel decorated with a pale blue floral scroll. Diameter: 2 cm.
Condition: the hoop bent and worn.

This ring contains an indifferent cameo of about 1580 and may have been set later still, about 1600. It is unlikely that Queen Elizabeth would have given her favourite something so plain and second rate but the legend reflects the practice of giving portraits of oneself as a mark of favour and trust. [A.SC.]

Provenance: said to have been given to Robert Devereux, 2nd Earl of Essex, by Elizabeth and intercepted by the Countess of Nottingham when sent by Essex in 1601 as a plea for his life. This legend is surprisingly old, circulating already in

the early 17th century when it was dismissed by Clarendon in his *Disparity between the Earl of Essex and Duke of Buckingham* (1621). It surfaced again in the *Secret History of Queen Elizabeth and the Earl of Essex* (1695) and De Maurier's *Mémoires* (1688). In fact there is no mention of the ring in Essex's daughter, Lady Frances Devereux's very detailed will. Its descent is supposed to have been from mother to daughter, from Frances Devereux, Duchess of Somerset (d. 1674) to the wife of Thomas Thynne, 2nd Viscount Weymouth (d. 1751). It remained in the Thynne family until it was sold in 1911 to Herbert Stern, 1st Baron Michelham. Bought in 1927 by the late Ernest Makower and presented to the Dean and Chapter of Westminster.
Literature: W. B. Devereux, *Lives and Letters of the Devereux, Earl of Essex* (London, 1853) ii 178-85; *Proc. of the Society of Antiquaries* IV (1858) 178-9; O'Donoghue, *Gems* (20); R. Strong, *Portraits*, p. 132; L. E. Tanner, *Recollections of a Westminster Antiquary* (1969) pp. 166-169; Oman, *British Rings*, pp. 65-66.
Lent by the Dean and Chapter of Westminster.

43 Finger Ring
Gold with cameo of Queen Elizabeth I. The hoop chased with scrolls and foliate designs in low relief; a high and bulbous bezel richly chased in high relief including (on each of the two sides) an imitation of a table-cut diamond in a plain rectangular setting; under the bezel, crossed diagonally by two pearled bands; bezel contains oval onyx cameo bust of Queen Elizabeth I to left, wearing a high ruff.
Condition: three or four pin-holes in the underside of the bezel, which may be original.

When this ring was in the Hertz Collection, the cameo was attributed to Valerio Vicentini but it is now known that he had died twelve years before Elizabeth came to the throne. The identity of the gem engravers of the extant cameo portraits of the Queen has yet to be solved. On stylistic grounds, both the ring and the cameo may be dated to the last quarter of 16th century. [H.T.]

Provenance: Hertz Collections; sold in 1859 at auction to Lord Braybrooke for 15 guineas;

Braybrooke Collection; bequeathed by Sir Augustus Wollaston Franks, 1897.
Literature: *Catalogue of the Extensive Collection . . . formed by Bram Hertz* (London, 1859) p. 189, lot 2734; O. M. Dalton, *Catalogue of Finger Rings in the British Museum* (London, 1912) p. 195, no. 1358, fig. and pl. XX; Dalton, *Engraved Gems*, p. 51, no. 380: R. Strong, *Portraits*, p. 132, no. C22; Oman, *British Rings*, p. 65, pl. 78 A-B.
Collection: The British Museum, London. Inv. no. FB.

44 Ring
Gold enamelled in white, black, painted pale blue, yellow and green, translucent green and gold; set with an onyx cameo of Queen Elizabeth.
Condition: the onyx border slightly chipped.

The outside of the hoop and the underside of the bezel enamelled with a combination of *champlevé* and painted enamel. The flowers are eglantine and pansies on white enamel with black points.
The portrait of this cameo is of the same type as the Barbor Jewel (cat. no. 41) and the cameo found in the Cheapside hoard. It must date from after 1575 because of the style of the costume. The enamelling of the ring, however, is *c*1600. The eglantine and pansies are flowers which allude to the Queen's virginity.

Provenance: Loria collection; Sotheby's, 7th July 1953 (lot 84). Desmoni Collection; Sotheby's, 17th May 1960 (lot 40).
Literature: *Exhibition of Renaissance Jewels Selected from the Collection of Martin J. Desmoni*, (M. H. de Young, Memorial Museum, 1958) cat. no. 61; *Connoisseur* CXXXIX (1957), p. 128; R. Strong, *Portraits*, p. 132 (C23); Oman, *British Rings*, p. 66, pl. 78.
Lent by Mr and Mrs A. Kenneth Snowman.

45 Hat Badge 'The Drake Star' (*see* p. 15)
Gold enamelled with black, translucent red and orange, set with table-cut rubies and diamonds, and cabochon opals, and containing a portrait of a woman. Diameter: 5 cm.
Condition: A suspension loop has been added to the top one. The enamel is missing from the reverse of six of the rays. The portrait is very damaged and difficult to identify with certainty.

The large foiled ruby in the centre is engraved in intaglio with an orb. The reverse, which is covered with a convex piece of glass, contains a miniature portrait of the head and large ruff of a lady, possibly Queen Elizabeth I. The reverse of the large rays are enamelled red; of the small rays, orange. There are four attachment rings.
From the style of the ruff worn by the woman in the miniature this must date from around 1585. The hat badge is in fact a sun, not a star, and is interestingly jewelled in a combination of cut-down and claw settings. The use of opals was very rare during this period. [A.SC.]

Provenance: traditionally associated with the Drake Jewel (*see* cat. no. 40) so probably in the

possession of Sir Francis Drake. Thence by descent.
Literature: Lady Eliott Drake, *The Family and Heirs of Sir Francis Drake* (London, 1911); Clifford Smith, pl. 34.
Lent by Lt. Col. Sir George Meyrick, Bart., M.C.

46 Marriage Pendant (The Gresley Jewel)
Gold enamelled in white, black, opaque pale blue, green, translucent royal blue, red, green and yellow; table-cut rubies, emeralds, pearls, an onyx cameo and enclosing two miniatures. Height: 6.9 cm.
Condition: the suspension ring a later replacement; extensive loss of enamel to the reverse of the lid and the two little cupids on either side; otherwise minor loss of enamel.

Busts and heads of negros and negresses were among the most common subjects for cameo-cutters in the 16th and 17th century (*see* cat. no. 70) combining the appeal of the exotic with advantageous use of the layers of an onyx. The moorish theme has been taken up in the small arrow-firing cupids emerging from cornucopiae at the sides, showing traces of black enamel and obviously once blackamoors. They, and the male and female portraits enclosed within the pendant suggest that it was made on the occasion of a betrothal or marriage. The portraits represent Catherine Walsingham (1559-1585), cousin of Sir Francis Walsingham, the secretary of State to Queen Elizabeth I, and her husband Sir Thomas Gresley (1522-1610) of Drakelowe in Derbyshire. Her identity is established by comparison with the painting of her wearing this jewel from multiple gold chains over her heart, dated 1585 (Birmingham Fine Arts Gallery). According to family tradition this pendant was a present from Queen Elizabeth on the occasion of their marriage. As Nicholas Hilliard (1547-1618), the painter of the miniatures, was official 'limner' to the court this tradition may well be true. With its broad white enamelled band set with table-cut gems the jewel is reminiscent of the pendants in the British Museum (cat. no. 33) and the Cabinet des Médailles (cat. no. 32) both of which frame cameo portraits of Queen Elizabeth. [A.SC.]

Provenance: reputedly by descent in the Gresley family until the late 19th century; Lord Wharton collection; private collection.
Literature: Auerbach, *Hilliard*; R. Strong, *Nicholas Hilliard* (London, 1975) cat. no. 10; H. Tait, 'Renaissance Jewellery: an anonymous loan to the British Museum', *Connoisseur* LIV (1963) pp. 150-151; Y. Hackenbroch, *Renaissance Jewellery*, p. 296, 792-793 b.
Lent anonymously.

47 Serjeant's Ring 1577
Single gold band inscribed in Roman capitals: + LEX.REGIS.PRAESIDIUM (The King's Law is protection). Diameter: 1.7 cm.

Until the Judicature Law of 1875 all new judges

were chosen from the ranks of the Serjeants-at-law who had developed out of the recognised pleaders of Plantagenet times. From the first half of the 15th century it was customary for newly called Serjeants to present gold rings like this one to the monarch, Princes of the Blood, the principal nobility, certain officials and personal friends. These rings were always plain gold bands with a motto which varied with each call. This motto was used at the call of 1577 when the candidate was Edward Fenner. It is known that some of the rings in this year were made by Richard Pindar, but each Serjeant used his own goldsmith for rings given privately.[1]

The value of the rings varied according to the rank of the recipient. King Philip and Queen Mary, for example, received rings costing £3 6s 8d in 1559, the Lord Chancellor and the high officials £1, the judges and Barons of the Exchequer, 16s and so on. [A.SC.]

Provenance: Sir John Evans Coll. given by Dame Joan Evans.
Literature: Oman, p. 41; L. G. Matthews, 'Sergeants' Rings', *Connoisseur* CXXXIII (1954) pp. 25-8; Oman, *British Rings* p. 95 d. p. 129.
Collection: V&A. Inv. no. M53—1960.
[1]Information received from Dr J. H. Baker.

48 Pendent Immaculata
Gold enamelled in black, white, opaque lilac, translucent red and blue; table-cut diamonds and rubies. Height: 7.6 cm.
Condition: the forefinger of the left hand is broken off; the crown is fractured over the forehead and the enamel on head, hands and feet is damaged.

The Madonna's dress is enamelled red *en ronde bosse*, while her cloak is pounced and covered with black scrolls in *champlevé* enamel. She once held an Infant Jesus on her left arm. The *mandorla*, set

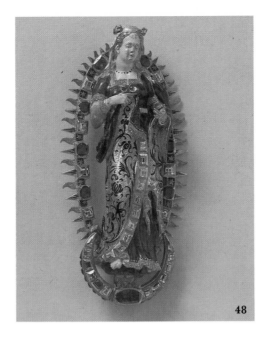

with rubies and diamonds, is soldered to the back, above and below, while the sickel moon is screwed below her feet. Reverse: the *mandorla* is decorated with small gold stars on a blue enamel ground; the Madonna's long hair covers her back, and the sickle moon is enamelled red.

Because of technical and stylistic similarities (e.g. the scrolling black *champlevé* enamel on a pounced ground) between this pendant and the small altarpiece with the Adoration of the Magi, (Khm. Inv. no. 3218) and pieces in the Residenz Schatzkammer, Munich, (e.g. the heart-shaped lockets, *see* H. Thoma and H. Brunner, *Katalog der Schatzkammer der Residenz München* (Munich 1964) nos. 639, 640), it is probable that this Madonna was made by a Munich court goldsmith around 1570. [R.D.]

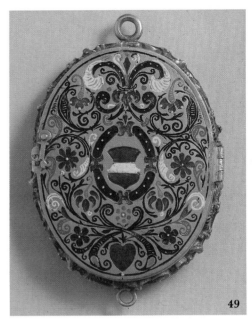

Provenance: given by the Elector of Bavaria to Emperor Leopold I; appears in the inventory of 1750.
Literature: Ilg, *Album* (1895) p. 12f. pl. XV; Y. Hackenbroch, *Renaissance Jewels*, p. 144, ill. 371.
Collection: Kunsthistorisches Museum, Vienna. Inv. no. 1606.

49 Miniature Case
Gold enamelled in white, black, opaque pale blue, green, translucent red, green, blue and yellowish brown, containing a portrait of Archduchess Anna, Duchess of Bavaria. Height: 5.1 cm.

The edges are enamelled on scrolling decoration in relief. The inside of the lid has regular rows of

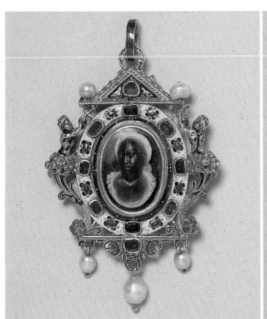
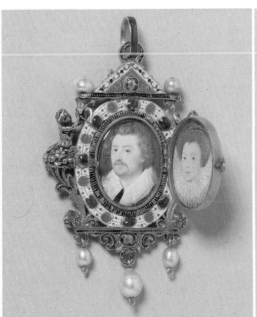
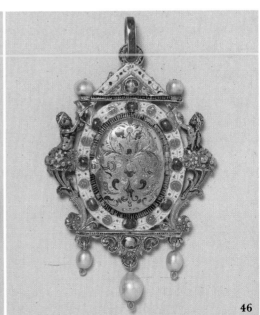

46

dots impressed on it. The miniature is stuck inside the case.

Anna is shown in widow's weeds and so the portrait must date from between 1579 when Duke Albrecht V of Bavaria died, and 1590 when she died. On the lid is the coat-of-arms of Austria. It is possible that the case was made by one of the Munich court goldsmiths. [A.SC.]

Provenance: The Imperial Treasury.
Collection: Kunsthistorisches Museum, Vienna.
Inv. no. 1594.

50 Swivel Ring (see p. 47)
Gold enamelled with black, white, opaque mid-blue, translucent red, blue and green; the miniatures of Archduke Matthias and an unidentified lady are painted directly onto the gold. Diameter: 3.5 cm.

One lid bears on the outside the dimidiated arms of Austria and Burgundy, often used at this time as the 'core' shield in the large Austrian coat-of-arms, under an archducal crown. The inside has the name MATHIAS written in monogram, again under an archducal crown. The miniature opposite shows Matthias. The other lid is enamelled with floral scrolls on the outside, a vase of flowers on the inside, and beneath, the portrait of a young lady.

Matthias (1557-1619) is represented as a young man wearing a ruff which dates the portrait to around 1585. The lady therefore cannot be Anna, daughter of Archduke Ferdinand, who only married Matthias in 1611. She may possibly be an earlier love of his. An earlier dating would also be compatible with the style of the strapwork decoration on the shoulders which suggests the 1580s. [A.SC.]

Provenance: The Imperial Collections.
Literature: A. Ilg, *Album von Objekten aus der Sammlung Kunstindustrieller Gegenstände des Allerhöchsten Kaiserhauses. Arbeiten der Goldschmiede- und Steinschlifftechnik* (Vienna 1895) p. 9f. pl. X.
Collection: Kunsthistorisches Museum, Vienna.
Inv. no. 2182.

51 Ring
Gold enamelled in white, black, translucent red, blue and yellow; set with pointed diamonds and enclosing a sundial under glass. Diameter: 3.5 cm.

The diamonds are set in the curved bezel to give the effect of a hedgehog. A diamond-set thumb-piece at the side releases the lid to reveal a small sundial inside. The underside of the lid is enamelled with a golden sun. The formal, symmetrical and rather flat strapwork suggests a date in the 1580s.

The Matthias Inventory of 1619 includes a sundial ring among numerous other sorts of rings under item 1047. [A.SC.]

Literature: A. Ilg, *Album von Objekten aus der Sammlung Kunstindustrieller Gegenstände des Allerhöchsten Kaiserhauses. Arbeiten der Goldschmiede- und Stein-*

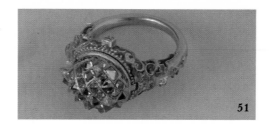

schlifftechnik. (Vienna, 1895), p. 9, pl. X, 1.
Collection: Kunsthistorisches Museum, Vienna.
Inv. no. 2196.

52 Badge
Gold enamelled in translucent red, green, yellow, ochre, and neutral (flesh-colour); set with a classical onyx cameo of Hadrian. Height: 7 cm.
Condition: the pendent jewel missing from the bottom and suspension rings broken off the sides.

The border is enamelled red with green enamelled Hs curving round it at two, six and ten o'clock. Between them is HADRIANVS AVG COSIII PP IMP in gold lettering. The reverse is covered with a gold plate *champlevé* enamelled with the devices from the reverses of two Hadrianic coins, one above the other. Top: Hercules seated in a cuirass holding a Victory, and Cos. III. Bottom: a galley and FELICITATI AVGVSTI. These are connected by an enamelled female mask, and there are harpies in the spandrels.

The HS on the rim may perhaps be allusions to Henry III or Henri IV as well as to Hadrian, who was one of the most active and admired of Roman Emperors. Like cat. no. 63 which makes flattering comparison between Rudolph II and the subject of the cameo, thought to be Constantine, this may be a tribute to the French King. It is not possible on the basis of the style of the setting to choose between the reigns of Henri III (1574-89) and the early part of the reign of Henri IV (1589-1610), but given Henri IV's well-known enthusiasm for engraved gems, he is the more likely owner. In its

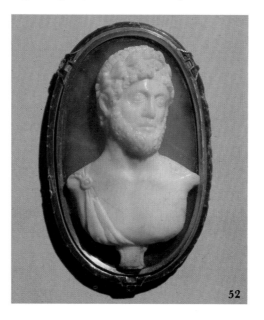

rather unusual palette of enamel colours and the attenuated form of the figures on the reverse it is closely related to cat. no. 53. [A.SC.]

Provenance: possibly the jewel mentioned in the 1664 inventory made by the Abbé Bruno of Louis XIV's collections, no. 179: '*Une agathe sardoine de deux couleurs, garnie d'or avec une pointe où est gravée de relief la teste d'Hadrien. Antique*'.
Literature: T. Marian du Mersan, *Histoire du Cabinet des Médailles* (Paris, 1838) p. 119, no. 201; Chabouillet, no. 242; V. Duruy, *Histoire des Romains* (Paris 1879-85) V, p. 144; J. J. Bernoulli *Römische Ikonographie*, (Stuttgart, 1882-4) II part 2, p. 118; Babelon, no. 291.
Collection: Cabinet des Médailles, Paris.

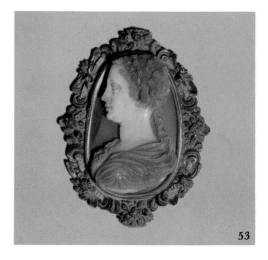

53 Pendant
Gold enamelled in white, translucent green, blue, red, neutral (flesh-coloured), ochre and gold; set with an agate cameo of a female bust. Height: 5.2 cm.
Condition: the suspension ring broken off. Extensive damage to the enamel on the reverse.

The backplate is *champlevé* enamelled with the elongated figure of a huntsman in Roman costume between two springing stags, beneath a radiating canopy with grotesque figures on either side. Below are cornucopiae, foliage and a winged putto head. The cameo is probably Italian. The design on the reverse relates to designs published in 1593 by Daniel Mignot, the Huguenot Frenchman working in Augsburg at the end of the 16th and beginning of the 17th century (*see* cat. nos. G32-34).

This does not however mean that this pendant dates from after that date as it is clear that goldsmiths' practice tended to precede the production of published ornament. The palette of enamel colours, with its yellow-ochre and fleshtint is very uncommon, but is the same as that on the reverse of the pendant with the cameo of Hadrian (cat. no. 52) also from the Cabinet des Médailles, whose mount is clearly of the same period, so it is possible that they stem from the same or a related workshop. The style of the strapwork on the front and the rather coarse character of the gold-

smithing are reminiscent of those on the emerald pendant with clasped hands (cat. no. 26). [A.SC.]

Provenance: possibly from the Cabinet du Roi.
Literature: Chabouillet, no. 668; E. Babelon, *Le Cabinet des Antiques*, p. 70, pl. XXIII, fig. 4; Babelon, no. 963; Y. Hackenbroch, *Connoisseur* 1966, pp. 33-3, figs. 12, 12a; Y. Hackenbroch, *Renaissance Jewels*, p. 99.
Collection: Cabinet des Médailles, Paris.

54 Pair of Bracelets
Gold enamelled in translucent blue and green; set with shell cameos. Length (of both bracelets): 17 cm.

The reverses of the clasps engraved with interlaced Cs within a green enamelled laurel wreath with barred Ss enamelled blue in each corner. The interlaced Cs on the clasps have been misread in the past as interlaced crescents, the device of the famous Diane of Poitiers, mistress of Henri II, and the legend had it that these bracelets had been in the royal collection ever since. The evidence of course destroys this pleasant romantic legend and it is impossible to suggest to whom they did belong. The barred Ss probably stand for *signum* or *seing* i.e., 'the mark of . . .' Shell cameos with inscriptions or signatures which show that they were being made at least in France and Germany, survive in Vienna (Eichler-Kris, *Die Kameen* nos. 394, 395) and elsewhere, but these minutely executed studies of animals most closely resemble in style three shell cameos of classical battle scenes (Bibliothèque Nationale, Babelon, nos. 343-345) which are unsigned and give no clue as to their provenance. Highly realistic studies of animals became quite common in graphic sources from the mid 16th century onwards; for example, the book with woodcut illustrations entitled *Icones animalium quadrupedum . . . bei Christoph Froschover* (Zurich, 1560) plagiarised by the Nuremberg ornamentist Virgil Solis (*see* Ilse O'Dell Franke, *Kupferstiche und Radierungen aus der Werkstatt des Virgil Solis.*) Thus it is impossible to decide for certain whether these are German or French; they probably date from the end of the 16th century when the wearing of pairs of substantial bracelets was becoming popular.
(*See* cat. no. P16). [A.SC.]

Provenance: bought by Louis XIV for the Cabinet des Médailles from his Procureur General, Achille de Harlay in 1674.
Literature: Marion du Mersan, *Histoire du Cabinet des Médailles* (1838) p. 124, no. 591; *Magasin Pittoresque*, 1838, p. 99, col. 2; Chabouillet, nos. 673 & 674; A. de Longperier, *Oeuvres* (G. Schlumberger) IV, p. 351; J. Adrien Blanchet, *Histoire Monétaire du Bearn* (1893) p. 84, no. 3; Babelon, cat. no. 624-625; Clifford Smith, p. 266; *Les Clouets et la Cour des Rois* (Ex. Bibl. Nat. Paris, 1970) cat. no. 189.
Collection: Cabinet des Médailles, Bibl. Nat. Paris.

55 IHS Pendant (*see also* p. 21)
Enamelled gold, set with hog-back cut diamonds. Height (without suspensions ring): 6.2 cm.

During the Revolutionary period the Cabinet des Médailles et Antiques du Roi was greatly enriched by works of art confiscated from religious institutions after the law of October 1790 which nationalised all church property. A great proportion of the works of art in precious materials was broken up and melted down after being sent to the *Monnaie*, but some of the finest pieces were kept and forwarded to the cabinet. On 21st December 1796 there was a particularly large consignment which included under category XXXV *Provenant des Carmélites* item 100, '*Le chiffre de Jésus en brillants monté en or emaillé en dessous.*' (Quoted, Babelon, p. CLXIII.)

The monogram IHS or YHS for 'Jesus' was extremely popular in all countries of Western Europe from the 15th right through the 17th century: Mary of Burgundy, first wife of Maximilian I wears an IHS pendant hung with three pearls in her portrait of 1477. Henry VIII owned one also with three pendent pearls, according to an inventory of 1519, possibly the one worn by Jane Seymour, his third wife, in the portrait of her by Holbein of 1536 (*see* cat. no. P5). The Jacob Mores design book shows four (*see* cat. no. 935) and Queen Anne of Denmark wears one on her ruff in her portrait by Paul van Somer (*see* cat. No. P21). What was clearly a strong fashion for this kind of jewel was also reinforced by the prophylactic powers attributed to the Holy name. This may explain, for example, why Alethea Talbot, Countess of Arundel appears in

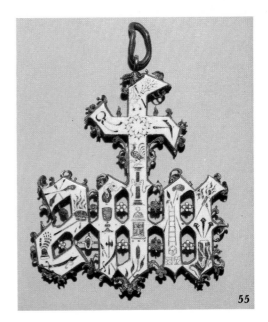

55

all her portraits wearing what was by then a very old fashioned jewel, her mother-in-law, Lady Dacre's, IHS breast ornament (*see* the portraits by Gheeraerts (1606) at Ingestre, by Mytens, (1618), at Arundel Castle, and by Rubens in the Alte Pinakothek, Munich).

This pendant uses black-letter, rather than Roman lettering, which suggests a Northern European origin, especially since it must date from the last decade or so of the 16th century because of the assymmetry of the small enamelled scrolls. The minutely detailed realism with which the *Arma Christi*, the symbols of the Passion, are shown on the back, also tends to confirm this.

It closely resembles the miniature of an IHS pendant in the Arnold Lulls pictorial inventory (*see* cat. no. G44) but cannot be identical with it, as Dr Falk suggests, since the enamelled decoration around the letters differs in certain important respects from it, and the pendant shows no signs of having been altered subsequently. It is also very similar to an IHS pendant, this time using Roman capitals, in this museum (cat. no. 56). [A.SC.]

Provenance: the convent of the Carmelites.
Literature: Chabouillet, no. 2720; Evans (1970) pl. 72; Falk, *Edelsteinschliff*, pp. 114-115; Y.

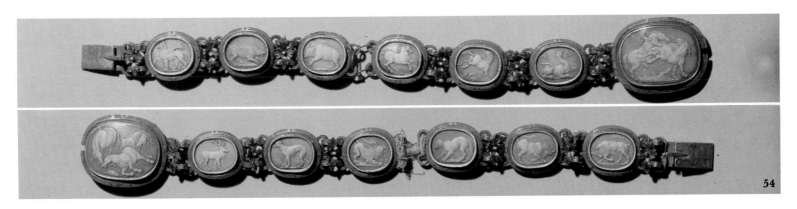

54

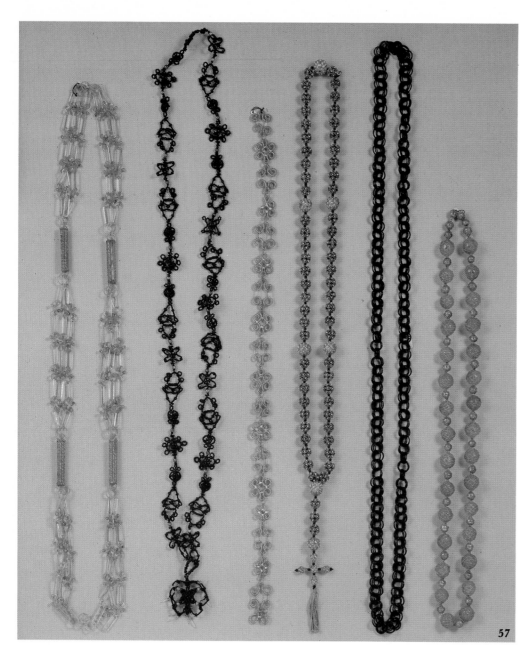

57

jewellery found at Schloss Ambras near Innsbruck in the Tyrol. They are probably the product of the Innsbruck glass-house founded by the art-loving Archduke Ferdinand II in 1570, which made pieces for the court there until 1591.

The production of glass chains was a regular part of the glass-makers' craft in the 16th century and Jost Amman illustrates a number of them in his book on the various crafts (1568). In December 1590 Ferdinand wrote to Count Wilhelm von Zimmer asking whether he could borrow his glass blower for two to three weeks to make glass chains for him, and Zimmer replied that he could have him for as long as he liked. The craftsman, like most of those in the Innsbruck glasshouse was probably a Venetian. The inventory of Ferdinand II's possessions, made in 1596 after his death, includes a 'small black glass chain'—*see* E. Egg, 'Die Glashütten zu Hall und Innsbruck' in *Tiroler Wirtschaftsstudien* XV (Innsbruck, 1962) pp. 49-57.

A great deal of the jewellery encrusting people's clothes in the 16th century must have been of this sort, although hardly any of it has survived. In 1566 for example, the wardrobe accounts mention five hundred and twenty pearls purchased for Queen Elizabeth I at one penny each for trimming partlets and ruffs.* [A.SC.]

Provenance: Schloss Ambras, Innsbruck.
Collection: Kunsthistorisches Museum, Vienna.
*Information gratefully received from Janet Arnold.

58 Talismanic Locket
Gold with black enamel. Height (without suspension ring): 4.5 cm.
Condition: worn, with some enamel missing from the inscription.

Inscribed in italic: 'John Monson born.the.tenth of September at.12.of the clok.at night 1597.'

According to family tradition, John Monson was born 'within the caul,' that is, with part of the membrane which encloses the foetus still over his head. This was, and is still, considered to be lucky, and especially to be a protection against drowning. The locket was made to contain this

Hackenbroch, *Renaissance Jewels*, p. 300, ills. 301 A-C.
Collection: Cabinet des Médailles, Paris.

56 IHS Pendant (*see* p. 12)
Gold enamelled in black, white, translucent red, green, yellow and blue; set with twenty-two hog-back-cut diamonds. Height: 5.5 cm.
Condition: some enamel loss on the reverse.

The front plate contains the stones while the back plate, which screws onto it, and has the scrolls attached to it, is enamelled with the *Arma Christi* in colour against a black ground. The sides are chased with a running foliate pattern.

Although the monogram is in Roman rather than black lettering it is obviously closely related to cat. no. 55, from a French Carmelite church,

because of the kind of rosettes and scrolls around the letters and the minutely detailed realism of the symbols of the Passion on the back; both must date from the same period, the last decade or so of the 16th century. [A.SC.]

Provenance: Said to have belonged to Sir William Howard, Viscount Stafford, beheaded in 1680 for alleged complicity in the Titus Oates plot. Bought from Sir Henry Jermingham, Bt.
Literature: Evans (1970) p. 97, ill. 72; Falk, p. 115.
Collection: V&A. Inv. no. M248—1923.

57 Glass Jewellery: necklaces, dress jewels, ear-rings
Coloured and plain soda glass.

These are some of the many pieces of glass

58

membrane, and shows signs of heavy wear. *See* cat. no. P11 for the variety of amulets and tailismans worns in the 16th century.

Provenance: by descent in the family.
Lent by the Hon. N. J. Monson.

59 Marriage Chain
Gold enamelled in white, black, opaque and translucent green. Length: 70 cm.
Condition: heavy loss of the *ronde-bosse* enamelling on the hands.

There are thirty-six links, the clasped hands holding a heart, cast and chased, the shields enamelled on one side with the arms of Saxony, on the other with FWHZS. The initials refer to Friedrich Wilhelm of Altenburg 1562-1602 who became Administrator of the duchy during the minority of Christian II from 1591-1601. The chain may have been made on the occasion of his first marriage in 1583 to Sophie of Württemberg, or of his second in 1591 to Anna Maria of Neuburg.

A famous example of a marriage jewel with two hands clasping a heart is the enamelled pendant around the neck of the future Albrecht V of Bavaria, painted by Hans Mielich just before his marriage in 1545. (Alte Pinakothek, Munich). Two German Gimmel rings (cat. nos. 60 & 61) have the same device combined with appropriate inscriptions, and there are clasped hands on the emerald pendant from the Cabinet des Médailles (cat. no. 26).

Such a heavy gold chain would have been out of fashion by either of the possible dates in court circles elsewhere in Europe, but in Northern Germany and Scandinavia they were still worn. This may have been worn by the Duchess herself, or by a member of her entourage. [A.SC.]

Provenance: Sotheby's (Monaco), 25th May 1975, lot no. 286.
Lent anonymously.

60 Gimmel Fede Ring
Gold enamelled in white, translucent red, green and blue. Diameter: 2.1 cm.
Condition: bent and worn, with much enamel loss.

Cast in two halves, the lower hand with a red heart enamelled on the palm. The inner sides of the hoops engraved in Roman capitals QUOD DEVS CONIVNXIT and HOMO NON SEPARET (What God has joined together let no man put asunder).

'Gimmel' derives from *gemellus*, a twin, and means a ring which separates into two intertwined halves. It reinforces the idea, already implicit in the clasped hands, of '*fede*,' which indicates union, the plighting of troth or friendship. The quotation from the marriage service indicates that this ring was definitely intended for use as a wedding ring. Until the second half of the 17th century when the plain gold band used today

59

61 60

became usual, any sort of ring could serve as a wedding ring. At the date when this ring was made, *c*1600, probably in Germany, this may well have been worn on the right rather than the left hand, as that was still the normal practice. In 1614 however, the *Rituale Romanum* laid down that the left hand was to be used, as now. Wearing the ring on the third finger is a much more ancient custom than this, going back to Roman times, and is based on the theory that a vein ran from this finger direct to the heart. [A.SC.]

Provenance: Waterton collection.
Literature: Ironmongers' Hall Exhibition, 1861 ii, 509; Oman, no. 662.
Collection: V&A. Inv. no. 851—1871.

61 Gimmel Fede Ring
Gold enamelled in white, black, opaque mid blue, green and translucent red. Diameter: 2.4 cm.
Condition: heavy loss of enamel, a thumb and one finger broken.

Cast in two halves, the hands clasping when joined, the insides of the hoops enamelled in black with blue stars between the words in Roman capitals CLEMEN.KESSELER DEN-25.AUG.A°.1605.

Unlike cat. no. 60 which was definitely intended as a marriage ring because of its inscription, one cannot be certain of the purpose for which this ring was made. The name of the owner does however show that, like cat. no. 60, it is also German. [A.SC.]

Provenance: Waterton Collection.
Literature: Ironmongers' Hall Exhibition, 1861, ii, 509; Oman, no. 664.
Collection: V&A. Inv. no. 854—1871.

62 Mounted Cameo
Gold enamelled in white, black and translucent blue; set with a chalcedony cameo of Rudolph II. The cameo foiled RII on the upper volute. Height: 5.6 cm.

This cameo shows a middle-aged Rudolph, the portrait relating to the medal of him by Antonio Abondio. It is signed OM on the arm for Ottavio Miseroni, the gem-engraver from Milan who was employed at the court in Prague from 1588 until his death in 1623-24. Rudolph II regarded him highly, not only as a gem engraver, but also as an adviser on artistic matters. Morigia, in the *Nobilitá di Milano* (1595) p. 292, says that 'a few years ago he carved a portrait of the Emperor in cameo which is so natural that whoever sees it marvels'. This may be the same cameo, although it is not unique, there being another cameo of Rudolph by the same hand at the Hermitage. The setting dates from around 1600. [A.SC.]

Provenance: The Imperial Collections since at least 1750 when it appears in the Treasury inventory, p. 49, no. 250.
Literature: Schatzkammer, Inv. 1750, p. 49, no. 250; Arneth, *Jahrbücher* (1838) p. 29, no. 67; Arneth, *CC*, p. 69, pl. I106; Sacken-Kenner 473/106; Kenner, *Jahrbuch der Kunsthistorischen Sammlungen IV*, p. 20ff.; Eichler-Kris, *Die Kameen*, no. 301.
Collection: Kunsthistorisches Museum, Vienna. Inv. no. XII 58.

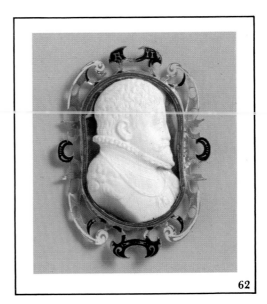

62

63 Pendant
Gold enamelled in black, white, opaque pale blue and translucent green; set with a green plasma cameo of an unidentified Roman Emperor, probably of the 3rd century AD. Height: 5 cm.

Condition: pendent pearls missing from the sides.

The front and back frames fit over each other, enclosing the stone. Obverse: enamelled inscription: AT. TV. RODVLPHE. CAESAR. DIVVLSVM. AB. HOC. IMPERIUM. SVAE. SEDI. ET. INTEGRITATI. RESTITVES. (But you Rudolph, Caesar, will restore to its proper place and completeness the Empire which has been torn apart). Reverse: a Greek cross with the chi rho, and α & ω above, HOC SIGNO VICTOR ERIS (You will conquer by this sign); below, INSTINCTV. DIVINITATIS (By the innate power of divinity); around the border: IMP.CAES.FL.CONSTANTINO. MAX. PIO. FELICI. VICTORI. SEMPER. AVG. (to the Emperor Caesar Flavius Constantine, the Greatest, the Pious, the Happy, the Victorious and always August). Scrolling foliage against a black enamelled ground on the outer edge.

This was probably a present of a highly flattering nature made to Rudolph. By implication it compares Rudolph's role with that of Constantine, the first Christian Emperor, as champion of Christendom. Rudolph frequently equated himself with the Emperor Augustus and borrowed from him his device of a fish-tailed goat, but this pendant is the only work which compares him with Constantine, although his role as Leader of Christendom rebuffing the Turkish threat in Hungary, is alluded to in numerous works of art and in his personal motto ADSIT (Adiuvante Domino Superavit Imperatorem Turcarum). The inventor of the legends on the jewel knew something about classical coins but produced an impossibly hyperbolic conflation of various conventional classical legends with this IMP.CAES.FL. CONSTANTINO etc. [A.SC.]

Provenance: Rudolph II's Collection; probably Matthias Inv. 927(?)
Literature: Matthias Inv. 927(?); Schatzkammer Inv. 1750, p. 11, no. 56; Arneth, *A.C.* p. 30, pl. XVII, 5; Sacken-Kenner, 413/15; Bernoulli, *R.I.*, II, 3, p. 226; Eichler-Kris, *Die Kameen*, no. 81.
Collection: Kunsthistorisches Museum, Vienna. Inv. no. IXa16.

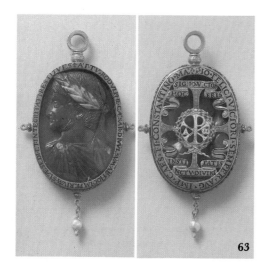

63

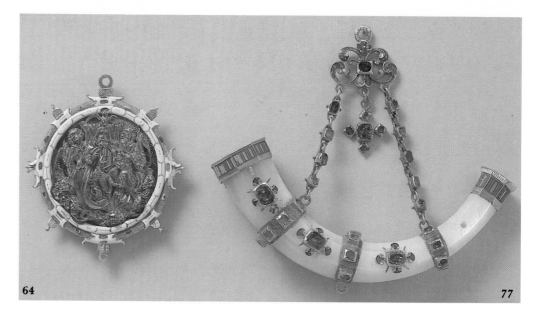

64 77

64 Pendant
Silver parcel-gilt, enamelled on the relief in translucent blue, on the frame in white, translucent red and opaque pale blue, and on the reverse in black.
Diameter: 4.6 cm.
Condition: the pendent jewel missing from the base.

The central medallion represents the Trinity and the crowned Virgin in heaven, the reverse is enamelled with the *Arma Christi*.

The medallion is German and dates from the end of the 15th century. Whether it was originally worn as a pendant or hat badge can no longer be seen. Emperor Rudolph II harked back with nostalgia to the time of the 'Last Knight', Emperor Maximillian I, and sought out the art of that period, in particular the works of Dürer. It is very likely that this medallion was given its very fine frame in the imperial workshops at Prague around 1600. [A.SC.]

Provenance: The Imperial Collections.
Literature: *Katalog der Sammlung für Plastik und Kunstgewerbe II* (Kunsthistorisches Museum, Vienna, 1966) no. 277.
Collection: Kunsthistorisches Museum, Vienna. Inv. no. 132.

65 Pendant (*see* p. 19)
Gold enamelled in white, black, opaque pale and mid blue, pale green, translucent red, green and blue; table-cut diamonds and an onyx cameo of the Judgement of Solomon, and hung with a pearl. Reverse: a red, green and blue enamelled scrolling pattern. Width: 4.7 cm.

The design prototype for the cameo subject has not been identified, but the execution is probably Netherlandish *c*1550. The tortoise beneath the white border of the cameo is probably emblematic and intended to imply '*festina lente*'—see O. de Strada, *Symbola* (Prague, 1600) pl. 19. The same

enamel work appears on the case of the cameo of Claudius (cat. no. 22) which is described in the 1619 inventory as 'French work'; also on the mount of a 15th century cameo of the Crucifixion in the same collection (Eichler-Kris, *Die Kameen*, no. 145), and on a mid 16th-century cameo of Adam and Eve (Eichler-Kris, *Die Kameen*, no. 401).

The contemporary attribution to France is borne out by similarity of all these pieces to the enamel mounts on the onyx ewer given by Charles IX to Ferdinand II in 1570. [A.SC.]

Provenance: The Imperial Collections; Matthias Inv. 1619, no. 2211.
Literature: Matthias Inv. 2211; Arneth, *C.C.*, p. 44, pl. 1,39; Sacken-Kenner 471/39; Eichler-Kris, *Die Kameen*, no. 400; Y. Hackenbroch, *Renaissance Jewellery*, p. 84, pl. 207.
Collection: Kunsthistorisches Museum, Vienna. Inv. no. XII 39.

66 Pendant
Gold enamelled in white, black, opaque pale blue, translucent red, green and blue; set with table-cut rubies and an onyx cameo of Emperor Charles V. Height: 5.4 cm.
Condition: the pendent pearl missing from the bottom. Some enamel loss.

On the reverse, an empty locket, the lid enamelled with the pillars of Hercules and PLUS ULTRA, Charles V's device. In between the double-headed eagle with the arms of Austria and Castille and, below, the Golden Fleece. Above, three crowns.

The cameo shows Charles V in later life and the style is that of the Nuremberg medallists of the mid 16th century, particularly the work of Joachim Deschler (active 1540-1569), the Nuremberg medallist in the service of Archduke Maximilian. However, this does not necessarily mean that the cameo is mid-16th century, as a portrait type, once established, tended to last

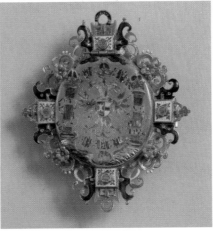

66

The setting, with its narrow inner border with astragals, its matted outer border with truncated white-enamelled volutes, and brightly enamelled stylized clusters of fruit is, like cat. no. 69, from the workshops of Andreas Oszenbruck who completed Emperor Matthias' sceptre in 1615. A clue to what 'Spanish work' was considered to be is given by a letter written in about 1590 by Duke Wilhelm V of Bavaria to one of his most important court goldsmiths, Hans Schwanenburg of Utrecht. He describes how he wants the gorgeous enamelled and bejewelled statuette of St George and the Dragon (Residenz, Schatzkammer) to look, with 'boxsettings of the stones of precise and fine work, but also everything in the Spanish manner, of gold, heavy and strong.' (Quoted in Frankenburger, p. 317) [A.SC.]

Provenance: no. 2205 in the Matthias Inv. 1619. 'In a gold frame of Spanish work enamelled, an agate, the ground blackish-brown, thereone a female bust, the face and neck flesh coloured, the hair reddish, the clothing of varied colours. Fairly big, in a red velvet case.'

Literature: Matthias Inv. 2205; Arneth, *CC*, p. 42, p. 11, 29; Sacken-Kenner 470/29; Eichler-Kris, *Die Kameen*, no. 305; Y. Hackenbroch, *Renaissance Jewels*, ill. 550.

Collection: Kunsthistorisches Museum, Vienna. Inv. no. XII 29.

some decades. The setting of this cameo is late 16th century. [A.SC.]

Provenance: Rudolph II's Collection(?); Matthias Inv. 924.

Literature: Matthias Inv. 924; A. Arneth, *Jahrbuch der Literatur* (1838), LXXXIV, p. 28, no. 55; Arneth, *C.C.*, p. 74, pl. I, 119 and pl. IV; Sacken-Kenner, 474/119; Leitner, Schatzkammer, p. 47, no. 235; Kenner, *Jahrbuch der Kunsthistorischen Sammlungen IV*, p. 12; Eichler-Kris, *Die Kameen*, no. 406; Y. Hackenbroch, *Renaissance Jewels*, p. 99, illus. 251 a and b.

Collection: Kunsthistorisches Museum, Vienna. Inv. no. XII 71.

67 Badge

Gold enamelled in black, white, opaque pale blue and green, translucent red, green and blue; set with an agate cameo of the animals leaving the Ark. Height: 5 cm.

Reverse: the agate carved in intaglio with the Annunciation and AVE GRATIA. PLENA, (the angelic greeting). The border *champlevé* enamelled with plants and animals.

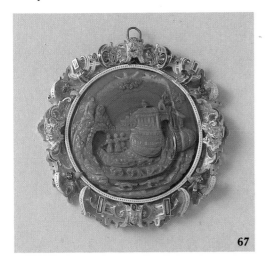

67

This cameo and its pair, the animals going into the Ark, are both attributed to Alessandro Masnago, the late 16th-century Milanese gem engraver. Seven gems in the Imperial Collections can be grouped around his name and all have the same dense, minute composition, with many figures and extensive backgrounds. The composition of this scene derives ultimately from a scene painted in Raphael's *Loggie* in the Vatican, transmitted via engravings. The setting is of exceptionally fine quality and has been associated with the workshop which produced Rudolph II's crown in 1602, almost certainly that of Jan Vermeyen, the parallel being perhaps the enamelled white volutes and pale blue strapwork of the front, and the stylised zoological naturalism of the enamelling on the back (*see* ill. 1). This evidence is not, however, conclusive. [A.SC.]

Provenance: Rudolph II's Collection, Matthias Inv. 1619, no. 2213.

Literature: Matthias Inv. 2213; Schatzkammer Inv. 1750, p. 42, no. 219; *Jahrbuch der Kunsthistorischen Sammlungen XXVI*, part 2, no. 19454, p. XVII; Arneth, *C.C.* p. 42, pl. I, 28; Sacken-Kenner, 470/28; Eichler-Kris, *Die Kameen*, no. 224; Y. Hackenbroch, *Renaissance Jewels*, no. 553 a & b.

Collection: Kunsthistorisches Museum Vienna. Inv. no. XII 28.

68 Pendant (*see* p. 7)

Gold enamelled in white, black, opaque mid-blue, translucent red, green and blue; set with a *commesso* of Ceres on a chalcedony ground. Height: 8.2 cm.

The Ceres is not a cameo but a *commesso*, that is a small sculptural work in a combination of semi-precious stones. The term is in origin an Italian one, but is used now by art historians to describe such works wherever they may originate. This *commesso* is attributed to Ottavio Miseroni of Milan, who spent most of his working life in

69 Hat Jewels (six out of a set of twelve)

Gold enamelled in black, white, translucent red, green and blue; set with onyx cameos of the Emperors. The inscriptions in black enamel give their names and duration of reign. Those included in the exhibition are: IVLIVS.CIR.4.I.M. 3917. OCTAVIANUS. CR. 56. I. TIBERIVS. C. R. 24. I. CALIGVLA.C.R.4. I.CLAVDIVS.C.R.14. I.DOMITIANVS. C.R.14. Reverse: plain gold plate. Height (of each hat jewel): 3.6 cm.

Condition: formerly two attachment rings on each jewel.

The 1619 inventory describes these as a 'hat band' and they would have been worn around the crown of the hat rather as Sir Christopher Hatton wears his in his portrait (*see* cat. no. P13). Cameos in series of emperors both ancient and modern, were popular in the 16th and early 17th century. They were used to decorate vessels, and even pieces of furniture (*see* the lapis lazuli display plate inv. 963 and the ebony cabinet with shell cameos both in the Kunsthistorisches Museum, Vienna), and Henri IV of France used them as buttons on his coat (Babelon, *La gravure en pierres fines*, p. 279). The classical cameos satisfied the antiquarian

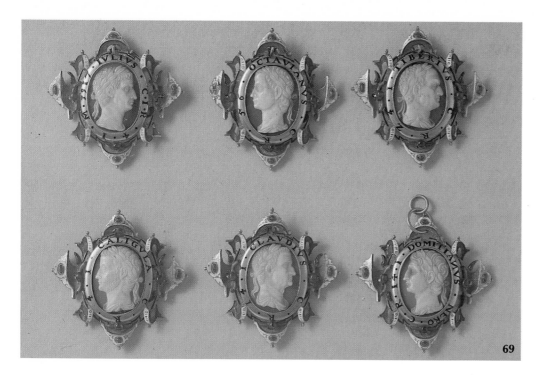

69

humanist tastes of the time as well as the genealogical interest which had recently developed.

The settings of these cameos are of special interest because, with their matted gold finish, heavy, broken, white scrolls with a spidery gold pattern in reserve and clusters of brightly coloured but stylized fruit, they closely relate to the goldsmiths' work of the imperial sceptre completed for Matthias in 1615 by Andreas Oszenbruck (*see* ill. 1 and cat. no. 68). The cameos are after the antique (although the portrait types are not correctly identified in the inscriptions), and date from the second half of the 16th century. Their style is not sufficiently individual for a country of origin or workshop to be attributed to them. [A.SC.]

Provenance: no. 1194 in Emperor Matthias' inventory of 1619 refers to a 'Hat band with 12 rosettes, with 12 Roman Emperors cut in cameo'.
Literature: Matthias Inv. 1194; Eichler-Kris, *Die Kameen*, nos. 357-368.
Collection: Kunsthistorisches Museum, Vienna. Inv. no. XII 823.

70 Badge (*see* p. 4)
Gold enamelled in white, opaque pale blue and green, translucent red, blue and green; set with table-cut and facetted point-cut diamonds and a jasper cameo of a negress, and hung with a pearl. Height: 6.4 cm.

This is one of nine cameos in the Imperial Collection in which negroes and negresses figure. Especially effective use was made of the contrasting layers of onyx in these cameos, and they also display a pleasing exoticism in contrast with the serenity of the more normal portrait cameos in the classical style. Relatively large numbers of them were carved in Italian workshops in the second

half of the 16th century (*see* the Gresley and Drake jewels, cat. nos. 46 and 40). This is a further elaboration on the 16th-century cameo, the goldsmith's work being incorporated in the stone, and there are other examples of similar work in the same collection, notably the famous jewel of Leda and the Swan (Eichler-Kris, *Die Kameen*, no. 260).

The setting has astragals separated by small gold lines on the inner rim and bold white-enamelled and red volutes around a matted border with clusters of multi-coloured fruit. It belongs to a large group of fourteen cameos which obviously were mounted by the same workshop, that of Andreas Oszenbruck who completed Emperor Matthias's sceptre in 1615 (Eichler-Kris, nos. 208, 209, 221, 222, 296, 298, 300, 311, 315, 325, 331, 383, 198, 388). Many of these are not properly pieces of jewellery, but framed cameos which were intended purely for the

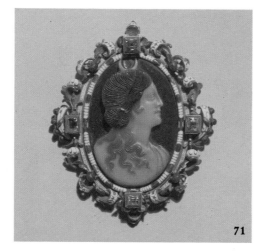

71

collector's cabinet. This, however, has loops at all four points so that it could be sewn onto fabric. The same workshop was responsible for another group, with a much narrower inner border and tighter, often truncated, volutes, (Eichler-Kris, nos. 202, 211, 229, 304, 307, 357-368, 398). [A.SC.]

Provenance: The Imperial Collections, Schatzkammer Inv. no. 49, 1750.
Literature: Schatzkammer Inv. 1750, p. 10, no. 49; Arneth, *CC*, p. 103, pl. II 26; Sacken-Kenner 477/26; Eichler-Kris, *Die Kameen*, no. 292; Evans, Ill. 90b; Y. Hackenbroch, *Renaissance Jewels*, ill. 546.
Collection: Kunsthistorisches Museum, Vienna. Inv. no. XII, 120.

71 Badge
Gold enamelled in white, opaque pale blue, leaf green, translucent turquoise, red and green; set with table-cut diamonds and an onyx cameo of Diana. Height: 5.3 cm.

The gold surfaces of the framing have scrolls with fine *sablé* matting. Reverse: unadorned, with the cameo retained in an open dog-tooth setting.

The cameo dates from the second half of the 16th century and is probably Italian. The setting, however, is very similar to one of the more common settings of cameos in the imperial collections, such as the one round the cameo of a negress (cat. no. 70). Its identifying features are the three-dimensional scrolling strapwork around the edge, the stylised clusters of fruit, the delicate matting and 'cobwebby' gold patterns in reserve on the white enamel and the astragalled inner border. These relate closely to the style of the imperial sceptre made in 1615 for Emperor Matthias by Andreas Oszenbruck, court goldsmith in Prague. It is very likely then that this jewel was mounted around 1610 and was originally in the Imperial Collections in Prague.

Provenance: The Imperial Collections (?)
Literature: Chabouillet, no. 413; E. Fontenay, *Les Bijoux anciens et modernes*, p. 407; E. Babelon, *La gravure en pierres fines*, p. 275, fig. 189; Babelon, no. 465.
Collection: Cabinet des Médailles, Paris.

72 Dress Jewels from Hall, near Innsbruck
Ranging from 1 cm—3 cm.
a) Single dress jewel. Gold enamelled in black, white, opaque pale and mid blue, green and translucent red; set with four table-cut rubies and four pearls. The gold frame cast, chased and matted; the box settings of the jewels rivetted to it. Inv. no. Bi. 931.
b) Two dress jewels. Both enamelled gold set with a ruby and pearls. Enamelled in (i) white and opaque pale blue, (ii) white, opaque pale blue and translucent red.
Inv. no. Bi. 949.
c) One dress jewel, ditto. Enamel colours: white and translucent red.
Inv. no. Bi. 943.

d) Seven dress jewels. Gold enamelled in black, set with three pearls. Marked on the reverse with a small rectangle of gold stamped A.B. in monogram.
Inv. no. Bi. 937.

e) Seven dress jewels. Gold enamelled in white, translucent red and blue; set with a garnet.
Inv. no. Bi. 956.

The convent at Hall was an imperial foundation for aristocratic ladies set up in 1567 by Archduchesses Magdalena, Margaretta and Helena. When Maria Christierna and Eleonora joined it in 1607 they brought with them all their dress jewels, 213 in number, and in the mid 17th century these were mounted on a gold chalice and two crowns for ciboria. This accounts for the preservation of this otherwise most ephemeral category of 16th-century jewels, which nonetheless contributed so much to the richness of the costume of the day. The dress jewels were dismantled from the crown by the museum in about 1900.

Maria Christierna and Eleonora were the daughters of Archduke Charles, Duke of the Steiermark, and Maria, daughter of the important patron of the arts and of goldsmiths, Duke Albrecht V of Bavaria (*see* cat. no. P24). Bavarian court accounts show that their mother continued to commission work from goldsmiths in Munich and as archduchesses they would also have had access to the imperial workshops. The dress jewels fall into a number of groups of varying quality, none however dating from much before 1590. A number of the dress jewels, including group d shown here bear a monogram stamped on an attached plate which must be a maker's mark. This is exceedingly rare at this period, the only other example being cat. no. 73, the chain said to have been found at the Imperial Castle of Ambras near Innsbruck. Many of the dress mounts (for example, Bi 927) also closely resemble cat. no. 73 with its thin, stamped out back-plate, filigree enamel, spiralling gold wire and enamel colours (dark blue, black and white). It is clear therefore

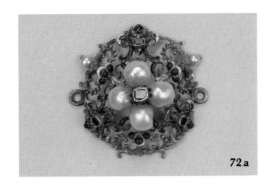

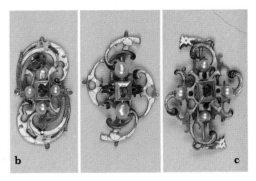

72.a b c

that they come from the same workshops, before 1607, but not much before 1600.

Groups b and c, on the other hand, are more substantial, cast in gold as asymmetrical C-scrolls with white enamel, and bear more of a relationship to the expensive frames put around the cameos in the imperial collections (e.g. cat. no. 69) by the court goldsmiths in Prague.

These jewels would have been worn sewn onto the garment as in the portrait dated 1595 of the Archduchesses' sister, Anna of Austria, wife of Sigismund III of Poland (cat. no. P25) or, in England, the contemporary portrait of Mrs Ralph Sheldon (cat. no. P16). [A.SC.]

Provenance: given by Archduchesses Maria Christierna (1574-1621) and Eleonora (1582-1620) of the Steiermark to the Convent at Hall when they entered it in 1607. Bought by the Museum für Angewandte Kunst, Vienna in 1881 for 15000 gulden.

Literature: *Mitteilungen der K.K. Central Komission zur Erforschung und Erhaltung der Baudenkmale* VI (Vienna, 1880) p. XVI, CXXXVI, VII (1881) p. XIII, XVII (1891) p. 177; A. Lindner, 'Aufhebung der Kloster in Deutsch-Tirol,' *Zeitschrift des Ferdinandeums* XXXIX (1885) p. 248ff; *Kunst und Kunsthandwerk I* (1898) p. 348; *Führer durch das Osterreichische Museum für Kunst und Industrie* (Vienna, 1929) p. 30, 32; N. Grass, 'Der

Verkauf der "Haller Pyramiden" und anderen Kirchenschätze aus der Allerheiligen (Jesuiten) Kirche zu Hall in Tirol,' *Festschrift Landeshauptmann Prof. Dr. Hans Gamper III* (Innsbruck, 1955); Steingräber, *Alter Schmuck* (Munich, 1956) p. 114, 124; *Gold und Silber: Kunstschätze aus Tirol* Exhibition, Innsbruck 1961, cat. no. 107, pl. 37.
Collection: Österreichisches Museum für Angewandte Kunst, Vienna.

73a Necklace

Gold enamelled in white, black and opaque mid blue; set with pearls. Length: 55.5 cm.
Condition: slight enamel loss.

The twenty-five elements built up on a stamped out back-plate with the enamel in cloisons. The gold is matted by a mass of small pinpricks. Gold wire coiled like a spring forms part of the decorations and there are small stars and points of gold in reserve in the enamel. The metal used throughout is very flimsy. Soldered onto the reverse of the link is a small square gold plate stamped R.V. in monogram.

This is identical in technique and enamel colours to some of the jewels in the *Haller Schmuck* (e.g. Bi. 927 and 928), the dress jewels presented to the convent at Hall near Innsbruck by Archduchesses Maria Christierna (1574-1621) and Eleonora (1582-1620) (*see* cat. no. 72). The

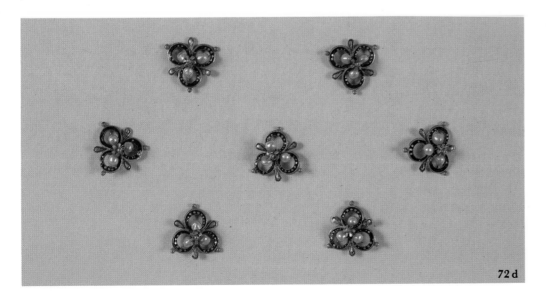

72 d

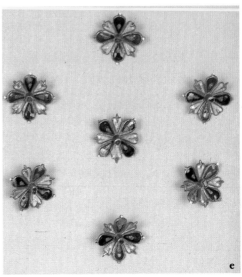

e

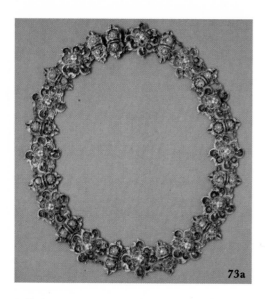

73a

stylistic connection is reinforced by the same characteristic method of making the jewels, with a similar stamped square mark, this time with AB in monogram, on many of the Hall pieces. The marking of jewellery during this period is almost unknown, so one can safely say that this chain and some at least of the Hall jewels come from the same workshop supplying jewellery to the imperial house.

Provenance: according to tradition, this, and the following pendant with which it was bought, came from the imperial Castle of Ambras, near Innsbruck.
Collection: V&A. Inv. no. 696—1898.

73b Pendant
Gold enamelled in white, black, translucent red and opaque pale blue; set with ten table-cut and nine facetted point-cut diamonds. Height: 8.9 cm.
Condition: much enamel loss and one of the diamonds in its scrolled setting missing.

Constructed in two layers, the back one fretted, matted and decorated with *champlevé* enamel, the front one with *champlevé* white enamel scrolls and red enamel and dots of pale blue. The stones in their settings screw through both layers and are held in place with bolts.

This open, many-layered, construction is characteristic of many early 17th century pieces of jewellery, such as the breast ornament (cat. no. 114) and the designs of David Mignot (cat. nos. 932-34) which show a front plate and a back plate for a jewel of this sort. The palette of enamel colours, and the broken scrolls are reminiscent of the work by Andreas Oszenbruck on the sceptre of Emperor Matthias, completed in 1615 (*see* cat. no. 69), and the settings on the cameo (cat. no. 70), and so the pendant probably dates from around the same period and may well, also come from a workshop in Prague or Austria. [A.SC.]

Provenance: *see* cat. no. 73a.
Collection: V&A. Inv. no. 696—1898.

74 Seal Ring with the arms of Pfalz-Neuburg
Silver-gilt, set with an agate. Diameter: 1.8 cm.

South Germany, c1600 (before 1614). Above the coat of arms in capitals C(*omes*) P(*alatinus*) B(*avariae*) R(*heni*). Back of the bezel convex. The ring must have been made before 1614, as the Lower Rhenish territories are not shown in the arms of the Count Palatine. [I.H.]

Collection: Bayerisches Nationalmuseum. Inv. no. NN 3001.

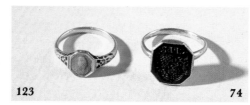

123 74

75 Items from the Lauingen Jewels
The jewellery from the tomb of the Palatine Wittelsbachs of the Neuburg protestant branch was recovered from the parish church in Lauingen on the Danube in 1781, and in 1862 it was handed over to the Bayerisches National-museum which also owns the textiles and lead coffins recovered in 1877. Here the history of jewellery as it was worn in the smaller princely courts in Germany over a period of 67 years can be followed. It is obvious that around 1600 the princes were buried with less lavish jewels than they wore during their lifetime; thus the find includes only three large pendants with gem-stones, four less splendid chains, four girdles and bracelets, but twenty-three rings and three large sets of buttons; the majority of the seventy-four

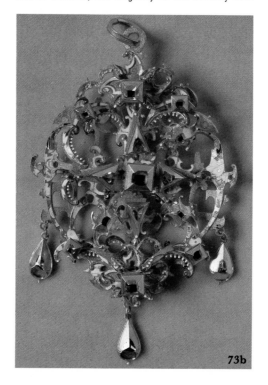

73b

items probably come from the South German centres of Augsburg and Nuremberg.

The most generously endowed tombs were the ones of the unmarried Countess Palatine Dorothea Sabina (Stolleis/Himmelheber, cat. no. 58, 66), Amalia Hedwig (ibid. cat. no. 71), and Dorothea Sophia (ibid. cat. no. 74), and the ones of Count Palatine Friedrich (ibid. cat. no. 44, 47, 49, 51, 53, 54, 55) in whose coffin alone there were eight rings, and Otto Heinrich, whose wife put her two bracelets (ibid. cat. no. 67) into his tomb. While the children were given talismans, a toothpick (ibid. cat. no. 82) and two very plain rings were found in the tomb of the Count Palatine Philip Ludwig. His, and the later burials were less splendid, partly because of the Thirty-Years-War, which devastated the Neuburg area, and partly because of sober protestant piety which demanded frugality. [I.H.]

Literature: Karl A. Bierdimpfl, *Die Funde aus der Fürstengruft zu Lauingen im Bayerischen National-museum*, (Munich, 1881); George Hager, 'Denkmäle und Erinnerungen des Hauses Wittelsbach im Bayerischen Nationalmuseum,' *Kataloge des Bayerischen Nationalmuseums XI* (Munich, 1909); Karen Stolleis, *Die Gewänder aus der Lauinger Fürstengruft*, with an essay on the jewellery by Irmtraut Himmelheber; *Bayerisches Nationalmuseum München*—Forschungsheft 3 (Munich, 1977).

75a Toothpick
Engraved gold toothpick in the form of a sickle. Length (without movable loop): 6.1 cm.

German, third quarter of the 16th century. The toothpick is depicted in the engraving of the Count Palatine on his death bed (Stolleis/Himmelheber fig. 12). [I.H.]

Provenance: from the tomb of Count Palatine Phillip Ludwig (1547-1614).
Literature: Bierdimpfl, no. 95; cat. BNM XX, no. 2809; H. Sachs, *Der Zahnstocher und seine Geschichte*, (Hildesheim 1967, reprinted) p. 21, fig. 21; F. Lindahl, 'Trandstikkerne fra Christian IVs Tid' *Nationalmuseets Arbejdsmark* (1962) p. 8, fig. 9; Stolleis/Himmelheber, cat. no. 82.
Collection: Bayerisches Nationalmuseum, Inv. no. T 4229.

75b Bracelet with a Pair of Hands
Gold enamelled in opaque light blue, white and green. Length: 22.5 cm.
Condition: On the closed buckles the matted ground has lost its enamel, on the strapwork the enamel has partly fallen out or worn off. Safety tongue is missing on the clasp.

This bracelet belonged to the wife of the Count Palatine, Dorothea Maria. She put it into her husband's grave, together with another one bearing her initials. A similar bracelet was sold at Sotheby Parke, Bernet, Monaco, 23rd-24th July, 1976, lot no. 282. [I.H.]

Provenance: from the tomb of the Count Palatine

Otto Heinrich (1556-1604), Southern Germany, last quarter of the 16th century.
Literature: Bierdimpfl. no. 57; cat. BNM XI, no. 2701; Stolleis/Himmelheber, cat. no. 67.
Collection: Bavarian Nationalmuseum. Inv. no. T 4218.

75c Coat Buttons
Gold enamelled in opaque black, white and light blue and translucent red. Diameter: 1.5 cm.
Condition: some enamel loss.

Spherical buttons, embossed with four oval, black rhomboid 'mirrors'. Stamped and engraved, then decorated with enamel. A loop at the back for attachment. These two buttons belong to a set of twelve. They probably come from South Germany and were made during the third quarter of the 16th century. [I.H.]

Provenance: from the tomb of Count Palatine Friedrich (1557-1597).
Literature: Bierdimpfl, nos. 12-17, 18-23; cat. BNM XI, 2743-2754; Stolleis/Himmelheber, cat. no. 55.
Collection: Bayerisches Nationalmuseum. Inv. no. 4223-4225.

75d Puzzle Ring
Six flat hoops of square gold wire which can be assembled to form one ring. Diameter: 1.7 cm.

German, second half of the 16th century. [I.H.]

Provenance: from the tomb of Count Palatine Friedrich (1557-1597).
Literature: Bierdimpfl, no. 6; cat. BNM XI, under no. 2756-2763; Stolleis/Himmelheber, cat. no. 54.
Collection: Bayerisches Nationalmuseum inv. no. T4231.

75e Love Ring
Gold enamelled in black and white. Diameter: 1.9 cm.

The dating of the love-ring can probably be confined to the time between 1587 to 1597 for genealogical reasons. A similar love-ring, though with two pairs of hands, is shown in P. Debo, *Alte Ringe*, (Pforzheim, 1923), pl. XX, no. 87. [I.H.]

Provenance: from the tomb of Count Palatine Friedrich (1557-1597).

Literature: Bierdimpfl. no. 7; cat. BNM XI, under no. 2756-2763; illustrated in *Liebesringe*, published by the Deutsche Gesellschaft für Goldschmiedekunst (Berlin, 1937); Stolleis/Himmelheber, cat. no. 53.
Collection: Bayerisches Nationalmuseum. Inv. no. T4157.

75f Ring
Gold, once set with a gemstone. Diameter: 1.9 cm.
Condition: the stone missing.

German, second half of the 16th century. According to F. Falk, who refers to rings with triangular shields seen in portraits, this is the only surviving ring of its kind. [I.H.]

Provenance: from the tomb of Count Palatine Friedrich (1557-1597).
Literature: Bierdimpfl, no. 2; cat. BNM XI, no. 2756-2763; Falk, p. 70, n. 6, p. 78; Stolleis/Himmelheber cat. no. 47.
Collection: Bayerisches Nationalmuseum. Inv. no. T4252.

75g IHS Ring
Gold and black enamel. Diameter: 1.7 cm.

German, last third of the 16th century. A similar ring from the find at Pfreimd (Upper Palatinate) in the Museum für Kunst und Gewerbe in Hamburg, shown in M. Sauerlandt, *Bericht über die Neuerwerbungen während des Jahres 1929*, p. 9, pl. V, and in E. Steingräber, *Alter Schmuck*, (Munich,1956) p. 128, fig. 224. [I.H.]

Provenance: the tomb of Count Palatine Friedrich (1557-1597).
Literature: Bierdimpfl, no. 2; cat. BNM XI, no. 2756-2763; Falk, p. 70, n. 6, p. 78; Collection: Bayerisches Nationalmuseum. Inv. no. T 4230.

75h Order of the 'Golden Society in Saxony'
Gold enamelled in opaque white, light blue, turquoise, light green, black and translucent red. Length of chain with rosette: 66.9 cm. Height of pendant: 5 cm.

Chain with badge, and rosette on the fastening mechanism. On the enamelled pendant a heart-shaped shield on a crossed sword and arrow with

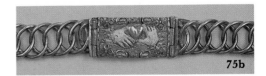
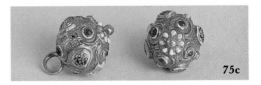

75b

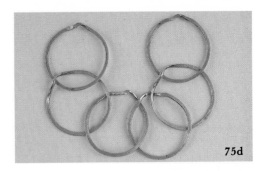

75c

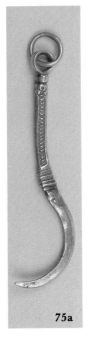

75d

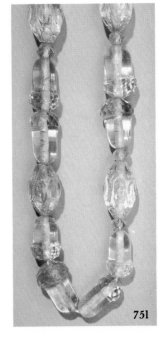

75a

75l

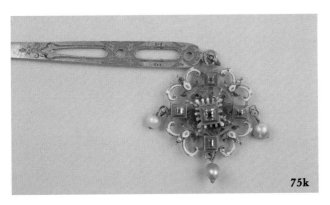

75k

75n

75j

75e

75g

75f

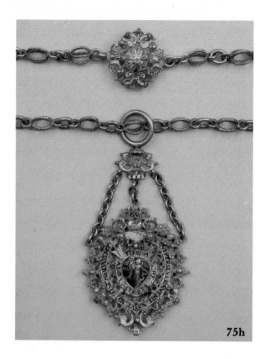

75h

the figure of CO(N)STA(N)CIE with an anchor. On the flat edge is the inscription VIRTVTIS AMORE 1589 (for love of virtue). On the outer edge the inscription QVI PERSEVERAVERIT VSQUE AD FINEM SALVVS ERIT (he who perseveres to the end will be saved). Above, clasped hands with a heart, and above them on a gold band FSV (*Fide sed vide*, the motto of Elector Christian I of Saxony, the founder of the order). The outer frame made of C-scrolls. Three smaller hanging chains come together beneath, the elector's crown. The back of the pendant shows FIDES with cross, chalice and tablets, the law on the shield and crossed sword and arrow.

A similar order, although in worse condition, was found in the grave of the Count Palatine Otto Heinrich. E.v. Watzdorf mentions the following orders of this society of Christian I: a) in the Town Museum of Dresden (now the Museum for the History of the Town of Dresden), removed 1910 from the Sophien Church, b) in the Schloss Museum, Berlin, bought 1849 for the Kunst-kammer, c) in the Hohenzollern Museum, Berlin, from the coffin of the Elector Johann Georg von Brandenburg (died 1598), d) and e) Bay. Nat. Mus., f) formerly in Felix Collection Leipzig. *See* also cat. no. 125 a, b, c. [I.H.]

Provenance: from the tomb of Count Palatine Friedrich (1557-1597), Dresden 1589.
Literature: Bierdimpfl, no. 9; F. Hofmann, 'Die Ordenszeichen aus der Lauinger Fürstengruft im Bayerischen Nationalmuseum', *Altbayerische Monatsschrift* VII (1907) p. 97 ff; cat. BNM XX, no. 2742; E.v. Watzdorf, 'Gesellschaftsketten und Kleinode vom Anfang des 17 Jahrunderts', *Jahrbuch der Preussischen Kunstsammlungen* LIV, (1933) p. 167 ff.; Stolleis/Himmelheber, cat. no. 44.
Collection: Bayerisches Nationalmuseum. Inv. no. T 4221.

75j Ring
Gold enamelled in opaque light green, light blue, white, black, turquoise, translucent red and dark-green; set with twelve table-cut rubies, the middle one point-cut. Diameter: 18 cm.

Southern Germany *c*1570-80. Enamelled richly on both sides. On the shoulders, five rubies increasing in size. The hoop decorated with egg-and-dart in enamel. The inside of the hoop enamelled red and dark-green, with white border and light blue and white lozenges and *fleurs de lis*.

A ring of similar construction in P. Debo, *Alte Ringe*, (Pforzheim, 1923), plate VI, no. 48 from the Collection Spitzer—*La Collection Spitzer* Tome III, (Paris, 1891) pl. VI, no. 26. Related to a so-called 'German, late 16th century' ring in the British Museum—Dalton, (1921) p. 281, no. 2008, pl. XXVI. A ring with six rubies on either side shown in P. Butler, '*Jewellery through the Ages*', Apollo LXXXVII (1968), p. 284 ff. ill. 3.

Proof of an origin in Southern Germany (Munich) is given by the typical combination of light blue and white enamel on gold and the white edges to the coloured enamel inside the hoop; compare with altar cross in the treasury of the Residenz Munich (cat. 3, Munich 1970, no. 66) and covered cup (*ibid* no. 561) both attributed to Hans Reimer. [I.H.]

Provenance: from the tomb of Count Palatine Friedrich (1557-1597).
Literature: Bierdimpfl, no. 1; cat. BNM XX, under no. 2756-2763; *Juwelen aus alter und neuer Zeit*, Catalogue of the exhibition at the Museum of Fine Arts in Düsseldorf, 12-26. 10.1962, no. 23 (without ill.); Stolleis/Himmelheber, cat. no. 49.
Collection: Bayerisches Nationalmuseum. Inv. no. T4183.

75k Hair Pin
Gold enamelled in white, opaque light blue and translucent red; set with table-cut diamonds and hung with pearls. Length: 10.6 cm., diameter of rosette: 2,3 cm.

South Germany, *c*1600. For the ornament on the hair pin, *see* the silhouette designs by Daniel Hailer (1604) and Jörg Arnold (1586 and 1589), published by A. Hämmerle, 'Daniel Hailer,' *Das Schwäbische Museum*, (1931) p. 42ff. and 'Jörg Arnold,' p. 190ff. The double rosette with paired C-scrolls is close to Daniel Mignot's designs, *see* 'Daniel Mignot' essay p. 33ff. Compare especially no. 94, pl. VI, no. 95 pl. XV and no. 97, pl. XXI. The hairpins were only partially stuck into the hair so that the rosette could hange freely next to the face, and the partially visible pin was therefore carefully ornamented. *See* M. H. Gans, *Juwelen en mensen. De geschiedenis van het bijou van 1400-1900* (Amsterdam), which discusses the hairpin and its use. [I.H.]

Provenance: from the tomb of Countess Palatine Amalia Hedwig (1584-1607), daughter of the Count Palatine Phillip Ludwig and Anna von Julich-Cleve-Berg.
Literature: Bierdimpfl, no. 100; cat. BNM XX, no. 2842; 'Juwelen aus alter Zeit', *Catalogue of the Museum of Art, Düsseldorf*, (1962) 12-26.10 no. 26 (without illustrations); Stolleis/Himmelheber, cat. no. 71.
Collection: Bayerisches Nationalmuseum. Inv. no. T4155.

75l Girdle
Rock-crystal, cut in nine spindles, twenty acorns, sixteen buttons. Overall length: 38 cm. Height of buttons: 4.6 mm.

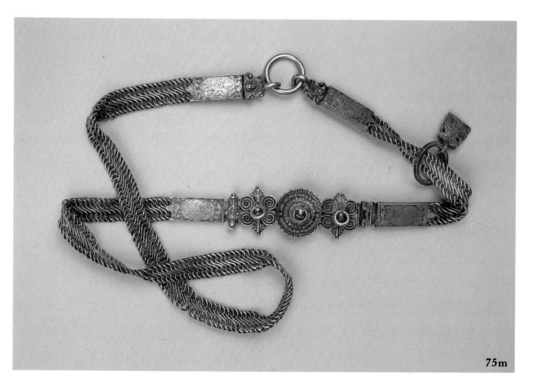

75m

Condition: strung on modern string; neither the arrangement of the beads nor length is original.

German, second half of the 16th century. Cut and polished rock-crystal of various colours. The spindles with six smooth surfaces and, above, regularly cut notches. The acorns and buttons richly facetted at the bottom.

The gold loops still mentioned in the 1781 record of the Lauingen find are no longer in existence. In the Österreichisches Museum für Angewandte Kunst in Vienna there is a rock-crystal chain whose spindles are cut in the same way as this example. (Inv. Bi. 199). In 1876 it was purchased from Kuhn of Munich. In his book, *Juwelen en mensen. De Geschiedenis van het bijou van 1400 tot 1900* (Amsterdam, 1961) p. 392 inv. no. 14, M. H. Gans mentions a rock-crystal girdle listed in the inventory of the Countess Elizabeth von Culemberg, *née* Countess von Hohenzollern, in 1593. Acorns of silver on what is probably an early 16th century are illustrated in R. Forrer, *Geschichte des Gold- und Silberschmucks nach Originalen der Strassburger historischen Schmuckausstellung von 1904* (Strassburg, 1905) p. 22, ill. 126. [I.H.]

Provenance: from the tomb of the Countess Palatine Dorothea Sabina (1576-1598) daughter of the Count Palatine Phillip Ludwig and Anna von Julich-Cleve-Berg.
Literature: Bierdimpfl, no. 109-113; cat. BNM XI, no. 2835; Stolleis/Himmelheber, cat. no. 58.
Collection: Bayerisches Nationalmuseum inv. no. T4124, T4188, T4201, T4203.

75m Chain Belt
Silver, cast and engraved. Length: 91.5 cm.

The flat, rectangular links are engraved with a putto sleeping on a skull (sleep of death) and one blowing soap-bubbles (Vanitas) in strapwork cartouches. On one of the hinges there is a small figure of a saint (cast from an older model).

Cologne, c1600. Maker's mark of Heinrich Isselburg (Rosenberg Vol. II no. 2730). There are two very similar chain belts, also from Cologne, but with different engravings on the links, in the Germanisches Nationalmuseum, Nuremberg, (Inv. no. T 3822) and in the Rijksmuseum, Amsterdam—*Cat. van Goud en Zilverwerken* (Amsterdam, 1952) no. 57.

Provenance: from the tomb of the Countess Palatine Dorothea Sophia (1588-1607) daughter of the Count Palatine Otto Heinrich and Dorothea Maria von Württemberg.
Literature: Bierdimpfl, no. 92; cat. BNM XX, no. 2707; Stolleis/Himmelheber, cat. no. 74.
Collection: Bayerisches Nationalmuseum. Inv. no. T 4132.

75n Prophylactic Pendant
Gold and polished malachite. Height with loop: 1.4 cm.

Southern Germany, first third of the 16th century. This would have been worn to protect

the little Countess, green malachites being considered to be symbols of life—*see* L. Hansmann/L. Kriss-Rettenbeck, *Amulett und Talisman* (Munich, 1966). Sadly, she died aged only one year. *See* the portrait of Don Diego of Spain (cat. no. P11) wearing a mass of talismans like this one. [I.H.]

Provenance: from the tomb of the Countess Palatine Maria Magdalena (1628-1629), daughter of the Count Palatine Johann Friedrich and Sophia Agnes von Hesse-Darmstadt.
Literature: Bierdimpfl, no. 122; cat. BNM XI, 2853; Stolleis/Himmelheber, cat. no. 85.
Collection: Bayerisches Nationalmuseum. Inv. no. T4219.

76 78

76 Seal Ring of Duke Maximilian I of Bavaria (1597-1651)
Gold enamelled in black, set with an engraved crystal over painted foil. Diameter: 2.9 cm.
Condition: slightly worn.

The foil beneath the crystal is painted with the coat-of-arms of Bavaria and MHIB (Maximilian, Herzog in Bayern). The shoulders are *champlevé* enamelled with *moresques*.
This seal ring belonged to Maximilian I, Duke of Bavaria, who succeeded his father in 1597. [A.SC.]

Provenance: The Imperial Collections.
Collection: Kunsthistorisches Museum, Vienna. Inv. no. XII 313.

77 Pendent Whistle in the shape of a horn
Gold enamelled in white, opaque mid blue, translucent red and green; set with table-cut emeralds and rubies. Height: 8.9 cm.
Condition: the enamel damaged in a few places; the ruby missing from the central band; two of the emerald set mounts and the pendent jewel at the bottom also missing.

The broad end is decorated with scrolls in *champlevé* enamel. There are openings in both ends so that it functions as a whistle. The backs of the stones on the chains enamelled red; the backs of the rubies on the little cross in the middle also red, and the back of the emerald, blue.
From the style of the scrolls around the suspension ring, this must date from around 1600 and was probably made in one of the South German centres. Whistle pendants were very popular in Germany during the first half of the 16th century, and there are numerous portraits showing men wearing them. This, however, is more likely to have been a woman's jewel. The

next item after it in the Matthias Inventory of 1619 is another horn, this time of gold, set with uncut diamonds, ruby and emerald, and made in India. [A.SC.]

Provenance: The Imperial Treasury; Matthias Inv. 1619 no. 982.
Collection: Kunsthistorisches Museum, Vienna. Inv. no. 2108.

78 Ring
Gold enamelled in black, set with a sapphire intaglio of the Medusa. Diameter: 2.4 cm.

The shoulders and sides of the bezel are decorated with scrolls in reserve on a *champlevé* enamelled ground. The setting with its rather attenuated scrolling pattern dates from about 1600 and is difficult to attribute to any specific centre of production. The very fine intaglio is Graeco-Roman, 1st century AD.
Thomas Howard, Earl of Arundel (1585-1646) was a collector on a European scale in the range, splendour and antiquity of the objects which he acquired. Works of the classical period, cameos and intaglios included, formed the nucleus of his collection, and this is one of the gems acquired by him, perhaps through one of his agents, such as Edward Norgate the miniature painter in Italy, perhaps bought by himself on one of his frequent journeys on the continent, (*see* L. Cust, 'Notes on the collection formed by Thomas Howard, Earl of Arundel and Surrey,' *Burlington Magazine*, XIX (1911) pp. 278-286). In the 1727 manuscript inventory of the Arundel Collection of 236 gems, *see* no. 43, Smart Lethieuthier, Library of the Society of Antiquaries, London, it is Thec. A. No. 1. The collection passed by descent into the hands of the third Duke of Marlborough (b. 1739), himself a great collector of engraved gems. The Marlborough collection was sold at Christie's 28th June 1875. [A.SC.]

Provenance: Arundel and Marlborough Collections; Salting Collection.
Literature: *Catalogue of the Marlborough Gems*, (London, Christie's, 28th June 1875) lot no. 98; and p. viii in the introduction by M. H. Nevil Story—Maskelyne, *Oman*, no. 306, pl. XXVI.
Collection: V&A. Inv. no. M553—1910.

79 Gnadenpfennig
Silver-gilt and gold, enamelled in white, opaque pale blue, translucent red, green and blue and hung with pearls. Height (excluding suspension ring: 10.1 cm.
Condition: moderate loss of enamel from both sides of the setting.

The gold openwork, cast and chased. The enamel decoration the same on both sides. Obverse: portrait bust to the right and inscription WILHELMVS D: G COM: PALA: RHE: BA: DVX. Reverse: the coat of arms of Bavaria and VIRTUS: ANNO 1572 VINCIT. VIM (Virtue triumphs of force).
The medal is of Wilhelm the Pious (1548-1626), second son of Duke Albrecht V of

Bavaria, who succeeded his father in 1579, and resigned in favour of his son Maximilian I in 1597/8 (*see* J. P. Beierlein, *Die Medaillen und Münzen des Gesammthauses Wittelsbach* (Munich, 1897) I, no. 599.)

Provenance: Spitzer Collection (Sale Catalogue, 1893) Salting Bequest.
Collection: V&A. Inv. no. M548—1910.

80 Gnadenpfennig

Gold enamelled in white, black, pale blue, mid-blue, translucent green and red; hung with a cluster of pearls. Height (excluding suspension ring): 10.2 cm.
Condition: some enamel loss.

The medal is set in a frame to which is soldered the cast, chased and matted scrolling decoration. The front of the scrolls enamelled white, the back, black.
Obverse: portrait bust and the inscription ALBE: D: G: CO: PA: RHE: VTRI: BA: DVX. The coat of arms at the top of the suspension chain is that of Bavaria, beneath a ducal bonnet.
Reverse: a hand of succour reaching down from the clouds to a drowning man, and OPERI MANVVM TVARVM PORRIGES DEXTERAM (Thou shalt stretch out they right hand to thine own handiwork). On the escutcheon IHS and three nails.

The medal is of Albrecht VI of Bavaria (1584-1666) sixth son of Wilhelm V. He was a discriminating connoisseur of art and a patron of Alessandro Abondio, who in 1618 executed 'three portraits of him.' Abondio would have done these in wax, the medium in which he specialised, the actual making up of the medal being left to a die cutter. In the case of the portraits executed in 1618 a die cutter was imported from Augsburg. Another example of this medal, with identical mounts, is in the Münzsammlung, Munich. The settings of both are almost certainly by Christian Ulrich Eberl (active 1600-1634), the Augsburg goldsmith, who became a master in the Munich Goldsmith's Guild in 1600 and began at once to work for the Bavarian Court. His main function was the making of chains and *Gnadenpfennigs*; for example, in 1619, he was paid 108fl. 50 cr. for casting, die-stamping and mounting 20 *Gnadenpfennigs* for Duke Maximilian. From this it is clear that he may also have been responsible for the medals as well as the setting. (*See* M. Frankenburger, *Die Alt-Münchener Goldschmiede and ihre Kunst* (Munich, 1912) pp. 335-337; J. P. Beierlein, *Die Medaillen und Münzen des Gesammthauses Wittelsbach I*, no. 1234.) [A.SC.]

Provenance: Henri Tross Collection, Paris.
Collection: V&A. Inv. no. 69—1867.

81 Gnadenpfennig

Gold enamelled in white, black, opaque pale and mid-blue, translucent red and green. the openwork frame cast and chased. Height (excluding suspension ring): 9.6 cm.
Condition: considerable loss of enamel, especially to the face of the medal.

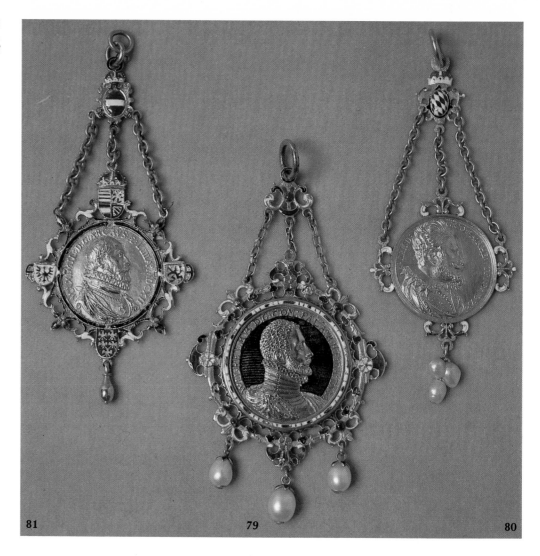

81 79 80

Obverse: portrait bust to the right and the inscription MAXIMIL: I: G: ARC.AVS: AE: LIII A: MDCXII.
Reverse: a military camp and MILITEMUS (let us fight). At the top of the chain the coat-of-arms of the Teutonic order.

The medal, dated 1612, is of Archduke Maximilian III (1557-1618), son of Emperor Maximilian I, elected King of Bohemia 1587, and later administrator of Inner Austria and Viceroy of Tyrol. It is by the sculptor Alessandro Abondio (*c*1570—after 1645) who worked for both the Imperial and Bavarian houses. In 1606 he was '*Skulptor und Bildgraber*' to Rudolph II in Prague, and after Rudolph's death in 1612 he continued to work for his successor, Matthias. He was still being mentioned in Emperor Matthias's accounts as his court sculptor in 1623 and 1625 despite the fact that by 1619 he was living in Munich. The coats of arms on the setting allude to all Maximilian's titles and functions. Another *Gnadenpfennig* with the same setting is in the British Museum (Waddesdon Bequest) and a third was in the Pierpont Morgan Collection N.Y. (ex Spitzer Collection). [A.SC]

Provenance: Salting Collection.

Literature: Habich, *Schaumünzen II*, pl. II, no. 3590.
Collection: V&A. Inv. no. M547—1910.

82 Chain Bracelet

Gold enamelled in opaque light blue, white, translucent red and green. Length: 22.2 cm.
Condition: chain links bent at edges.

German, around 1600 (1613). Stamped with the French import mark for 1864-93. The front of the fastening mechanism with enamelled scroll work ornament in an enamelled border, the back of the clasp engraved S.E. and, below, 1.6.1.3.

The most closely related pieces are two bracelets of 1632 from a tomb find in Saxony, but with rounded links and *champlevé* enamelled clasps (Auction cat. Marc Rosenberg Coll. Ball & Graupe, Berlin, 4th, 1929, lot no. 236 a, pl. 23.) *See also* cat. no. P23 which shows a South German patrician woman wearing similar bracelets. [I.H.]

Provenance: Max Frankenburger, Munich.
Literature: 'Berichte der Staatlichen Sammlungen. Die Neuerwerbungen des Bayerischen Nationalmuseums Januar-Mai 1913', *Münchener*

83 | **85**

Jahrbuch der bildenden Kunst, 1913, p. 67 f., fig. 8.
Collection: Bayerisches Nationalmuseum. Inv. no. 13/65.

83 Ring
Gold enamelled in black, set with a table-cut diamond intaglio. Diameter: 3.7 cm.

The hoop and sides of the bezel are decorated with *champlevé* enamel. The bezel is hinged to reveal a small compartment inside. The diamond is engraved with the imperial double-headed eagle.

The pointed leaf forms in austere black enamelling indicate that the ring dates from *c*1610. It must have been executed as a tour-de-force because the diamond was famous for being the hardest stone and so very difficult to polish, let alone engrave in intaglio. The double-headed eagle being the heraldic supporter of the imperial arms it is most likely that this ring belonged to the Emperor himself, whether Rudolph II or Matthias. [A.SC.]

Provenance: The Imperial Collections.
Collection: Kunsthistorisches Museum, Vienna. Inv. no. XII 310.

84 Watch Seal Ring (*see* p. 17)
Gold enamelled in white, black, translucent green, blue and yellow; set with an emerald and table-cut diamonds and enclosing a watch. Diameter: 3.5 cm.
Condition: heavy enamel loss from the underside of the bezel and the inside of the lid.

The emerald is engraved with a coat-of-arms showing a double-headed eagle, crowned with an imperial crown and surrounded by the order of the Golden Fleece. The watch is set in the deep bezel surrounded by openwork petals with black and white 'peapod' dots, and translucent blue enamel. The face of the watch and inside of the lid are enamelled with stylised leafy forms. The watch is signed '*Johan Buz A.*'

The coat-of-arms shows that this very fine ring must definitely have belonged to the Emperor himself, whether Rudolph II (d. 1612), Matthias (d. 1619) or Ferdinand II (d. 1637) and the style of the enamelling with its white points, and

82

stylised leaf shapes suggests a date between 1610 and 1620.

Johannes Buz of Augsburg was the maker of an octagonal clock watch in a pierced gilt-brass case in the V&A (Inv. no. 3236—1856) and of a watch in the British Museum.

Another famous example of a watch in a ring is that in the Residenz Schatzkammer Munich (ill. in Steingräber, *Alter Schmuck* pls. 220-222) whose works are by the Antwerp master Jakob Wittmann working in Augsburg. [A.SC.]

Provenance: The Imperial Collections.
Collection: Kunsthistorisches Museum, Vienna. Inv. no. 2179.

85 Pendant
Gold enamelled in white, opaque blue, translucent green, red and royal blue; set with mother-of-pearl cameo. Height: 3.2 cm.
Condition: the pendent stone or pearl missing from the end.

The portrait has around it the inscription HENRICUS.1111.DEI.GRATIA. The reverse has the same border as the obverse. The back plate is *champlevé* enamelled with a stylised spray of flowers.

The nucleus of the royal collection in the Cabinet des Médailles dates from the reign of Henri IV, the earlier royal collections having been largely dispersed or destroyed by the Leaguers in 1589-90 and the Wars of Religion. Henri IV summoned the antiquarian collector Rascas de Bagarris from Aix-en-Provence in 1602 to assemble what remained of the royal collections in one of the rooms at Fontainebleau, to inventory, and finally to add to it. Engraved gems and medals were to play a large part in this: the King bought antique examples but also had his own gem engravers: Julien de Fontenay appears in 1590 in the accounts of the royal household as a gem engraver; on 22nd December 1608, letters patent of Henri IV record that he was among the craftsmen lodged under the great gallery of the Louvre, and in 1611 he enjoyed the title of the King's *valet de chambre* and engraver of precious stones. Guliame Dupré, the famous medallist, also engraved gems which he signed with his initials.

Thus it is no coincidence that the Cabinet des Medailles owns no fewer than nine cameos of Henri IV, more than of any other monarch. This example is obviously related to medallic

portraiture in its shallow and even relief, its composition and the style of the inscription, but no exact parallel exists among the coins and medals of his reign. It is closest in style to those of around 1600—*see*, for example, *Trésor de Numismatique et de Glyptique* (Paris 1836) II pl. XXIX, no. 7. The Kunstkammer of Emperor Rudolph II in Prague contained a 'small portrait, carved in low relief on mother-of-pearl of *Jacob: 6. rex Scotorum, aetat: 28* given by Carl Cuortois,' no. 2446 in the Inventory of 1607-11, *Jahrbuch der Kunsthist. Slgn*, XXVI (1976). [A.SC.]

Provenance: possibly the Cabinet du Roi.
Literature: Chabouillet, no. 332; Babelon, pp. XCIV-XCV, CXIX-CXXII, cat. no. 787.
Collection: Cabinet des Médailles, Paris.

86 Pendant (*see* p. 4)
Gold enamelled in white, set with a sardonyx cameo of Silenus. Height: 3.2 cm.

Obverse: the cameo open-set; the frame the same back and front.

This small classical cameo has a 'pea-pod' style enamelled setting of rather mediocre quality. It is very possible, nonetheless, that it was one of the standard settings for gems in Henri IV's Cabinet. It appears on three other cameos in the collection: Agrippa and Hadrian (Babelon nos. 246 and 29) both of which are in the 1664 inventory of the Cabinet du Roi, and Tiberius (Babelon 704). Since the 'pea-pod' style dates from the early years of the 17th century, precisely when Henri IV was collecting, and Louis XIII, who succeeded as a child in 1610, made hardly any additions to the Cabinet, the probability is that this was one of Henri's many acquisitions, and that the setting was his choice or the choice of his antiquary, Rascas de Bagarris. Another, slightly more elaborate, pea-pod style frame appears on four other cameos (Babelon nos. 263, 739, 33, 271) and the same is probably true of them. [A.SC.]

Provenance: Cabinet du Roi.
Literature: Chabouillet no. 75; Babelon, no. 55.
Collection: Cabinet des Médailles, Paris.

87 Pendant (*see* p. 18)
Gold enamelled in white, black and translucent green; set with an opal cameo of Louis XIII (1601-1643). Height: 6.2 cm.
Condition: the pendent jewel from the bottom missing.

Open setting, the front and back similarly enamelled.

Unlike Henri IV, Louis XIII took very little interest in antiquities and made no additions himself to the Cabinet des Médailles. Nonetheless, like his predecessors, and like other European princes, he was the subject of a number of portraits in cameo, five of which are in the Cabinet today. This one is rare in its use of opal, and must date from around 1610 because of the age of the subject. The delicate, stylised 'pea-pod' style of the setting is characteristic of the period (*see* related design cat. no. G43. [A.SC.].

Provenance: Cabinet du roi (?)
Literature: Marion du Mersan, *Histoire du Cabinet des Médailles* (1838) p. 121, no. 434; Chabouillet, no. 336; E. Fontenay, *Les Bijoux anciens et modernes* (Paris, 1887) p. 226; Babelon, no. 791; Evans (1970) p. 134, pl. 118.
Collection: Cabinet des Médailles, Paris.

88 Pendent Watch

Gold enamelled in black, opaque pale green, translucent red, green, blue and yellow and rose-cut crystal. Height (without suspension ring): 4.5 cm.
Condition: minor enamel loss to the edge.

The reverse is decorated with a stylised floral motif within a red and green border, executed in *champlevé* enamel. The dial plate is oval and of gilt-brass; the chapter-ring is enamelled with Roman numerals and fine strokes at the half-hours. There is a single iron hand. The movement is of brass with oval plates 25mm × 21mm separated by baluster pillars. The top plate is signed 'A. Fremin'; there is a fusee of brass, verge escapement and iron balance wheel, pierced and engraved single-foot balance-cock, the mainspring set-up detent and spring (the latter missing) also covered by a pierced and engraved single-foot cock.

Another watch by this maker, who is assumed to be French, is illustrated in *Dictionnaire des Horloges Francais* (Tardy) location unrecorded. Because of the works one can reasonably assume that the case is also French. By about 1600, when this watch was made, watches had become quite common forms of adornment. The first portable timepiece is said to have been invented by the Nuremberg maker, Peter Henlein, soon after 1500. Henry VIII gave Catherine Howard a gold pomander enclosing a watch; Marguerite of Valois in 1579 had a little watch set with diamonds and rubies, and the 1587 inventory of Queen Elizabeth's jewels had a whole section devoted to watches. Eight were of gold or crystal and one was decorated with a frog and a lion (Evans (1970) p. 108). They were worn around the neck, as on the dwarf in cat. no. P12, or hanging from the waist, as in cat. no. P30.[1]

Provenance: Spitzer Collection. Given by Dame Joan Evans P.P.S.A.
Literature: *La Collection Spitzer* sale cat. (Paris and London, 1893) p. 54, no. 6.
Collection: V&A. Inv. no. M238—1975.
[1]Technical data given by Dr F. A. B. Ward.

89 Pendent Watch

Gold enamelled in white, black, translucent red, green and blue; set with foiled Antwerp rose-cut almandine garnets and table-cut diamonds. Height: 3.9 cm.
Condition: heavy loss of white enamel.

Assymmetrically formed to the shape of a flower bud, the diamonds in between the garnet 'petals' in leaf-shaped gold settings. The interior of the lid enamelled with a parrot among stylised leaves,

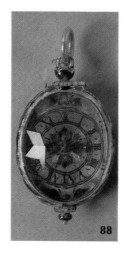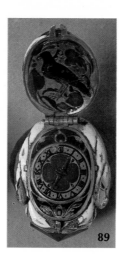

88 **89**

the face with a red quatrefoil in the middle and dark blue enamel above and below. Oval dial plate of gilt brass with Roman numerals and dots at the half hours in black enamel. Single iron hour-hand with a long tail. The dial surround enamelled deep blue. The movement in brass, with oval plates 22mm × 17mm separated by baluster pillars; the top plate is signed J. H. Ester. There is a brass fusee (the chain or gut missing), verge escapement, the balance staff broken near the bottom and lower pallet consequently missing. There is an iron balance-wheel, with a pierced and engraved single-foot balance lock. The mainspring set-up, detent and spring are also covered by a pierced and engraved single-foot cock.

Another watch by this maker, in a silver case shaped as a swan, is in this Museum (758-1864). There is some disagreement as to whether Henry Ester was French or Swiss. His dates are also not known, but stylistic grounds suggest a date of 1610-20 for this watch. [A.SC.]

Provenance: bought from a Mrs Noble of London.
Collection: V&A. Inv. no. 785—1901.

90 Locket

Gold enamelled in white, opaque blue, translucent red, green and yellow; hung with a pearl. Height: 6.5 cm.
Condition: some enamel missing from the edge.

The front and back of the locket are of *émail en résille* on foiled blue glass. The design is the same on both. The interior is empty but faintly engraved with a sunburst.

The technique used to make the two plaques is extremely difficult, and surviving examples are very rare. The glass is engraved with the design, and the declivities are then filled with gold leaf. Ground enamel is put into them and the whole fired. This is a very ticklish operation as a mistake in temperature will cause the glass background to crack. Objects executed with this technique all date from the first two decades of the 17th century and fall into two different groups: one, like this locket, with a formal floral decoration on an

intense blue or green background, and the other with figurative scenes. The first group includes a watch (V&A. Inv. no. 2353-1855) signed AB Loys and a miniature case (V&A. Inv. no. M66—1952) enclosing a portrait of Henri II which may well be French. The other group to which cat. no. 93 may well belong is Central European. [A.SC.]

Provenance: Given by Dr Joan Evans.
Literature: Evans (1970) p. 137, pl. IXa.
Collection: V&A. Inv. no. M65—1952.

91 Locket

Gold enamelled in black, white, opaque pale blue, translucent red, yellow, green and royal blue; set with four table-cut diamonds. Height: 2.5 cm.
Condition: some enamel loss from the interior.

Basse-taille enamelling with dots of white painted enamel. The interior of the lid enamelled with a quatrefoil with ogival leaves, yellow and green, and blue, the background stipple matted. The sides engraved in italic with FIDEL.IUSQ.A.LA. MORT.LE.PAREIL.DE.VOUS.A.MON.CONFORT (Faithful unto death, the likeness of you is my comfort).

This small French amorous locket is of outstanding quality: the enamelling with its two colours blending into one another, as on the reverse, is technically very accomplished and the design is sophisticated and abstract. For another example of leaf-shaped stone settings *see* the breast

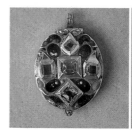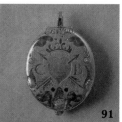

91

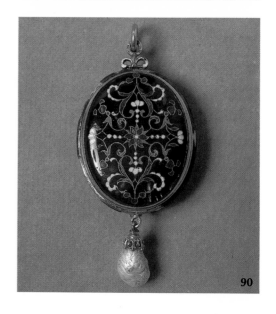

90

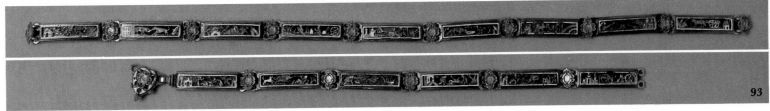

ornament cat. no. 114. This locket must date from about 1610-20. [A.SC.]

Provenance: Given by Dame Joan Evans P.P.S.A.
Collection: V&A. Inv. no. M110—1975.

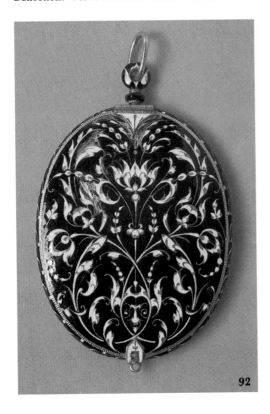

92 Miniature Case

Gold enamelled in black and white. Height: 8.1 cm.
Condition: The pendent jewel missing from the end, the enamel on the sides heavily scored in four places; and entirely missing from the wreath.

Champlevé enamelled with the same design on both sides, the gold surfaces left in reserve hatched; the edge of the lid milled. The interior of the lid engraved with a sunburst and a wreath of laurel leaves keyed for enamel.

This clearly relates to the designs by the Chateaudun Master, Jean Toutin, published in 1619 (*see* cat. no. G40). The style of its floral decoration is called 'pea-pod', because it includes elements which look like the peas in a pod. It is a botanical evolution of the stylised, and broken C-scroll ornament, also often executed in *champlevé* black and white enamel. The orb and sceptre of Queen Christine of Sweden (*see* cat. no.

126) are decorated with an all-over pattern of 'pea-pod' scrolling executed in black enamel, and the opal cameo of Louis XIII (cat. no. 87) is surrounded by an openwork frame of it.

This miniature case which dates from *c*1620 may be French, but as the Swedish regalia shows, its style was one which travelled. [A.SC.]

Provenance: given by Dame Joan Evans P.P.S.A.
Literature: Evans (1970) p. 127, pl. 106a.
Collection: V&A. Inv. no. M246—1975.

93 Girdle

Silver-gilt, set with *émail en résille* plaques in white, black opaque, red, pale blue, lilac, yellow, translucent red, blue, blue-green, yellow and brown. Length: 68 cm.
Condition: two enamel plaques damaged.

Fifteen plaques of alternately colourless and bright blue glass enamelled *en résille* with hunting, domestic and rural scenes, in box settings with rope borders, connected by cast quatrefoils, the clasp at one end with coarse white enamel.

Although the plaques are executed in the same technique as those on the locket (cat. no. 92), the palette of enamel colours is much larger, and the figurative style is obviously different from the disciplined floral motifs found in the group to which the miniature case belongs. These girdle plaques have everything in common with a pendent plaque after the design by Valentin Sezenius of 1623 (V&A. Inv. no. 6996—1860). Nothing is known about the designer but the tiny

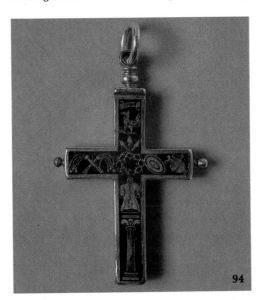

rather spidery figures on the belt plaques are reminiscent of the small figures incorporated in the *champlevé* scrollwork enamelling on early 17th-century South German and Prague goldsmiths' work (e.g. the enamelled gold bowl with the arms of Salzburg and archbishop Wolf Dietrich von Raitenau, Museo degli Argenti, Florence.)

The plaques may have been made separately from the belt and mounted up later, as the coarse white enamel on the catch is not the same as that on the plaques. There have been reports recently of identical plaques attached to an ebony shrine in a church in Poland, location unspecified. There is another belt made up of identical plaques in the Wallace Collection, London. [A.SC.]

Provenance: J. Webb Collection.
Collection: V&A. Inv. no. 484—1873.

94 Reliquary Cross

Gold with black enamel. Height: 6.2 cm.
Condition: one screw missing.

The front and back hinged at the top so that when the screws at the ends of the arms are undone numerous small compartments holding relics are revealed on the interior. The insides of the lids are engraved in Italian with the names of the saints and relics in question, e.g. S. PIETRO.AP. S. PAULO.AP. LEGNO DI CROCE . . . LATTE DELA VERGINE etc. The sides are decorated with enamelled money moulding.

This, like the IHS pendants, would have been regarded as having protective powers. Indisputably the most important relic inside is that of the True Cross, and the *Arma Christi*; the symbols of the Passion, on the outside, refer to and reinforce this. The wearing of reliquary crosses containing a multiciplicity of small relics became common in Spain towards the end of the 16th century. This Italian cross (attributed on the basis of the inscription) probably also dates from around 1600, because of its heavy plain shape and decoration.

Provenance: Given by Miss L. Pacey.
Collection: V&A. Inv. no. M77—1979.

95 Pendant

Gold enamelled in white, painted pink, translucent blue and green enamel. Height: 6.4 cm.
Condition: some enamel loss on back.

The figure is crudely cast, the stars and sickle moon are in reserve on her cloak. Suspension loop at the back.

The practice of giving jewels to shrines and cult figures is one which still goes on today. The

Reformation eliminated many of the collections at cult centres (none, for example survive in England) but many remained intact on the continent until the end of the 18th century when the Napoleonic conquests and the secularisation which followed led to the disposal of the great majority of them. For example, in Spain there were at least half a dozen including Compostella and Montserrat, but only Saragossa survived into the 19th-century. The legend attached to Saragossa is that the Virgin was miraculously transported here in AD 40 to the banks of the Ebro to assist St James the Greater who was evangelising. Before her return to Palestine she gave instructions that the marble pillar on which she stood should have a church built around it. The cult of the Virgin of the Pillar grew in strength from about the year 1000 and in 1681 it was decided to build a new Cathedral in place of the medieval church. The building campaign progressed in fits and starts until, in 1863, it was decided to complete the church once and for all. It was to finance this that in 1870 the canons decided to sell off the jewels presented over the centuries to the Shrine. Nothing seems to have dated from earlier than about 1550, so there must have been a liquidation of the Shrine's assets once before. The South Kensington Museum (now the V&A) was nonetheless keen to acquire as many of the pieces as possible, and it spent £880 4s 8½d at the auction. Cat. nos. 95-109 are the late 16th and early 17th century pieces which it purchased. This rather coarse statuette, a devotional 'souvenir' was probably made in Saragossa for pilgrims to the Shrine. It must date from the second quarter of the 17th century because of its decoration with painted enamel.

A Virgin of the Pillar pendant can be seen in cat. no. P24, the portrait of Maria, widow of Archduke Charles of Austria (1551-1608). She would have been familiar with this Spanish cult through her Hapsburg connections. [A.SC.]

Provenance: the Treasury of the Cathedral of the Virgin of the Pillar, Saragossa.
Literature: C. Oman, 'The Jewels of our Lady of the Pillar at Saragossa', *Apollo* (June 1967).
Collection: V&A. Inv. no. 343—1870.

96 Reliquary Pendant
Crystal, set with gold enamelled in white, black, translucent green, blue and red, and with two *verre églomisé* paintings. Height: 6 cm.

The carved crystal oval is hollow in the centre and a capsule is formed by the two enamelled gold sections fitting into the hollow from either side. The paintings represent the Virgin of Loreto and a figure which is too damaged to be legible. The enamelled strapwork element at the four points of the compass are held in place by rivets which fit through holes bored in the crystal.

This is one of three such carved crystal reliquary pendants from the Treasury, which are generally regarded as being Spanish. The painting of the Virgin of Loreto, a cult figure in Italy, does however raise the possibility that this

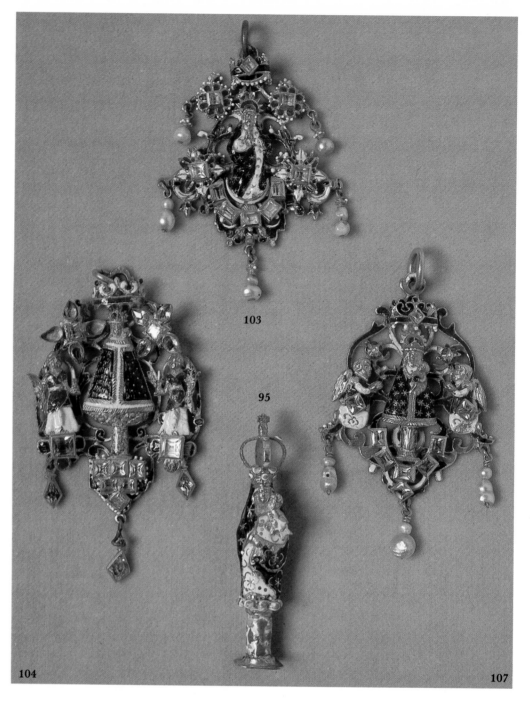

103

95

104

107

might be an Italian example. Be that as it may, the piece must date from about 1600 because of the rather formal geometric strapwork. [A.SC.]

Provenance: the Treasury of the Cathedral of the Virgin of the Pillar, Saragossa (*see* cat. no. 95).
Literature: C. Oman, *Apollo* (June 1967) p. 405.
Collection: V&A. Inv. no. 347—1870.

97 Pendent Cross
Gold enamelled in white and translucent green, set with table-cut amethysts. Height: 6 cm.
Condition: the pendent jewels missing from the arms and base. The enamel slightly damaged.

Reverse: a green cross on a white ground with gold dots in reserve.

There were twenty-six cross pendants in the sale of 1870 (*see* cat. no. 95) and the museum bought this and one other. Amethysts were discovered in Catalonia in the first half of the 17th century and were used much more by Spanish goldsmiths than by other nationalities. The small 'pearls' of white enamel down the sides indicate that the cross dates from the first two decades of the 17th century. The large stones set closely together and the sombre green enamel are characteristically Spanish. [A.SC.]

Provenance: the Treasury of the Cathedral of the Virgin of the Pillar, Saragossa.
Literature: C. Oman *Apollo* (June 1967) p. 405, ill. 2.
Collection: V&A. Inv. no. 344—1870.

98 Pendent Cross (*see* p. 15)
Gold enamelled in white, opaque blue and green, translucent red, green and blue; set with table-cut crystal. Height: 7.8 cm.
Condition: five crystals missing, a pendent jewel missing from the base.

The central section has the cross and palm leaves separately inserted. Reverse: white background with *champlevé* enamelled stylised foliage.
This is the second pendent cross bought by the Museum from the auction. Like the other one (cat. no. 97) it is bold in design and closely set with large table-cut stones. With its broadly curving enamelled foliate scrolls around the edge it is verging on the Baroque and by comparison with similar pieces in the *Llibre de Passanties III* (*see* cat. no. G1) it must date from about 1630. [A.SC.]

Provenance: the Treasury of the Cathedral of the Virgin of the Pillar, Saragossa (*see* cat. no. 95).
Literature: C. Oman, *Apollo* (April 1967) p. 405; Evans (1970) pl. III.
Collection: V&A. Inv. no. 345—1870.

99 Pendant
Crystal set with gold enamelled in white, opaque pale blue, translucent green and blue; enclosing two paintings, and hung with pearls. Height: 7.5 cm.

For construction, *see* cat. no. 96. The two paintings, one of which shows the Virgin of the Assumption, the other St Peter, are executed in the technique later called *verre églomisé* where the painting is executed behind glass and then backed with gold foil. The technique of filigree enamelling is at present thought to have been a speciality both of the Adriatic area (especially Venice and its dependencies), and of Hungarian goldsmiths' work. As the making of filigree was, however, common to many parts of Europe, including Spain, this may well be a Spanish example of its combination with enamel. [A.SC.]

Provenance: the Shrine of the Cathedral of the Virgin of the Pillar, Saragossa.
Literature: C. Oman, *Apollo* (June 1967) ill. I.
Collection: V&A. Inv. no. 338—1870.

100 Pendent Scent Flask
A pine cone set in gold enamelled with white and translucent red. Height: 8 cm.
Condition: almost all enamel lost.

This scent flask of about 1600 has an interesting parallel in a small scent flask belonging to the Hispanic Society of America, N.Y. which is carved out of jet in the shape of a pine cone. [A.SC.]

Provenance: the Treasury of the Cathedral of the Virgin of the Pillar, Saragossa, *see* cat. no. 95.
Literature: C. Oman, *Apollo* (June 1967) p. 404, fig. 2.

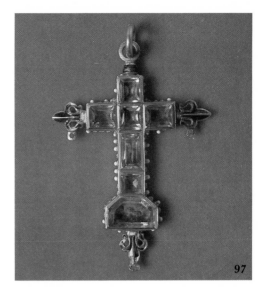

97

101 Pendant
Gold enamelled in white, opaque mid blue and pale blue, translucent red, blue and green enamel; set with crystal and pearls. Height: 8.3 cm.

The profiled crystal has a hole through the middle into which fit two capsules, one containing an enamelled bas relief of the Crucifixion, the other the Virgin of the Immaculate Conception in an enamelled aureola, both under crystal. The frames are held by enamelled scrolls to the elaborately scrolled outer frame which is set with pearls and enamelled with prominent red beading.

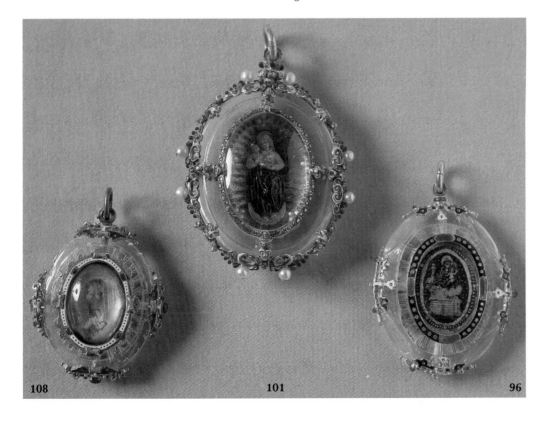

108 101 96

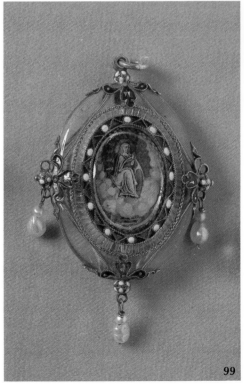

99

The pictorial style of the Crucifixion is no clue as to the identity of this very fine piece, as it is of a very standard Italianate type. The cult of the Virgin of the Immaculate Conception was however particularly strong in Spain during the first two decades of the 17th century, which accords with the dating of scroll-work. This fact, and its Spanish provenance, indicate that the pendant is almost certainly Spanish. [A.SC.]

Provenance: from the Treasury of the Shrine of the Virgin of the Pillar, Saragossa. Said to have been given by Louis XIII of France.
Literature: C. Oman, *Apollo* (June 1967) p. 404, pl. III.
Collection: V&A. Inv. no. 332—1870.

100

105 106

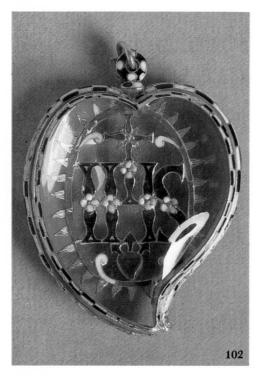

102

102 Heart Pendant

Gold and crystal with black, white, opaque pale blue, translucent red, green and blue enamel.
Condition: much enamel missing from the sides.

The sacred monogram, a cross and a heart pierced with three nails, the whole in an aureola, are enclosed between two sheets of rock crystal. The sacred monogram is enamelled blue on one side, green on the other.

This large pendant with the monogram IHS forming a prominent part of the design is characteristic of the many devotional pendants, often incorporating sacred initials, common in Spain during the first half of the 17th century. Many of them have similar geometric, rather coarsely enamelled decoration. [A.SC.]

Provenance: the Treasury of the Cathedral of the Virgin of the Pillar, Saragossa (*see* cat. no. 95).
Literature: C. Oman, *Apollo* (June 1967) ill. 4.
Collection: V&A. Inv. no. 346—1870.

103 Pendant

Gold enamelled in black, white, opaque pale blue, translucent blue, red and green; set with table-cut crystals and hung with pearls. Height: 6.7 cm.
Condition: extensive enamel loss to the back.

An open-work back-plate of addorsed C and S scrolls with swags, enamelled bright blue, green and white, with the cast figure of the Virgin rivetted to it. The semi-circle of crystals beneath her, and the rosettes on either side are separately rivetted on as are the canopy and rosettes above. The stars on the Virgin's gown in reserve on the enamel.

Jewels with the Virgin of the Immaculate Conception on her sickle moon were common in Spain during the first half of the 17th century. They were a manifestation of the movement, which became especially fervent *c*1610-20, to have the Immaculate Conception promulgated as dogma. Confraternities were founded to press for it and during fiestas in honour of her, members wore on silken ribbons around their necks, gold images of the Immaculata with the inscription '*Concebida sin pecado original*'.

This pendant must have been made as an expression of the same movement. In its construction, with the openwork back plate of scrolls, it resembles, for example, the designs produced in Augsburg by Daniel Mignot between 1590 and 1619. In its coarseness, and the crowded composition on the front it is however typical of the more commercial sort of Spanish jewellery.

In the style of the back-plate, and its enamel colours it resembles the pendant with the Virgin of the Pillar (cat. no. 95) which may well have been made in Saragossa and so it may be tentatively attributed to a workshop in that town. [A.SC.]

Provenance: the Treasury of the Cathedral of the Virgin of the Pillar, Saragossa.
Literature: C. Oman, *Apollo* (June 1967) p. 404, pl. III.
Collection: V&A. Inv. no, 340—1870.

104 Pendant

Gold enamelled in black, white, opaque mid-blue, translucent red, green and blue; set with ten table-cut and eight rose-cut crystals. Height: 7.5 cm.
Condition: two stones missing, heavy enamel loss.

For construction, *see* cat. no. 103. Despite its similarity to the former, this pendant was obviously not made from the same moulds or with the same tools. They both date from *c*1600-20 and come from Saragossa but it is likely that different goldsmiths made them. [A.SC.]

Provenance: the Shrine of the Cathedral of the Virgin of the Pillar, Saragossa.
Literature: C. Oman, *Apollo* (June 1967) p. 404, pl. III.
Collection: V&A. Inv. no. 342—1870.

105 Pendant
Gold enamelled in white, black, opaque mid-blue and yellow, translucent red and green; set with foiled glass and hung with pearls. Height: 8 cm.
Condition: most of the enamel missing from the wings.

The pelican cast and finely chased, standing on a green enamelled perch. Its back ribbed, *champlevé* enamelled with black and white moresques. The fanned tail enamelled white. The reverse of the displayed wings finely chased and with yellow and green enamel. The fledglings standing on semi-circular dish shape also enamelled with moresques.

The pelican wounding her breast to feed her young was a common symbol of Christ in the Middle Ages, and at this period, it had the advantage of combining the fashion for sculptural animal pendants with pious symbolism. This example must date from about 1550-75 because of its moresque decoration and the style of the suspension ring. It is very finely executed with subtle enamel patterns and delicate chasing; this makes it slightly surprising that a foiled paste is used instead of a real stone in the breast.

Provenance: the Treasury of the Virgin of the Pillar, Saragossa (*see* cat. no. 95).
Literature: C. Oman, *Apollo* (June 1967) p. 404, pl. IIa; Evans (1970) pl. 84.
Collection: V&A. Inv. no. 335—1870.

106 Pendant
Gold enamelled in white, opaque pale blue, yellow, translucent green, red and ochre; set with a table-cut foiled crystal and hung with pearls. Height: 9 cm.
Condition: slight enamel loss on the parrot's tail.

The green enamel is fired with the spots of yellow, ochre and red already incorporated rather than painted onto it afterwards.

Fol. 350 of the *Llibre de Passanties*, Vol. II (cat. no. G1), shows a design for a pendant with a suspension ring almost identical to this one, with its addorsed C-scrolls, connecting boss etc. dated 1600. The period of intense activity in the making of animal pendants in Spain seems, according to this book, to have been *c*1580 to *c*1620. The pictorial inventory (*c*1770) in the *Archivo del Real Monasterio*, Guadalupe illustrates a very similar green parrot pendant with a jewel in its breast in plate 32. This must also date from about 1600.

Attempts have been made to give symbolic meanings to these animal pendants: for example, a jewelled parrot was meant to indicate eloquence according to Ripa's *Iconologia*; but these interpretations are not obligatory; there would in any case have been renewed interest in exotic animals like parrots because of the flourishing contact between Spain and the New World. [A.SC.]

Provenance: the Treasury of the Cathedral of the Virgin of the Pillar, Saragossa (*see* cat. no. 95).
Literature: Evans (1970) p. 84; C. Oman, *Apollo* (June 1967) pl. II.
Collection: V&A. Inv. no. 337—1870.

107 Pendant
Gold enamelled in white, black, opaque pale blue, yellow and green, translucent red, green and blue; set with table-cut crystals and hung with pearls. Height: 7.5 cm.
Condition: moderate enamel loss on the reverse and from the angels and the pillar.

An open work scrolling back plate enamelled green and white, with a blue swag at the bottom. To it are rivetted the cast figures of the Virgin, the kneeling acolyte angels, her canopy and the setting for the stones. Spanish, probably from Saragossa. About 1610-20. [A.SC.]

Provenance: the shrine of the Cathedral of the Virgin of the Pillar, Saragossa, (*see* cat. no. 95).
Literature: C. Oman, *Apollo* (June 1967) p. 409.
Collection: V&A. Inv. no. 341—1870.

108 Pendant
Crystal set in gold enamelled in white, opaque pale blue, translucent red and green, with gouache paintings on paper. Height: 5.5 cm.

The engraved crystal body is hollow in the centre and set with two capsules, one on either side. One contains a painting of the Virgin in profile, the other a painting of Our Lord. The space between the two capsules inside the crystal contains a folded-up strip of paper on which the Last Gospel in Latin and a prayer in Spanish are written in an italic hand. The strap-work elements at the four points of the compass are held in place by rivets bored through the crystal to the central hollow.

The wearing of phylacteries, that is, prayers or invocations written on pieces of paper, is very common in the Jewish and Islamic religions, though less common in the West. The words of the Last Gospel, 'In the beginning was the Word, and the Word was with God and the Word was God . . .' (John: 1-14) were more commonly quoted with amuletic purpose than any other part of the scriptures in the Middle Ages and during this period, because they actually identified the word with the Word, that is, the Godhead, and so were explicit about the supernatural power of certain words and phrases. Other examples of this kind of belief are the IHS pendants invoking the name of Jesus (cat. no. 55) and the pendant with the common invocation ANNANISAPTA DEI TETRA-GRAMMATON (cat. no. 8). Both the Last Gospel

and the private prayer on the reverse of the piece of paper in this pendant end with the more usual invocations of Holy Names 'IHS, Maria, Ana'. The settings are very fine, of equivalent quality to the settings of jewels in the Imperial Collections (e.g. cat. no. 69) with delicate chasing and matting. The rather disciplined, formal but attenuated strapwork suggests a date around 1600. [A.SC.]

Provenance: the shrine of the Virgin of the Pillar, Saragossa, (*see* cat. no. 95).
Literature: C. Oman, *Apollo* (June 1967) p. 405, pl. III.
Collection: V&A. Inv. no. 333—1870.

109 Pendant
Gold enamelled in white, black, opaque pale blue, translucent red, blue and green; set with table-cut rubies and crystals, a rose-cut emerald and hung with pearls.
Condition: considerable loss of *basse-taille* enamelling.

The elements all cast and chased, the enamel mostly *champlevé* and *basse-taille*. The reverse of the cornucopia enamelled white with gold scroll work punctuated by red rosettes.
A closely similar pendant design dated 1603 is in the *Llibre de Passanties* II fol. 362 (*see* cat. no. G1), submitted by a Barcelona goldsmith called Gabriel Ramon. It was also a design taken up by the 19th century goldsmith and faker, Reinhold Vasters (*see* cat. no. H G7). [A.SC.]

Provenance: the treasury of the Cathedral of the Virgin of the Pillar, Saragossa, *see* cat. no. 95.
Literature: C. Oman, *Apollo* (June 1967) p. 405; Muller, p. 96, ill. 153.
Collection: V&A. Inv. no. 334—1870.

110 Pendent Scent Bottle
Silver-gilt with bosses and plaques enamelled in translucent green and royal blue. Height: 8.3 cm.
Condition: slight enamel loss.

109

110

The bottle cast and chased, with the *champlevé* enamelled bosses set into both sides and with enamelled plaques set down the sides.

This scent bottle would have been worn on a chain or belt hanging from the waist. It is definitely Spanish, *c*1620, on grounds of comparison with marked Spanish goldsmiths' work of the period, which often sets precisely similar enamelled silver bosses into silver-gilt or copper-gilt, *see* C. Oman, *The Golden Age of Hispanic Silver* (H.M.S.O. 1968) nos. 231-235. [A.SC.]

Provenance: bequeathed by Colonel Babington Croft Lyons.
Collection: V&A. Inv. no. M799—1926.

111 Pendant of the Holy Inquisition (*see* p. 16)
Gold enamelled in white, black and translucent green, encasing a Columbian emerald polished *en cabochon*. Height: 4.2 cm.
Condition: extensive enamel loss.

The black and white cross on the front is that of St Dominic, the Dominicans being the friars who spearheaded the inquisition of heretics. The green cross on the reverse symbolises the hope of repentance before punishment, and of salvation; the olive branch signifies the mercy offered to the repentant, and the sword of Justice on the right represents the punishment meted out to the obdurate.

In 1603, Philip III of Spain decreed that all Officers of the Holy Inquisition should wear its insignia on their clothing during public functions. Gradually the practice spread to all who wanted to show themselves to be loyal supporters of the Catholic church and its efforts to stamp out heresy. Officers and familiars of the Inquisition continued to be the only ones who wore the insignia on their clothing, but a painting dated 1680 by Francisco Rizi (Prado) shows members of the court attending an *auto-da-fe* in Madrid, many of them with pendent *veneras* set with gems. This one must date from *c*1620-30 because of the shape of the suspension ring, and must have been intended for female wear. [A.SC.]

Provenance: none.
Literature: Muller, pp. 116-7.
Collection: V&A. Inv. no. M308—1910.

112 Pendent Order of Santiago (*see* p. 16)
Gold enamelled in black, translucent green and red, and crystal. Height: 2.8 cm.
Condition: some enamel loss.

The order of Santiago is the senior of the four Spanish military orders which rank as follows: *Compostela*, *Calatrava*, *Alcantara* and *Montesa*. Wearing devices which proclaimed one's adherence to an order or confraternity was a pronounced fashion in 17th-century Spain. This pendant is so small that it may perhaps have been worn by a child. [A.SC.]

Provenance: bought at Saragossa by J. C. Robinson.
Collection: V&A. Inv. no. 226—1864.

113a Agraffe of Maximilian I of Bavaria
(*see* p. 14)
Enamelled gold set with large pearls, table-cut, rose-cut and pointed diamonds, and table-cut rubies. Height: 17.5 cm.

A trophy of weapons, cuirass and helmet. On the reverse a flag with the blue-and-white lozenges and ducal arms of Bavaria. The inscription reads MAXIMILIANVS BAVARIAE DVX, and another inscription on the shield is DOMINVS VIRTVTVM NOBISCVM (the Lord of bravery is with us) MDCIII (1603). The spray of diamonds and pearls at the top can be removed and the trophy worn as a pendant on its own.

According to the records of the Bavarian Court Exchequer, Georg Beuerl was paid 1300 florins for this very fine jewel in 1610. Beuerl's name recurrs constantly in these accounts between 1599 and 1625 among the payments made to the Augsburg goldsmiths' trade. He is variously referred to as goldsmith, jeweller, citizen of Augsburg, and merchant, and the variety of goods which he supplies, from gold chains, to ewers and basins, from unmounted stones to this agraffe, suggests that like many successful goldsmiths of the day he operated partly as a middle man. There is, therefore, no absolute certainty that he made this piece.

The jewel was designed to be worn in a hat, like the spectacular jewels in the hats of Sigismund of Poland (cat. no. P27) or Henry Prince of Wales (cat. no. P22), but there is also a portrait, after 1623, showing Maximilian's first wife, Elizabeth, wearing it on her left arm.

Maximilian added to the list of jewels declared to be inalienable heirlooms by Albrecht V (1550-1579), and this was among the new items. [A.SC.]

Provenance: the collection of Duke Maximilian I (1597-1651); part of his Disposition of 20th January 1617; appears in the list of jewelled objects (*Kleinoden*) n.d. *c*1650.
Literature: A. Weiss, *Das Handwerk der Goldschmiede in Augsburg bis zum Jahr 1681* (Leipzig, 1897) pp. 346-357; E. von Watzdorf, 'Mielich und die bayerischen Goldschmiedewerke der Renaissance,' *Münchner Jahrbuch der bildenden Künste* (1937) pp. 73-74; *Guide to the Schatzkammer of the Munich Residenz I* (Munich, 1931 and 1937) p. 606; H. Kohlhaussen, *Geschichte des deutschen Kunsthandwerks* (Munich, 1955) p. 318, pl. 286; Lord Twining, *A History of the Crown Jewels of Europe* (London, 1960) p. 41; U. Krempel, 'Augsburger und Münchener Emailarbeiten des Manierismus aus dem Besitz der bayerischen Herzöge Albrecht V, Wilhelm V, und Maximilian I', *Münchner Jahrbuch der bildenden Künste XVIII* (1967) p. 115, 119; *Schatzkammern Europas*, ed. E. Steingräber (Munich, 1968) p. 50, pl. 19; H. Tillander, 'Die Tafeldiamanten der Schatzkammer in München', *Gold und Silber* (April 1969); *Official Guide to the Schatzkammer of the Munich Residenz I* (Munich, 1937) p. 606; II (Munich, 1958) p. 572; III (Munich, 1970) p. 631.
Collection: Bayerische Verwaltung der Staatlichen Schlösser, Gärten und Seen.

113b Case for the Agraffe of Maximilian I
Silver, parcel-gilt. Diameter: 12 cm.

Town mark for Munich R³ 3440. Maker's mark R³ 3489 for Abraham Zeggin. Engraved on the lid with MAXIMILIANVS D:G.CO.PA:RHE:VT RISQ:BAVA: DVX over the Bavarian coat of arms and ducal bonnet and the Golden Fleece. Below, MDCIII (1604).

The maker, Abraham Zeggin, was the son of a Munich goldsmith, trained in Augsburg. He is believed to have become a master in the Munich goldsmiths' guild in 1586. He was clearly a skilled craftsman, who received important commissions from the town council, Archduke Ferdinand of Austria and the Munich court: for example, in 1604 he made a silver shaving kit for Duke Albrecht.

Provenance: the collection of Duke Maximilian I and part of his Disposition of 20th January 1617; mentioned in all the inventories up to 1752 together with the *agraffe*.
Literature: M. Frankenburger, *Die Alt-Münchener Goldschmiede* (Munich, 1912) pp. 154-156, ill. 59, 318-319; *Official Guide to the Schatzkammer of the Munich Residenz I* (Munich, 1931 and 1937) 177; II (Munich, 1958), 573; III (Munich, 1970) 632.
Collection: Bayerische Verwaltung der Staatlichen Schlösser, Gärten und Seen.

114 Breast Ornament (*see* p. 13)
Gold enamelled in black and white, set with table-

cut and facetted point-cut diamonds. Height: 13 cm.

Constructed in three layers with a cast openwork backplate enamelled black on the inner surface, and an openwork front-plate enamelled black with touches of white studded with diamonds in leaf-shaped settings. The third layer is the central rosette with its beads of white enamel and black enamelled leaves, and a large central diamond. This screws through the other two layers with a nut and holds the construction together. For a similarly constructed pendant *see* cat. no. 73.

This admirably illustrates the tendency in the 17th century towards the preponderance of gem-stones. Enamel retreats in importance, and is used here only to give depth and highlights to the design. The many-layered construction with the greater depth and shifting perspectives which it gives begins with late 16th-century pendants and lasts until about 1640. The leaf-shaped settings for the stones are characteristic of the first third of the 17th century. G42, the design after Jacques Caillart, gives an idea of how such a jewel was envisaged at the time, although the massive stones, in practice, alter its final appearance considerably.

Rubens' portrait of his second wife, Hélène Fourment, (Alte Pinakothek, Munich) whom he married in December 1630, shows her wearing a very similar breast ornament.

Provenance: given by Dame Joan Evans P.P.S.A.
Literature: Evans (1970) p. 134, pl. 114.
Collection: V&A. Inv. no. M. 143—1975.

115 Revolving Seal Ring
Gold. Diameter: 2.6 cm.

The bezel revolves and is engraved on one side with the crest '*a falcon rising, proper, belled and jessed*' (Throckmorton) and on the other, a shield '*three lions passant guardant*'(Carew).

The practice of wearing an heraldic seal ring became common in England in the 15th century, but wearing a seal engraved with a complete coat-of-arms, rather than merely a crest, arose only after the mid 16th century. The reason for the double seal here is that its owner, Sir Nicholas Throckmorton, was married to Anne Carew who

became heiress to her brother, Francis Carew of Beddington, on his death in 1607. The Throckmortons assumed the name Carew there-after, so this ring must date from after 1607. Sir Nicholas was still alive in 1623. A very similar ring with a revolving bezel is in the Ashmolean Museum, Oxford (Fortnum Collection 643).

Provenance: Waterton Collection.
Literature: Ironmongers' Hall Exhibition 1861, ii 563; Oman, no. 494, pl. XX; Oman, *British Rings*, p. 32, pl. 45f.
Collection: V&A. Inv. no. 808—1871.

116 Miniature Case
Gold enamelled in white, black, opaque pale blue, translucent red, green and blue; set with diamonds (table-cut and one facetted point-cut) and rubies (table-cut and one cabochon); hung with a pearl. Height: 8.1 cm.

Condition: the original miniature replaced by a later one, enamel chipped off the back, and heavy enamel loss from the openwork cover.

The front cover *champlevé*-enamelled with the inscription FAST THOVGH VNTIED. The miniature is by John Hoskins (d. 1655) and cannot be the original as the case dates from *c*1600-10. In the method of construction of the lid, with its heavy bolts and nuts holding the parts together, the palette of enamel colours, and the dots of pale blue enamel around the stone settings, it

115

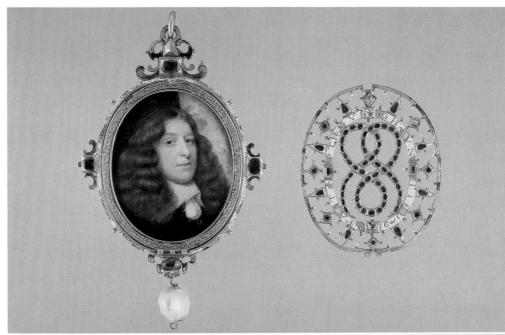

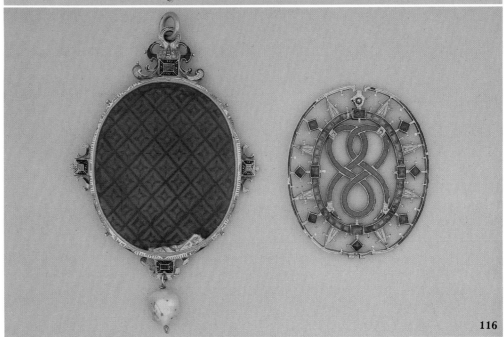

116

resembles a contemporary necklace (cat. no. 119); the bright translucent enamel diapered ground which decorates the back is the same as on the miniature case with the portrait of James I (cat. no. 117), and a case with a portrait by Peter Oliver in the V&A (Inv. no. 117—1898) so may have been the characteristic of a particular goldsmiths' workshop in London. This device of an open knot with the motto 'Fast though untied' also appears on a silver counter of Sir Thomas Heneage dated 1588, *see, Medallic Illustrations of the History of Great Britain and Ireland* (London, 1904) I, p. XI, 5. Heneage was appointed Treasurer of the Chamber to Elizabeth in 1576, and was Treasurer at War at the time of the Spanish Armada. Openwork fronts to miniature cases occur also with the Hilliard portrait (cat. no. 36) and the Lyte Jewel of c1610 given by James I to Thomas Lyte, which has an R for Rex on the front (British Museum, Waddesdon Bequest).

Provenance: Pierpont Morgan Coll. (Sold Christie's June 24th, 1935 lot 146.) Bequeathed by L. D. Cunliffe, 1937.
Literature. *Treasures of Cambridge Exhibition*, Goldsmiths' Hall (London 1959) cat. no. 342; Evans (1970) pl. 103c; *Diamantjuewelen uit Rubens 'tijd*, Provincial Diamond Museum (Antwerp 1977).
Lent by the Syndics of the Fitzwilliam Museum, Cambridge.

117 Locket
Gold enamelled in white, opaque pale green and translucent red; set with two miniatures. Height: 3 cm.
Condition: a pendent jewel missing from the bottom.

The two sides identical, with translucent red enamel over a coffered ground. The locket contains a miniature of King James I (1603-1625) within a sun burst, and an ark on a stormy sea with the inscription STET SALVA PER UNDAS (may it go safely through the waves).

The miniatures are from the workshop of Nicholas Hilliard, and show King James in his second portrait type, which derives from the miniature of him in Windsor Castle, painted c1605. They and the case must therefore postdate the Windsor portrait.

The emblem inside the lid, with its allusion to the monarch guiding the ship of the English Church safely through the stormy sea, was originally Queen Elizabeth's (*see* the Armada Jewel cat. no. 38), but was adopted by James, also for a number of medals. The bright translucent enamelling on a coffered ground also appears on another miniature case containing a miniature by Peter Oliver, date 1619, (V&A. Inv. no. 117—1888). This style of decoration may have been conventional, or was perhaps the characteristic of a particular goldsmith's workshop. [A.SC.]

Provenance: given by Dame Joan Evans P.P.S.A.
Collection: V&A. Inv. no. M92—1975.

118 Miniature Case
Gold enamelled in white and translucent red and green; set with table-cut diamonds. Height: 7.6 cm.

The lid with CAR in monogram beneath a crown, two Ss and interlaced Cs, all closely set with diamonds. The inside of the lid hatched with addorsed C-scrolls and stylised foliage. The reverse enamelled red with a double A beneath a crown and three Ss around it in white enamel.

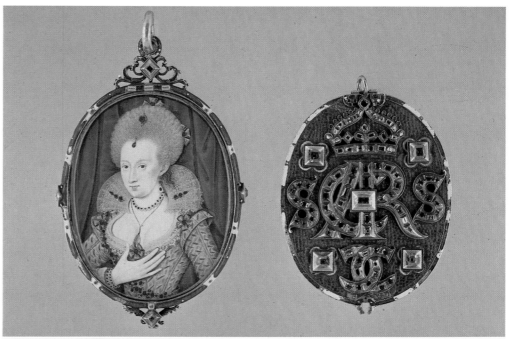

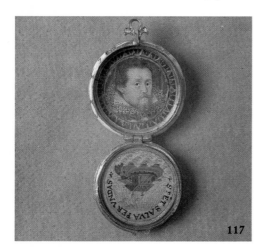

117

118

The miniature of Queen Anne of Denmark, Consort of James I is very close to the work of Nicholas Hilliard (1547-1619), but not actually by him. This makes it very unlikely that the jewel actually belonged to Anne, but it may have been a present from her to a courtier. Her costume dates it to around 1610 to 1615. The monogram on the front incorporates her initial with C for Charles IV, King of Denmark, her brother, and R for Rex and Regina. The S alludes to her mother Sophie of Mecklenburg. Jewels in the shape of C and S can be seen in the portrait of her by Van Somer (cat. no. P21) where she wears them in her ruff. [A.SC.]

Provenance: Earl of Eglinton & Winton Coll. (Christie's July 13th, 1922 lot 77). Bequeathed by L. D. Cunliff 1937.
Literature: *B.F.A.C. Exhibition of late Elizabethan art* 1926, case II, no. 14, pl. XXIII; *Treasures of Cambridge*, Goldsmiths' Hall (London 1959) no. 333; Evans (1970) pl. 103 a&b.
Lent by the Syndics of the Fitzwilliam Museum, Cambridge.

119 Necklace (*see* p. 16)
Enamelled gold in white, opaque pale blue, translucent red, blue and green; set with table-cut rubies, diamonds and pearls. Length: 44.2 cm.

The pendant consists of FB in monogram, on an anchor and beneath a coronet. The reverse is enamelled white, translucent red, green and blue, and bears the inscription HOVP.FEIDIS.ME. (Hope feeds me). The anchor, of course, is a symbol of Hope, and so reinforces the motto. The chain is made up of knots and addorsed Cs or perhaps sickle moons.

There is no doubt that the inscription is in Scottish, but this does not necessarily mean that the necklace was made in Scotland. With the accession of James VI of Scotland to the English throne in 1602, a large Scottish element entered Court life in London and this necklace may well have been made there for a Scottish client. A contemporary portrait at Berkeley Castle shows the wife of Sir Robert Shirley wearing a long chain with a monogram pendant closely set with stones like those in this necklace and pendant.

In technique this presents a number of similarities with the locket in the Fitzwilliam Museum, Cambridge, (cat. no. 116). Apart from the generic similarity of the knots on both, and of the table-cut rubies, the locket also has stones with settings surrounded by globules of pale blue enamel. The palette of enamel colours on the reverse is identical and the pendant and lid of the locket have the same slightly crude construction with flattened rivets holding the parts together. The Fitzwilliam locket can be grouped with two other English lockets, because of its translucent enamelling over a diapered ground, one containing a portrait of King James I (cat. no. 117) and the other, a miniature by Peter Oliver (V&A. Inv. no. 117—1888) and it is highly likely that they all stem from the same workshop. [A.SC.]

Provenance: S. J. Phillips Limited, London; R. W. M. Walker Collection; Melvin Gutman Collection (Sotheby's Parke Bernet, 24th April 1969, lot 115). Thyssen-Bornemisza Collection.
Literature: M. L. d'Otrange, 'A collection of Renaissance Jewels at the Art Institute of Chicago', *Connoisseur* (September 1952) p. 69, ill. p. 71; Parker Lesley, *Renaissance Jewels and Jeweled Objects* (Baltimore, 1968) no. 52.
Collection: Thyssen-Bornemisza Collection.

120 The Cheapside Hoard (*see also* p. 25)
A selection of late Elizabethan and Jacobean jewellery and associated finds; enamelled gold and gem-stones.

Chains: of the thirty-five in the Hoard, nine have been selected:
a) Chain, gold, links of alternate flowers and leaves, enamelled white and green. Length: 159.6 cm. (British Museum. 1914, 4-23, 1.)
b) Chain, gold, links alternately quatrefoils in white enamel with blue centres, and double-corded rings. Length: 55.8 cm. (British Museum. 1914, 4-23, 2.)
c) Chain, of rings of fancy-cut amethysts, alternating with rose-cut crystals, set in gold. Length: 13.2 cm. (Museum of London. A 14074.)
d) Chain, gold, enamelled and set with pearls and trap-cut rubies. Length: 18.1 cm. (Museum of London. A.14204.)
e) Chain, gold, alternate leaves and flowers, enamelled white and green. Length: 20.5 cm. (V & A.)
f) Chain, gold, alternate roses and bows, divided by leaves, enamelled white and green. Length: 21.5 cm. (V & A.)
g) Chain, gold, white enamelled flowers, and set with cabochon and trap-cut emerals. Length: 17.5 cm. (V & A.)
h) Chain, gold scroll-work, set with turquoises, table-cut diamonds and rubies. Length: 21.5 cm. (V & A.)
j) Chain, gold enamelled, white knots alternating with interlacing links. Length: 120 cm. (V & A.)

Finger-rings: of the forty-eight finger-rings in the Hoard, twelve have been selected:
a) Finger-ring, gold, bezel set with paste intaglio of Roman origin(?) engraved with a seahorse. Height: 2.1 cm. (Museum of London. A.14242.)
b) Finger-ring, gold, small circular bezel set with seven cabochon emeralds, Diameter: 2.0 cm. (British Museum. 1914, 4-23, 9.)
c) Finger-ring, gold, circular bezel set with cabochon emeralds (two missing), the hoop and back enamelled. Diameter: 2.3 cm. (British Museum. 1914, 4-23, 10.)
d) Finger-ring, small circular bezel set with seven fancy-cut garnets, the hoop and back enamelled. Diameter: 2.0 cm. (British Museum. 1912, 7-24, 5.)
e) Finger-ring, similar to last. (British Museum. 1914, 4-23, 12.)
f) Finger-ring, gold, circular bezel set with nine cabochon emeralds, part of hoop enamelled.

Diameter: 2.3 cm. (British Museum. 1914, 4-23, 13.)
g) Finger-ring, gold, circular bezel set with nine cabochon emeralds (three missing), hoop and back enamelled. Diameter: 2.4 cm. (British Museum. 1912, 7-24, 4.)
h) Finger-ring, gold, circular bezel set with six fancy-cut sapphires (one missing), and a central pearl. Diameter: 2.3 cm. (British Museum. 1914, 4-23, 11.)
j) Finger-ring, gold, oval bezel set with a cat's eye. Diameter: 2.2 cm. (British Museum. 1914, 4-23, 14.)
k) Finger-ring, large flat bezel set with a table-cut emerald surrounded by eight cabochon emeralds (one missing), back and part of hoop enamelled. Diameter: 2.3 cm. (British Museum.1912, 7-24, 3.)
l) Finger-ring, enamelled; bezel set with a table-cut diamond. Diameter: 2.4 cm. (Museum of London. A.14244.)

Pendants, including ear-rings(?), fan-holders, hair-ornaments(?), reliquaries and crosses. Of the eighty-three pendants in the Hoard, eighteen have been selected:
a) Pendent reliquary, gold, hinged on one side; the band is enamelled white with the emblems of the Passion. Obverse: set with a bloodstone engraved with the Head of Christ wearing the Crown of Thorns in profile and encircled by the inscription: EGO SUM VIA VERITAS ET VITA. Reverse: Head of the Virgin in profile encircled by the inscription: MATER JESU CHRISTI; the loops above and below are set with table-cut diamonds. Height: 3.8 cm. (Museum of London. A.14011.)
b) Pendant, gold; reverse *cloisonné* enamelling in white and green of a stylised floral motif. Obverse set face-inwards in the pendant, a crystal cameo of Byzantine or early medieval date, representing the Incredulity of Thomas. Both sides of the cameo have been cut subsequently which resulted in the mutilation of the Greek inscription which only remains visible on other parts of the stone.
Above the figures are the letters:
IC X/--- ΛΑΨH
Behind St. Thomas are the letters:
Φ H C I C T O
and between the figures are:
X θ ω MA
The first letters (signifying Jesus Christ) and the last (Thomas) are reasonably legible, but no satisfactory completion or explanation of the others has yet been offered.

The gold pendant is suspended from a thin gold rod and a large pearl. Height: 5.9 cm. (Museum of London. A.14158.)
c) Pendent ear-ring(?), comprising two fancy-cut amethysts with gold links. Length: 5 cm. (Museum of London. X.9.)
d) Pendant, gold; obverse set with a hollow cabochon garnet encircled by fifteen star-cut garnets; reverse enamelled and from the lower loop, a gold enamelled flower and attachment for a pendent pearl (now missing). Length: 4 cm. (Museum of London. A.14016.)
e) Pendant, gold; obverse set with a cabochon

carbuncle, foiled; reverse enamelled in white and green; suspended from a pendant ring of floral design. Length: 4.2 cm. (Museum of London. A.14015.)

f) Pendant, gold, in the form of a bow, set with fancy-cut and trap-cut rubies and table-cut diamonds. Width: 5 cm. (Museum of London. A.14100.)

g) Pendant, gold, pear-shaped, openwork set with pearls in alternate rows of small and large settings (nearly all the larger pearls missing), with an upper spray of six pearls (four missing). Height: 5.6 cm. (British Museum. 1914, 4-23, 16.)

h) Pendant, similar to last, but without upper spray. Height: 6.1 cm. (British Museum. 1914, 4-23, 15.)

j) Pendant, gold, of three white enamel links with ten rose-cut amethyst drops (*briolettes*). Height: 6.4 cm. (British Museum. 1914, 4-23, 6.)

k) Pendant, pairing with last. Height: 6.6 cm. (British Museum. 1914, 4-23, 7.)

l) Pendant, similar to the last, missing the three large central amethyst drops. Height: 6.5 cm. (V & A Museum).

m) Pendant, gold, with white enamel, set with a cabochon garnet and having a pendant water-sapphire (iolite) rough-polished. Height: 4.1 cm. (British Museum. 1912, 7-24, 2.)

n) Pendant of amethyst set in gold and carved in the form of seven bunches of grapes (two missing), arranged in two rows of triple branches. Height: 4.1 cm. (British Museum, 1914, 4-23, 8).

o) Pendant; similar to last, composed of six bunches of grapes. Height: 5 cm. (V & A Museum).

p) Pendent fan-holder(?), gold, enamelled in green and blue, and made in the form of a lotus flower. Length: 5.1 cm. (British Museum. 1914, 4-23, 4.)

q) Pendent fan-holder(?), of white enamelled gold set with eleven cabochon emeralds on each side, and made in the form of a flower. Length: 6.1 cm. (British Museum. 1914, 4-23, 3.)

r) Pendent fan-holder(?) of gold enamelled in white, green and amber, and made in the form of a caduceus. Length: 5.6 cm. (British Museum. 1912, 7-24, 1.)

s) Pendant, in the form of a cross, gold, with rose-cut amethysts and, on reverse, enamelling. Length: 4.8 cm. (Museum of London. G.M. 33.)

Hat ornaments: of the six found in the Hoard, four have been selected:

a) Gold, set with six foiled and rose-cut amethysts and seven diamonds, the central rose-cut and the others modified rose-cut; reverse enamelled in white. Length: 2.6 cm. (Museum of London, A.14082).

b) Gold, set with foiled amethysts, flat and rose-cut; reverse, white enamelled. Length: 2.8 cm. (Museum of London. X.4.)

c) Gold, set with table-cut diamonds. Height: 3 cm. (Museum of London. A.14096.)

d) Gold, enamelled, in the form of a salamander, and set with cabochon emeralds and table-cut

120

120

diamonds. Length: 4.5 cm. (Museum of London. A.14125.)

Hair-pins: of the two found in the Hoard, both have been included:

a) Gold, in form of a shepherd's crook, enamelled, the head set with table-cut rubies and diamonds. Length: 8.9 cm. (Museum of London, A.14124.)

b) Gold, enamelled, the head set with a large table-cut topaz flanked by four rose-cut diamonds. Length: 5.9 cm. (Museum of London, A.14164).

Buttons: of the thirty-three buttons found in the Hoard, five have been selected:

a) Button, gold, enamelled in white, blue and green, in the form of a 5-petal rosette. Diameter: 2.0 cm. (British Museum, 1914, 4-23, 5).

b) Button, gold, enamelled in white and blue (traces only) set with four table-cut rubies and a central diamond (missing). Diameter: 1.3 cm. (British Museum, 1914, 4-23, 19).

c) Button, similar to last, but one ruby and setting missing. (British Museum, 1914, 4-23, 18).

d) Button, similar. (British Museum, 1914, 4-23, 17).

e) Button, similar. (British Museum, 1914, 4-23, 20).

Cameos: of the twelve unset cameos found in the Hoard, four have been selected:

a) onyx, bust of 'Cleopatra', attributed to an Egyptian workshop in the Augustan period of the Roman Empire. Length: 2.7 cm. (Museum of London, A.14271).

b) onyx, bust of Elizabeth I (reigned 1558-1603). Length: 1.7 cm. (Museum of London, A.14063).

c) onyx, fable of the dog and the reflection in the water. Length: 3.8 cm. (Museum of London A.14266).

d) onyx, profile bust to right of unknown man with beard. Length: 2.5 cm. (Museum of London, A.14022).

Intaglios: of the eight unset intaglios, two have been selected:

a) carnelian; female figure, perhaps Minerva, with helmet and shield on the ground and holding a leafy branch. Length: 3.2 cm. (Museum of London, A.14270).

b) amethyst; profile head wearing laurel wreath, perhaps Domitian. Length: 1.7 cm. (Museum of London, A.14257).

Pastes: of the five unset gems of paste found in the Hoard, two have been selected:

a) blue paste oval medallion; half-length figure of St. John the Evangelist, with Eagle, against a rocky landscape in low relief. Length: 4.7 cm. (Museum of London, A.14277).

b) blue paste oval medallion; Christ scourged, reproduced from the medal by Antonio Abondio (1538-1596). Length: 4.2 cm. (Museum of London, A.14278).

Scent-bottle and suspension chain: gold, enamelled in white with enamel colours painted on top, set with four opaline chalcedony plaques engraved with a herring-bone pattern, and with table-cut and trap-cut rubies, topaz and diamonds. Height: 5.6 cm. (Museum of London, A.14156).

Watches: of the two watches found in the Hoard, both are included:-

a) set in a single large emerald of hexagonal form, the movement and dial-plate are so corroded and embedded that it cannot be opened on its hinge; gold dial is enamelled green and the gold suspension loop set with small emeralds and white enamel. Length: 4.2 cm. (Museum of London, A.14162).

b) an alarm watch which strikes the hours and quarters and records the following astronomical information: the age and phase of the moon, the day of the week, the date of the month and the month of the year, together with the appropriate sign of the Zodiac and the season of the year. The hours are indicated according to the dual system (1-12 in Roman numerals and 13-24 in Arabic numerals); the separate dial indicating the quarters encloses a minute dial (1-60), which is a most exceptional feature rarely found on watches

before the middle of the seventeenth century. Length: 7.5 cm.

The dial-plate of gold is richly ornamented with Renaissance motifs executed in translucent and opaque enamels, but the movement was, until recently, solidly embedded within the gilt-metal pierced case and no description of the mechanism could previously be made. The delicate process of conservation, carried out in the Horological Students' room workshop at the British Museum, succeeded in releasing the movement from the case and restoring much of the corroded mechanism to view. In cleaning the back-plate of the movement, the maker's signature was revealed:

G. Ferlite. This maker is recorded as a resident of Geneva from 1599-1633, having probably sought refuge there in 1599.

This watch is probably the product of his last period, c1630, since it contains a horologically complicated and finely executed mechanism, that is more likely to date from the second quarter of the seventeenth century than from the first decades. In the period of his working life in Geneva from 1599-1633, this watch would have ranked among the finest achievements of watch-making, illustrating the craft at its most advanced and its most ambitious (for a full discussion of this watch and its horological significance, see Hugh Tait's forthcoming account in *The Horological Journal*).

Condition: variable but generally good; some loss of enamel in places and a corrosion of base metal, especially in the watches.

This Hoard is the most important source of our knowledge of Jacobean jewellery in England, because there can be little dispute that most of the jewellery dates from the first three decades of the seventeenth century.

The jewellery typifies the change towards a lighter style in which faceted stones were suspended swinging within thin, almost flimsy, settings. The diamonds are mainly table-cut but many of the coloured gem-stones are faceted *briolettes* and there are examples of flat rose-cutting. However, the continued use of cabochon gem-stones is apparent and many of the smaller ones are grouped in clusters within an enamelled setting.

Enamelling is profusely used to enrich the effect and the colours are light and gaily delicate, with many backgrounds in a white enamel. The very varied chains illustrate the fashion for delicate enamelled flowers linked by small gem-stones. The enamelling is rarely of very high quality but is clearly of English origin, revealing very little influence from abroad.

Perhaps the most interesting aspect of the Hoard is the range of engraved gems and the fashion for cameos at this period. Not only Renaissance examples but also ancient and medieval engraved gems and glass pastes are in the Hoard, many without mounts but others still in their original settings. Perhaps the most unexpected carved stones are the amethyst grapes

hanging in bunches from gold enamelled ear-rings(?) and the tiny carved figures of birds and animals. Equally rare and unexpected is the gold pendant scent-bottle with its combination of enamelled decoration and plaques of carved opaline chalcedony.

The miscellaneous nature of the Hoard and the many unmounted gem-stones have led to the Cheapside Hoard being accepted as the stock of a jeweller but as yet there is no conclusive evidence in support of this interpretation. However, the date of the deposit appears to be little earlier than the Civil War, since some of the items can be dated on grounds of style to the second quarter of the seventeenth century. [H.T.]

Provenance: Found in 1912 when a house was being pulled down between St. Paul's Cathedral and the Post Office. The major portion of the Hoard is preserved in the Museum of London; a further selection at the British Museum and seven items at the Victoria and Albert Museum.

Literature: Joan Evans, (1921), pp. 112-4, pl. XXI; *The Cheapside Hoard of Elizabethan and Jacobean Jewellery*, London Museum Catalogues: No. 2 (1928); *Exhibition of Gemstones and Jewellery*, City Museum and Art Gallery, Birmingham (1960); Hugh Tait in *The Great Book of Jewels*, edited by Ernst and Jean Heiniger (Lausanne, 1974), p. 170; Hugh Tait in *Jewellery Through 7000 Years*, British Museum (1976), no. 296, p. 180ff.

121 Memento Mori Pendant

Gold with black and white enamel. Height: 5.8 cm.
Condition: a corner of the sarcophagus broken, the enamel, especially on top, much worn.

The sarcophagus unscrews to reveal a white enamelled skeleton, the initials I.G.S. above its head and the inscription HIE.LIEG.ICH.VND. WARTH.AVF.DIH (Here I lie and wait for you). The inscription indicates that this is a German jewel, probably from the first half of the 17th century

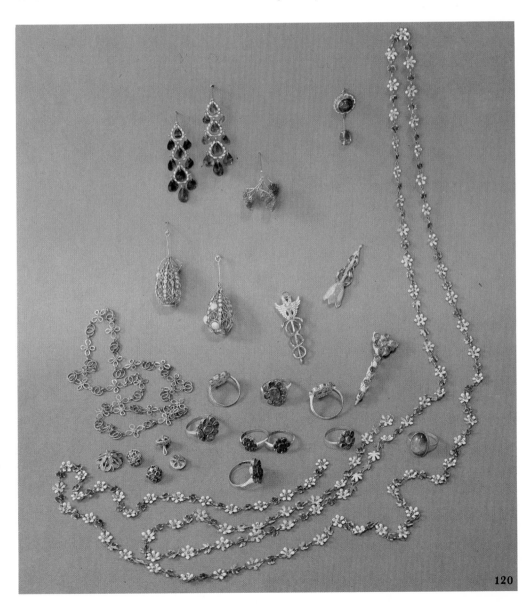

120

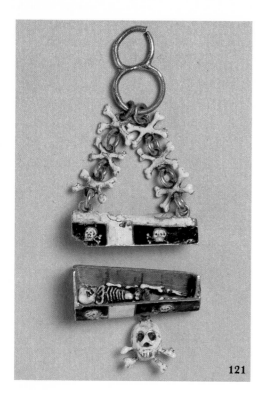

121

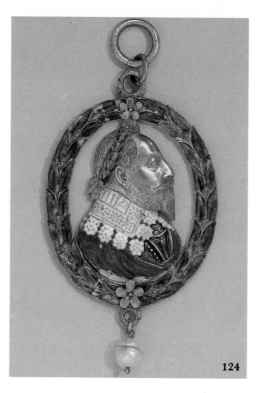

124

because of the use of painted enamel on the skulls at the sides. It is of much lower quality, and of a more popular nature than the Tor Abbey Jewel (cat. no. 13).

Provenance: Given by Dame Joan Evans P.P.S.A.
Literature: Evans (1970) ill. 125.
Collection: V&A. Inv. no. M74—1975.

122 Ring of Bishop Marquard von Eichstatt
(*see* p. 46)
Gold enamelled in black, white and red. Diameter: 2.1 cm.

South Germany, 1636. Plain golden hoop with black enamelled inscription: MARQUARDUS + D + G + EPS: EYSTET. Enamelled and engraved arms with a crozier. Inside the hoop the black enamelled inscription: IN + DEO + MEO + 1636. Marquard Schenk of Castell was the Bishop of Eichstätt 1636-1685. A similar, though rimless, ring with the same inscriptions is also in the Bayerisches Nationalmuseum, Inv. no. R 2211. [I.H.]

Collection: Bayerisches Nationalmuseum Inv. no. R 2211a.

123 Memorial Ring set with a cameo of Gustavus Adolphus (*see* p. 72)
Gold with black and light blue enamel set with an agate cameo. Diameter: 1.7 cm.
Condition: the agate considerably worn.

German, *c*1632 (*see* cat. no. 124). The shoulders with enamelled ornament in the style of Daniel Hailer (*see* A. Hämmerle, 'Daniel Hailer', *Das Schwäbische Museum* (1931) p. 42 ff.) On the convex reverse of the bezel there is a black and light blue ornament in the style of Daniel Hailer. The shape of the shoulders and the ornament relate to seal rings in the Jewellery Museum in Pforzheim (*see*, *Ringe aus vier Jahrtausenden. Aus der Sammlung Battke im Schmuckmuseum, Pforzheim*, (Frankfurt/M 1963) p. 28, no. 39) where they are described as German, around 1620. [I.H.]

Collection: Bayerisches Nationalmuseum Inv. no. R2212.

124 Pendant
Gold enamelled in opaque green, white, blue, light blue and red. Height: 8 cm.
Condition: slight loss of enamel.

Enamelled gold medal of, obverse: Gustavus Adolphus, lion rampant, standing on a crowned figure with cross and staff. In its right paw a sword, the left on a book with '*Pro Lege et Grege*' (For the Law and the Flock). In the sky to the right the sun in splendour; on the left G(*ustavus*) A(*dolphus*): on the right R(*ex*) S(*uedorum*).
Gustavus Adolphus, born 1694, King of Sweden 1611-1632, died 1632, was the son of Charles IX and Queen Christine (*see* cat. no. 126 for their burial regalia). He became renowned, during a time of bitter political and religious division, as a military commander and champion of the Protestant princes of Northern Europe against the Catholic emperor, who, by his military victories, was threatening to destroy the balance between the two faiths in Europe. Gustavus Adolphus won a famous victory at Lutzen, but died in the course of the battle. This led to a large number of commemorative medals, pendants, necklaces and even beakers, being made at a variety of centres in protestant Germany. Here a medal by the German, Sebastian Dadler (1586-1657), is used. From 1621 to 1630 Dadler was court medallist at Dresden and thereafter he moved via Nuremberg to Berlin. It is uncertain where the enamelled mount was executed, but it might have been in Nuremberg, which had placed itself under Gustavus Adolphus's protection during the Thirty Years War. Other examples of this medal, all with different reverses to this one, are in Rosenborg Castle, Copenhagen, Frederiksborg Castle, Hillerod and the Coins and Medals Collection of the National Museum, Copenhagen.

Provenance: Count K. Pejaksevich; Eugen Gutmann Collection; Dr F. Mannheimer Collection, Amsterdam.
Literature: O. V. Falke, *Catalogue of the Gutmann Collection* (1912) no. 17, pl. 7; R. v. Luttervelt, 'Een medaillon met het portret van Gustaaf Adolf', *Bulletin Rijksmuseum* (1954) pp. 21-22.
Collection: Rijksmuseum, Amsterdam. Inv. no. RBK 17190.

125 The Szczecin Jewels
The bombing of Szczecin (Stettin) in the Second World War opened up the burial vaults in the ducal castle of the Dukes of West Pomerania. Francis I, Duke of Szczecin and West Pomerania was found lying in his coffin with all his orders and jewels about him. Unlike the Palatine Wittelsbachs at Lauingen (*see* cat. no. 75) he was laid to rest with his best pieces, which he had also worn when being painted. A similar quantity of jewels, with an even greater profusion of orders, a portrait medallion, two rings and a hat jewel were found on the body of the contemporary young Duke Albrecht of Holstein who died in 1613 at Dresden, and was buried in the Kreuzkirche there.

Francis I was born in 1577, the son of Bogusl aw XIII and Clara, daughter of the Duke of Braunschweig-Luneberg. In 1610 he married Sophia, daughter of Elector Christian II of Saxony. In 1618 he succeeded to the Dukedom, and in 1620 he died. Pomerania's political and dynastic links were with Saxony and North Germany, and the obvious sources of its non-indigenous luxury goods were Dresden and Hamburg.

All pieces from National Museum, Szczecin.

125a Order of Loyalty to the Emperor (A)
Gold enamelled in white, black, translucent red, blue and green. Made by Hans Durr *c*1601. Height of pendant: 12 cm.
Condition: the dependent pearl missing from the bottom and slight enamel loss.

The chain is formed of thirty openwork oval links. Half are enamelled with the arms of the provinces under the Elector of Saxony, while the other half have the initial C for Elector Christian II (1601-1611). The pendant has on the obverse the Eye of God over the arms of Saxony, and the

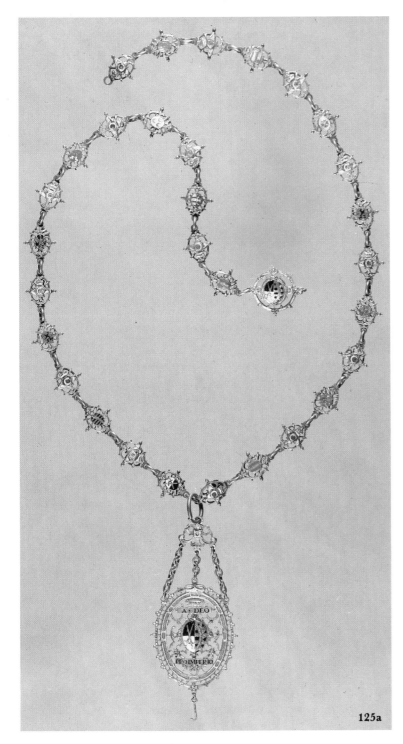

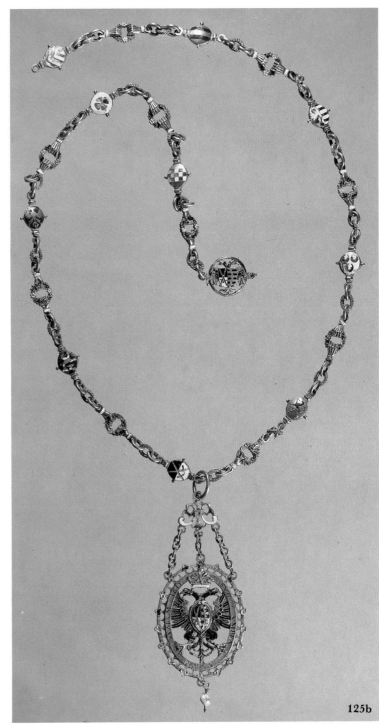

125a

125b

inscriptions TIME DEVM (fear God) above, and below A DEO/PRO IMPERO (from God and for the Emperor). Reverse: the sun, symbolic of the Emperor, surrounded by six stars, the six Electors, and the inscriptions TIME DEVUM (Fear God) and HONORA CAESAREM (Honour Caesar).

The Order of Loyalty to the Emperor was founded by Christian II in the year of his accession and this may be one of the five chains for which the court goldsmith, Hans Durr, was paid on 16th October 1607—see E.v. Watzdorf,

'Gesellschaftsketten und Kleinode Anfang des XVII Jahrhunderts,' *Jahrbuch der preussischen Kunstammlungen* LIV (1933) pp. 169-170. Duke Albrecht of Holstein (d. 16.3) was also buried wearing one of these orders (Dresden, Town Museum). For a list of other surviving orders of this type *see* E.v. Watzdorf, p. 173, note 2.

125b Order of Loyalty to the Emperor (B)
Made *c*1611 by Gabriel Gipfel.
Gold enamelled in white, black, translucent red,

blue and green; the pendant hung with a pearl. Height of pendant: 12 cm.
Condition: the pendent pearl is decayed and some of the enamel is missing.

The chain is formed of pairs of hands clasping wreaths, and the links are enamelled with the arms of the various provinces of Saxony. The pendant has, on the obverse, the double-headed imperial eagle with the arms of Saxony on its chest surrounded by the inscription SVB.VMBRA.

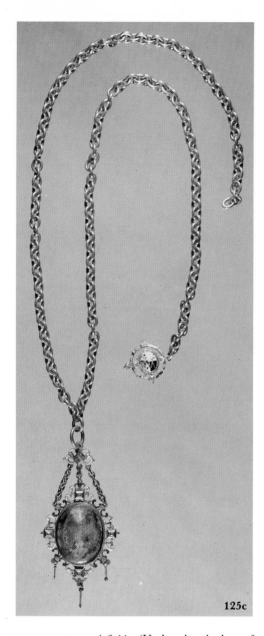

125c

August 1612 thirty-two chains of order were given away, first to the other imperial Electors of Mainz, Trier and Cologne. Each cost 124 fl—*see* E. von Watzdorf, 'Gesellschafts-Ketten und Kleinode vom Anfang des XVII Jahrhunderts,' *Jahrbuch der preussichen Kunstammlungen*, pp. 178-9. The Electors of Saxony had special cause to be grateful to Emperor Rudolph II who granted them rights over Julich, Cleves and Berg in July 1610.

Literature: B. Kopydlowski, 'Goldsmithswork', *Decorative Arts Gifts and purchases 1945-1964, National Museum, Warsaw Catalogue* (1964) p. 60, cat. no. 186 a, b, ill. 29; Z. Krzymuska-Fafius, 'Studies in the History of the Jewels and Costumes of the Dukes of Szczecin' in *Decorative Arts in Poland* (Warsaw, 1976) pp. 57-86, ills. 14, 15.
Inv. nos. MNS/Rz 2565 & 2564.

125c Chain with Pendent Miniature
Gold with white, black, translucent blue and green enamel; set with table-cut diamonds and rock crystal. Height: 12 cm.
Condition: the portrait miniatures and dependent pearls destroyed.

The clasp bears the arms of the Elector of Saxony. In the 17th century this, like the previous two chains, would have been called a *Gesellschaftskette* i.e. brotherhood chain, and indeed, it has the same clasp as order (A). A very similar chain, also with this clasp, and with miniatures on copper of Christian II of Saxony and his wife Hedwig of Denmark (1581-1641), was found on the body of Duke Albrecht of Holstein and is in the Kunstgewerbemuseum, Berlin. Gabriel Gipfel was paid for numerous chains with miniature pendants between 1607-1611, some of them set with diamonds and some with rubies, (*see* E.v. Watzdorf, p. 174).

Literature: B. Kopydlowski, p. 60, cat. no. 187; Z. Krzymuska-Fafius, pp. 57-86, ill. 11.
Inv. no. MNS/rz 2563.

125d IHS Monogram Pendant
Gold with white and blue enamel, set with table-cut diamonds or white sapphires. Height: 3.8 cm.
Condition: some stones missing, and the enamel damaged; the dependent jewel missing.

Stylistically related IHS monogram pendants

125g 125e

occur in the Jacob Mores design book (for example, fol. 4; *see* cat. no. G35) with gem-set letters surrounded by enamelled scroll-work, about 1600.

Literature: Z. Krzymuska-Fafius, pp. 57-86, Inv. no. MNS/Rz 2562.

125e Marriage Ring
Gold with black enamel. Diameter: 2.8 cm.
Condition: the stone is missing and the enamel is damaged.

Cast and chased with two clasped hands at the base of the hoop. This was presumably made on the occasion of Duke Francis's marriage to Sophia of Saxony in 1610.

Literature: Z. Krzymuska-Fafius, pp. 57-86.
Inv. no. MNS/Rz 2571.

125f Seal Ring *c*1618
Gold, set with an octagonal ruby (?). Diameter: 2.1 cm.

The stone is engraved with the arms of the Dukes of West Pomerania and Stettin, and the partly defaced inscription FRANCISCVS STET . . . This must date from around 1618 when Francis succeeded as Duke.

Literature: Z. Krzymuska-Fafius, pp. 57-86.
Inv. no. MNS/Rz 2570.

125g Ring
Gold, set with a turquoise. Diameter: 3.2 cm.

Literature: Z. Krzymuska-Fafius, pp. 57-86, ill. 12.
Inv. no. MNS/Rz 2569.

125h Chain
Gold. Length: 109 cm.

Literature: Z. Krzymuska-Fafius, pp. 57-86, ill. 9.
Inv. no. MNS/Rz 2560.

125j Chain (fragment of)
Gold. Length: 36 cm.

Literature: Z. Krzymuska-Fafius.
Inv. no. MNS/Rz 2559.

125k Pair of Bracelets 1596
Enamelled gold. Length: 25.3 cm.
Condition: only the blue enamel remains.

The arms of the Dukes of West Pomerania appear on both clasps. V(on). G(ottes). G(naden). FRANTZ-H(erzog). Z(u). S(tettin). POM(mern).
 On the reverse: V(on). G(ottes). G(naden). CLARA G(räfin). B(raunschweg). u(na). L(uneberg). H(erzogin) Z(u). S(tettin). PO(mmern) 1596. These were given by Francis I to his mother, Clara of Braunschweig-Luneberg, who died in 1598.

Literature: B. Kopydłowski, p. 71; cat. no. 240; Z. Krzymuska-Fafius, pp. 57-86, ill. 10.
Inv. no. MNS/rz 2561.

ALARUM.TVARVM.1.6.11. (Under the shadow of your wings). On the reverse is the eagle with flowers on its chest, and PRIVS.MOR.QVAM.FIDEM. FALLIERE (Sooner to die than betray the Faith).

This order was founded in 1611, the year of his accession, by Elector Johann Georg I of Saxony, Duke Francis's brother-in-law. It was made by Gabriel Gipfel, the Nuremberg goldsmith who moved to Dresden in about 1590 and became court goldsmith to the Electors of Saxony. He died in 1617.

Another identical chain of type (A) is in the Kunstgewerbemuseum, Berlin, and was found in Duke Albrecht of Holstein's tomb (d. 1613). These chains were not true orders in the sense of the Order of the Garter or of the Golden Fleece, but rather more like livery chains, that is, given away by the Dukes of Saxony as a mark of favour, and worn in token of friendship or allegiance. For example, between 25th August 1611 and 25th

125k

125l Rosettes (possibly hat jewels)

Gold with white, black, opaque blue, green and translucent red enamel; set with table-cut diamonds. Width: 4.2 cm.
Condition: the enamel slightly damaged.

These may come from the same workshop as the aigrettes, as the patterns on the white-enamelled scrolls resemble each other closely.

Literature: Z. Kryzymuska-Fafius, pp. 57-86, ill. 7.
Inv. no. MNS/Rz 2567.

125m Hat Jewels (see p. 24)

1) Seven jewels. Gold enamelled in white, black, translucent red, opaque blue and green; set with table-cut diamonds. Width: 5.5 cm. and 4.5 cm.
2) Six jewels. Gold enamelled in white, black, translucent red, opaque blue and green; set with table-cut diamonds and four pearls. Width: 4.2 cm.
Condition: on four of the rosettes the pearls have rotted away.

The beaver hats of the period were decorated with chains of rosettes like these around the crown, as well as the aigrettes on the side. The inventory of the Emperor Matthias, 1619, lists numerous hat jewels of this kind, such as cat. no. 69. When Sophia of Saxony married Duke Francis in 1610 her brother, Elector Augustus bought 95 diamond rosettes at three different prices. It is tempting to think that these are some of them. (E.v. Watzdorf, *Jahrbuch der preussischen Kunstsammlungen LIV* (1933), p. 85). These appear in a posthumous portrait of Francis I painted by M. Marwitz and illustrated in Z. Krzymuska-Fafius (see below).

Literature: B. Kopydłowski, p. 64, cat. no. 207; Z. Krzymuska-Fafius, pp. 57-86, ill. 8, 18.
Inv. no. MNS/Rz 2568.

125n Dress Jewels

1) Gold with opaque mid-blue enamel, set with pearls.
Condition: the pearls decomposing, and heavy loss of enamel.

There are similar dress jewels with enamelled enamel in flimsy *cloisons* combined with filigree among the pieces given to the Convent at Hall (cat. no. 72).

Literature: Z. Krzymuska-Fafius, pp. 57-86.
Inv. no. MNS/Rz 2557.

2) Gold with white, black and opaque mid-blue enamel. Width: 3 cm.
Condition: the filigree damaged. One gold bead lost.
Somewhat similar dress jewels can be seen on the shoulders of Duke Johann Friedrich (1542-1600), uncle of Francis, in his portrait by Giovanni Battista Perini of 1571 (ill. in Z. Krzymuska-Fafius, see below.)

Literature: Z. Krzymuska-Fafius, pp. 57-86, ill. 6, 26.
Inv. no. MNS/Rz 2555.

3) Enamelled gold, set with pearls (3)
Enamel colours: Gold with white and opaque mid-blue enamel, set with pearls. Width: 1.5 cm.
Condition: the pearls mostly lost and heavy

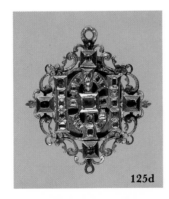

125d

125f

damage to the enamel and filigree. As above.
Literature: Z. Krzymuska-Fafius, pp. 57-86, ill. 13.
Inv. no. MNS/Rz 2556.

4) Gold with white enamel, set with table-cut and facetted point-cut diamonds. Width: 1.5 cm.
Condition: 1 diamond missing and the enamel damaged.
Literature: Z. Krzymuska-Fafius, pp. 57-86.
Inv. no. MNS/Rz 2558.

125o Strapmounts from a Sword Hanger and two Belt Toggles

Nielloed silver. Length (of strapmounts): 15 cm. Length (of toggles): 3 cm.
Condition: worn, with heavy loss of niello from the belt toggles.

These would have gone on the belt which supported Duke Francis's rapier. Similar decoration including the little birds and dense scrolling background can be found on powder flasks and rapiers in the Armoury at Dresden (see E. Haenel,

125j

125h

93

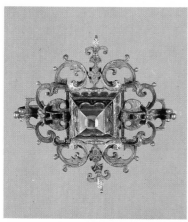
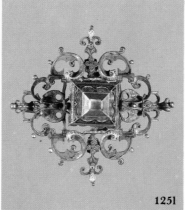

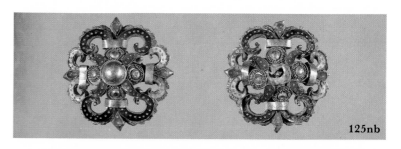

125l

125nb

125nc

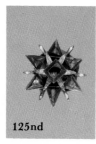
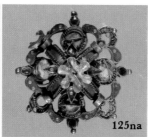

125nd

125na

Kostbare Waffen (Leipzig, 1923) p. 116, pl. 58b dated 1599). These were most probably made by a Saxon craftsman and date from about 1600-1620.

Literature: Z. Krzymuska-Fafius, pp. 57-86, ill. 24.
Inv. no. MNS/Rz 609.

125p Aigrette

Gold enamelled in white, black, translucent red, green and opaque mid-blue; set with table-cut and facetted point-cut diamonds and hung with a pearl. Height: 5.5 cm.
Condition: twenty diamonds are lost and the

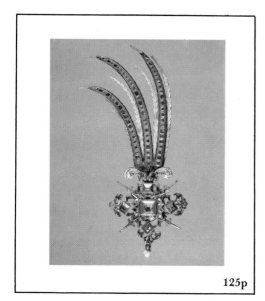

125p

spikes on the diagonals once had pearls threaded on them. Slight loss of enamel.

The portrait of Sigismund of Poland (cat. no. P27) shows an especially fine example of a beaver hat decorated with an aigrette. Francis I is shown wearing this one in his posthumous portrait of 1613 by Jan Leonius (ill. in Z. Krzymuska-Fafius, *see* below). Duke Albrecht of Holstein was buried with two aigrettes on his hat, one in the shape of a Roman trophy, the other in the shape of an oak leaf. E.v. Watzdorf, *op. cit.*, pp. 185-186. [B.J.&A.SC.]

Literature: B. Kopydłowski, p. 64, cat. no. 206, ill. 28. Z. Krzymuska-Fafius, pp. 57-86, ill. 8a, 19, 19a.
Inv. no. MNS/Rz 2566.

126 The Burial Regalia of King Charles IX and Queen Christine of Sweden

126a Crown

Gold, white and blue-black enamel, rock crystals, pearls. Height: 25 cm.
Condition: enamel damaged, pearls in poor condition, some details missing.

Eight large and eight smaller standards in cast, pierced work make up the ring, from which four arched pieces meet to support an orb surmounted by a cross. Adorned with enamelled ornaments, pearls and large rock crystals, table-cut and pointed.
 Charles IX, born 1550, King of Sweden 1600-11, died 1611, was the youngest son of Gustavus I (Vasa) of Sweden and his second consort, Margareta Leijonhufvud. For religious and political reasons he became opposed to his nephew Sigismund—simultaneously King of Protestant Sweden and Catholic Poland—and drove him out of the country, whereupon the *Riksdag* proclaimed Charles King of Sweden in 1600. After an eventful, strong reign he died in 1611 and was buried in great state in 1613 in the cathedral at Strängnäs in his former royal duchy of Södermanland. The crown was made by Antonius Groth, active in Stockholm as a goldsmith and mint-master 1599-1613. It was removed from the royal coffin in 1830.

126b Sceptre

Gold, white and blue-black enamel, rock crystals, pearls. Length: 71 cm.
Condition: enamel rock crystals somewhat damaged, pearls and some ornaments missing.

Gold sceptre with chiselled design and protuberances with table-cut rock crystals and pearls set in cut and enamelled floral ornaments. The sceptre was made by Peter Kempe, a goldsmith in Stockholm 1589-1621. It, too, was removed from the coffin in 1830.

126c Orb

Gold, white and blue-black enamel, rock crystals, pearls. Height: 17 cm.
Condition: pearls and stones missing, dented.

Gold orb with table-cut rock crystals and pearls alternating in enamelled leaf-rosettes on the horizontal band, and a vertical band with twelve closely arranged, table-cut rock crystals, crowned by a cross that is covered with ten table-cut rock crystals on the obverse and ornamented with dark-blue enamel on the reverse.

126d Crown

Gold with blue-black enamel. Height: 12.5 cm.
Condition: enamel damaged.

Four large and four smaller pierced standards in two rows make up the ring and are held together by eight arched pieces that support an orb crowned by a cross. The entire crown is covered with a pattern of flowers and scrollwork in black enamel and worked gold.
 Kristina the elder, born 1573, Princess of Holstein-Gottop, second consort of Charles IX of Sweden, died in 1625 and was buried in 1626 in the cathedral at Strängnäs. It was her son, Gustavus II Adolphus, who decreed that black enamel was to be the only ornament on her burial crown. The crown was removed from the coffin in 1830.

126e Sceptre

Gold with blue-black enamel. Length: 51 cm.
Condition: enamel damaged.

The sceptre covered all over with scrollwork in gold offset by black enamel, pierced knob with leaf ornament.

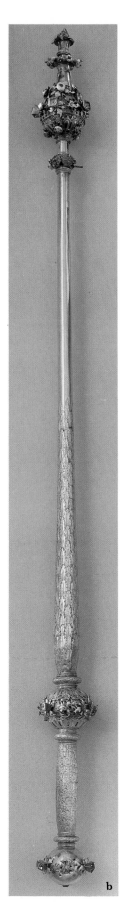

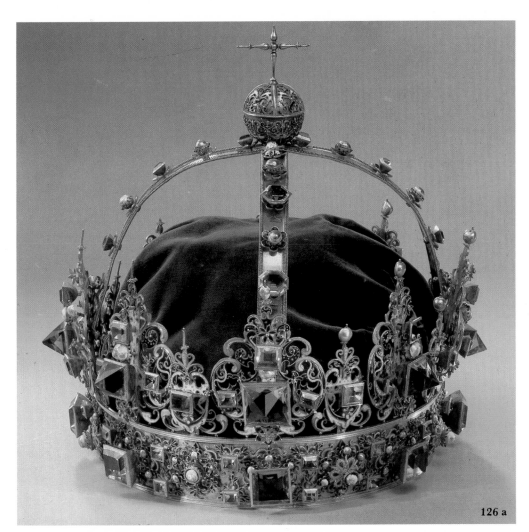

126 a

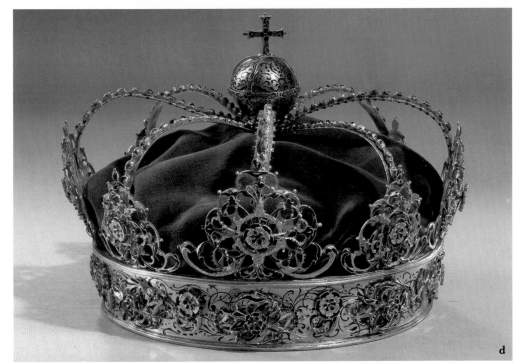

d

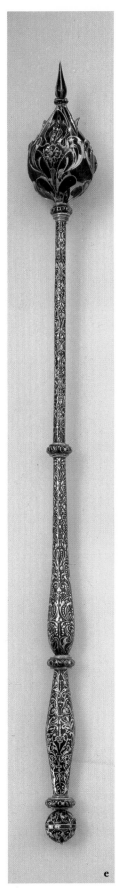

b

e

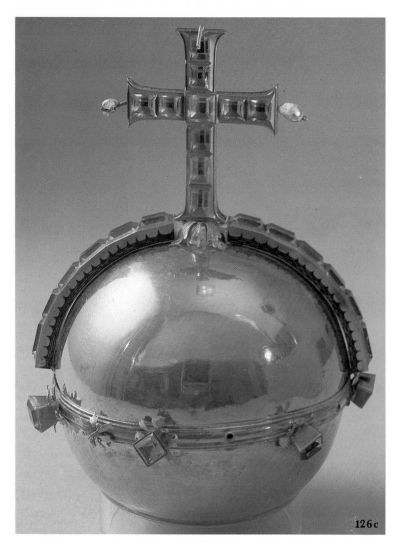

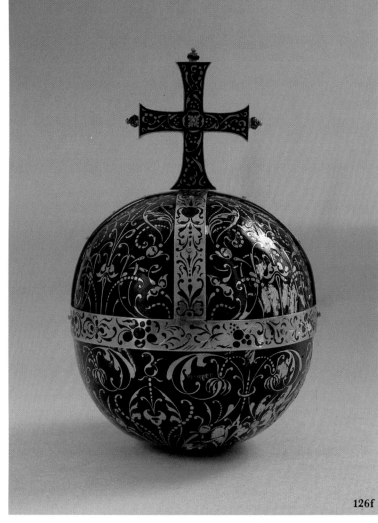

126c

126f

126f Orb
Gold with blue-black enamel. Height: 12.5 cm.
Condition: enamel damaged.

The orb crowned with a cross. The design in gold offset by black enamel, vice versa on the horizontal and vertical bands—*see* **d.** [K.H.]

Provenance: Strängnäs Cathedral, Sweden. Deposited in 1980 in the Royal Armoury (Livrustkammaren) at the Royal Palace in Stockholm, Sweden.
Literature: Lord Twining, *A History of the Crown Jewels of Europe* (London, 1960); R. Bennett, E. Bohrn, *Strängnäs domkyrka Gravminnen—Sveriges kyrkor, 159* (Stockholm, 1974); B. Hovstadius, *Brudkronor i Linkopings stift* (Lund 1976).
Lent by the Dean and Chapter of Strängnäs Cathedral, Sweden.

127 Insignia of the Order of the Garter
Gold enamelled in opaque white, opaque green, opaque light blue and opaque yellow; translucent dark blue, translucent green, translucent mauve, translucent red, and translucent bluish-green; set with diamonds and rubies, gold and silver thread

or fine chainwork on velvet. Length: 57 cm.

The Garter made from blue velvet terminating at one end with a gold strap-end and at the other end with a gold buckle-plate hinged to a gold buckle. Obverse: both the strap-end and the buckle-plate have a white enamel ground; the strap-end enriched with an *appliqué* gold openwork rosette and scrolls set with eleven table-cut diamonds, and the buckle-plate enriched with a cruciform design set with five diamonds (three table-cut and set in square collets and two facetted and set in petal-shaped collets). The tongue of the buckle is enamelled in red and white, the bow of the buckle is set with twelve diamonds. Attached to the velvet, the letters of the motto of the Order, + HONI + SOIT + QVI + MAL + Y + PENSE, each letter formed separately of gold enamelled in opaque white and translucent red, the 'spacers' between the words being formed by silver thread. The remaining length of the Garter is punctuated by five holes (for the tongue of the buckle), each enclosed by a gold flower with six petals alternately white and red enamel; the last three holes are enclosed by a double twisted silver thread looped around them. Along the entire

length of the velvet, above and below the motto, a border composed of a narrow row of twisted gold thread and wider band of fine gold chainwork. Reverse: the gold strap-end is enamelled in translucent green over an engraved Mannerist foliate design in the 'pea-pod' idiom; the buckle-plate and the buckle is similarly enamelled in translucent green over an engraved foliage design in the Mannerist style.
Condition: damage to enamel is mainly in those areas where friction is created when in use, for example, the back of the buckle and strap-end.

The Collar of the Order
Length: 150 cm. Obverse: twenty-five gold roses enamelled red, each contained within a blue-enamelled gold Garter with a red enamelled buckle, and twenty-five openwork gold knots, each terminating in four tassels. Four small gold loops (white enamelled or plain) project from each of these fifty elements and through them pass the plain gold rings that join the elements together to form a chain. A gold suspension ring and pendant-loop hang down from one of the 'rose-and-Garter' elements (for the Great George). The Motto of the Order on each Garter encircling a

red rose reads from left to right; on one Garter (the fourth to the right of the suspension loop for the Great George), the goldsmith has made an error and the motto reads: HONI:SOIT:QVI:Y:MAL:YENSE—and, even the last 'N' is upside down. Reverse: the 'rose-and-Garter' elements are undecorated except for narrow bands of blue enamel indicating where the Garter beyond the buckle is looped behind before being threaded through to hang down vertically.

Condition: one of the twenty-six roses and one of the twenty-six knots (to correspond with the number of the Knights companions of the Order) are missing. It was under Henry VIII that the material and precise form of the Collar were regulated. Three of the 'rose-and-Garter' elements seem to be later replacements; they can most readily be identified, on the obverse, by the larger form of lettering and the use of a cruciform 'spacer' between the words and, on the reverse, by the slightly different form of construction and distinctly more regular finish. Furthermore, the suspension ring and pendant seem to be of a later date and, for some unknown reason, were not added to the 'rose-and-Garter' element already fashioned with a loop for this purpose—the sixth one to the left of the present suspension ring and pendant. Finally, variations in the size and workmanship of the gold knots suggest that some may be replacements.

The Great George

Height: 7.2 cm. Enamelled gold, modelled in the round. St. George, with beard and moustache, wears a helmet and suit of armour enamelled in blue and set with eight diamonds (six table-cut, one pyramidal and the large one on the chest five-sided and facetted within a gold enamelled shield-shaped setting). St. George, seated on a leaping horse, holds the gold reins in his left hand and above his head in his right hand he wields a gold sword set with six diamonds. The white-enamelled horse has blue enamelled hooves and its blue enamelled mane is set with four pyramidal-cut diamonds. Its red enamelled trapper (or caparison) is set with two groups of diamonds, totalling eighteen and mostly table-cut. The gold bridle is set with five small table-cut diamonds and three large diamonds are placed, respectively, on the horse's neck, forehead and tail. Beneath the horse's belly, the gold dragon with its bird-claw feet and its tail entwining around the hind legs of the horse is enamelled in bright green with yellow and blue enamel markings and spots. The upraised wings of the dragon are enamelled in a bluish-green with spots of yellow enamel. A plume of feathers, one white and two red, survive above the tail and remains of a similar plume of feathers can be seen between the horse's ears. Reverse: entirely enamelled but without enrichment with precious gem-stones; the sword enamelled in the same blue as the armour; the trapper has an engraved design covered by a translucent mauve enamel, bordered by translucent red enamel; the lacing up of the armour is indicated by tiny projecting beads of white enamel. A white enamelled gold suspension loop is attached between the shoulders to St. George's armour and has a gold ring passed through it (for linking it to the suspension loop on the Collar). A long but discreetly hidden gold screw extending from the belly of the horse through the body of the dragon to the underside of the dragon fastens these two animals together.

Condition: the stamp between the ears of the horse is probably all that remains of a plume of enamelled feathers; the thin gold reins are probably later replacements crudely attached to the rings on the horse's bit; the enamel has been damaged on the legs of the horse and, on the reverse, on the sword and around the left leg of St. George.

The Lesser George

Width: 3.7 cm. An enamelled gold Garter enclosing an openwork scene of St. George and the Dragon on a 'bridge'; modelled on both front and back but not entirely modelled in the round in the upper part; hence, the head of St. George, the head of the dragon, and the head of the horse are each fashioned with two separate heads in high relief curving outwards; the narrow gap between is left rough since in neither case can it be seen easily from the normal distance. Similarly, the sword above the head of St. George has had to be modelled and fashioned twice, the one on the back being quite separate and distinct from the sword on the front. Obverse: the equestrian St. George facing right and holding a diamond-set shield, is seated on a leaping white enamelled horse set with three rubies; below, the green enamelled dragon with yellow enamelled markings and a ruby-set wing stands on a 'bridge' with light blue enamelled scrolls and with a diamond flanked by a ruby on either side; the motto of the Order reads from right to left around the Garter (unlike the mottoes on the Collar). At the top an enamelled scroll surmounted by the enamelled pendant-ring is enriched by a table-cut ruby.

Reverse: the equestrian St. George faces left and appears left-handed as he wields the sword above his head, but in all other respects the reverse is identically modelled, enamelled and set with gem-stones (seven rubies and two diamonds); of course, the buckle of the Garter is not repeated and the looping over of the end of the Garter is a continuation of the Garter on the obverse. However, the Motto of the Order again reads from right to left around the Garter.

Condition: slight damage to the enamel; especially in the area of the forelegs of the horse which have been broken and where, on the reverse, the raised left arm of St. George has been broken and separated from the clenched hand holding the sword above his head.

The Order of the Garter, the most ancient order of chivalry in Europe, was founded on St. George's Day, 1348, by King Edward III and comprised the Sovereign with twenty-five Knights, one of whom was the Black Prince, the King's son. The Order, apparently first conceived as a brotherhood of the King's close companions in arms, has fundamentally remained unaltered and even its number is still unchanged.

The Earl of Northampton's Insignia, made between September, 1628 and April, 1629, is the earliest complete set to have survived in England. In 1637 it was decreed that the Insignia of the Order should be returned to the Sovereign at the death of a Knight and, consequently, almost all have disappeared. Of the few extant sets known most were bestowed on foreign rulers and have been preserved abroad.

Unfortunately, the age and origin of the Collar and Great George of the Order of the Garter preserved in Edinburgh Castle are unknown but it is generally assumed that they were in the possession of King James II of England and VII of Scotland when he fled to France in 1688. His grandson Henry, Cardinal of York and last male descendant of the Royal House of Stuart, bequeathed them to King George III, who had granted him a pension. They were deposited with the Regalia of Scotland by order of William IV in 1830. The Collar has only 21 Garters, each with a double rose enamelled in red and green. The Great George, however, is studded with 118 rose and table-cut diamonds on the obverse and richly enamelled on the reverse and on the base. The most likely dating for these two items from the House of Stuart's Insignia is the third quarter of the 17th century.

A few items of earlier Garter Insignia have survived, such as the Garter knee-bands of the Emperor Maximilian I (c1489), of Frederick II of Denmark (1581) and of Frederick V of the Palatinate (1612); one remarkable set of Insignia of Christian IV, King of Denmark and Norway (1606) has survived in the Danish Royal Collections complete with the Garter Mantle, the earliest surviving example of the Robe. Significantly, the Garter Mantle of Christian IV is purple and was so described by King James I in the 1606 warrant: '. . . one Robe of Purple Velvet of our Noble Order of the Garter.' The mantle has been blue throughout most of the Order's long history but purple was the colour briefly adopted between 1564 and 1637, and so the 1st Earl of Northampton's Insignia would undoubtedly have been seen in 1629 worn in conjunction with a Robe of purple velvet. In the reign of Charles I (1625-1649) an increased magnificence of the ceremonial of the Order was permitted and the Earl of Northampton's installation in 1629 was an occasion of particular splendour, for which the Chapter of the Order decreed a vote of thanks.

The number of attendants of the Knight-Elect reached eighty and his Cavalcade set out from Salisbury House in the Strand for Windsor in great style; according to Ashmole: 'The order of riding to the Installation' included 'Trumpets whose Banners were of Damask, and thereon the Earl's Arms with a Garter, with his Crest and Supporters; Grooms and Yeomen, in Blue Coats two and two; Gentlemen, Esquires, and Knights

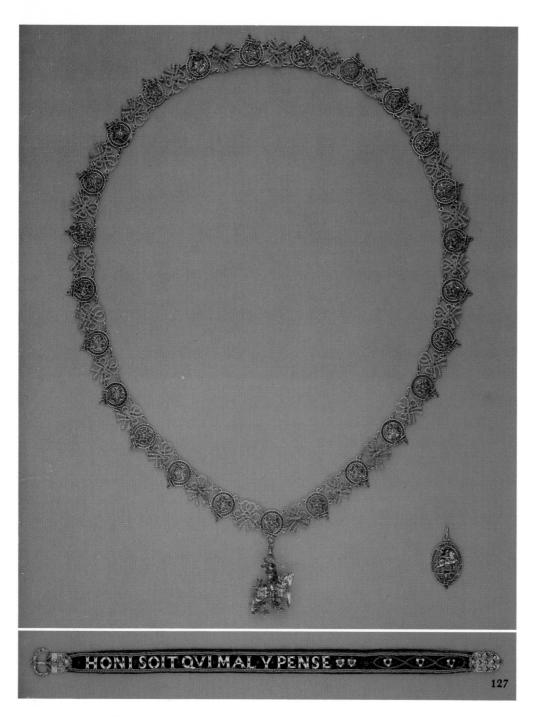

127

A stall-plate, bearing his name and the date of his installation still remains in the thirteenth stall on the Sovereign's side in the Chapel of the Order at Windsor.

William, 1st Earl of Northampton (born 1567/8 —died 1630) was a prominent figure at the courts of Elizabeth I, James I and Charles I. He was one of the Regency in 1603 who invited the Stuart monarch and his Queen to the throne, escorting them to London; thereafter, he entertained them at Castle Ashby, his principal country seat, on a number of occasions. In 1605 he was created Knight of the Bath and, in 1618, Earl of Northampton. His great wealth was in part due to his marriage in 1599 to the heiress of Sir John Spencer, a cloth merchant and Alderman of London, who had amassed a remarkable fortune. In 1610 when both Sir John and his widow, Dame Alice, died, the Earl inherited, according to the lowest accounts, £300,000 and when some years later his wife sets out in a letter (British Library, Additional MS. 4176) her financial requirements as befitted a lady of high estate, it is significant that she includes the following item: 'Also I would have £6000 to buy me Jewels and £400 to buy me a pearle chain.'

The Earl's set of Insignia reflects his great wealth and patronage, for the quality of the goldsmithswork, both in the modelling and the enamelling as well as in the gem-setting is of the highest order, surpassing even that of King Christian IV's Insignia of 1606 at Rosenborg Castle, Copenhagen. The 1628 Insignia of the Earl of Northampton is striking evidence of the presence of the most skilled goldsmiths in London and at the court of Charles I. Within the prescribed limits of a strictly traditional form of Insignia, the goldsmith has made a significant contribution towards the development of sculptural jewellery—that class of gem-studded miniature sculpture composed of enamelled gold, which evolved in France during the fifteenth century and reached a high artistic level during the Italian Renaissance in the sixteenth century. [H.T.]

Provenance: made in 1628 for William Compton, 1st Earl of Northampton and Lord President of the Council of Wales, who was elected a Knight of the Garter on 25th September 1628, was installed on 20th April 1629 and died in 1630. Subsequently, passed by descent in the Compton family to the Sixth Marquess of Northampton, upon whose death in 1978 it was offered to and accepted by H.M. Treasury in lieu of capital transfer tax and allocated to the British Museum. Literature: E. Ashmole, *The Institution, Laws and Ceremonies of the Most Noble Order of the Garter* (London, 1672); William Bingham Compton, *The History of the Comptons of Compton Wyngates* (London, 1930) p. 62; *British Heraldry from its origins to c1800*, compiled and edited by R. Marks and A. Payne (British Museum, 1978) no. 250, colour pl. p. 87.
Collection: The British Museum, London. Inv. no. M&LA 1980, 2-1, 1-4.

two and two; two Secretaries; his Steward and Controller; two Pages; his spare horse; his Chaplain to distribute his alms; Pursuivants at Arms two and two; Heralds at Arms two and two; the Gentleman Usher, bareheads; the Senior Herald, covered; the Earl, accompanied by the Earls of Salisbury and Berkshire; Noblemen, Knights, Esquires and Gentlemen, each two and two; and followed by a procession of their attendants.

'At Slow (Slough) they all made a stand, and being put again into order, proceeded to Windsor Castle, where alighting in the lower Court the Knight-Elect was conducted to his Lodgings. The

Knights of the Order proceeded with fewer attendants but similar splendour to Windsor. Arriving there in the afternoon they put on their Mantles and entered St. George's Chappel to offer Gold and Silver at the Altar, followed by Vespers with each sitting in his Stall. This was followed by a Supper at night in the nature of a private meal, which was prepared in the Dean's House. The Installation took place the following morning with great pomp at the Altar of the Chapel, and was followed by a grand Feast at the Sovereign's charge. During this meal the Knights disrobed themselves, and the ceremonies were considered ended.'

Portraits

P1 Portrait of a lady, c1520-30
Lucas Cranach the Elder (1472-1553)
Oil painting on panel. Size: 36 cm × 25.1 cm.

Cranach was taken into the service of the Elector Frederick of Saxony at Wittenberg in 1505 and remained there, working for two successive Electors. This portrait was associated by Friedländer and Rosenberg with a group of similar female portraits of the 1520s. The gown is particularly close in style to that worn by Princess Emily in the picture of *The Princesses Sibyl, Emily and Sidonia of Saxony*, painted c1530, (Friedländer, cat. no. 301) but the typically Saxon fashion is seen earlier in the portrait of *Duchess Catherine, Spouse of Henry the Devout*, dated 1514 (Friedländer, cat. no. 61).

The gown is of red velvet or dull-surfaced satin and the standing collar is lined with black velvet. The sleeves are heavily snipped and slashed, encircled by bands of cloth-of-gold patterned with a linear design woven in black silk. The white linen smock is pulled out in big puffs at the elbows and the two parts of the sleeves are linked together with narrow black cords. The ends of the sleeves overlap the white leather gloves slashed over the knuckles to reveal rings beneath. In addition, gold rings with collet-mounted stones are worn over them. The latter must have been quite loose-fitting to slide over the gloves and other rings beneath. The bodice fronts are laced with black cords over a white stiffened stomacher front through gold eyelet rings which are just visible. Above this is a panel of cloth-of-gold with a trellis pattern of double rows of seed pearls. The initial M is embroidered in single rows of pearls in the spaces. The headdress is made of the same material as the panel over the chest, but without the initial M. The hair is coiled up and concealed inside it. A wide collar of interlocking gold rings, probably twenty-six in all, is worn over the shoulders. Collars of this type are seen in many portraits of noblewomen of Saxony. Above it, round the neck, is a gold carcanet set with gems, with a gold 'necklace' beneath. This may be of 'golde wyer woven hollow', (*see* p. 33). [J.A.]

Provenance: acquired by the Earl of Shrewsbury from a collection at Nuremberg, very likely that of Friedrich Campe. At Alton Towers by 1835; the Earl of Shrewsbury sale, Alton Towers, 8th July 1857, lot 259. Bought for the National Gallery.
Literature: Max J. Friedländer and Jakob Rosenberg, *Lucas Cranach* (London, 1978) no. 172; Michael Levey, *The German School* (London, 1959) p. 19.
Collection: National Gallery, London. No. 291.

P2 Portrait of a little girl, c1520-5
Jan Gossaert, called Mabuse (active 1503, d. 1532)
Oil painting on panel. Size: 36.1 cm × 28.5 cm.
Complete painted surface at present: 38.1 cm × 28.8 cm.

The sitter has traditionally been identified as Jacqueline, youngest daughter of Adolphe de Bourgogne, Lord of Beveren and Veere, and of

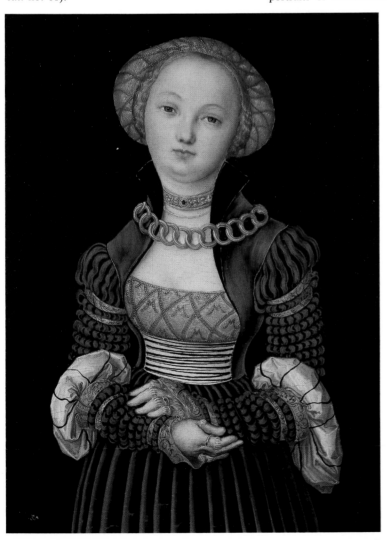 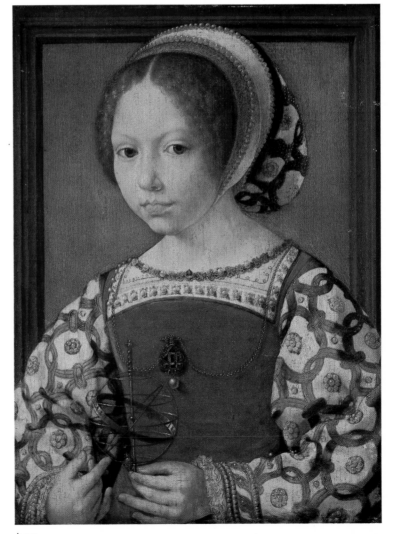

P1 ▲ ▲ P2

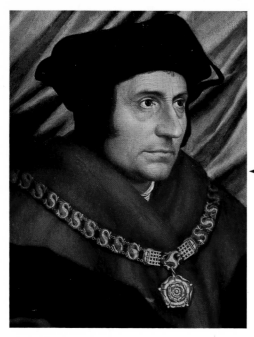

Anne de Bergues. She wears a warm reddish tan velvet gown with a square neckline. The sleeves are of white satin with an interlocking ribbon design of *appliqué* work, with three lines of gold cord stitched on top. Alternating jewels of single pearls and sets of eight pearls in gold mounts are placed in the lozenges and circles formed by the interlocking pattern. The single pearls are placed on rosettes of white cobweb lawn or fine-silk, now almost invisible as the picture has been cleaned. The head-dress is like a French hood at the front, with gold biliment lace woven with a zig-zag pattern on each edge and lozenges between them. Above this are the upper and nether biliments of pearls, attached to the white linen coif which is fastened under the chin. The hair is crimped at the front and coiled up at the back into a bag of the same material as the sleeves; two rows of pearls are mounted on the blue bands between the three lines of gold cord, with large knots of pearls at the intersections. The gold jewel pinned to the front of the bodice is set with three triangle and three square table-cut diamonds and one long table-cut diamond, with one round pendent pearl. There is an illegible inscription over the top of the jewel, and another on the armillary sphere which still shows the letters I-I-I-A-A-N-N-R-R-R-P-E . . . G-T-Y. A gold chain hanging over the shoulders is twisted round the large pin, probably as a safety device to secure the jewel. The square of gold jewels set with single pearls arranged on white material, probably satin, outlines the neckline. Underneath it is the smock with a scrolled pattern carried out in fine gold cord on the edge. The narrow carcanet, or collar of jewels, is composed of gold and red enamelled links, with one small pointed diamond at the front, the rest single pearls. [J.A.]

Provenance: Collection of Sir E. A. H. Lechmere, the Rhydd. Lechmere sale, Christie's, 27th April 1901, lot 75, bought Pottier. Paul Leroi sale, Paris, 16th December 1907, lot 29, bought Agnew. Purchased from Agnew, Clarke Fund, 1908.
Literature: Martin Davies, *Early Netherlandish School* (London, 1968) cat. no. 2211; Worcestershire Exhibition, 1882, no. 87; Toison d'Or Exhibition (Bruges, 1907) no. 68; Gossaert Exhibition (Rotterdam-Bruges, 1965) no. 19.
Collection: National Gallery, London. No. 2211.

P3 Portrait of Sir Thomas More
Artist unknown, English School, after Hans Holbein the Younger. 16th century.
Oil painting on panel. Size: 74.9 cm × 58.4 cm.
Inscribed MDXXVII on panel.

Sir Thomas More is shown at the age of almost fifty in 1527, by which time he was Chancellor of the Duchy of Lancaster, a royal servant by his Collar, of SS, 'always about the King'. He is dressed in a loose gown, with a lining and a wide collar of brown fur over a velvet doublet. The collar of SS was a livery chain, signifying the allegiance or adherence of the wearer. The use of SS as the livery of the Lancastrian party during the reigns of Henry IV, Henry V and Henry VI is widely shown in effigies and brasses of this period —with both men and women wearing the collars. After the reigns of the Yorkist Kings, when the collar of SS was out of favour, Henry VII restored its use with the addition of the Tudor badges of a pair of portcullises for fastening and a pendent rose, as depicted in this portrait. Perhaps the finest surviving example of a collar of SS is that still worn by the Lord Mayor of London (cat. no. 00). [J.A.]

Provenance: 5th Duke of Bedford (1765-1805); Christie's 30th June 1827 (Lot 83); Nieuwenhuys; William II of Holland; by descent to Prinz zu Wied from whose family it was bought by Dr Peter Grcié; purchased by the National Portrait Gallery in 1964.
Literature: S. Morison and N. Barker, *The Likeness of Sir Thomas More* (London, 1963) pp. 11 ff; R. Strong, *Portraits* (London, 1969) I, pp. 228-9; *Erasmus* (1969) no. 66; *'The King's Good Servant' Sir Thomas More* (National Portrait Gallery, 1977) no. 26.
Collection: National Portrait Gallery, London. No. 4358.

P4 Henry VIII (see p. 32)
Artist unknown, English School, after portraits by Holbein c1539-40.
Oil painting on panel. Size: 104 cm × 66 cm.

There are numerous portraits of Henry VIII, many painted after his death, showing minor variations in clothes and jewellery. The details in this one appear similar to those in the Holbein cartoon of 1537 in the National Portrait Gallery, London. However, the doublet is higher in the neck as in the Holbein portrait in the National Gallery, Rome, c1539-40, although here a different material has been used for the gown. It is uncertain whether the doublet is of gold-coloured satin or cloth-of-gold, as the painting has been cleaned, but the interlacing design is clearly carried out in gold cord. The jerkin, with deep U-shaped opening to the waist and wide skirts, is of the same material but the guards, or decorative bands, are embroidered with gold cord in a scrolling design.

The doublet is slashed with little puffs of white linen pulled through for decoration. The linen shirt is pulled through in large puffs between the panes of the doublet sleeve, which are clasped together with gold jewels set with rubies, matching the four at the centre front. The narrow shirt neck-band is embroidered with gold thread and fastens with gold cords. The russet velvet gown may originally have been crimson and is lined with brown fur, with an interlacing design of gold cord embroidered on the sleeves. This can be seen more clearly in the full-length portrait at the Walker Art Gallery, Liverpool. A gold chain hangs from the red silk sash girdle to support the dagger. A large tassel beneath is similar to three in the 1550 inventory of Henry's jewels in the Tower: 'two Tasselles of small perle thone with a knoppe of gold enameled and small Cheynes golde the other with a knoppe of perle and veanys (veins?) of golde' and 'a tassell for a Dagger of golde garnesed with small stones and perles having a Clocke in the toppe set with a cristall.' The black velvet cap, which appears in several portraits, is trimmed with white ostrich feathers. On the underside of the brim is a row of jewels, cinques of pearls joined with gold chains alternating with table-cut diamonds in gold claw settings. The heavy jewelled collar may be the King's legendary collar of balases, as Hall described it in 1539: 'a collar of such Balistes and Perle that few men ever sawe the lyke,' although the Walker Art Gallery portrait shows a chain with even larger balases and links of gold set with sixteen pearls in each. The collar in the Chatsworth portrait, which also appears in the National Gallery, Rome, and the Castle Howard portraits, has a stone at the centre front which is table-cut with eight sides. A gold circular tablet, or pendant, set with four table-cut stones, possibly containing a miniature, hangs from a chain with alternating links of 'hachis' and black enamelled gold 'pillars'. [J.A.]

Provenance: By descent in the family.
Literature: R. Strong, *Portraits* (1969) pl. 305 and pl. 309; Paul Ganz, *The Paintings of Hans Holbein the Younger* (1950) pl. 147.
Collection: Trustees of the Chatsworth Settlement.

P5 Jane Seymour, c1550 (see p. 24)
Artist unknown, English School, after Hans Holbein the Younger (1497/8-1543).
Oil painting on panel. Size: 115 cm × 94.5 cm.

Costume detail and tree-ring analysis of the panel

show that this portrait was painted some fifteen years after the two portraits of Jane Seymour by Holbein, both dating from 1536. One is in the Mauritshuis, the Hague, while the other is in the Kunsthistorisches Museum, Vienna. The Mauritshuis version is a smaller, more sensitive painting and probably the first, as it shows the same jewellery as the preparatory drawing (Royal Collection, R.L.12267; *Holbein and the Court of Henry VIII* (Queen's Gallery, 1978) no. 46). Differently embroidered wrist ruffles, under-sleeves and jewels are used in these two pictures, those in the Mauritshuis portrait being less elaborate items which she may have worn on in-formal occasions or even before her betrothal. The Woburn version copies the russet velvet gown, with gold thread couched in a trellis pattern at the neckline and on the turned-back sleeves seen in both pictures. Worn with it are the undersleeves and forepart, in green brocaded silk with a looped metal thread pile, and jewellery used for the Kunsthistorisches Museum version. These accessories and jewels are richer and more regal and are entirely suitable for a formal portrait of the Queen. The biliment of sets of four pearls alternating with dark red stones in gold settings bordering the front of the gable headdress, a peculiarly English style, matches the jewelled band, or square, edging the neckline. The same arrangement is used for the pair of necklaces, or carcanets, and girdle. The neckline in the Mauritshuis portrait is decorated with a square of two pearls alternating with a round, dark red stone with a gold flower on top, in a gold setting. The headdress is bordered with three pearls alternating with one gold bead, while the necklaces are of pearls with one gold bead between each. The same jewel, a ruby above an emerald in a gold setting, with a single pendent pearl, hangs from the carcanet in all three pictures, and apparently was also used in a miniature of *An Unknown Lady, formerly said to be Katherine Howard*, by Holbein (cat. no. P6). There are minor variations of detail in the jewel in all these pictures caused partly by the different media and scale of the work and partly, in the Mauritshuis version, by restoration. A jewel formed of the letters IHS, with a cross and three pendent pearls, is pinned to the bodice in the two original portraits, where the pins may be seen clearly above the I and S. They do not appear in the Woburn copy. Another IHS jewel appears on Anne of Denmark's standing band (cat. no. P21) and both may be compared with the IHS jewel (cat. no. 55). Elizabeth had 'a Jhesus contayninge xxxij diamondes three Emerodes and a Rubie with three pearles pendaunt' entered in a list of her jewels delivered to Mary Radcliffe's charge in 1587. This and two others were among the jewels given to Katherine Howard by Henry VIII on their marriage in 1540. One was 'a Ihus of golde conteignynge xxxij Diamondes havying three peerlls hanging at the same' and may be the one in this portrait, although the cross is not described. The elaborate double chain hanging from the waist in the Woburn portrait may support a pomander or a girdle prayer book. It is of a similar design to a single chain depicted in the portrait of *Elizabeth I, when Princess*, painted in 1547 (p. 28) and may be a 'flagon cheyne,' as described in the 1587 list of jewels: 'a pece of Unicornes horne sett in golde hanging at a flagon cheyne.' [J.A.]

Provenance: By descent in the family.
Literature: Janet Arnold, *A Handbook of Costume* (London, 1973) pp. 21-3; John Fletcher, 'Oak Antiques: Tree-ring analysis,' *Antique Collecting and Antique Finder*, October 1976, pp. 9-10. *Dendochronology*, National Portrait Gallery (London, 1977) no. 12.
Collection: The Marquess of Tavistock, Woburn Abbey.

P6 Portrait of an unknown Lady, formerly said to be Katherine Howard, *c*1540 (*see* p. 30)
Hans Holbein the Younger (1497/8-1543)
Watercolour on vellum laid onto playing card.
Diameter: 6.4 cm.

The gold jewel with ruby, emerald and pendent pearl hanging from the carcanet of pearls and rubies, is seen at a slightly different angle from that in the portrait of Jane Seymour (cat. no. P5). The medium of watercolour allows the emerald to appear as a clear translucent green. This lady may be Mary, Lady Monteagle (Royal Coll. R.L.12223, *Holbein and the Court of Henry VIII* (Queen's Gallery, 1978) no. 20) or some other lady at Court who received a gift of jewels from Queen Jane. The wide jewelled band, or square, of goldsmith's work bordering the neckline seems to have been influenced by Flemish styles worn briefly at the English Court by Anne of Cleves in 1540. The centre of the French hood matches the jewelled square, with an upper biliment of alternating jewels and pearls set in gold and a nether biliment of pearls. A matching row of pearls is set on the edge of the neckline. This is similar in design to the 'Square conteignyng xxxiij Diamondes and lx rubyes with an Edge of peerll conteignyng xxiij' given to Katherine Howard by Henry VIII in 1540, except that there are probably nearer fifty pearls in the square shown in the miniature. A second version of the miniature, which belongs to the Duke of Buccleuch (Ganz, *Paintings*, no. 142, pl. 180) shows very clearly the smock with a ruffle at the top of the neck-band, worn beneath the carcanet. [J.A.]

Provenance: Almost certainly acquired by Queen Victoria. In the Royal Collection since the early 1840s.
Literature: Paul Ganz, *The Paintings of Hans Holbein the Younger* (London, 1950) cat. no. 141; *Holbein and the Court of Henry VIII*, Exhibition Catalogue (Queen's Gallery, 1978) no. 84; R. Strong, *Portraits* (London, 1969) p. 44.
Collection: Her Majesty the Queen.

P7 Portrait of an Unknown Lady
Hans Eworth (active 1540-73)
Oil painting on panel. Size: 88.9 cm × 71.2 cm.

Inscribed to the right, later: A° /AETA. SU/.16./ and bottom right, very faintly: 1565/HE.

Roy Strong has suggested that the sitter is Mary Fitzalan, Duchess of Norfolk, who died in 1556, painted at the time of her marriage in 1555. However, tree-ring analysis by John Fletcher has indicated that the panel was used after 1555 and may well have been used in 1565, as inscribed (personal communication in 1978).

The ruffs at the wrists are set rather too tightly for the earlier date of 1555 and that at the neck is too low beneath the chin for a date much after 1560. Although no longer in the lastest fashion in 1565 the sitter may have decided to wear the gown for her portrait for sentimental reasons, perhaps because it was a gift, or made for some special occasion. It is also possible that the portrait is a second version by Eworth of an earlier painting. The red velvet gown and turned-back sleeves in cloth-of-gold revealing the richly embroidered undersleeves suggest that the gown may have been worn to Queen Elizabeth I's coronation in 1559. The sitter may be one of 42 ladies who were each given 16 yards of crimson velvet and 2½ yards of cloth-of-gold for 'turning up the sleeves.' There was one delivery of red velvet among all the lengths of crimson velvet, so this may have been used for the gown, or the colour in the painting may have changed from crimson with cleaning. The wide turned-back sleeves are in what might well be termed 'Clothe of golde greene with woorkes' described in the list of silks used at the coronation. The front of the French hood is bordered with gold biliment lace (braid) and pearls; seventeen jewels separated by groups of pearls are mounted on the upper biliment. A jewel set with a ruby and a pendent pearl is attached to the front of the deep jewelled carcanet worn beneath the ruff. Pinned to the bodice is a gold and enamelled jewel set with three large table-cut stones, two nymphs supporting the upper one, and three pendent pearls. The links of the gold and enamelled girdle are of three designs, arranged alternately: sets of seven pearls, white enamelled arabesque shapes with dark stones, and table-cut stones in gold settings. The embroidered undersleeves are clasped on the lower edge with jewels containing three large pearls set in gold, enamelled red. Puffs of white linen embroidered with gold thread are pulled out between them. [J.A.]

Provenance: presumably Hamilton Inventory, 1704, no. 174.
Literature: Janet Arnold, 'The "Coronation" Portrait of Queen Elizabeth I,' *The Burlington Magazine*, CXX (1978) p. 730; Lionel Cust, *Notes on the Authentic Portraits of Queen Mary of Scots*, (1903) pp. 131-2, pl. xxix; Lionel Cust, 'The Painter HE,' *Walpole Society*, II (1913) pp. 34-5; R. Strong, 'Hans Eworth Reconsidered,' *Burlington Magazine*, CVIII (1966) pp. 225-6; R. Strong, *The English Icon* (London, 1969) p. 88, 89, 345; Exhibition in Edinburgh, 1884, no. 15; *Stuart* (New Gallery, 1889) no. 33; *Eworth* (National

Portrait Gallery, London, 1965) no. 5; *Elizabethan Image* (Tate Gallery, London, 1969) no. 30. Collection: The Duke of Hamilton, Lennoxlove.

P8 Portrait of an Unknown Lady *c1555-65*
(*see* p. 24)
Artist unknown, Florentine School (?)
Oil painting on canvas. Size: 113 cm × 80 cm.

The style of gown is similar to that of a Venetian woman of 1550 and a noble woman of Orleans in Vecellio's *Habiti antichi, et moderni di tutto il Mondo* of 1598. The fashion for this low square neckline, filled in by a jewelled partlet with a standing band edged with a frill, was probably taken to France by Catherine de Médicis. The black velvet gown is embroidered in diagonal bands on bodice and sleeves with silver and gold thread. The velvet is slashed between the bands, showing white beneath. The semi-transparent white silk partlet is caught down with a trellis work of fine gold chains, puffing up slightly between them. The frill at the neck is edged with gold cord. A gold cross set with four triangle and six square diamonds, all with foil, and three pendent pearls, hangs from the pearls worn at the neck. Beneath it is the edge

of the white linen smock embroidered with gold thread, showing under the partlet. The smock wristbands are turned back at the ends of the sleeves. Large gold jewels form the links of the girdle, set alternately with four pearls, a single small ruby and a small flower, enamelled white. The jewel at the front of the girdle is a double rose of diamonds with foil (*see* p. 25). This is set in gold, with a small ruby at the centre and four pearls at the rim. [J.A.]

Provenance: probably the picture noted by Waagen (1854) in the possession of Lord Shrewsbury. Purchased in Paris with the Beaucousin Collection, 1860.
Literature: Cecil Gould, *The Sixteenth Century Italian Schools* (1962) p. 57.
Collection: National Gallery, London. No. 650.

P9 William Brooke, 10th Earl of Cobham and his family (*see* p. 37)
Hans Eworth or the Master of the Countess of Warwick
Oil painting on panel. Size: 96.6 cm × 124.5 cm.
Inscribed with the ages of the children and within the cartouche—'AN° DNI 1567.

Earlier in the sixteenth century men wore more jewellery than women and Lady Cobham shows the change which occurred after Elizabeth's accession. Her black velvet gown, in Spenser's words, 'All above besprinkled was throughout/ With gold aygulets that glistened bright.' These pairs of gold and enamelled aglets, or aiguillettes, were formerly the small metal tags of points or lacing ribbon, which enabled them to be threaded through eyelet holes. Gradually aglets grew in size and were heavily ornamented until finally, as in this portrait, they were simply decorative features and no longer functional. The carcanet of large gold jewels set alternately with pearls and square table-cut diamonds is thrown into relief against the high, black velvet collar of the gown. From it hangs a large gold jewel, made like a ship, set with diamonds and rubies with a pendent pearl. This was a favourite Elizabethan design and the Queen had several like it. One, a New Year's gift in 1583, was 'a fayre jewell of golde being a shippe borde, therein a personage standing and under the shippe a fayre emrald, the same shipp garnished with smale dyamonds and rubyes and four meane pearles pendant.' Another, given to her by Sir Francis Drake and thought to represent

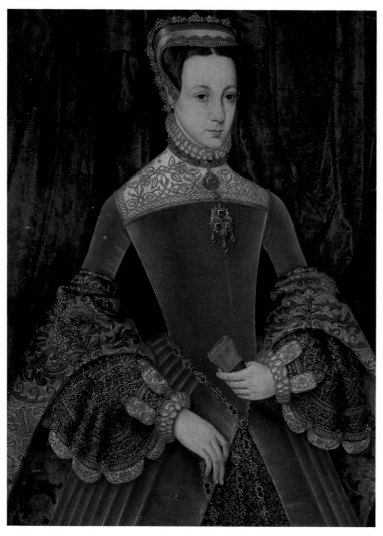

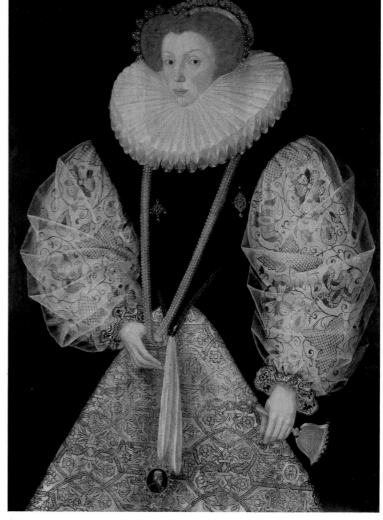

P7▲ ▲P10

the Golden Hind, was later presented to Lord Hunsdon and is now in the collection at Berkeley Castle (Joan Evans, *English Jewellery* (1921) p. 95).

Lord Cobham wears a black velvet gown with a deep fur collar which conceals any jewellery he may be wearing on his doublet. Each of his three small daughters wears a pair of plain gold chains with a large jewel pinned to the front neckline. Above this, in the opening of the partlet, is a gold jewel set with an oval ruby, a table-cut stone, and a pendent pearl. This is tied round the neck with a narrow black ribbon.

The eldest son wears a black velvet doublet embroidered with gold braid and a gold jewel set with a table-cut diamond hanging from a black ribbon. The two baby boys wear matching braid-trimmed doublets with tiny decorative buttons stitched to the shoulder wings. The lady looking after them has a jewel at her neck similar in design to those of the little girls and also to that worn by Jane Seymour (cat. no. P5) and cat. no. 8. It is suspended from a black and white enamelled carcanet worn over the smock or partlet, beneath the ruff. [J.A.]

Provenance: By descent in the family.
Literature: Lionel Cust, 'The Painter HE,' *Walpole Society*, II (1913) p. 35; Ralph Edwards, *Early Conversation Pictures* (London, 1954) pp. 155-6; R. Strong, *The English Icon* (London, 1969) p. 110; *Eworth*, National Portrait Gallery (London, 1965) no. 43.
Collection: The Marquess of Bath, Longleat House.

P10 Mary Cornwallis, *c*1585-7
George Gower (active 1540?-d. 1596)
Oil painting on panel. Size: 117 cm × 93.1 cm. Inscribed top right at a later date: 'Mary Cornwallis Wife of The Earl of Bath'.

The plain black velvet gown provides an excellent foil for the five ropes of pearls reaching below the waist and the jewels pinned on the bodice. This somewhat insecure method of attaching jewels was, no doubt, why so many were recorded as 'lost from her Majesties back' in a day book with entries of items of clothing and jewellery leaving Queen Elizabeth's Wardrobe of Robes between 1561 and 1585. The linen sleeves, heavily embroidered with blackwork, are protected by coverings of fine, semi-transparent silk, or possibly cobweb lawn. In some portraits these coverings are caught down with gold buttons, set with gems and pearls. The short girdle is decorated with pearls and a white silk ribbon is looped through it at the front to support a jewelled miniature of a bearded man. When young Lady Derby wore a similar picture round her neck in 'a dainty tablet,' Queen Elizabeth asked what it was, and in spite of the young lady's reluctance insisted on opening it. When she found the portrait 'to be Mr Secretary's, snatch it away and tyed it upon her shoe, and walked long with it there; then took it thence, and pinned itt on her elbow, and wore it there some time also.' The gold fan handle has a coat of arms engraved on it.

The hair is dressed over pads on either side of the face with a wired decoration formed of sets of three pearls each one surrounded by a ring of smaller pearls. Stubbes described this type of decoration in his *Anatomie of Abuses (1583)*: 'Then on the edge of their bolstred hair . . . there is layd great wreathes of gold and silver, curiouslie wrought and cunninglie applied to the temples of their heads.' Behind this decoration is the caul set with pearls, enclosing the rest of the hair. [J.A.]

Provenance: presumably removed from Hengrave Hall when it came into the possession of the 4th Earl of Kenmare in 1887; sold by Elizabeth, Countess of Kenmare, Sotheby's 21st July, 1943 (lot 82); with G. Marshall Spink; acquired in 1953.
Literature: Janet Arnold, *Queen Elizabeth's Wardrobe Unlock'd*, (to be published by Macmillan); *Manchester City Art Galleries Report* (1953) p. 20, pl. 1; R. Strong, *The English Icon*, (London, 1969) p. 180; *Manchester Coronation Exhibition*, 1953, no. 2; *Age of Shakespeare* (Manchester, 1964) no. 12; *Between Renaissance and Baroque* (Manchester, 1965) no. 126.
Collection: Manchester City Art Gallery.

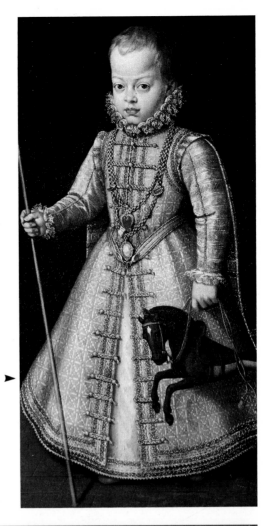

P11 Don Diego, Infante of Spain, 1575-1582 ►
Artist unknown, School of Coello
Oil painting on canvas. Size: 110 cm × 81 cm.

Don Diego was the son of Philip II of Spain and Anne of Austria, daughter of Emperor Maximilian II. It seems to have been customary to festoon the Spanish royal children with talismans and amulets, as in the portraits by Juan Pantoja de la Cruz of Infanta Maria, 1607 (Kunsthistorisches Museum, Vienna), and of

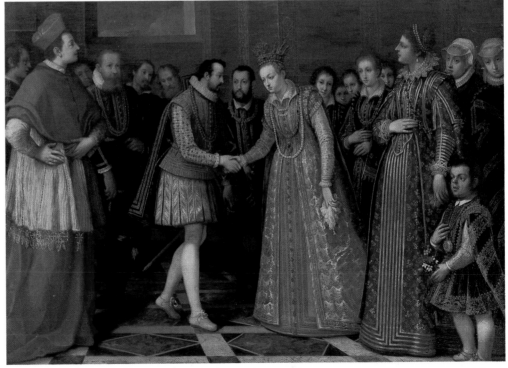

▲ **P12**

Infanta Anna, 1602, (Convent of Las Descalzars Reales, Madrid). In this case, sadly, it was to no avail as Don Diego died aged only seven. He wears a coral heart, a favourite prophylactic material and shape, the heart being the seat, beginning, and end of life (*see* cat. no. 58 and L. Hansmann and L. Kriss-Rettenbeck, *Amulett und Talisman* (Munich, 1966) pp. 180-181); a silver cross and medallion of the Virgin, a crystal and gold reliquary capsule, (cat. no. 108) a bit of bone or tooth in a gold setting, a malachite pendant, (cat. no. 75n) and an unidentified black stone or bone set in gold.

The 1585 inventory of the jewels belonging to the late Duchess Anna of Saxony includes a very similar sounding gold chain : 'a small gold chain to which all manner of health-preserving stones (*Gesundheitssteine*) are attached, thus, a jasper, a

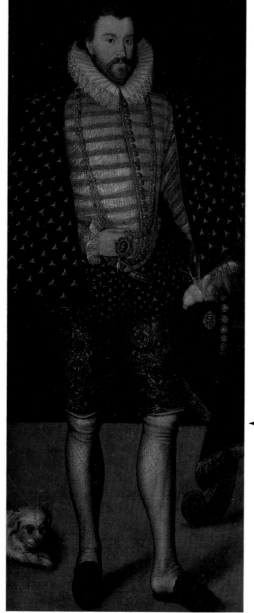

lapis lazuli, an amber, coral, two load-stones and a small gold heart'(E. v. Watzdorf, 'Fürstlicher Schmuck der Renaissance,' *Münchener Jahrbuch der Bildenden Künste* XI (1934) p. 61). [A.SC.]

Collection. Bavarian State Paintings Collection. Inv. no. 4199.

P12 The Marriage of Francesco de Medici to Joanna of Austria, 1627
Jacopo Ligozzi
Oil on canvas. Size: 152 cm × 213 cm.

This formed part of a series of paintings illustrating the history of the Medici family commissioned by Marie de Médicis for the Palais de Luxembourg. Jacopo Ligozzi, who painted it in Florence, was paid 200 scudi for it in 1627.

The marriage between Francesco de Medici and Joanna of Austria took place in 1565, so the painting is a historical reconstruction of the event. The central figure is Cosimo I wearing the order of the Golden Fleece. On the left is Francesco's younger brother, the Cardinal Ferdinand. Francesco himself is wearing a diamond chain with the order of Malta hanging from it, while Joanna of Austria wears the Medici crown. In reality, of course, the title of Grand Duke had not yet been granted to the Medicis, and the crown was only made by Jaques Bylivelt 1577-83. It was kept in the *Guardaroba* and Ligozzi must have seen it as it is accurately observed, judging by the 18th century drawing of it (cat. no. G9). The other jewels are more impressionistically rendered, with the exception of the probably German watch hanging around the neck of the dwarf, Morgante. [A.SC.]

Provenance: Le Palais de Luxembourg, Paris; bought between 1803 and 1806 by the 7th Earl of Elgin when he was detained by the French authorities on his way back from Constantinople. Literature: A. Blunt, 'A series of Paintings illustrating the History of the Medici family executed for Marie de Médicis,' *Burlington Magazine*, CIX (1967), pp. 492-498; C. W. Fock, 'The Medici Crown: Work of the Delft Goldsmith Jaques Bylivelt,' *Oud Holland*, LXXXV (1970), p. 199, ill. 8.
Collection: The Earl of Elgin, Broomhall, Fife.

◄ **P13 Sir Christopher Hatton,** *c*1582-5
Artist unknown, English School.
Oil painting on canvas. Size: 195.6 cm × 107.3 cm.

Inscribed above right, probably at a later stage: 'A° MVLXXXII AETAT. XLII' and below left 'Christr Lord Chancr Hatton.'

The doublet is in white satin. It is cut in horizontal bands for decoration, one wide and two narrow strips alternating in each band, divided by strips of gold braid. The wide strips have decorative pinks or tiny cuts, about 3 mm across. Both front edges are bordered with gold braid and the doublet fastens with a row of gold buttons.

The black satin cloak is covered with an appliqué pattern of black velvet scallop shapes in a deep border round the outer edge. Triangular gold shapes set with pearls within this border are apparently stitched down. As they lie flat, they are probably pieces of cloth-of-gold rather than gold jewels. The short trunk-hose match the cloak border, but the design is smaller in scale and the triangles are in two sizes. The trunk hose are paned to show puffs of the material used for the canions beneath. These canions display to full advantage the woven pattern, in black silk and gold thread, of interlacing shapes and stylised flowers and leaves. The same material is probably used to line the cloak, as a narrow band of it can be seen all round the edge. The long stocking-like boots pulled over the knees are of finest leather, pinked in decorative patterns to make them even more flexible. The black velvet pantofles are fraying at the front, where they have been snipped for decoration.

Hatton wears three matching gold chains round his neck, similar to some of those in the Cheapside hoard (cat. no. 120). The links are made of single pearls in a red enamelled gold setting, alternating with a green enamelled circle with a gold triangle in the centre, and three gold links between them. At the end of these chains hangs a cameo of Queen Elizabeth, surrounded by table-cut diamonds, with four crosses of diamonds and a large pendent pearl. The black velvet hat in his left hand has a gathered crown. A plume of white feathers is attached beside a large cameo with three figures and a statue, possibly the story of Lot's wife. This is bordered with alternating square table-cut diamonds and rubies set in gold. Above the brim is a band of green and red enamelled gold jewels set alternately with pearls and square, table-cut rubies. A half length version of this portrait with a later inscription giving the date 1589 (N.P.G. 2162) shows the same doublet and cloak. Instead of the ruffs at neck and wrists, Hatton wears the lace-edged cuffs and collar of his shirt, embroidered with blackwork. The hat is worn at a jaunty angle, with the white feathers curling over the cameo; a different set of jewels decorates the hatband. The golden equilateral triangles on cloak and trunk-hose and the three chains, with triangles set inside circles as one of the designs for the links, may be symbols of the Trinity, however they may have had some other symbolic meaning, now lost. [J.A.]

Provenance: by descent in the family.
Literature: R. Strong, *Tudor and Jacobean Portraits*, (London, 1969), I, p. 137.
Collection: The Earl of Winchelsea, South Cadbury House, Yeovil.

P14 Queen Elizabeth I, *c*1595-1600 (*see* p. 32)
Artist unknown, English School.
Oil painting on canvas. Size: 223 cm × 165 cm.

The Queen stands in a similar pose to that in the 'Ditchley' portrait at the National Portrait Gallery, wearing the same style of dress with a

wide farthingale. She wears a crown on top of her elaborately curled auburn wig. Small pearls are used to form the arches and single fleur-de-lis. Beneath the crown are pearls, which appear to be mounted on loops of ribbon, and various gold jewels set with rubies, pearls and table-cut diamonds, both square and lozenge-shaped. The whole head-dress is similar to one listed in the 1587 inventory of Elizabeth's jewels: 'an Attier made like a crowne of venice golde and silver garnished with two faire diamondes sett in golde three faier rock Rubies sett in golde five peeces of goldsmithes work with two pearles in a peece, eight buttons of golde with diamondes, eleven buttons with rubies five faier pearles pendaunt iiijxxxv pearles and xiiij pearles uppon Labells.' The wired veil behind the ruff is bordered with small pearls. Large and small pear-shaped pearls are arranged alternately to stand away from the edge.

Two pale pink roses are pinned to the left side of Elizabeth's ruff and above them an eight-pointed star of triangle diamonds, with one square table-cut diamond in the centre. A six-pointed star is worn on the opposite side of the ruff and six square table-cut diamonds set in gold are pinned on each side. Two larger gold jewels are attached to the front of the sleeves, on the cuffs, each comprising four triangle diamonds, one square diamond and four pearls.

Elizabeth wears two strings of pearls round her throat. Suspended from them are two lozenge and four triangle diamonds, each with a pendent pearl. The earring is a single pear-shaped pendent pearl. A massive rope of over 160 pearls is knotted at the front and hangs in a loop to the end of the long pointed bodice. The girdle may be that listed in the 1587 inventory of the Queen's jewels: 'a short girdle with eleven faier table diamondes and tenn Rubies sett in golde and xliiijtie pearles betwene them sett in twoes in golde.' This is clasped at the front with a jewel containing a large triangle diamond and a pendent pearl, to which is attached a red ribbon looped up to a large jewel pinned to the skirt. The spire, or obelisk, in this jewel is made of six diamonds with a base of a large square diamond which appears to be 'cutt with diverse triangles' (see p. 35), and three square table-cut diamonds, each with a pendent pearl. There is a woman's figure in gold on either side of the spire; one of them, with wings and a trumpet, is probably 'Fame.'

The black velvet gown skirt is decorated all over with pairs of pearls and the front edges and hem are bordered with a row of small pearls. Above this are set alternately large pear-shaped pearls and gold jewels like buttons, each set with a single diamond, surrounded by three pearls. The gown sleeves are lined with silk to match the forepart and are jagged at the edge. These triangular-shaped jags stand out, bordered with gold braid, and a pearl is sewn at the end of each. The white satin forepart and matching stomacher were probably stained (i.e. painted), rather than embroidered, with a wide variety of motifs

including flowers, birds, butterflies, sea monsters and serpents. The hem of the forepart is bound with gold braid and edged with over 150 pearls. The black velvet sleeves are decorated with knots of pearls similar to the knot encircling the initials ER embossed on the ceiling of the room in which the Queen is said to have slept at Cobham Hall. Between these pearl knots are gold jewels set with rubies holding down puffs of the finest silk or cobweb lawn. On her left sleeve is pinned a large gold jewel set with one large square table-cut diamond, eight other diamonds and a pendent pearl.

The fan handle is of gold set with rubies and the part holding the white feathers is set with rubies and diamonds. The cuffs of the leather gloves are bordered with gold fringe and set with four pearls on either side of a square-cut stone set in gold. The Queen's wedge-heeled, white leather shoes are decorated with gold jewels, each set with a single diamond, surrounded by pearls. [J.A.]

Provenance: Possibly one of the three portraits mentioned in the inventory of April 1601; Devonshire collection; first recorded at Hardwick in 1760; transferred to the National Trust in 1957.
Literature: Freeman O'Donoghue, *A Descriptive and Classified Catalogue of Portraits of Queen Elizabeth* (1894) no. 53; Lord Hawkesbury, *A Catalogue of the Pictures at Hardwick* (Liverpool, 1903) p. 41; R. Strong, *Portraits*, pp. 83-4.
Collection: The National Trust, Hardwick Hall.

P15 Sir Francis Drake, 1594
Marcus Gheeraerts the Younger.
Oil on canvas. Size: 137 cm × 114 cm.

Inscribed: *Aetatis Svae 53/An°* 1594. This shows Sir Francis Drake wearing the still surviving pendant (cat. no. 40) containing a miniature by Hilliard of Queen Elizabeth I, and given to him by the Queen, perhaps as a reward for his part in the defeat of the Spanish Armada. [A.SC.]

Provenance: from Buckland Abbey, by bequest in 1937, of Elizabeth Fuller-Eliott-Drake, widow of 3rd Lord Seaton.
Literature: J. Steegman, *A Survey of Portraits in Welsh Houses*, I (Cardiff, 1957) p. 3 (1).
Collection: Lt. Col. Sir George Meyrick, Bart., M.C.

P16 Mrs Ralph Sheldon, *c*1593-5
(*see* back cover)
Artist unknown, English School.
Oil painting on panel. Size: 115 cm × 92 cm.

Mrs Sheldon was married four times. Her last husband, Ralph, was the manufacturer of the Sheldon Tapestry maps which are now in the Victoria and Albert Museum. She wears a black silk damask gown with big sleeves, either bombasted or 'borne out with whalebones,' over a kirtle of light brown and pale grey silk damask woven in a pattern of acorns, roses and other flowers. The material is caught in a tuck to the

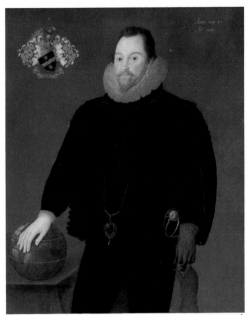

P15▲

edge of the farthingale at the front. The sleeves are decorated at the top and round the armholes with two black velvet bands folded chevronwise. These are held down with large gold and enamelled buttons set with cinques of pearls. Touches of red on these buttons may indicate rubies instead of pearls in a few cases, enamelling in others and some restoration work. At the centre of her left sleeve is a large enamelled jewel set with an uncut balas ruby, or a rock ruby, with a pendent pearl. A red ribbon is tied in a bow through the ring at the top, attaching it to a pin which cannot be seen. This would give extra security, as well as being a decorative feature. A matching ribbon fastens the bunch of ten ropes of pearls to the neckline; the other end is concealed in the hand, but may also be caught to the gown. The large gold and enamelled jewel on her left side is set at the top with four round rubies. Suspended from it by three chains is a sculptural group of enamelled gold, of Orpheus and his lute with a lion, a unicorn, a white horse, a white bird and a cow. Surrounding this are two pillars, each with six square diamonds, two triangle diamonds, one larger square diamond, an emerald and four rubies, with more gems below. Beneath hang three gold jewels, enamelled red. The gems in this jewel are all table-cut, but at her neck, Mrs Sheldon wears a gold jewel with a single diamond cut in facets. It is suspended by a ring from a necklace made of three pearls alternating with a single black bead, which may be glass or jet. The short girdle is of black velvet, decorated with jewels set with eight pearls, fastening at the front beneath a gold jewel and pendent pearl. Queen Elizabeth had a similar 'waste girdle of vellat with buckles . . . of golde garnished with xxiij small pearle sett in golde' listed in the inventory of her jewels made in 1587. [J.A.]

Provenance: 6th Viscount Wenman and by descent to W. H. Wykeham-Musgrave, Esq.

Purchased by Christopher Gibbs Ltd., London.
Private Collection.

P17 Lady Speke, 1592

Artist unknown, English School.
Oil on panel. Size: 91.5 cm × 73.6 cm.
With a coat-of-arms, '*1 argent, two bars azure, overall
a spread eagle with two heads gules, 2 per pale, gules and
vert overall a lion rampant argent*'. Inscribed: 1592
Non gloriae sed memoriae.

This portrait shows either Elizabeth, second
daughter of Sir Andrew Luttrell, and wife of Sir
George Speke, M.P. for Somerset 1579, or Joan,
daughter of Sir John Portman, wife of Sir George
Speke of White Lackington and Ollington, who
was appointed Sheriff of Somerset in 1592. The
latter is the more likely as such an appointment
may well have been the occasion of the portrait's
being commissioned.

Her black overdress is studded with plain gold
ornaments and more elaborate pearl-set and
enamelled 'flowers' at the waist. A triple chain of
gold decorated with black and white enamel and
set with pearls hangs down to her waist; the
billiment is *en suite* with this.

A sea-horse pendant with a baroque pearl body
and enamelled tail hangs from her left sleeve and
she fingers a plain gold ring in her right hand.
Heavy gold chain bracelets like cat. no. 82 adorn
her wrists, the clasps are enamelled with black
moresques and are inscribed ER. From a red cord
hangs a girdle book with a moresque enamelled
spine and an enamelled relief on the cover. This
depicts the Judgement of Daniel and the inscrip-
tion around it reads REDITE IN IVDITIVM QVIA ISTI
FALSVM IN HANC TESTIMONIVM DIXERVNT (Daniel
XIII, 49)—Return to the place of judgement for
they have given false testimony against her.

The girdle book is very similar to two book
covers in the British Museum (cat. no. 12). These
are around sixty years older than the portrait and
as the rest of the jewellery is contemporary this
suggests that they were a valued heirloom. The
bracelets with the ER so prominently displayed
may have been a present from the Queen and
therefore also especially prized. [A.SC.]

Provenance: By descent in the family of the
owner.
Private Collection.

P18 Elizabeth Vernon, Countess of Southampton, *c*1600

Artist unknown.
Oil painting on panel. Size: 164 cm × 110.5 cm.

Elizabeth Vernon informally attired, stands at her
dressing-table pulling an ivory comb with the
inscription '*Menez moi doucement*' through her hair.
Her embroidered jacket, with zig-zag hemline
trimmed with spangles, is left unfastened, the
ribbon ties hanging loosely. The smock, bordered
with lace, is turned back at neck and wrists. The
pink silk corset, stiffened with whalebone, is laced
up at the centre front. The petticoat, with its
woven design of slips of flowers, is covered with

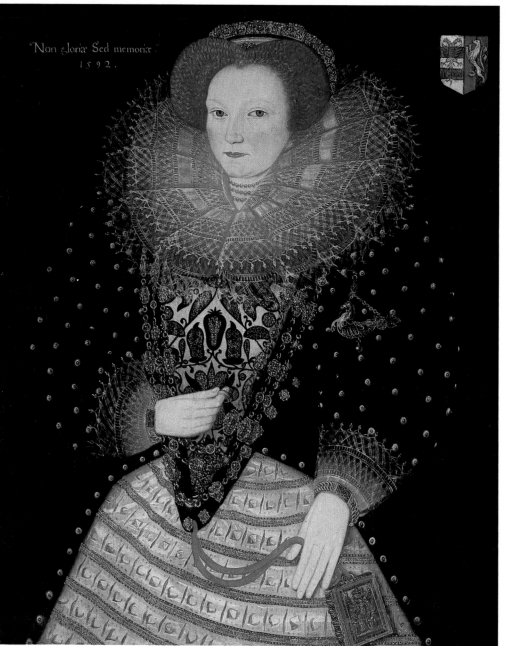

Non gloriæ Sed memoriæ. 1592.

an almost transparent apron of either cobweb
lawn or finest silk. Pinned to the curtain at her left
is a ruff with a ruffle of silk inside it and below, an
elaborate piece of jewellery to be worn over the
front of the gown. This is similar to a New Year's
gift to Queen Elizabeth in 1600, described as 'one
Carkonett or stomacher conteyning v knottes of
gold . . . set with small rubyes & half pearle.'
Another, in the next year, was 'One carcanett
hanginge at a Ruffe conteyning ix peeces of golde
set with garnetts.' It is not, however, entirely
clear how any of these pieces of jewellery were
worn. On the table at Elizabeth Vernon's right is
a large pincushion with plenty of pins to attach
jewels and fasten pieces of clothing. A large jewel
of gold set with nine diamonds and three pendent
pearls is propped against the pincushion, beside
three coiled ropes of pearls which would have
been draped across the bodice. Another large
jewel of gold set with diamonds and rubies and
one pendent pearl, probably to be worn on a
sleeve, is arranged against the jewel casket. In
front of it is a necklace or carcanet with links of
two rows of three pearls alternating with gold
jewels set with a diamond and pendent pearl
beneath. Both this and the carcanet in front are
fastened at the back of the neck with red ribbons.
A small jewel lies beside them to the right, to
fasten below the neckline, or on a sleeve. [J.A.]

Provenance: By descent in the family of the
owner.

Literature: George Wingfield Digby, *Elizabethan Embroidery* (London, 1963) p. 88.
Collection: The Duke of Buccleuch, Boughton House.

P19 James I, *c*1605-10
Attributed to John de Critz (1555-1641)
Oil on canvas. Size: 201 cm × 118 cm.

The King wears a padded doublet of white silk and trunk hose of black velvet embroidered with pearls. The hose are pulled up over the canions and tied with a ribbon garter on the right leg and the Garter on the left leg. The hat brim is caught up with the Mirror of Great Britain, a jewel made for James to symbolise the Union of the Kingdoms in 1604, described in the schedule of Royal Jewels in 1606: 'Item, a greate and Riche Jewell of gould, called the Mirror of Greate Brittaine, containing one very faire table diamonde, one very faire table-rubie, two other large diamonds cutt lozengewise, the one of them called the stone of the letter H. of SCOTLANDE, garnished with small diamonds, two rounde pearles fixed, and one fayre diamonde cut in fourcetts, bought of Sancy.' The Sancy diamond was one of the jewels of the House of Burgundy. When Charles the Bold died in battle near Nancy in 1477, the stone came into the possession of a priest, and later the King of Portugal, who gave it to Count Nicholas Harlay de Sancy. James bought the diamond in 1604 for 60,000 thalers and wore it in his hat for the coronation entry on 21st March. Another famous jewel formerly owned by Charles the Bold, the 'Three Brethren,'

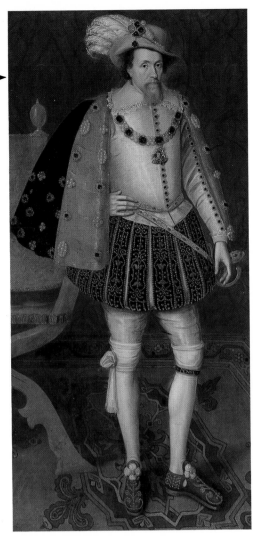

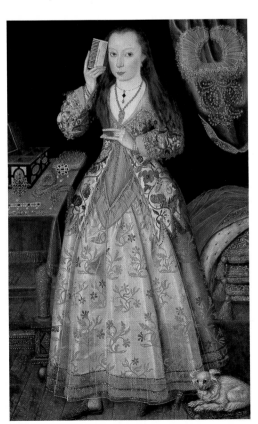

was also worn by James. It appears in the 'Ermine' portrait of Elizabeth (p. 38). James had it reset in 1623 for Prince Charles to wear as a hat ornament during his visit to Spain to meet the Infanta. The wide collar from which the Great George hangs seems to be that listed in the 1606 schedule as 'a Coller of gould containing thirteene great ballaces, and thirteen peces of gould with thirteen cinques of pearle between them.' This was a gift for the Infanta of Spain in 1623. [J.A.]

Provenance: By descent in the family of the owner.
Literature: R. Strong, *Tudor and Jacobean Portraits* (London, 1969) I, p. 179; *The Elizabethan Image* (Tate Gallery 1969), no. 174.
Collection: J. R. More-Molyneux, Esq., Losely Park.

P20 James I, *c*1605-10
Attributed to John de Critz (1555-1641)
Oil painting on panel. Size: 114.3 cm × 83.9 cm.

One of many similar portraits of James I, this version shows a padded doublet fastened with round gold buttons set with square table-cut

diamonds. James, according to Weldon's *Court and Character of King James* (1650) was 'of a middle stature more corpulent through his cloathes than in his body . . . the Doublets quilted for stiletto proof his Breeches . . . full stuffed: He was naturally of a timorous disposition which was the reason of his quilted doublets.' The painter has left out the buttonholes and arranged the top four buttons rather oddly, beneath the lace-edged open collar of his linen shirt. The cloak is lined with brown fur. The hat brim is caught up with one of the three legendary jewels of the crown, the Feather, which is described in the schedule of the Royal Jewels in 1606 as 'one fayre jewell, like a feather of gould, contayning a fayre table-diamond in the middest and fyve-and-twentie diamondes of divers forms made of sondrous other jewells.'

The wide collar with sets of four pearls, square table-cut diamonds and black enamelled esses is neither the usual design of collars of SS (cat. nos. 18, P3) nor of the Garter collars (cat. nos. 127, P22) as described by Ashmole in *The Institution, Laws and Ceremonies of the Most Noble Order of the Garter* (1672): 'Nor ought the Collar to be garnished or enriched with precious Stones (as may the George which hangs thereat) such costly embellishments being absolutely prohibited by the Law of the Order.' However, monarchs seem to have been exceptions to the rule. In 1587 Queen Elizabeth had 'a coller of golde contayninge xxiij^{tie} peeces whereof tenn peeces sett with two pearles in a peece and two peeces with one pearle in a peece and eleven peeces with Imagery of men and beastes . . . with a Flower of golde hanging at it having in it a George with one Emerod, three Rubies and two diamondes.' The Great George hanging from James's collar shows St George on horseback, killing the dragon. Elizabeth also had 'a litle garter wherein is a George of golde with an horse enameled white' and 'a litle George of golde' in 1587: both these were Lesser Georges and were usually suspended from the neck with blue ribbon. [J.A.]

Provenance: presumably painted for the 1st Earl of Haddington, 1563-1637.
Literature: R. Strong, *The English Icon*, (London, 1969) p. 264.
Collection: The Earl of Haddington, Tyninghame, Dunbar, (on loan to the Scottish National Gallery).

P21 Anne of Denmark. After the Paul van Somer portrait, *c*1617
Artist unknown.
Oil painting on canvas. Size: 62.9 cm × 53.3 cm enlarged to 77.8 cm × 63.5 cm.

Roy Strong has noted that this is after the Paul van Somer portrait of *c*1617 in the Royal Collection (Oliver Millar, *The Tudor, Stuart and Early Georgian Pictures in the Collection of Her Majesty The Queen* (1963) no. 106). Anne of Denmark wears three pieces of jewellery in the form of letters attached to her standing band, or collar with red

ribbon bows; the sacred IHS monogram with a cross, the crowned S for her mother Sophia of Mecklenberg and the crowned C encircling a 4 which alludes to her brother Christian IV of Denmark, a jewel given to her in 1611. In her hair she wears a jewel which may have belonged to Queen Elizabeth, as it fits a description in the inventory of 1600, 'a jewel of gold like a Crossbow garnished with diamonds.' Beside it is a margin note: 'Taken by the Kings Majestie, the 19 of May, 1603.' It may have been one of the first gifts which James presented to Anne on his accession.

The design of the jewel is similar to an illustration in Geoffrey Whitney's *Choice of Emblems* printed in 1586, with the motto 'Ingenium superat vires,' and the verse 'Man's wisedome great, doth farre surpasse his strengthe,/For proofe, beholde no man could bende the bowe:/But yet, his witte devised at the lengthe,/To winde the stringe so farre as it shoulde goe:/Then wisedome chiefe, and strengthe, must come behinde/But bothe be goode, and giftes from God assignde.' The neckwear is not observed very accurately and comparison should be made with cat. no. 118,

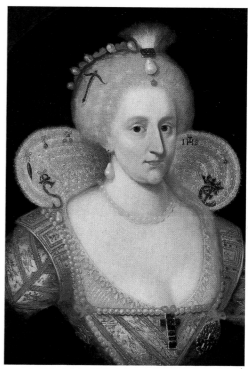

P21▲

where the standing band, or *rebato*, of needle lace is stretched over a wire frame with a fine semi-transparent starched lawn covering darted to shape placed over it, to prevent soiling. A matching pair of jewels are pinned, one on either side, on top of the covering in the miniature; these may have been used as hair ornaments on another occasion. In the portrait Anne wears a large table diamond set in gold with a small white feather. This may be the Mirror of France 'the fellowe of the Portugall Dyamont, quhiche I wolde wishe you to weare alone in your hatte with a litle blakke feather' as James I described it in a letter written to Prince Charles during his visit to Spain to meet the Infanta in 1623. A pendent pearl is worn beneath it here and beneath this a ruby, which may also have belonged to Elizabeth. Entered in the list of her jewels made in 1587 was 'a small pendant Rubie, to be worne on the forehedd.' The gold jewel set with diamonds and tied with a red ribbon at the neckline on Anne's left is probably a miniature case (*see* cat. no. 118). [J.A.]

Provenance: purchased from George Baker, 1861.
Literature: Janet Arnold, *Queen Elizabeth's Wardrobe Unlock'd* (to be published by Macmillan); R. Strong, *Tudor and Jacobean Portraits* (London, 1969) pp. 7-8.
Collection: National Portrait Gallery, London, no. 127. (On loan to the National Trust, Montacute House.)

P22 Henry, Prince of Wales, 1604
Artist unknown, English School.
Oil painting on canvas. Size: 134.7 cm × 100.6 cm.
Inscribed above '*Ae 10 A°1604*'.

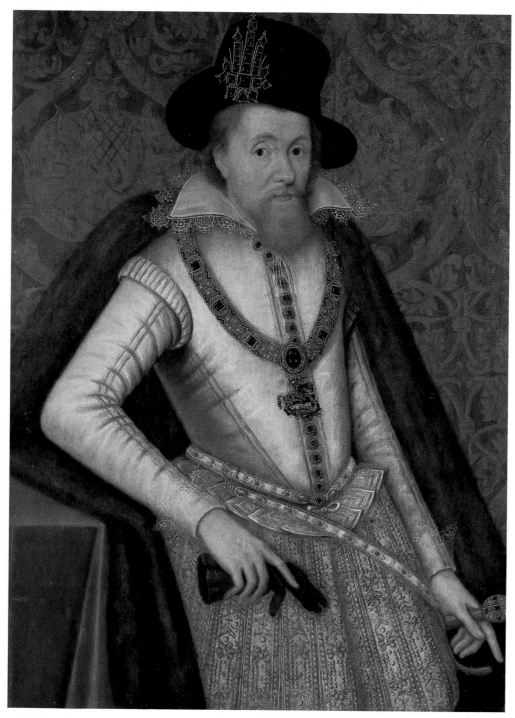

P20▲

Prince Henry wears the Garter robes over doublet and breeches of white cloth-of-silver. The red velvet surcoat, or kirtle, and deep prussian blue velvet mantle are both lined with white silk. The mantle fastens with laces of silk and gold, ending in large tassels. The Garter of the Order, embroidered with the motto '*Honi soit qui mal y pense*,' is fastened round his left leg. The Garter collar with red enamelled roses encircled with garters alternating with gold knots, the Great George suspended from it, hangs over his shoulders and is almost identical to that seen in cat. no. 127. For most of the Order's history the mantle has been blue, except between 1564 and 1637 when the colour was changed to purple, described in one contemporary account as fig brown. One mantle which survives today, was presented to Christian IV, King of Denmark and Norway, when he was installed as a knight by proxy in 1606. It is in very dark purple velvet, which might be described as aubergine or liver colour, a similar shade to a ripe fig. The kirtle or surcoat is described as crimson in contemporary accounts, so the colours of both this and the mantle have probably changed with cleaning. The black velvet hat is decorated with three white ostrich feathers held in position by a large jewel with a ship at the top, a cross of diamonds beneath and eight rubies standing away at the sides. Eight rows of diamonds radiate outwards from a central ruby in a circle at the bottom of the jewel, with a pendent pearl below. Two other jewels, similar in design, are placed above the brim, giving the effect of a crown. [J.A.] **P22 ▶**

Provenance: The Lords Berwick at Attingham Park, Shrewsbury; sold at Christies, 22nd July 1938, lot 108.
Literature: R. Strong, *The English Icon.* (London, 1969) p. 235; *The Winter Queen* Exhibition, (National Portrait Gallery London, 1963) no. 9; *Shakespeare* Exhibition (Stratford-upon-Avon, 1964) no. 44.
Lent by: the Earl of Mar and Kellie.

P23 Portrait of a Wife of a Councillor
Nicolas Juvenel, *c*1540-1597
Oil on canvas. Size: 97.5 cm × 82.5 cm.

South German, last third of the 16th century. Half-length portrait of a young woman in townswoman's dress: black velvet jacket with lace cuffs and lace ruff, red moiré skirt, and black apron. The black hat decorated with gold cord and gold jewellery consisting of slender chain, bars, rosettes, and a medallion with St George. Broad golden necklace with grotesque ornaments, an enamelled pendant with three stones and pendant pearl in acorn mounting, and two long gold chains. Two identical bracelets with alternating enamelled and triple-row pearl compartments. Six enamelled stone set rings, one stone heart shaped.

By comparison with the contemporary portraits of courtiers and royalty this shows how a well-to-do patrician lady continued to wear jewellery either made for, or in the style of, the previous generation. [I.H.]

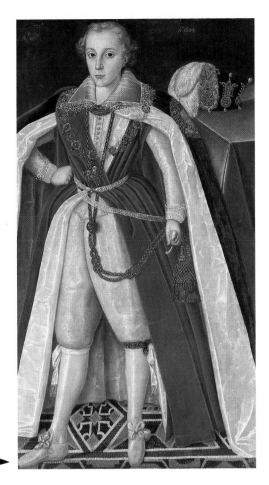

Literature: *Kataloge des Bayerischen Nationalmuseums Vol. VIII. Katalog der Gemälde des Bayerisches Nationalmuseums* (Munich, 1908) no. 775; *Studien zur Fugger Geschichte* Ed. Max Jansen, no. 2; G. Lill, *Hans Fugger und die Kunst. Ein Beitrag zur Geschichte der Spätrenaissance in Süddeutschland.* (Leipzig, 1908) p. 176; U. Thieme und F. Becker, *Allgemeines Lexikon der bildenden Künstler von der Antike bis zur Gegenwart* (Leipzig, 1926) p. 364 f.
Collection: Bayerisches Nationalmuseum. Inv. no. R 535.

P24 Maria, Duchess of Bavaria, wife of Archduke Charles of Austria, 1600-05
Ottavio Zanuolo (?)
Oil on canvas. Size: 61 cm × 53 cm.

Inscribed: MARIA DVCISSA BAVARIAE CONIVNX CAROLI ARCH. AVST. In 1571 Maria of Bavaria (1551-1608) married Archduke Charles, Duke of Styria (d. 1590) (who had earlier been considered as a possible husband for Queen Elizabeth I.) She must have been about 50 years old when this portrait was painted around 1600-05. The attribution to Zanuolo is on the grounds of the numerous references to him about this time in the Graz Court accounts as having painted portraits of the Archduchess—*see* J. Wastler, *Das Kunstleben am Hofe zu Graz* (Graz, 1897) p. 129.
Maria was the daughter of the Duke Albrecht V of Bavaria, a highly distinguished patron of the

arts, and of goldsmiths in particular, who set up the Wittelsbach *Schatzkammer*. Maria inherited his inclinations and she was especially fond of jewels; for the feast of St Nicholas in 1571, for example, her husband gave her 'five large Spanish roses (dress ornaments?) each set with three large round pearls' (p. 71). She was the mother of Anna, who married King Sigismund of Poland in 1592 (*see* cat. no. P25) and of Maria Christerna and Eleonora who entered the Convent at Hall in 1607 and presented their jewels to it (*see* cat. no. 72). Another daughter, Margareta, married the Infante Philip, son of Philip II of Spain (*see* cat. no. P26).

The Archduchess was a very pious woman who practised regular devotions, and could often be seen walking in open processions. As befits her widow's weeds she is wearing no purely decorative jewellery, but numerous religious pieces. A Virgin of the Pillar (*see* cat. no. 95) hangs around her neck, perhaps a present from her Spanish in-laws. On her right breast is an enamelled statuette of St Anthony of Padua, and a wooden cross with the name JESVS MARIA in gold upon it. On her left breast is a blue enamelled silver Tau Cross considered to be prophylactic because of the text in the Vulgate version of the

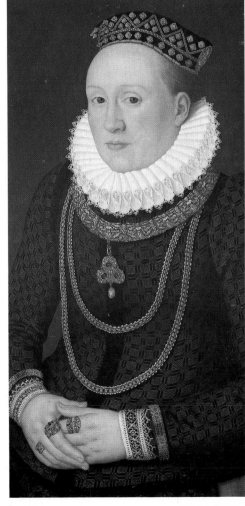

▲ P23

book of Ezekiel (IX, 4) which says that the elect have the '*signa Thau super frontes*' (the sign of Tau on their foreheads), and an enamelled gold medallion of the Virgin and Child. Below hang a gold medal with the head in profile of Christ, probably the medal by Antonio Abondio, in an enamelled scrolling frame, and a gold and black enamelled cross. [A.SC.] **P24** ▶

Collection: Bavarian State Paintings Collection. Inv. no. 4200.

P25 Anne of Austria, Wife of Sigismund III of Poland, 1595 (*see* p. 30)
Oil on canvas. Size: 232 cm × 144 cm.

Anne of Austria was the daughter of Archduke Charles of Austria and Duchess Maria of Bavaria (*see* cat. no. P24). She married Sigismund III of Poland in 1592. This painting is almost certainly one of the series of royal portraits painted by Marcin Kober, in 1595.

It is a state portrait with a canopy and cloth of honour behind her and the crown of Poland on the table beside her. The Queen is wearing her finest and most formal jewels, with a dress embroidered with pearls, while the black over-dress has jewels like cat. no. 72 sewn to it. A heavy enamelled gold chain set with pearls and rubies hangs over her shoulders. Attached to it is a very large pendant with an elephant. A string of pearls is looped up below, another large enamelled gold pendant set with gems hangs lower down while a richly jewelled belt comes to a point just beneath it. A jewelled monogram AS hangs by a ribbon from the jewelled biliment as though it were an ear-ring. Around her wrist she wears a pair of matching bracelets, and on her thumb a large table-cut diamond ring.

This illustrates the late 16th-century tendency to accumulate a great number of jewels on the upper part of the body, combining numerous chains and belts, often *en suite*, with a multiplicity of pendants. [A.SC.]

Literature: J. Ruszezycowna, 'Portrety Zygmunta III i jego rodziny' (Portraits of Sigismund III and his family) *Roczmik Muzeum Narodowego w Warszawie XIII/I* (1969); J. T. Petrus, 'Dzieciece portrety Wladyslawa IV i Anny Marii Wazowny w zbiorch hiszpanskich' (Imperial portraits of Ladislaw IV and Anna Maria Vasa in Spanish colls.), *Folia Historiae Artium* XX (1975); 'Miniaturowa galeria portretow podziny Zygmunta III' (Gallery of Miniature portraits of Sigismund III's family) *Biuletyn Historii Sztuki* XXXVIII (1975) pp. 153-157; *Court Art of the Vasa dynasty in Poland* Exhibition (Cracow, 1976) cat. no. 21.
Collection: Bavarian State Paintings Collection. Inv. no. 6992.

P26 Margaret of Austria, Queen of Philip III of Spain, 1605
Pantoja de la Cruz
Oil painting on canvas. Size: 212 cm × 130 cm.

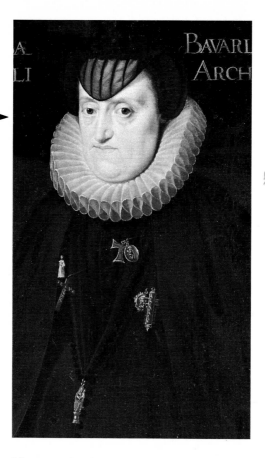

Margaret, daughter of Archduchess Maria (cat. no. P24) and sister of Queen Anna of Poland (cat. no. 25) was married to Philip III in 1599. This portrait showing the Spanish fashion, cone-shaped farthingale, close-fitting doublet encasing the body, high collar and ruff tight beneath the chin, was painted in 1605, after the signing of the peace treaty between England and Spain. This and a companion portrait of Philip were sent to England as a gift for James I. Margaret wears a gown of white silk with silver thread in the ground, with a woven design incorporating a gold castle (for Castile), a gold lion (for Leon), a black double-headed eagle with red and white shield (for Austria), a gold scallop shell surmounted by a crown (possibly for the Order of St Michael of France or signifying a pilgrimage to Santiago de Compstella), a spray of fleur-de-lis or lilies (perhaps for the Order of the Lily in Aragon), red flowers and green leaves bound together with a gold crown and a gold crowned monogram with three pearls across the centre, PL?MSH. Pearls are also stitched all over the fabric to enrich the pattern. The wide ruff is supported by a wire supportasse, with pendent pearls all round the edge. Large pearls are attached to a band of diamonds in red and white enamelled gold settings, decorating the hair. A black hat is tipped back on the head, the brim decorated with a double row of diamonds in plain gold settings. Two white feathers are held in position by a jewel with a large square diamond in a red and white enamelled gold setting. Priscilla Muller identified

the famous '*joyel de los Austrias*' or '*joyel rico*' created for the royal family at the beginning of the seventeenth century, worn immediately below the ruff. Its principal components were the Estanque, a 'most perfect' squared table diamond bought by Philip II from Carlo Affetata in Antwerp and first presented to Isabel of Valois, and the Peregrina, a 58½-carat pear-shaped pearl brought to Seville from Panama in 1579 and considered priceless by Trezzo. This pearl was noted in the inventory of Philip II's jewels as belonging to the Queen since February 1600: it is now owned by Elizabeth Taylor, given to her by Richard Burton. In 1605 Margaret wore the '*joyel rico*' during state functions and apparently at tournaments celebrating the baptism of the future Philip IV. It was described in the seventeenth century as having fruit and flowers in relief, enamelled in diverse colours, some black and white '*cuerdas*' or cords—probably a Moresque design—on its reverse. The enamels of the setting at the front are red, black and white, as in the inventory. The jewel is apparently attached to the bodice with a type of ring brooch, but in the equestrian portrait of the Queen by Velasquez and his studio, where the jewel is more freely executed without the fine detail, it is attached to the gown with a ribbon bow. The girdle and pair of bracelets are designed *en suite* with a square table diamond and two pearls arranged alternately in gold settings, enamelled white. Each jewel clasping the hanging sleeves at top and elbow has three square table-cut diamonds in a gold setting enamelled white and red. The sleeve linings are of white satin printed, or stamped, with hot irons to give the pattern. Jewels matching those on the sleeves are placed on each tab of the shoulder wings and two on the centre-front bodice. Eight pairs of aglets with ribbon loops of white silk, with silver weft threads, decorate the centre front skirt. Each aglet is four-sided, of red and white enamelled gold, with four oblong diamonds and one triangle diamond on each side. The new style of jewellery, where attention is focussed on gems rather than settings, is seen in the heavy chain of lozenge and circular shaped links of gold. Each lozenge is set with twenty-five diamonds without foil, the alternate spaces being either enamelled black, or possibly left open with dark shadows behind. Every circle is set with twenty-seven smaller diamonds without foil. [J.A.]

Provenance: painted for James I, with a companion portrait of Philip III of Spain.
Literature: Oliver Millar, *Tudor, Stuart and Early Georgian Pictures in the Royal Collection* (London, 1963) I, pp. 14-15; Priscilla E. Muller, *Jewels in Spain 1500-1800* (New York, 1972) pp. 53-54; *Catalogue of the Spanish Exhibition* (Bowes Museum, 1967).
Collection: Royal Collection, Hampton Court Palace. Inv. no. 1492.

P27 Prince Wladislaw Sigismund, later King of Poland, c1605
Artist unknown, Polish School.

Oil on canvas. Size: 165 cm × 109 cm.

Wladislav Sigismund was the son of Sigismund III and Anna of Austria (*see* cat. no. P25). He reigned from 1632-1648. Here he is depicted wearing a suit of white silk embroidered with gold thread which was almost certainly the costume he wore at the wedding of his father to Constance of Austria in 1605, when he made his first public appearance. The hilt of his sword, and his sword belt, are richly bejewelled with diamonds and rubies, and there are diamond and ruby buttons at his shoulders, down the front of his jacket, and the seams of his hose. The most spectacular item of his attire, though, is the jewelled aigrette with its enamelled figures of Victory and its jewelled band. Another portrait of him in the Warsaw National Museum, Royal Castle Collections (Inv. no. 145) shows this same bejewelled hat.

For an approximate contemporary, but less lavish, aigrette *see* cat. no. 125l, worn by Francis I, Duke of Szczecin and West Pomerania. [A.SC.]

Provenance: it may have been part of the dowry of a Princess Anne Catherine Constance and was bought to Germany in 1642.
Collection: Bavarian State Paintings Collection. Inv. no. 6617.

P28 Elizabeth of France, Queen of Spain, *c*1615
Frans Pourbus (1569-1622)
Oil painting on canvas. Size: 193 cm × 117 cm.

The subject of this portrait was previously assumed to be Christine of Savoie and is now thought to be Elizabeth of France, daughter of Henri IV, who married Philip IV of Spain. This portrait is another version of the portrait at the Musée des Beaux Arts, Valenciennes, called 'Dorothée de Croy', *see* Evans (1970) pl. 101. A third version is in the Bavarian State Paintings Collection and a fourth in the Pitti Palace, Florence. The daughter-in-law of Margaret of Austria, Queen of Spain, (cat. no. 26), Elizabeth wears equally rich jewels, but demonstrates the increasing importance of gems instead of elaborate settings. Her gown is of black silk with a woven design of russet and white (possibly silver) stylised leaves, pomegranates and pineapples. The inverted V-shape of the forepart, hanging-sleeve linings and lower layer of the paned sleeves are of white silk with a woven design of stylised flowers and leaves in yellow ochre silk or gold thread, with small red flowers and green leaves growing from them. Bands of white satin embroidered in gold and silver thread are mounted diagonally on the forepart and round the hem, at the front skirt edges and on the bodice of the gown. The sleeves are formed from matching bands arranged diagonally and caught in with narrow strips of braid. Inside the hanging sleeve from below elbow level to hem are pinned six gold jewels set with small diamonds and pearls. On the centre front embroidered band in the forepart are eight jewels of a different design (nine in the Valenciennes version) with nine on each side of

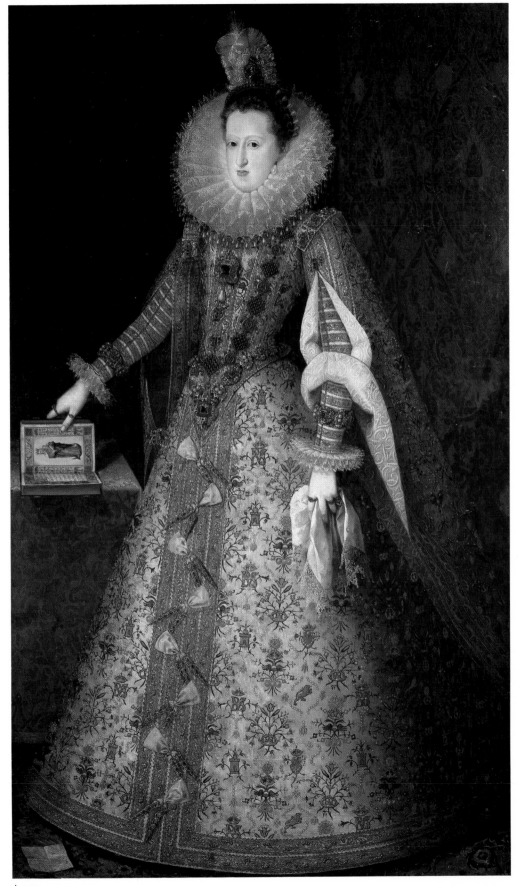

▲ **P26**

the front skirt of the gown to match (ten in the Valenciennes version). Each contains one large square diamond surrounded by eight small diamonds in a gold and red enamelled setting. A chain of matching jewels separated by single diamonds set in gold is worn round the shoulders, caught together at the front, and hangs in a loop to the waist. Above it the tucked white lawn partlet may be seen beneath the lace-edged ruff. A large jewel designed *en suite* is worn over the chain at the front. It is heart-shaped, surmounted by a crown, with one large diamond and others of varying sizes set in gold. The girdle is made of gold links set alternately with two square table-cut diamonds and one cut in octagonal form giving the effect of a circle. A different girdle is worn in the Valenciennes portrait, with alternate links of large oblong diamonds and square diamonds in a petal setting, the latest fashion. Elizabeth's ear is pierced to wear the pearl attached to a plain gold wire. The ear-ring in the Valenciennes portrait has a diamond above the pearl. Almost concealed by her hair, Elizabeth wears a diamond set in gold

with a pendent pearl attached to a band of diamonds. In the Valenciennes portrait two larger pieces of jewellery are worn, one in the centre of her hair, the other at the side. The latter has seven large pear-shaped diamonds cut with facets and two large square diamonds, all of which appear to be set so that they would move independently as the wearer turned her head. These variations in the jewellery between the two portraits would indicate that the Parham version was painted first, perhaps at Elizabeth's betrothal, and the Valenciennes version was painted after her marriage, when she was Queen of Spain. [J.A.]

Provenance: Collection of Mrs Lyne Stevens 1895; Collection of Miss N. Oswald Smith, Shottesbrook Park, Maidenhead.
Collection: Parham Park.

P29 Lady Anne Erskine, Countess of Rothes with her daughters Lady Mary and Lady Margaret Leslie, 1626
George Jamesone (1589/90-1644)

Oil on canvas. Size: 219.4 cm × 135.3 cm.

Inscribed: *Effigies Nobilissimae Anna Rothesiae et Leslei Domina et [coet. quam] ad vivum depinxit Georgius Jamsonus Abirdonensis An[n]o 1626*; beneath child on right *Aetatis 5*; beneath child on left *Aetatis 6*. Also later inscription: *Lady Ann Erskine 2 [n]d Daughter of John, Earl of Marr, Married to John, 5th [sic] Earl of Rothes*; and below the children *Lady Margaret Leslie; Lady Christian [sic] Leslie.*

The Rothes family was not an exceptionally wealthy one but the Countess appears before us clad in the height of fashion, with jewellery entirely typical of the period. A generation earlier, ladies had achieved a sumptuous magnificence by wearing heavy neckchains and stones in elaborate settings either pinned or sewn directly onto their garments. Now there was a desire for a less overpowering effect and, as cutting techniques improved the brilliance of the stones, the settings became less important. The intricate splendour of the late sixteenth century had not yet vanished but it was gradually disappearing.

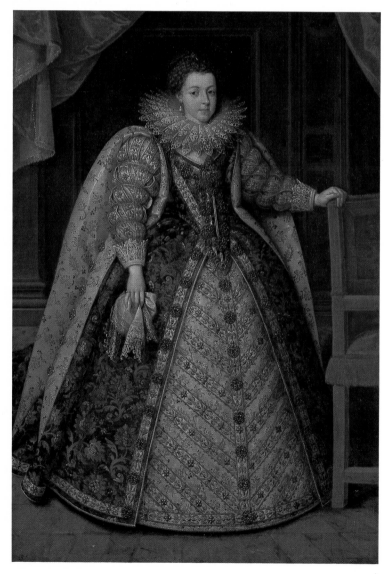

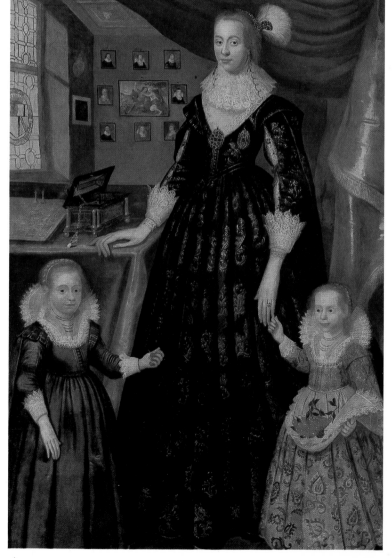

P28 ▲ **▲ P29**

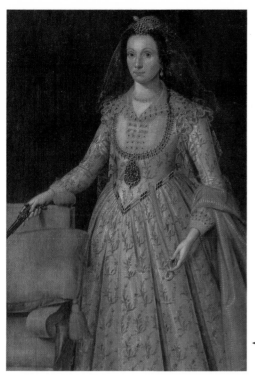

No longer was a hood trimmed with jewelled biliments worn on the head. Instead, the Countess has a jewel-studded band with an aigrette and a large plume. This is a style which first appeared in Scottish portraits about 1620 and it died out just after the Countess's picture was painted. Equally in vogue are her ear-rings or, to be more precise, earstrings. These curious short cords terminating in small jewels found favour with Anne of Denmark and her contemporaries. Quite often the jewel was in the form of a symbolic device or a monogram and occasionally the string was replaced, as it is here, by a long, loose corkscrew of hair. Like the plumed biliment, earstrings seem to have been adopted in Scotland about 1620, adding an unusual, almost bizarre touch to ladies' dress. They are usually worn with a falling ruff of the kind seen here, presumably because it showed them off to best advantage.

Unlike their English counterparts, Scottish ladies do not seem to have developed the earstring idea further by using cords or ribbons to attach their finger rings to their bracelets. The Countess wears on her left hand a ring set with five dark stones surrounding what may be a heart-shaped central stone. Round her right wrist she has bracelets which appear to be composed of gold, pearl and coral. These are very light and delicate, essentially modern in feeling. By contrast, the two large jewels on her bodice and the pendant spilling from the box on the table are of a style fast becoming outmoded at that time. Sometimes the stones in this type of ornament are arranged to form a monogram or emblem and they echo the elaborate jewels worn thirty years before. They do appear in various Scottish paintings of the 1620s, however, and almost invariably they are

associated with plumed biliments and earstrings.

Finally, the Countess's two small daughters wear biliments of gold, pearl and coral, and round her neck each has five strings of small coral beads. By the time the girls reached adult life, fashions in both clothing and jewellery would have undergone a transformation. However the pale, elegant silks and the ubiquitous pearls of Charles I's Court still lay in the future. [R.K.M.]

Provenance: Rothes Collection at Leslie House; collection of Sir Robert Spencer-Nairn after his purchase of Leslie House; sold at Christie's 18th December 1967 and again 22nd June 1973, lot 17. Purchased by the Fine Art Society, then by Oscar and Peter Johnson. Sold to the Scottish National Portrait Gallery, February 1980.
Literature: Rosalind K. Marshall, 'Jewellery in Scottish Portraits 1560-1700' in *The Connoisseur*, (April 1978) 283-91; D. Thomson, *The Life and Art of George Jamesone* (O.U.P., 1974) cat. no. 7.
Collection: Scottish National Portrait Gallery. PG 2456.

◄ **P30 Teresia Lady Shirley, between 1624 and 1627**
Oil painting on canvas. Size: 214 cm × 124 cm.

Teresia Shirley was the daughter of Ismael Khan, a noble Circassian living in Persia. She married Sir Robert Shirley (c1581-1628) the traveller in Persia, some time before 1607. He returned to Europe with Teresia in February 1607/8 as envoy of Shah Abbas, and was received at many European Courts. Rudolph II made him a Count Palatine in 1609, and in August 1611 he reached England where he was entertained by James I. In January 1613 he set off again for Persia; he was in England again only between January 1624 and March 1627.

Because of the style of the dress, this portrait must date from the second stay in England. It is made of brocaded Italian silk and has a distinctly oriental flavour with its sleeveless surcoat. The jewellery, however, is European. There is a parallel example of her jewelled headdress in the Jacob Mores Jewellery book (cat. no. G35) fol. 20, which dates from between 1593 and 1607. Cat. no. 119 is a jewelled chain and pendant of rather similar appearance to Lady Shirley's and definitely made in the British Isles.

Lady Shirley also holds a jewelled pistol of the 'fish-tail' variety, and an open watch in the other hand. No satisfactory explanation for this has yet been given. [A.SC.]

Provenance: unknown, but the frame of this and its companion portrait, Sir Robert Shirley, are the same as those on a group of early Stuart portraits at Berkeley Castle, so it has probably been there since the 17th century.
Literature: I. Eaves, 'Further Notes on the Pistol in early 17th century England', *Journal of the Arms and Armour Society*, VIII, (1974-77) pp. 292-311.
Lent by the Trustees of the will of the late Earl of Berkeley.

Graphics

G1 The Llibres de Passanties, Vols. I and II
(*see* p. 6)
Two of seven volumes of designs for the objects made by apprentices aspiring to masterships in the Barcelona goldsmiths' guild. Vol. I: pen and ink and watercolour, drawings on paper. 93 pages, 30 cm × 19.6 cm. Bound in cardboard. Vol. II: 349 pages with four pages of index, 33.7 cm × 23.2 cm. Bound in vellum.

In all goldsmiths' guilds the apprentice had to pass various tests before being made a master. In the Spanish guilds the examination was both theoretical and practical. The former was oral, and for the latter the aspirant had to present his masterpiece. In Seville, he had to copy an existing design, but in Barcelona he could submit his own. These designs dating from 1500-1800 are bound together in these volumes. The earliest dated drawing in Vol. I is 1518 (fol. 63) while in Vol. II the earliest is 1532, the latest, 1618. Most designs are signed and dated within a decorative cartouche and the volumes are an invaluable record of the styles current at the time. Barcelona obviously had a flourishing goldsmiths' guild because together with Valencia, it had been one of the most important centres in the Western Mediterranean for the exchange of precious stones, and as in Antwerp, this trade encouraged the jewellers' craft.

The designs are rarely very original, and some are quite obviously derivative (e.g. fols. 199 and 353 in Vol. II which are based on published designs by Pierre Woeriot the Frenchman, and the Flemish Collaert family) so it is rare to find something peculiar to Spain. The majority of the jewellery designs (many are for vessels) are for pendants but aglets, links of chains, rings, dress jewels and pomanders also occur.

Similar design books survive for the guilds of Valencia and of Gerona, the former in the Archive of the Diputacion of Valencia, the latter in the Biblioteca of Catalonia. [A.SC.]

Provenance: the Goldsmiths' Guild of Barcelona.
Literature: M. Gonzales y Sugranes, *Contribucio a la Historia dels Artiscles Gremis dels Arts y oficis de la Ciutat de Barcelona* (Barcelona, 1915) II pp. 167-294; Ainand/Gudiol/Verrie, *Catalogo Monumental de Espana. La Ciudad de Barcelona* (Madrid, 1947) pp. 318-319; J. Subias Galter, 'Los libros de Passanties', *Goya* LII (1963) pp. 224-228; *Guia del Museo*, Museo de la Historia de la Ciudad Guia del Museo (Barcelona, 1969) p. 131; P. G. Muller, *Jewels in Spain 1500-1800* (New York, 1972); A. Duran Sanperre, *La Societat i l'organitzacio del treball* (Barcelona, 1973) II pp. 410-421; M. de Dalmases, L'orfebreria

G2

barcelonese del riglio XVI a traves de los 'Llibres de passanties', *Rev. Dep. Historia del Arte Universidad de Barcelona*, III-IV, pp. 5-30; N. de Dalmases, *L'orfebreria* (Barcelona, 1979); A. Gou Vernet, *Aportacion al estudio de la orfebreria y joyeria de Barcelona en los siglos XVII al XIX* Doctoral thesis in preparation at the University of Barcelona; F. P. Verrie 'Es Llibres de passantia dels argenters barcelonins' in *Plata Espaynola de del segle XV al XIX* (Barcelona, 1980).
Collection: Museo de Historia de la Ciudad, Barcelona. Inv. nos. 656, 657.

G2 Design for a gold girdle

Giulio Romano (Giulio Pippi) *c*1499-1546.
Pen and brown wash, over light-black chalk. On four pieces of paper, joined. Size: 26.5 cm × 37.8 cm.

Design with a human mask, snakes and acanthus ornament and lion terminals. One of the terminals repeated, and a rough sketch of the Gonzaga eagle. Inscribed *Cinta d'oro fatta al a Vincentio guerin* (Querini?). A double-looped object in the V&A album, cat. no. G3j, may be a linking element for a similar girdle. [M.S.]

Provenance: bequeathed to Christ Church by General John Guise, 1765.
Literature: J. Byam Shaw, *Drawings by Old Masters at Christ Church, Oxford* (1976) no. 432, pl. 230; F. Hartt, *Giulio Romano* (1958) no. 127, fig. 148.
Collection: Christ Church, Oxford. No. 0853.

G3 Album containing 92 drawings of goldsmiths' work

Pen and ink and wash over black chalk.
Seventy-one designs by Giulio Romano or his studio, all contained in a late eighteenth or early nineteenth century album.

Giulio Romano

a) A collar of foliate ornament set with pearls, all within ropework borders, at the centre a square stone and a suspended pearl beneath. (41)
b & c Two necklaces, the links formed as S scrolls and knotted loops. (44 & 45)
d) A belt link or buckle formed of strapwork and foliage. (47)
e) Two necklace links formed of interlaced foliate loops set with pearls. (48)
f) Three tapering necklace(?) links joined. (52)
g) Two necklace links formed as flowers and knotted loops. (56)
h) A link in the collar of the Order of the Golden Fleece. Retouched by another hand. (57)
j) A necklace, the links formed as cut curving tubes and knotted looped cloths. (59)
k) Two snakes intertwined to form two large loops, possibly for a belt (60) (*see* cat. no. G2).

Studio of Giulio Romano

l) Four differing tapering necklace links arranged in a circle. (33)
m) Two links of a collar or belt, set with pearls. (43)
n) A buckle(?) formed of two cut loops set with pearls, attached to a chain composed of repeating husk elements. (50)
o) Two belt(?) links formed as foliate scrolls enclosing masks. (55)
Formerly catalogued as anonymous drawings of the school of Raphael, these designs have recently been placed with Giulio; the detailed attributions are due to Mr John Gere.
Giulio Romano was called in 1524 to the Gonzaga court in Mantua where he worked as a painter, architect and designer. According to Hartt (F. Hartt, *Giulio Romano* (1958) I, p. 71) the Gonzagas were particularly fond of jewellery, and Giulio is known to have designed jewellery for Federigo II Gonzaga's mother, Isabella D'Este, in about 1526 (F. Hartt, I, p. 86). It replaced pieces which had been melted down in 1516. The fleshy naturalistic forms of many of the present designs are apparently characteristic of Giulio's jewellery and differ from the stiffer and more architectural forms of most Italian Mannerist jewellery. A heavy gold chain necklace composed of crossed curved tube-like elements very similar in feeling to the present designs, is present in a portrait by Giulio of Isabella D'Este at Hampton Court. Hartt suggests that both the costume and the jewellery of the portrait were designed by Giulio. A similar chain is also shown in a portrait by Pontormo of a lady traditionally described as the Duchess of Urbino (Kunstinstitut, Frankfurt). It dates from the 1530s. Also of the same period is Titian's portrait of Eleanora Gonzaga, Duchess of Urbino (Uffizi, Florence) in which a chain of set stones alternating with knotted elements similar to the present designs is shown.

The design for the collar of the order of the Golden Fleece is presumably connected with its presentation in 1531 to Ferrante Gonzaga, Federigo's younger brother and a general in the service of the Emperor Charles V. Also in the album are sketches of sea animals which may be related to a design for a salver made for Ferrante, now at Chatsworth, and a design for a stand bearing the arms of Cardinal Ercole di Gonzaga

G4a

G3

(created Cardinal in 1527). Hartt proposes that Giulio's Mantuan designs for goldsmiths' work were made between 1524 and 1526, before he became fully occupied with the Palazzo del Te, but the collar of the Golden Fleece here suggests that he designed jewellery until at least 1531. [M.S.]

Provenance: E. Parsons, 1883.
Collection: V&A. Inv. no. 8951 (1-91).

G4 Designs for fan-holders
Studio of Giulio Romano
a) Pen and ink and wash and gold paint. 3 designs on 1 sheet. Size: 30 cm × 18.4 cm.

The handles are formed as demi-figures of putti, one of whom bears a basket on his head, from which spring acanthus scrolls into which the ostrich feathers of the fan have been placed; attached to the bottom of the handle is a chain composed of looped and cut branches connected by straps. *c*1540?
b) Pen and ink wash. 3 designs on 1 sheet. Size: 30.5 cm × 19 cm.
Formed respectively as a peacock's head and neck, a swan with raised wings, and knotted branches and acanthus. To each is connected a chain. Two are formed as looped and S-scroll cut branches, and one as knotted cloth. *c*1540?

The drawings are by the same hand. The attributions are due to Mr John Gere. Several elements are close to Giulio's decorative style, notably the cut-branch and knotted-cloth chains which can be compared with cat. no. G3i, and the supports of a design for a dish in the British Museum (P. Pouncey & J. A. Gere, *Italian Drawings, Raphael and His Circle* (1962) 130 *recto*, pl. 105). The other drawings apparently by the same hand were acquired with the fan-holder designs; one is a copy of the British Museum drawing cited above, the other a design for a candlestick in the style of Giulio. Nevertheless, the hesitation in the handling of parts of cat. no. G4a suggests that at

any rate it is an original design and not a copy of another drawing. The putto-shaped handles recall the fan-holder design by Lelio Orsi (cat. no. G6), who was strongly influenced by Giulio. A design for a fan-holder in the Uffizi, which has been attributed to Orsi, (repr. *L'Arte*, III, 1900, p. 27, and Y. Hackenbroch, *Renaissance Jewellery*, G96) contains several elements reminiscent of cat. no. G46, and can be more securely attributed to the studio of Giulio Romano. [M.S.]

Provenance: A. W. Thibaudeau.
Collection: V&A. Inv. nos. 8624A, 8624D.

G5 Design for a fan-holder
Francesco Salviati (1510-63)
Pen and brown wash. Size: 20.3 cm × 11.6 cm.

The handle formed of scrolled mouldings, the upper portion as an elaborate frame incorporating eagles, dogs, and lion masks, all enclosing a seated figure holding a mirror.

Catalogued by Popham as by Lelio Orsi. John Gere, James Byam Shaw and Timothy Clifford have all independently pointed out its closeness to the style of Salviati, a Florentine painter who designed a considerable amount of metal-work. [M.S.]

Provenance: P-J. Mariette (Lugt 1852); Count M. von Fries (L.2903); C. Poggi (Lugt.617); W. S. Sheperd.
Literature: A. E. Popham, *Italian Drawings. Artists working in Parma in the Sixteenth Century* (1967) no. 54, pl. 42B; J. Byam Shaw, *Drawings by Old Masters at Christ Church, Oxford* (1976) p. 287.
Collection: British Museum. No. 194 8.1.9.3.

G4a

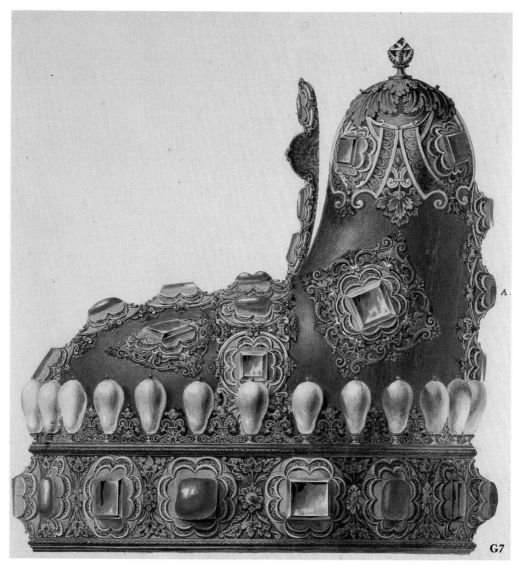

G7

G6 Design for a fan-holder
Lelio Orsi (1511-1587)
Pen and brown ink over black chalk. Size: 35.3 cm × 24.8 cm.

The handle formed as a demi-figure of a putto, supporting an oval frame containing a figure of a female warrior and a dragon's head on each side.

Orsi, a painter, architect and designer of metal-work, worked in Reggio, Novellara, Venice and Rome. His work was strongly influenced by Giulio Romano; the putto handle of this design should be compared with the Giulio studio design (cat. no. G4). Giulio's influence is also visible in two other designs by Orsi for fan-holders (J. Byam Shaw, *Drawings by Old Masters at Christ Church, Oxford* (1976) nos. 1130, 113, pl. 670). A design for a fan-holder in the Uffizi which has been attributed to Orsi is discussed under cat. no. G4. [M.S.]

Provenance: Sir T. Lawrence (Lugt. 2445); S. Woodburn; W. B. Tiffin.
Literature: A. E. Popham, *Italian Drawings. Artists working in Parma in the Sixteenth Century* (1967) no. 45, pl. 42A.
Collection: British Museum. No. 1860-6-16-17.

G7 The Doge's Corno (horn or cap)
Watercolours heightened with gold. Size: 35.6 cm × 28.5 cm.

Inscribed: 'The Corno or rich State Crown carried before ye Doge of Venice twice a Year; preserved in ye Treasury of St. Mark at Venice. The State Horn or Crown Carryed before ye Doge of Venice at his Coronation; ye Cap is of Crimson velvet, ye Circle & ornament are all of beaten-gold most exquisitely wrought & enamelled; in ye circle are seven large and fine Emeralds, and as many Ballasses; Ye in border behind marked A, is a Balass of wonderfull beauty & value: on ye rim of ye said circle are 24 pearls of a large Size & extraordinary colour, ye Diamond on ye top of ye Horn was presented to ye Republick by Henry III King of Poland at his return to France. The Nuns of St Zacharia

116

presented this Crown about a hundred years ago to ye State, on condition ye it should be showed annually in a procession wherat ye Doge is always present. Delin 1719.'

The Horn or 'Corno' was used as the Ducal crown for the Doges of Venice from the fourteenth century, and was worn at the Coronation of each Doge from 1485 until the absorption of the Venetian Republic into the French Empire in 1797.

This particular Doge's Cap once formed part of the Treasury of St. Mark's, and can probably be identified with the '*Corno ossia Corona Ducale con pietro preziose e perle*' from the first *cassone* listed in the inventory taken in 1797 when Napoleon's demands for a huge indemnity from the Italian States made the dispersal of the precious objects from this, the Cathedral Treasury at Monza and the Papal Treasury in Rome a necessity. The pearls from the 'Corno' were regarded as the most valuable stones, and accordingly, three jewellers were summoned to the Palazzo Ducale to dismantle the 'Corno' as well as many other gem-set pieces from the Treasury. A full account of this is given by Alvise Zorzi in *Venezia Scomparsa* (1971) vol. I, pp. 51 f. This album of drawings assembled, and partly executed, by John Talman, the architect of Chatsworth and a notable collector, contains records of other famous jewels which are now lost including the gem-encrusted Papal tiara made by Caradosso for Julius II and the even more famous Morse designed by Benvenuto Cellini for Clement VII. The tragic act of vandalism which resulted in the destruction of Cellini's Morse was witnessed by the Papal goldsmith, Spagna, who had, as a young apprentice, assisted at the dismantling of the jewellery from the Papal Treasury (*see* Revd. Herbert Thurston, S.J., 'Two Lost Masterpieces of the Goldsmith's Art', *The Burlington Magazine*, vol. VIII (1905) pp. 37-43). [C.G.]

Collection: British Museum. No. 1893-4-11-10. (15).

G8 Gold enamelled ring set with an aquamarine from Monza

Gold paint overlaid with black, and watercolours. Size: 9.2 cm × 9.4 cm.

Inscribed: 'The ring which ye Arch-Priest of ye Collegiate Church of Monsa near Milan, useth when he celebrates Mass. It is of gold enamelled & set w: an Aqua Marie. T. Grisoni delin 1719.'

The ring is not among the treasures now at Monza. Several pieces of great historic significance were dispersed in 1797 with the objects from Venice and Rome. The ring is from the smaller of the two albums of drawings collected by John Talman, which includes the same sort of material as the larger album. Three artists assisted Talman in the execution of these elaborate record drawings of architectural details, vestments and jewelled and precious objects, Giuseppe Grisoni, Pietro Santo Bartoli and his son Francesco. A detailed history of the albums is to be included in the forthcoming *Catalogue of*

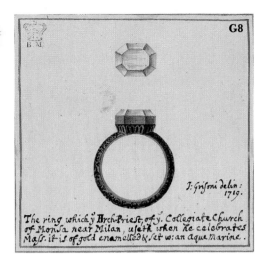

British Drawings in the British Museum. [C.G.]

Collection: British Museum. No. 1928-3-10-91 (39).

G9 Copy Drawing of the Medici Crown
Giovanni Casini (1689-1748)
Pencil, pen and ink, and water-colour. Inscribed: *Corona di Casa Medici*. Size: 20 cm × 31.1 cm.

Drawing showing the exterior and the interior decoration of the rays. Early eighteenth century.

Cosimo I Medici was granted the right to use the title of Grand Duke of Tuscany in December 1569, and a crown was made for his coronation, which took place in March 1570. The form of the Grand Ducal crown had been laid down in the Papal Bull of Sanction which included a drawing showing a crown of the ancient radiate type, having 17 rays, a red fleur-de-lis (denoting St

John) in the front, and an inscription. Between 1577 and 1583 the Medici goldsmith Jaques Bylivelt of Delft made a second crown, perhaps using material from the first, and it is this crown which is shown in the present drawing. The crown is now lost; it was last mentioned in 1788 and presumably disappeared during the Napoleonic occupation of Florence.

The crown was of enamelled gold, the large fleur-de-lis being set with eleven rubies, and the rest of the crown with a very valuable collection of emeralds, rubies and diamonds and pearls, all supplied and cut by Venetian craftsmen. By the date of the execution of the drawing a number of the original stones had been changed, and a row of pearls removed from the lower edge of the circlet. The elaborate red, green and black enamelled decoration was also applied to the inside of the circlet and the rays. Its character reflects Bylivelt's northern origins and recalls the engraved designs of Etienne Delaune and Hans Collaert. The crown was accompanied by a red satin cap.

This drawing has been associated with a group of drawings of regalia prepared for John Talman (1677-1726), others of which are in the British Museum. A letter from Talman to the Florentine painter Giovanni Casini dated 1710 (Bodleian, MS. Eng. Lett. e34, fol. 108), mentions a drawing of a crown in the Medici *Guardaroba* which Talman hoped Casini had begun. Also in the V&A is a pencil sketch (Inv. no. E.305-1940), probably for John Talman, of a base-metal radiate crown which is listed in the *Guardaroba* inventory of 1744. This crown has also disappeared. The drawing is inscribed 'Grisoni 1715'. Giuseppe Grisoni carried out a number of the regalia drawings in the British Museum. [M.S.]

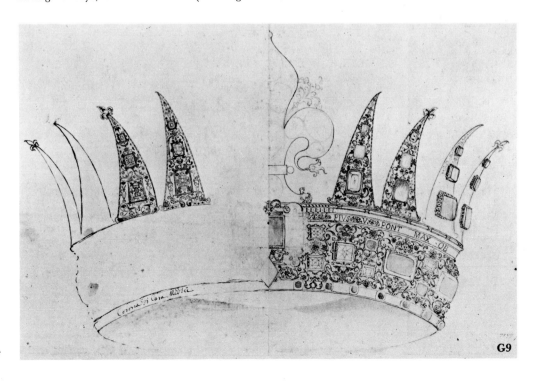

G9

Provenance: bought in 1871 together with a collection of drawings of jewellery formerly attributed to the Santini family of Florentine goldsmiths.

Literature: J. Hayward, 'An Eighteenth-Century Drawing of the Grand-Ducal Crown of Tuscany', *The Burlington Magazine*, XCVII (1955) pp. 308-310, and a letter in *The Burlington Magazine*, XCVIII (1956) p. 243. C. W. Fock, 'The Medici Crown: Work of the Delft Goldsmith Jaques Bylivelt', *Oud Holland*, 85, (1970) pp. 197-209 Birmingham Museum and Art Gallery, *Jewellery* (1960) no. 450.

Collection: V&A. Inv. no. 7899.1.

G10 Three groups of jewellery designs by or attributed to Hans Holbein the Younger (1497/8-1543)

These drawings all come from Additional Ms. 5308, which was transferred from the Department of Manuscripts to the Department of Prints and Drawings in the British Museum in 1860. Unfortunately the volume which contained this large and important collection of designs by Holbein for jewellery, metalwork, weapons, medallions, ornamental motifs, lettering, etc. is now missing, and one suspects was destroyed at the time of the transfer. With a few exceptions, two of which occur in the groups of designs displayed here, all the drawings can be credibly attributed to Holbein on stylistic grounds. The extraneous drawings could, of course, have been added at any time to the volume which came to

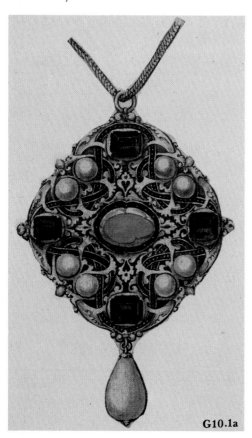

G10.1a

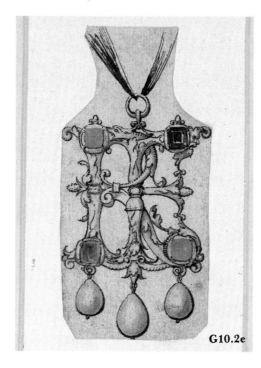

G10.2e

the Museum as part of the bequest of its founder, Sir Hans Sloane, in 1753, on the assumption that they were also by Holbein. But this is perhaps more likely to have happened before rather than after 1753.

Unlike the metalwork designed by Holbein of which one notable example is still extant, there is no piece of jewellery surviving whose design can be attributed with certainty to Holbein, although there are a few that might broadly speaking be called 'Holbeinesque' in manner. It would seem, however, that none of the jewellery work designed by him has survived or possibly, in some cases, that the designs were never realized, where Holbein's command of intricate detail strained or outstripped the capacity of the jeweller. Certainly there are several instances of Holbein's sitters, especially those of his later English period (1532-1543) wearing Holbeinesque jewellery which echo many of the ideas expressed among the designs at the British Museum and at Basel. A striking case of a jewellery design (not exhibited here) corresponding to a piece worn by a sitter is the design of a jewelled medallion with 'Lot and his family fleeing from Sodom', which also occurs in the magnificent portrait of a woman called 'Catherine Howard', now at Toledo, Ohio. A single gemstone, or perhaps crystal, in the centre of the design was intended to represent the block of salt into which the disobedient wife of Lot is transformed. The question of the dating of the designs cannot be discussed at length now: however, those exhibited here by Holbein seem to be from the artist's second stay in England, (*c*1532-1543).

Most of the drawings have been silhouetted within the outline of the design, presumably when they were put into the volume that was in the Sloane collection. [J.R.]

1 a) Design for a pendant set with a ruby, sapphires and pearls.
Pen and black ink, with black, grey, light brown and red washes, touched with white bodycolour.
Size: 11.6 cm × 6.4 cm. Inv. no. 5308-107.
b) Design for a pendant set with sapphires and pearls.
Pen and black ink, with black, grey and light brown washes, touched with white bodycolour.
Size: 13.5 cm × 6.6 cm. Inv. no. 5308-95.
c) Design for a pendant set with sapphires and pearls.
Pen and black ink, with black, grey and light brown washes, touched with white bodycolour.
Size: 9 cm × 5.3 cm. Inv. no. 5308-104.
d) Design for a pendant set with sapphires and pearls.
Pen and black ink, with black, grey, and light brown washes, touched with white bodycolour.
Size: 11.2 cm × 6.2 cm. Inv. no. 5308-101.
e) Design for a pendant set with sapphires and pearls.
Pen and black ink, with black, grey and light brown washes, touched with white bodycolour.
Size: 12.2 cm × 6.3 cm. Inv. no. 5308-91.

Literature: L. Binyon, *Catalogue of Drawings of British Artists and Artists of Foreign Origin working in Great Britain, preserved in the Department of Prints and Drawings in the British Museum*, (British Museum, ii, 1900) nos. 26, a-e; P. Ganz, *Die Handzeichnungen Hans Holbein d. J.: Kritischer Katalog* (Berlin, 1937) nos. 311, 308, 312, 310, 309; C. White, 'Supplementary list of foreign artists' drawings connected with Great Britain,' in E. Croft-Murray & P. Hulton, *Catalogue of British Drawings, (XVI & XVII Centuries)*, (British Museum, 1960) nos. 109, 97, 106, 103, 93.

2 a) Design for a cruciform pendant.
Pen and black ink.
Size: 6.8 cm × 5 cm. Inv. no. 5308-50.
b) Design for the back of a heart-shaped pendant with two doves below a scroll inscribed with a motto, TVRTVRIVM CONCORDIA, and with three suspended pearls.
Watercolours with gold leaf.
Size: 5.4 cm × 3.4 cm. Inv. no. 5308-30.
c) Design for the front of a heart-shaped pendant with a large sapphire and with three suspended pearls.
Watercolours and gold leaf.
Size: 5.6 cm × 3.5 cm. Inv. no. 5308-32.
d) Design for a pendant set with four emeralds and with a single suspended pearl.
Pen and black ink with green, yellow and grey washes.
Size: 8.6 cm × 5.5 cm. Inv. no. 5308-37.
e) Design for a pendant in the form of a monogram RE, set with various stones and with three suspended pearls.
Pen and black ink with watercolour washes.
Size: 8.4 cm × 4.1 cm. Inv. no. 5308-117.
f) Design for a pendant in the form of a monogram HI, set with an emerald and with three suspended pearls.

Pen and brown ink, with watercolour washes.
Size: 7.2 cm × 4.8 cm. Inv. no. 5308-116.

Literature: L. Binyon, *op. cit.*, nos. 27, a-f; P. Ganz, op. cit., nos. 418, -, -, 313, 328, 326; C. White, op.cit., nos. 53, 33, 35, 40, 119, 118. Ganz is surely correct in omitting nos. 2 a) & b) from his catalogue of drawings by Holbein, as both the design of the jewel and the colouring used are quite uncharacteristic. Indeed these drawings were probably executed in the seventeenth century. The country of origin is, however, unsure, although they may have come from France.

3 a) Design for a pendant surmounted with a half-length figure of a lady holding a tablet inscribed: WELL/LAYDI/WELL, with three suspended pearls.
Pen and black ink with grey wash.
Size: 6.6 cm × 3.4 cm. Inv. no. 5308-43.
b) Design for a pendant set with a lozenge and an oval stone and with three suspended pearls.
Pen and black ink.
Size: 5.3 cm × 3 cm. Inv. no. 5308-98.
c) Design for a pendant set with a lozenge and an oval stone and with three suspended pearls.
Pen and black ink.
Size: 5 cm × 3.2 cm. Inv. no. 5308-97.
d) Design for a pendant with a central stone surrounded by pearls and with a single suspended pearl.
Pen and black ink and wash.
Size: 4.7 cm × 4.1 cm. Inv. no. 5308-92.
e) Design for a pendant set with stones and pearls and with a single suspended pearl.
Pen and black ink and wash.
Size: 5.7 cm × 4.3 cm. Inv. no. 5308-93.
f) Design for a lyre-shaped pendant with a suspended pearl and a scroll inscribed QVAM ACCIPERE:/DARE MULTO BEATIVS/ (How much better it is to give than receive.)
Pen and black ink and wash.
Size: 6 cm × 4.2 cm. Inv. no. 5308-89.
g) Design for a pendant with a half-length nude female figure and two cornucopias set with stones and pearls and with a single suspended pearl.
Pen and black ink and wash.
Size: 5.9 cm × 4.3 cm. Inv. no. 5308-96.
h) Design for a lozenged-shaped pendant, with wavy scroll-work set with diamonds and pearls.
Pen and black ink with grey and yellow washes.
Size: 6.3 cm × 4.1 cm. Inv. no. 5308-33.
j) Design for a pendant with a central stone surrounded by leaf ornament, flanked with wavy scroll-work, set with stones and pearls and with a single suspended pearl.
Pen and black ink and wash.
Size: 5.9 cm × 4.3 cm. Inv. no. 5308-90.
k) Design for a pendant with leaf ornament and wavy scroll-work set with stones and pearls, and with a single suspended pearl.
Pen and black ink and wash.
Size: 5.6 cm × 3.9 cm. Inv. no. 5308-94.
l) Design for a pendant with leaf ornament and wavy scroll-work, surmounted with a grotesque

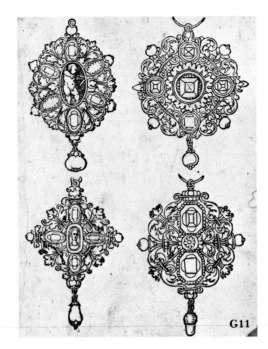

G11

figure, set with stones and pearls, and with a single suspended pearl.
Pen and black ink and wash.
Size: 6.7 cm × 4.1 cm. Inv. no. 5308-16.
m) Design for a pendant with intertwined scroll-work set with stones and pearls, and with a single suspended pearl.
Pen and black ink and wash.
Size: 5.8 cm × 4.9 cm. Inv. no. 5308-35.

Literature: L. Binyon, op. cit., nos. 28, a-m; P. Ganz, op. cit., nos. 345, 323, 324, 314, 320, 318, 321, 322, 315, 317, 316, 319; C. White, op. cit., nos. 46, 100, 99, 94, 95, 91, 98, 36, 92, 96, 19, 38.
Collection: British Museum.

G11 Book of woodcuts
Hans Brosamer (active *c*1520-1554)
Entitled: *Ein new kunstbüchlein, von mancherley schönen Trickgeschiren, zu gut der yebenden jugend der Godschmidt Durch Hansen Brösamer, Maler zu Fuld, an tag gegeben* (first edition). Title-page and 33 pages of woodcuts showing designs for cups and a pilgrim flask, and two pages of designs for whistles and pendants, full-bound in contemporary leather. On the last page are two drawings for whistles (*see* cat. no. G12) *c*1540. Size of volume: 20.5 cm × 15 cm.

The artist was a painter, engraver and woodcutter, but the precise dates of his life are uncertain. The editor of the Quaritch facsimile suggests that the first edition of the *Kunstbüchlein* was printed in Frankfurt *c*1548. The developed early Renaissance style, however, points to *c*1540, a date commensurate with the artists's residence in Fulda apparently between 1536 and 1545. The most complete copy of the first edition contains 39 woodcuts. The second edition, containing 46 woodcuts (facsimile published by G. Grote, 1882) includes two more pages of pendants in the same

style and a design for a tabernacle after J. A. Ducerceau (active 1549-1584)—*see* cat. no. G21. A fragment of a third edition is dated 1570. The pendants are symmetrical foliate designs set with pearls, precious stones, and cameos. For the whistles *see* cat. no. G12. Facsimile of this copy published by B. Quaritch, 1897. [M.S.]

Provenance: H. Destailleur; M. Rosenheim; purchased (Sotheby's, 7th, 8th May, 1923, lot 66) under the bequest of Captain H. B. Murray.
Literature: Guilmard, p. 365; Berlin, 1899. Holl. G., IV, p. 255; C. Dodgson, *Catalogue of German and Flemish Woodcuts* (1911) II, p. 382.
Collection: V&A. Inv. no. 1089-1104, 1107-1108-1923.

G12 Designs for whistles
Attributed to Hans Brosamer
a) Design for a pendant whistle containing toilet implements, formed as a mermaid holding a ball before her. Inscribed on the side DAS. WART. GOTES. PLIFT. EWIG. (The word of God is eternal) *c*1540.
Pen and ink and yellow wash. Size: 6.3 cm × 9.1 cm.
b) Design for a pendant whistle containing toilet implements, formed as a putto riding a dolphin, *c*1540.
Pen and ink and yellow and grey wash. Size: 4.5 cm × 10 cm.

A whistle containing implements engraved by Heinrich Aldegrever in 1539, terminates in a very similar dolphin's head (Holl. G, I, p. 127). This type of robust practical whistle is also represented by the whistles in Brosamer's *Kunstbüchlein* (cat. no. G11) and an engraving of three whistles by Martin Treu (Monogrammist MT), dated 1540 (V&A. Inv. no. E.1137-1930). Although using the same ornamental devices, this type differs considerably from the elaborate gem-set whistles

G12

of Virgil Solis (cat. no. G14). A surviving silver-gilt example containing implements is in the Kunstgewerbemuseum, Berlin (*see* H. Kohlhaussen, *Nürnberger Goldschmiedekunst des Mittelalters und der Dürerzeit* (1968) p. 429, no. 446, fig. 630). Nagler associates such whistles with hunting, and they appear frequently, worn around the neck, in German portraits of the second quarter of the sixteenth century. [M.S.]

Provenance: both inserted on the last leaf of Brosamer's *Kunstbüchlein* (cat. no. G11).
Literature: Y. Hackenbroch, *Renaissance Jewellery*, figs. 305 A, B.
Collection: V&A. Inv. nos. E.1109—1923, E.1110—1923.

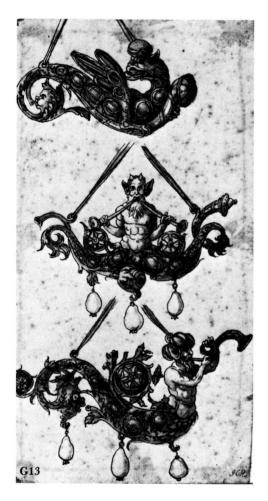

G13 Three designs for pendent whistles
Virgil Solis (1514-1562)
Pen and ink and water-colour. Cut to 13.7 cm × 7.3 cm.

All designs on one sheet for pendent whistles set with clear and coloured stones, formed respectively as a griffin, a two-tailed merman and a trumpeting merman, *c*1550. the whistles are closely related in design to those engraved by Solis (cat. no. G14). The dry and careful handling suggests that the drawing is a copy, or is connected to an engraving. [M.S.]

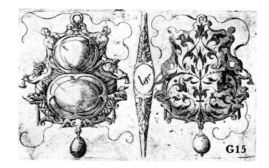

Provenance: Sir J. C. Robinson (Lugt. 1433); F. S. Robinson.
Literature: Y. Hackenbroch, *Renaissance Jewellery*, fig. 315.
Collection: V&A. Inv. no. E.1141—1924.

G14 Four designs for whistles
Virgil Solis
Engravings. Sizes: 7.4 cm × 5.8 cm and 7.4 cm × 5.7 cm.

Four designs on two plates. Three whistles formed as demi figures one as a *putto* ringing a hippocamp, *c*1540. Each signed in monogram vs.

The large number of ornament prints by Virgil Solis, a painter and engraver of Nuremberg, have been seen as the product of an active workshop. They range in style from the developed early Renaissance style shown here to the dense Mannerist ornament characteristic of Nuremberg in the 1550s and 1560s, which is exemplified in the work of the goldsmith Wenzel Jamnitzer.

Many are certainly borrowed from other print sources, such as Cornelis Floris and Peter Flötner. [M.S.]

Provenance: S. F. Colley-Smith.
Literature: Berlin, 614 (2); I. O'Dell-Franke, *Kupferstiche und Radierungen aus der Werkstatt des Virgil Solis* (1977) K 1, 2, pl. 123; Y. Hackenbroch, *Renaissance Jewellery*, fig. 321.
Collection: V&A. Inv. no. E.5387, 5388—1960.

G15 Design for a pendant
Virgil Solis
Engraving. Size: 5.2 cm × 8.8 cm.

Design for the front of a pendant with trumpeting satyrs, the back is decorated with arabesques. The design also shows the shoulders and setting for a ring, *c*1540? Signed in monogram v.s.

From a group of 16 plates of pendants, 5 of which also include rings. These are very similar to two plates by Peter Flötner (*c*1485-1546). [M.S.]

Provenance: L. Rosenthal.
Literature: Berlin, 614 (1); I. O'Dell-Franke, *Kupferstiche und Radierungen aus der Werkstatt des Virgil Solis* (1977) K 16, pl. 125; Evans (1970) p. 159; Y. Hackenbroch, *Renaissance Jewellery*, figs. 303A, B.
Collection: V&A. Inv. no. E.4271—1910.

G16 Rectangular arabesque panel (1546?)
Jean Gourmont *c*1506-1551
Engraving. Size: 5 cm × 7.2 cm.

Apparently from a set of at least sixteen plates. A

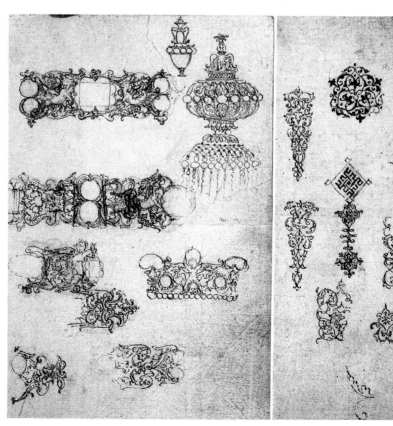

title-page for a set of arabesques by Gourmont, dated 1546, may refer to this set. The arabesque had its origin in Saracenic ornament and was developed in Italy in the 1530s. The form spread rapidly through Europe through the medium of engravings. The earliest examples of these are the designs by Francesco Pellegrini, published in Paris in 1530. [M.S.]

Provenance: Sale, C. G. Boerner and Co., Leipzig, 15th-16th November, 1928.
Literature: Guilmard, p. 24, no. 17; Berlin, 274; B. N. Fonds, XVI Siècle, II, p. 337, as by Jean Gourmont II and dated 1564.
Collection. V&A. Inv. no. E.3316—1928.

G17 Jeweller's Pocket Album
A book of 174 pages bound in brown calfskin with thong-ties. Size of page: 14.1 cm × 9.8 cm.

To judge from the soldering instructions written in a low German dialect it seems likely that the first owner of the book came from North Germany. The drawings are mainly for jewellery and other goldsmiths' work, and though executed with different pens appear to be by the same hand. Comparison with surviving jewellery suggests that the draughtsman was working in South Germany, possibly in Munich, in the middle of the sixteenth century.

Apart from a number of leaves that have become detached from the book, it contained, on its acquisition, a number of more or less related drawings inserted between its pages. But with the possible exception of one group, they are not necessarily connected with the book's early history. Indeed, it is most probable that these were assembled by a relatively recent owner who kept them in the book because of their general association with it in period and subject matter. To avoid confusion, only the detached pages that can be related to the original owner are exhibited together with the book; while of the rest only drawings that can be usefully connected with the theme of the exhibition are shown. The remainder will be discussed in the forthcoming *Catalogue of German and Swiss Drawings in the British Museum*.

The following is a summary description of the drawings on the bound-in pages; those exhibited are marked with an asterisk.

Bound in pages
Inside front cover: caricature profile head; slight design for a reliquary pendant or scent flask. Pen and brown ink.
Page I: a) design for two conjoined pearl and gemset girdle links, b) design for a single pearl-set girdle link with grotesque head, c) tentative design for a girdle link with a flower-head in the centre, d) design for a girdle link with foliate ornament, e) design for a gem-set pendent jewel with alternatives for the framework (setting); pen and brown ink, with, brown wash on a).
Page II: nine rough sketches for pearl-set girdle links with foliate ornament and slight sketches for gem setting; pen and brown ink.
Page III: two drawings and a slight sketch of

parrots; pen and black ink, with grey wash.
Page IV: blank sheet.
Page V: a) slight sketch partly in black chalk and pen and black ink; b) unfinished design for a motif of 'mauresque' ornament, pen and black ink. This design relates to an extensive series of engravings of 'mauresque' ornament by Virgil Solis (assigned by I. O'Dell-Franke to shortly before 1550). This type of ornament was widely used for basse-taille enamelling on the backs and settings of jewels of this period.
Page VI: blank sheet.
Page VII: unfinished sketch of a merman, pen and brown ink, partially over a preparatory drawing in black chalk of a scrolling framework. Possibly for the ornamental setting of a pendant jewel.
Page VIII: a) slight sketch for a curving border in black chalk: b) design for a circular plaque with a segmented border with two alternative patterns of 'mauresque' ornament, possibly to be executed in enamelling: c) slight sketch for the floral ornamentation of an unidentified object, black chalk with partially incised outline.
Page IX: unfinished design for circular plaque in 'mauresque' ornament, pen and black ink with grey wash over black chalk, within an incised circle, bisected, and measured into segments with a compass; surmounted by a sketch of three grotesque heads in pen and brown ink, possibly a later addition to transform the object into a scent-flask to be worn on a girdle.
Page X: a) design for a circular plaque with a standing Roman soldier in a landscape, pen and black ink with grey wash; b) rough design for an oblong plaque with a standing Roman soldier leaning on his staff, pen and black ink with grey wash.
Page XI: fragmentary sketch in pen and black ink.
Page XII: blank sheet.
Page XIII: five goldsmiths' soldering instructions.
Pages XIV-CXIV: blank sheets.
Page CXV: design, probably for a seal-stamp with an armorial crest showing a wolf holding a branch, executed by a later hand in pen and brown ink with touches of black and brown washes.
Pages CXVI-CLXVIII: blank sheets.
Page CLXIX: goldsmiths' soldering instructions.
Page CLXX: three slight sketches of profile heads in pen and black ink.
Pages CLXXI: blank sheet.
Page CLXXII: unfinished design for the foot of the shaft of a gem-set pendent cross with foliate ornament, a cherub's head and the suggestion of a ram's head. Inside back cover: Blank.

Collection: British Museum. Inv. no. 1978-12-16-14 (1 . . . 172).

Pages detached from the album
Reg. no. 1978-12-16-15 . . . 20

1 a) Design for an urn-shaped scent-flask, probably to be set with pearls. b) design for a

pearl and gem-set enamelled girdle link. c) design for a gold filigree(?) girdle pomander, probably to be set with pearls. d) design for enamelled pearl and gem-set girdle links, showing the articulated joints. e, g, h, j) designs for similar girdle links to b) and d). f) design for finial of a knife handle. Pen and brown ink with traces of an under drawing in black chalk. Verso blank.
2 Sheet of ornamental designs in the 'mauresque' style for engraving on pendent jewellery, to be enamelled en basse-taille and champlevé, and for knife blades. Pen and brown ink. It is interesting to note that in 1545 Thomas Geminus (working in England c1541-c1563), a notorious pilferer of other men's ideas, published in London plates with designs, not necessarily by himself, of 'mauresque' work, which is very closely related to this sheet of drawings.
3 a) sketch for the central part of a gold and gem-set girdle. b) sketch for the framework of a gem-set cross pendant. c) sketch for the framework and the gem-setting of a cross pendant. d) superimposed design for the suspension-loop and one of the suspension-chains of a sculptural pendent jewel. e) superimposed fragmentary sketch for a girdle link. Pen and brown ink with some traces of an underdrawing in black chalk. Verso blank.
4 a) Sketch for the links of a girdle, possibly a continuation of or alternative for 3 a) above. b) a slight sketch of an eagle displayed for an heraldic device. c) a slight sketch of a lion's mask. d) two sketches of rams, possibly for pendants. e) rough heraldic sketch for a shield with the arms of the House of Castille. Pen and brown ink. Verso blank.

Sheets probably from another pocket book
Reg. no. 1978-12-16-21 . . . 23.

A set of designs by another distinctive hand on three sheets of the same type of paper, two of which have a part of the unicorn watermark. These drawings are the only material inserted in the pocket album that might conceivably have been kept there from early in the book's history. The designs, no doubt by a German jeweller, probably date from the 1560s and could also be from South Germany like the work of the first owner of the pocket album.
1 Sheet of ornamental designs in the 'mauresque' style of the same kinds and for the same purposes as those on 1978-12-16-16, see above; with two slight sketches for pendant jewels in black chalk, in the lower right hand corner. Pen and brown ink, with some faint traces of underdrawings in black ink. Verso blank.
2 a) Design for a pendent jewel to be set with a table-cut gem-stone, and two oval stones, all in cusped settings, and drop-shaded pendent pearls. b) design for a similar pendent jewel. c) a similar design for a pendent jewel, with at the foot the superimposed drawing of a figure, possibly for a 'house altar,' see below e) & f). d) another design for a pendent jewel set with two large stones. e) & f) two slight sketches, one partially inked over, for

figure groups and decorative elements, probably for a house altar. Pen and brown ink over an underdrawing in black chalk. Verso blank.

3 a) Design for an ornamental frame, possibly for a mirror pendant, with a slight sketch of the drapery beside it. b) design for a pendent scent-flask (similar to surviving reliquary pendants of a slightly later date and mainly of supposedly Spanish origin). c) design for a pearl-set ornament. d) design for a pendent jewel to be set with two large stones, and drop-shaped pendent pearls. e) incomplete sketch for a gem-set pendent jewel. Pen and brown ink over a black chalk underdrawing. Verso: some rough lettering.

A small group of related designs for pendent jewels by another hand, and of lesser quality, very strikingly close in style, is in the Universitäts-bibliothek, Erlangen (Bock, cat. no. 880-4). 880-4).

Impressions taken from Jewellery

1 Impression, inked in black, taken from the back plate of a large pendent cross, engraved with 'mauresque' style ornament. Size: 15.2 cm × 11.0 cm.
1978-12-16-25.

2 a) Impression, inked in black, taken from an unfinished plate engraved with panels of 'mauresque' style ornament. Size: 7.4 cm × 3.9 cm.
1978-12-16-26.
The sheet shows further similar shaped panels marked out for engraving and the trial marks made by the engraver to test the sharpness of the graving tool. These panels may be for the back and sides of coffin shaped 'memento mori' pendants, see the 'Tor Abbey Jewel,' cat. no. 13.
b) Cut-out impressions from the same plate as (a). Size: 3.2 cm × 2.9 cm.
1978-12-16-27.
c) Impression taken from a different plate engraved with similar ornament. Size: 3.6 cm × 1.2 cm.
1978-12-16-28.
These impressions are very closely related to the similarly shaped ornaments on a plate in the book published by Geminus in 1548 (see 1978-12-16-16).
3. Impression, taken blind (uninked) from the engraved 'mauresque' style ornament on the back plate of a pendant jewel. Size: 6.5 cm × 5.5 cm.
1978-12-16-29.
The ornament is more elaborate than usual, incorporating flower heads, birds and shellfish.
The above material was found within the pages of the Pocket Album on its acquisition by the British Museum.

Three highly finished designs for jewelled ornaments

a) Pendant set with two gem stones, the lower one facet-cut at the back, and three drop-shaped pearls. Size: 9.6 cm × 6.6 cm. b) Two girdle links, one gem-set, the other set with two pearls. Size: 9.5 cm × 6.4 cm. c) Three rings set with gem-stones and a pearl. Size: 6.6 cm × 9.5 cm.

Pen and black ink with grey and yellow washes on vellum.
1978-12-16-35 . . . 37.
These designs of very fine quality can be closely connected stylistically with the surviving work of Hans Reimer (c1535-1604), jeweller to the Bavarian Court, and in particular with a documented pendant preserved in the Schatzkammer in Munich. On this basis they are attributed to him there.

Design for the metal framework of a bag with a merchant's mark on shield and the date 1545.
Red chalk partly over black chalk underdrawing.
Size: 19 cm × 14.2 cm.
1978-12-16-38.

Even though most surviving examples of the metal framework of bags of this period (e.g. those in the Wallace Collection) are described as Italian, the style of this design is decidedly Germanic, and recalls some of the ornamental designs in the sketchbook containing goldsmiths' and jewellery designs, some of which are dated 1545 or 1546, by Wenzel Jamnitzer (1507/8-1585), now in the Kunstbibliothek, West Berlin (Inv. no. 97/94, Signatur OZ 1). The present drawing does not, however, betray Jamnitzer's characteristic hand, and is best merely classed at present as South German. Here, as is usual in such cases where one half of the design would be a mirror-image of the other, the draughtsman has only executed one half: the other he would have obtained by the offset process. [J.R.]

Collection: British Museum.
Lent by: The Trustees of the British Museum.

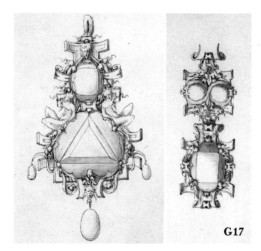

G17

HANS MIELICH (1516-1573)
G18 Four Miniatures
These miniatures come from an album with illustrations of jewellery, jugs, etc., stuck into it, which was bought by Dr J. H. von Hefner-Alteneck, (director of the Bayerisches Nationalmuseum from 1868 onwards) in 1846 from the antiquary Kronacher of Bamberg. The Bayerisches Nationalmuseum and the Prints and

Drawings Collection bought them in 1904 from Hefner-Alteneck's estate.

When Hefner-Alteneck acquired the album, the miniatures were in a very bad state and the mouldy leather cover bore the stamp of the library of the Electress Magdalena Sibylla von Sachsen (d. 1659). Possibly the miniatures were a present, or came after the looting of the Bavarian Ducal library during the Thirty Years War into the possession of the Electress; they originally belonged to the Duke of Bavaria, as shown by the Bavarian arms on some of the objects.

Some pages are signed H.M. that is, Hans Mielich, court painter of Duke Albrecht V, who also painted the jewellery book of the Duchess Anna, wife of Albrecht V (Bavarian State Library Munich, Cod. icon. 429). According to Ulla Krempel in 'Augsburger and Münchener Emailarbeiten des Manierismus aus dem Besitz der bayerischen Herzöge Albrecht V, Wilhelm V und Maximilian I', Münchener Jahrbuch der bildenden Kunst, 3. Folge XVIII, (1967) p. 111 ff., n.b. 12, Mielich's style is only recognizable in twenty of the works. The inventory of 1598 by Fickler records that there were three more similar volumes in the library of the Duke. The one described under no. 3382 could have contained these Mielich miniatures, 'A large book of the same measurements, bound in cardboard and leather, with gold plated straps and rosettes, in it all sorts of small objects and drinking vessels, drawn by hand'.

The miniatures were formerly thought to be designs by Mielich; it is now realised that they represent a kind of stock-taking exercise. The coats-of-arms, and the pages with the unmounted stones demonstrate this. The eagle pendant (G18b) is still in the treasury of the Residenz Munich. Its measurements are identical with the miniature, a proof that all the jewellery was depicted actual size.

G18a Miniature showing unmounted stones, dated 1551 (see p. 20)
Tempera on vellum. Size: 55.4 cm × 35.5 cm.

In shaped purple border with a double gold edge, seventeen rows of diamonds, emeralds, and rubies in their natural sizes. At the top four large, simply polished, emeralds; beneath it in gold, 1551. Then three rows of rubies, diamonds, and emeralds in groups of threes. All the remaining rows alternate the arrangement of the stones and thus of the colours rhythmically. The length of the rows varies between three, six and nine stones. Some of the stones are point-cut, some table-cut, some merely polished, and one ruby is heart-shaped. The diamonds are cut in a great variety of ways. All stones are painted with shadows behind them.

The page is a painted inventory of unmounted stones in the ducal collections, just as they are frequently mentioned in written inventories of the day. This admirably illustrates the variety of stone-cutting techniques which were current at this date, and which is much greater than has

hitherto been supposed: besides point-cut and simple table-cut stones there are step-cuts, rose-cuts (e.g. second row, right) etc. [I.H.]

Provenance: acquired in 1904 from the estate of Dr J. H. von Hefner-Altneck, who had bought it in 1846 from the antiquary Kronacher of Banberg.
Collection: Bayerisches Nationalmuseum. Inv. no. R 8220.

G18b Miniature, crowned double-headed eagle, 1550/60
Tempera on vellum.
Inscription on the back: The jewel of Duchess Renata.

Gold pendant in form of a crowned double-headed eagle, studded with diamonds; on its breast the Austrian arms with diamonds and two rubies, the tail feathers surround a diamond fleurs de lys. The eagle holds in each claw a big round pearl; an oval pendant pearl on its tail.
The miniature depicts a pendant which is still in the Schatzkammer, Residenz, Munich (cat. Munich 1970, no. 49). As on the miniature the neck, plumage, and legs are studded with diamonds in point and table-cut, shield-cut *briolettes*, and fancy-cut. In the enamelled crown there are diamonds, rubies and pearls. The eagle on the miniature is nearly identical to the one on the original, only the crown being different. The eagle already appears in the Disposition (of inalienable dynastic jewellery) of Albrecht V in 1565: 'Item six: a golden, black enamelled eagle which has on its breast a beautiful ruby, and beneath it, between its claws, a large, beautiful diamond tail with a beautiful pendant pearl.'
According to the Disposition of Maximilian I, this was in the possession of Albrecht V's wife, Duchess Anna, daughter of the Emperor Ferdinand I. Thus the inscription on the back of the miniature is later in date than the object itself, which must have been made in Vienna or Italy. The Austrian arms would in any case be rather inappropriate for Duchess Renata (1544-1602) a daughter of Francis I of Lorraine married to Duke Wilhelm V of Bavaria in 1568; they would however be in keeping with the Emperor's daughter Anna. It is possible that the pendant was worn by Duchess Renata after the death of Duchess Anna. [I.H.]

Provenance: acquired in 1904 from the estate of Dr J. H. v. Hefner-Alteneck, who had bought it in 1846 from the antiquary Kronacher of Bamberg.
Collection: Bayerisches Nationalmuseum. Inv. no. R8246.

G18c Miniature of a necklace and two bracelets. Dated 1555, signed H.M.
Tempera on vellum. Size: 20.6 cm × 53.4 cm.
On the right a split in the strapwork frame and through the purple ground, glued at the top and bottom, and open in the middle.

Ochre-coloured strapwork frame, with, above it, the Austrian coat-of-arms with the Golden Fleece, held by two putti; below, in a strapwork cartouche, the gold signature and date. On a purple-coloured ground a necklace of enamelled links, alternately set with diamonds and rubies, between each, above and below, a pearl; grey pear-shaped pendant pearl. Below it, side by side, two bracelets of the same design though smaller in size. The coat-of-arms refers to Anna of Austria (1528-1590), daughter of Emperor Ferdinand I, and wife of Duke Albrecht V von Bayern. [I.H.]

Provenance: acquired in 1904 from the estate of Dr J. H. von Hefner-Alteneck, who had bought it in 1846 from the antiquary Kronacher of Bamberg.
Collection: Bayerisches Nationalmuseum. Inv. no. R8236.

G18d Miniature, a necklace with a large cross pendant, 1550/60 (see back cover)
Tempera on vellum. Size: 21.6 cm × 57.5 cm.
Condition: the lower left edge slightly torn along an old fold.

Narrow gold-rimmed purple frame with grey-blue strapwork; at the top a lion's head heightened with gold, at the bottom masks and swags. On the neutral coloured background a necklace of enamelled links, set alternately with diamond rosettes and four pearls, with, in between, narrow links with lions heads. Hanging from it a large pendant in the shape of a crossed crosslet decorated with enamelled putti and satyrs. Such pendants also occur frequently in the jewellery book of Duchess Anna. The alternation of links set with stones and ones set with pearls also occurs frequently. The unusual compactness of the link sequence is accentuated by the enamelling and seems to be characteristic of the jewellery made for the Munich court. [I.H.]

Provenance: acquired in 1904 from the estate of Dr J. H. von Hefner-Alteneck, who had bought it in 1846 from the antiquary Kronacher of Bamberg.
Literature: J. H. v. Hefner-Altenbeck, *Deutsche Goldschmiedewerke des 16. Jahrhunderts.* (Frankfurt a. Main 1890), pl. 1.
Collection: Bayerisches Nationalmuseum. Inv. no. R8240.

G19 Two designs for jewellery
Matthias Zündt (1498-1586)
Engraving. Size: 4.9 cm × 9.1 cm.

Designs for two pieces of jewellery, perhaps brooches or links for collars or bracelets. One incorporates a bearded head, the other a ram's head both set in strap-work. From a set of twelve plates, 1553. The engraved designs of Zündt, who was also a goldsmith and carver, exemplify the dense ornament of Nuremberg Mannerism. His engravings of pendants and necklaces are very similar to those of Virgil Solis (see P. Jessen, *Meister des Ornamentstichs*, I, 1923, pl. 93; Y.

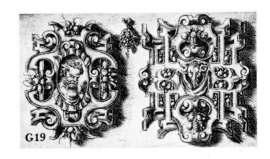

Hackenbroch, *Renaissance Jewellers*, figs. 341, 342, 346). [M.S.]

Provenance: Gilhofer and Rauschburg, Sale, Lucerne.
Literature: Berlin, 617 (1); A. Andresen, *Der deutsche Peintre-Graveur*, I, (1864) no. 67; Evans, fig. 10.
Collection: V&A. Inv. no. E.1814—1927.

G20 Designs for Jewellery
René Boyrin (c1525-1610)
A pendant incorporating the figures of male and female fauns. Set with table-cut stones and a cameo and hung with pearls. From the set of jewellery designs. Engraving. Cut to: 8.4 cm × 5.8 cm.
An *etui* pendant set with pearls and stones, and decorated with two caryatid figures. Part of a plate from the set of jewellery designs. Lettered *Paulcs* [de la houue excud.] Engraving. Cut to: 9.2 cm × 3 cm.
Five rings set with pearls and stones, and a necklace, set with pearls, stones, and cameos. Both from a plate in the set of jewellery designs. Engravings. Cut to: 9 cm × 3 cm and 9.2 cm × 2 cm.

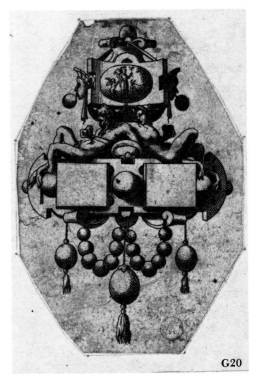

G20

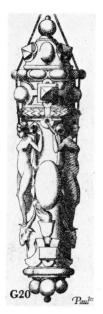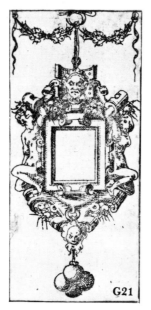

G20 *Paulⁱᵉ* G21

Boyvin did not set up on his own as an engraver until about 1550, but his plates consistently record the heavy and dramatic early Mannerist style originated by Il Rosso and other artists at Fontainebleau in the 1530s. This set of jewellery is dedicated to Aubin de Carnoy, goldsmith and *valet de chambre du roi*, who was appointed to that post in 1598. The publisher Paul de la Houve was working in *c*1600. Boyvin's responsibility for some of the engravings attributed to him has been doubted (*L'École de Fontainebleau*, Exhibition Catalogue (Grand Palais, 1972) pp. 332-333, no. 438). [M.S.]

Provenance: T. Smith; G. Mathias, jeune; F. F. W. Jackman.
Literature: Robert-Dumesnil, VIII, p. 75, nos. 165, 160; M. Amand-Durand, *Le Livre de Bijouterie de René Boyvin* (1876) pls 4, 18, 16; J. Levron, *René Boyvin* (1941) 272, 267; BN Fonds, XVI siècle, I, pp. 198-200, nos. 4, 18, 16.
Collection: V&A. Inv. nos. 22779.1, E.2569—1913, E.398—1926, E.2567—1913.

G21 Design for a pendant
Jacques Androuet Ducerceau (1515-1585)
Etching. Size: 7.5 cm × 3.4 cm.

A small scroll-work frame incorporating two female figures. Probably from the untitled set of fifty designs for jewellery. [M.S.]

Provenance: H. Reeves.
Literature: Guilmard, p. 12, no. 4; Berlin, 760 (2).
Collection: V&A. Inv. no. E.1894—1930.

G22 Designs for four pendants
Etienne Delaune *c*1518-1583
Pen and ink and wash on vellum. a) A frame composed of strapwork, cornucopiae and figures, with an oval opening, hung with pearls. Size: 7 cm × 3.5 cm. b) A large pearl in mounts formed as dolphins with a pendent pearl beneath. Size: 6.5 cm × 4 cm. c) A pendant formed of five (visible) dolphins joined by their tails with a pendent pearl beneath. Size: 7.6 cm × 4.1 cm. d) The arms of France surrounded by the chain and badge of the Order of St Michael. Size: 8.1 cm × 3.6 cm.

Etienne Delaune was an engraver, medallist and goldsmith and an extremely accomplished designer in the elegant decorative style of the court of Henri II of France (1547-1559). He was appointed royal goldsmith and engraver (to the mint) in 1552 and in the later 1550s designed the King's armour. A Protestant, he fled from France in 1572 and lived in Strasbourg and Augsburg. The important Douce Delaune drawings, which are chiefly round designs for medals etc., were apparently first noticed by Mariette (Robert-Dumesnil, IX, pp. 20-21) but they have not been catalogued in detail. Examination suggests that they are by a number of different hands; we are

indebted to Mr George Wanklyn for his observations on this collection.

The dolphin jewel c) was perhaps intended for Francois II when he was Dauphin, and can in that case be dated between 1552 and 1559. [M.S.]

Provenance: bequeathed by Francis Douce to the Bodleian Library, 1834; transferred to the Ashmolean Museum, 1942.
Literature: *Gemstones and Jewellery*, Exhibition (City of Birmingham Museum and Art Gallery, 1960) no. 445.
Collection: The Ashmolean Museum, Oxford. Delaune mount 65.

G23 Designs for three pendants
Etienne Delaune and an unidentified artist.
Pen and ink and wash on vellum.
a) A pear-shaped container decorated with interlaced strapwork, set with stones and hung with a pearl. Size: 8.2 cm × 3.3 cm. b) A setting for a diamond rosette, consisting of a fruit and strapwork frame incorporating two female figures bearing palms, with a pendent pearl. Size: 7 cm × 4.4 cm. c) Two stones within a heavy fruit and strapwork frame incorporating two female figures, with a pendent pearl. Size: 7.5 cm × 4.4 cm.

Hackenbroch has connected c) with a jewel in a Parisian private collection, and has compared the figures with two figures of Fame on the back-plate of the armour Delaune made for Henri II (Louvre). The armour figures are, in fact, much closer to those in b). A very similar design is in a private collection (*L'École de Fontainebleau* Exhibition, Grand Palais, 1972-73, no. 78, repr.) The pendant c) is by a hand not normally associated with Delaune, and the heavy scrollwork and loose design are also unlike him. It does, however, contain a number of elements present in cat. no. G26 and is probably by the

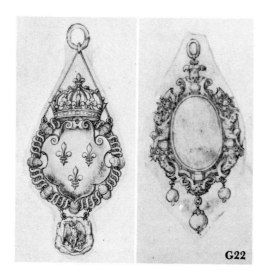

G22

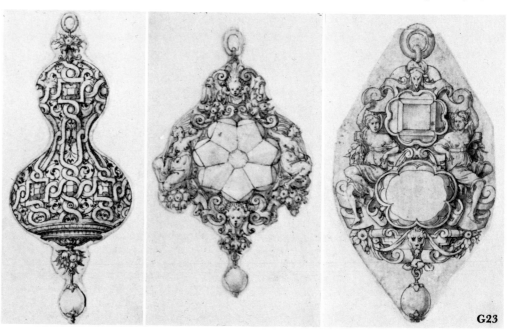

G23

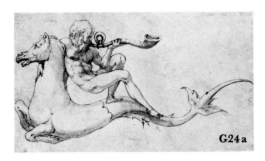

G24a

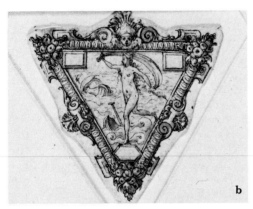

b

e f

same hand. *See* also cat. nos. G24 (a) and G25 (b) (c). [M.S.]

Provenance: *see* cat. no. G22.
Literature: Y. Hackenbroch, 'New Knowledge on jewels and designs after Etienne Delaune', *The Connoisseur*, CLXII (1966) pp. 85-6, fig. 10; Y. Hackenbroch, *Renaissance Jewels*, fig. 185, 186, 198; Evans, pl. 61.
Collection: The Ashmolean Museum, Oxford. Delaune mount 66.

G24 Designs for six rings, a pendant and a whistle *(see also* p. 22)
Etienne Delaune and an unidentified artist.
Pen and ink and wash on vellum.
a) A pendent whistle formed as trumpeting mermen riding a hippocamp. Size: 5.2 cm × 8.5 cm. b) A triangular gem-set pendant showing Fortune riding above shipwrecks, in a frame. Size: 5.2 cm × 5.5 cm. c) The fronts and sides of two rings decorated with fruit and strapwork, set with pearls. Size: 2.6 cm × 6.9 cm. d) The fronts and sides of two rings decorated with strapwork, fruit, and cherubs' and goats' heads. Set with pointed stones. Size: 3 cm × 7 cm. e) A ring, the hoop formed as two mailed gloves grasping the setting. Size: 2.1 cm × 2.1 cm. f) A ring, decorated with fruit and strapwork. Size: 2.4 cm × 2.1 cm.

An anonymous engraving in the Bibliothèque Nationale (ed. 5f res) shows modified versions of the rings in d)—*see* O. Reynard, *Ornements Anciens des Maîtres*, I (1845) p. 187, top. The dispositions of the ring designs recall the front and side formula of the engravings in Pierre Woeriot's *Livre d'Aneaux* (1561), but the drawings eschew Woeriot's use of fantastic figures. The whistle design a) appears to be by a hand close to that of G26, G23 and G25 (b) & (c), and may not be by Delaune. [M.S.]

Provenance: *see* cat. no. G22.
Literature: Y. Hackenbroch, *Renaissance Jewellery*, figs. 195, 197.
Collection: The Ashmolean Museum, Oxford. Delaune mount 67.

G25 Designs for necklaces or belts *(see also* p. 22)
Etienne Delaune and an unidentified artist.
a) Two links composed of fruit and strapwork, set with two stones and four pearls. Size: 2.8 cm × 7 cm. b) & c) Two designs of two links each, composed of fruit and strapwork, set with stones and pearls. Size: 1.8 cm × 5 cm. d) Two links composed of strapwork bearing arabesque decoration, fruit, and dogs' heads. Set with a stone and a baroque pearl. Size: 2.5 cm × 10.5 cm.

Neither the hand nor the decorative style of b) and c) appear to be characteristic of Delaune's known drawings; they can perhaps be related to nos. G23c), G24a) and G23c). The heavy necklaces a) and d) are of the type shown attached to the bodice and worn tightly around the neck in Francois Clouet's portrait of Anne of Austria, dated 1571 (Louvre) *see* Evans (1970) pl. 74 and also Y. Hackenbroch, *Renaissance Jewellery*, fig. 496, but which could also be used as a belt (Evans (1970) pl. 75). Necklaces of very similar character and design can be found in the engraved designs of Virgil Solis, Matthias Zündt and Erasmus Hornick, all working in Nuremburg. [M.S.]

Provenance: *see* cat. no. G22.
Collection: The Ashmolean Museum, Oxford. Delaune mount 90.

G26 Design for pendant *(see* p. 22)
Artist unknown (*c*1560)
Pen and ink and wash on vellum. Cut: 11.4 cm × 9.2 cm.

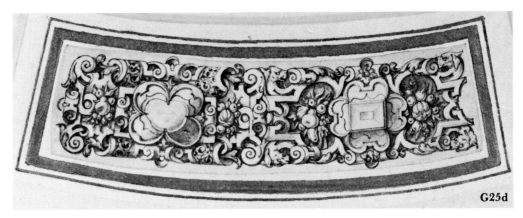

G25d

Design for a large pendant consisting of three clear stones and one cabochon ruby set in scrollwork decorated with arabesques. At the top are two reclining female figures holding cornucopiae, at the bottom are two winged putti thrusting their right arms into the scrolls.

This drawing is probably by the same hand as cat. no. 23 c), and perhaps by that of G24 a) and G25 b) & c). It displays the same type of open scrollwork as all these drawings, which differs from the tighter scrollwork which can perhaps be regarded as characteristic of Delaune. The figures, both in their types and their relationships to the decorative elements recall those in the prints of Ducerceau (cat. no. G21) and Boyvin (cat. no. G20), also Pierre Woeriot, which appear to go back to prototypes of the first Fontainebleau school. Reclining figures of a very similar type are present on a design for a frame by 'Maître Guido' (*see* cat. no. G27), whose designs for pendants also contain open scrollwork. An anonymous print in the Bibliothèque D'Art et d'Archéologie, Paris, is a variant of this design, and includes a pendent pearl, which has been cut off the drawing. [M.S.]

Provenance: *see* cat. no. G22.
Literature: *Gemstones and Jewellery Exhibition* (City of Birmingham Museum and Art Gallery, 1960) no. 449; Y. Hackenbroch *Renaissance Jewellery*, fig. 196.
Collection: The Ashmolean Museum, Oxford. Delaune sheet 75.

G27 Design for pendant
Artist unknown (*c*1560)
Pen and ink and wash. Size: 15.6 cm × 9 cm.
Design for a pendant consisting of a frame with three openings. The upper opening is framed by two male figures supporting a strapwork container holding fruit. The two lower openings are framed by a mask, rams' heads and garlands of fruit, from which are suspended three pearls, and scrollwork.

This drawing cannot be connected with Etienne Delaune. The leathery scrollwork and grotesque exaggerations of the design suggest a Flemish origin and the figures can be compared with those in a decorative design attributed to Cornelis Bos (Bibliothèque Nationale, *Inventaire Generale des*

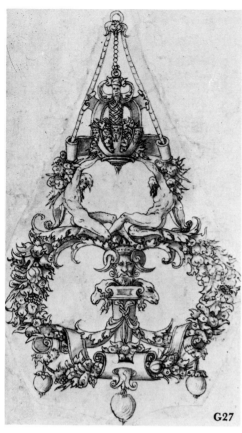

G27

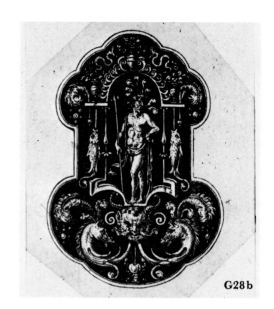

G28b

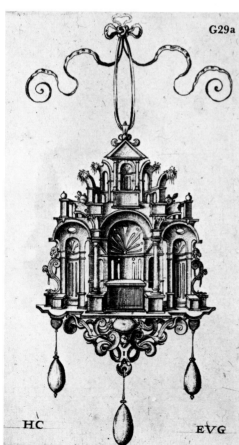

G29a

HC EVG

Dessins des Ecoles du Nord, 1936, 159, pl. L). The use of garlands forming a frame too irregular to be a setting is, however, characteristic of the pendant designs of the mysterious 'Maitre Guido', one of whose drawings is inscribed '*Sensuivent les desseins de Mr. Guido et Jean Cousin, designeurs d'environ toutte L'oeuvre de Stephanus. Exepte une grande partie designees de son fils, et quelque peu d'autres. L:penis etc.*' (E. Berckenhagen, *Die Französischen Zeichnungen der Kunstbibliothek Berlin* 1970, pp. 34, 35, Hdz. 6, 7, 8, 45, 46; and Y. Hackenbroch, *Renaissance Jewellery*, figs. 176, 177.) [M.S.]

Provenance: *see* cat. no. G22.
Literature: *Gemstones and Jewellery Exhibition* (City of Birmingham Museum and Art Gallery, 1960) no. 448; Y. Hackenbroch, *Renaissance Jewellery*, fig. 187.
Collection. The Ashmolean Museum, Oxford. Delaune Mount 68.

G28 Two designs for backs of pendants

Etienne Delaune (*c*1518-1583)
Engravings, two plates of designs for the enamelled backs of pendants. a) Shaped as a cross of Lorraine showing a figure of Hercules, from a set dated 1573, signed SF (i.e. Stephanus Fecit). Size: 4.7 cm × 5.7 cm. b) A lobed oblong showing a figure of Neptune signed SF. Size: 5.7 cm × 4.8 cm.

The set is entitled *Stephanus Delaune inventor et Excidebat Ano D1573 in Argetia* (i.e. Strasbourg). Some of Delaune's later design for pendant backs were engraved by his son Jean. [M.S.]

Provenance: G. Mathias, jeune.
Literature: Robert-Dumesnil, IX, pp. 114, 116; nos. 394, 398. BN Fonds, XVI Siècle, I, p. 294, nos. 372, 376.
Collection: V&A. Inv. no. E.2613, 2616—1913.

G29 Design for Pendant and Earrings

Hans Collaert I (*c*1530-1581)
Engraving. Cut to 15 cm × 9.2 cm.

Design for a pendant in the form of a cross decorated with naturalistic flowers against a matted ground and a niche enclosing a figure of Hope, and two (?) earrings. From a set of plates entitled: *Antverpiae apud Joannem Liefrinck cum privilegio Hans Collaert*. Signed *H.C.*
 Heuser points out that the publisher Hans Liefrinck of Antwerp died in 1573. Another state, or edition, of the set was published by Theodor Galle in 1604. [M.S.]

Provenance: Messrs. Heussner and Lauser.
Literature: Guilmard, p. 480, no. 13 (4); Berlin, 719 (2): H-J. Heuser, 'Drei Unbekannte Risse Hans Collaert des älteren', *Jahrbuch der Hamburger Kunstsammlungen*, Band 6 (1961) p. 53.
Collection: V&A. Inv. no. 27857.8.

G29a Design for pendant

Hans Collaert I (*c*1530-before 1581)
Engraving. Size: 13.5 cm × 9 cm.

Design for a pendant in the form of a vaulted Roman building in ruin. From a set of at least six plates. Lettered HC EUG. Other plates in the set are lettered HC.FE. EUG. INVE. The identity of EUG remains unknown. A very similar set of plates incorporates classical figures into the architectural settings, *see* Berlin, 720 (1) and Y. Hackenbroch, *Renaissance Jewellery*, figs. 628A, B.

Provenance: Messrs. Heussner and Lauser.
Literature: Berlin, 720 (2); H. J. Heuser, *see* cat. no. G29.
Collection: V&A. Inv. no. 26404.4.

G30 Design for a Pendant

Probably by Adriaen Collaert I (*c*1560-1618) after Hans Collaert I
Engraving, cut to 16.9 cm × 11.5 cm.

Design for a pendant set with gems and hung with pearls, incorporating the figure of a seated warrior and two other figures. From a set of ten plates entitled: *Monilium Bullarum Inauriumque Artificiocissime Icones. Joannis Collaert Opus Postremum. 1581. Philippus Galle Excudebat.* Numbered *4*.
 The problem of the authorship of the jewellery prints produced by the Collaerts of Antwerp is further confused by the uncertainty surrounding their family relationships. The engraver of this set of designs is generally believed to be Hans Collaert I, who appears to have died shortly before 1581. His son, who engraved cat. no. G31 was believed by Hollstein to be Hans (Jan Baptist I) Collaert (1566-1628) who would then have been sixteen years old. A more probable candidate appears to be Adriaen Collaert (*c*1560-1618), who appears in the guild list of 1580, and who married the daughter of Phillip Galle in 1586. Both Jan Baptist I Collaert and Adriaen Collaert are recorded as the sons of masters. The cross, cat. no. 19, known to have been designed by Hans Collaert and ordered in 1562, is in a different style from that used in his jewellery engravings. [M.S.]

Provenance: G. Mathias, jeune.
Literature: Guilmard, p. 480, 13 (1); Berlin, 721 (1); Holl. D & F. IV, 213; H. J. Heuser, *see* cat. no. G29, p. 53, IVa, 4.
Collection: V&A. Inv. no. E.878—1912.

G31 Designs for two pendants
Probably by Adriaen Collaert I (*c*1560-1618) after Hans Collaert I
Engravings. Size: 17.5 cm × 12.7 cm, 17.5 cm × 12.7 cm.

Designs for two pendants: a) a man with an oar riding a sphinx-like sea-monster; b) Venus on a shell, a triton, and a man with an oar, all riding on a sea-monster. Both set with stones and hung with pearls. Two plates from a set entitled *Pars Altera, Bullarum Inaurium etc. Archetypi Artificiosi, 1582. Ioes Collaert del. Eius filius sculp. P. Galleus excud.* Numbered *5* and *8*. Contemporary watercolour copies of plates from this set of engravings have been noted; one is in the Schmuckmuseum, Pforzheim. [M.S.]

Provenance: Kunstgewerbe Museum, Berlin.
Literature: Guilmard, p. 13 (2); Berlin, 721 (2); Holl. D&F p. 214 (with wrong illustrations); H. J. Heuser, *see* cat. no. G29, p. 53, V, 5, 8; Y. Hackenbroch, *Renaissance Jewellery*, fig. 638.
Collection: V&A. Inv. no. 2207, 2210—1911.

G32 Designs for three pendants
Daniel Mignot (active *c*1590-1616)
Engravings. Sizes: 15.3 cm × 13 cm, 15 cm × 10.5 cm (cut), 15.5 cm × 11 cm (cut).

Designs for three enamelled pendants hung with

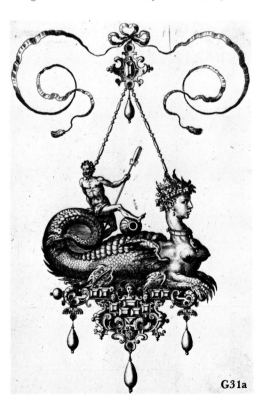

pearls, incorporating figures in niches representing, respectively, Hope, Charity and Prudence, each pendant surrounded by designs for enamel. Three plates from the set of pendants showing the Cardinal Virtues entitled: *In timore ac charitate Dei Daniel Mignot fecit hoc Augustae Vindelicorum anno 1593.* Each signed DM in monogram, and F. The pendants lettered respectively *Spes, Charitas, Prudentia.* The Hope and Charity pendants contain elements which can be compared with the enamel on the reverse of cat. no. 53, notably the leaping stags. These, and several other decorative elements in this set appear to be derived from a set of oval grotesques by Etienne Delaune (Robert-Dumesnil), IX, 359, 361, 366).

Mignot was a French, presumably Huguenot, immigrant who engraved numerous jewellery prints in Augsburg between 1593 and 1596. Their practical nature suggests that he was also a working goldsmith, although never a citizen of Augsburg. [M.S.]

Provenance: K. W. Hiersemann; G. Mathias, jeune; E. P. Jones.
Literature: Guilmard, p. 376, no. 60; Berlin 639 (2); A. Hämmerle, 'Daniel Mignot', *Das Schwäbische Museum* (1930) p. 56, nos. 27, 28, 30 (all 1st state); Y. Hackenbroch, *Renaissance Jewellery*, figs. 483 B, D.
Collection: V&A. Inv. nos. E.5239—1907, E.893—1912, E.2632—1917.

G33 Designs for 3 brooches
Daniel Mignot
Engravings. Sizes: 14.7 cm × 10.3 cm, 14.9 cm × 10.4 cm.

IN TIMORE DEI DANIEL MIGNOT *Inuent. sculp. & excudit.* HOC AVGVSTÆ VINDELICORVM ANNO 1590

Title-page and two plates from a set of jewellery designs entitled: *In timore Dei Daniel Mignot invent. sculp. et excudit. hoc Augustae Vindelicorum anno 1596.* The title-page shows the frame of an open-work badge or brooch, plate II the gem-set front of a similar jewel, plate XIII an aigrette formed as a flowering stem, set with pearls and stones. Each piece surrounded by designs for enamel. The title-page lettered with title and numbered I. The plates signed DM in monogram, F, and numbered II and XIII respectively. [M.S.]

Provenance: Kunstgewerbe Museum, Berlin.
Literature: Guilmard, p. 376, no. 60; Berlin, 640; A. Hämmerle, (*see* cat. no. G32) pp. 64, 66, nos. 49, 50, 62.
Collection: V&A. Inv. nos. E.2129, 2130, 2141—1911.

G34 Design for the back of a pendant
Daniel Mignot
Engraving. Size: 14.7 cm × 10.5 cm.
Design for the back of a pendant hung with a pearl, decorated in enamel with a grotesque and a female figure holding a branch and a flag. Below the pendant are two designs for enamel. Plate from the set which was first published with the title: *In timore Dei Daniel Mignot invent. sculp. et excudit hoc Augustae Vindelicorum anno 1596.* Signed DM in monogram, F and numbered X, with traces of VI erased.

The plate is probably from the second edition of the set, published in 1616. Relief is given within the figures by engraving the copper plate to different depths, a technique also used in engraving before enamelling. [M.S.]

Provenance: Berlin, Kunstgewerbe Museum.
Literature: A. Hämmerle, *op. cit.*, p. 61, no. 44

(2nd state); Y. Hackenbroch, *Renaissance Jewellery*, fig. 488B; Evans, fig. 18.
Collection: V&A. Inv. no. E.2150—1911.

G35 Book of Jewellery Designs
Jacob Mores (c1540—before 1612)
Silver point, pen and ink and watercolour.
Average size of page: 35.5 cm × 23.5 cm.

Folio book bound in vellum over cardboard with 41 pages, 36 of which are of vellum, with jewellery designs on 40 of the pages. Between 1593 and 1602.

Stylistic reasons make it clear that this book of coloured drawings, which includes five crowns, a jewel casket, and numerous pieces of jewellery of various sorts, represents works by the same designer, unlike the Arnold Lulls book (*see* cat. no. G44) or the jewellery paintings by Hans Mielich (*see* cat. no. G18).

The paper guard sheets between the vellum pages bear the water mark of a small firm outside Nuremberg which flourished between 1593 and 1607, which means that the volume must have been assembled after 1593. One page of drawings is dated 1602 twice, and the internal evidence of some of the pieces of jewellery confirms this date-span for the book. For example, on fo. 2 is the design for a crown with an inscription which records that it was done for Christian IV of Denmark when he had been declared of age as Duke of Schleswig-Holstein, but not yet as King of Denmark, that is, between 1593 and 1596.

The attribution to the Hamburg goldsmith, Jacob Mores, is made on the basis of comparison with a large group of designs for goldsmiths' work, mostly drinking vessels, in the Kupferstich-kabinett, Kunstgewerbemuseum, Berlin, one of which is signed by Mores. For example, an eagle on Berlin folio 1481 wears an imperial crown almost identical to that on folio 9 of this book. Indeed it is almost certain that these two groups of designs are those mentioned in the inventory made at the death of Jacob Mores' son, also Jacob, in 1549, which lists 'one book in folio, in white vellum, wherein are drawn all manner of jewels', and 'one book in folio, bound in writing vellum wherein are drawn all manner of cups'.

Jacob Mores was born around 1540-50 into a Hamburg family. Nothing is known about his apprenticeship, but he was already working for King Frederick II of Denmark in the 1570s. From the late 1570s onwards the town accounts also record numerous payments to him for the manufacture of grand pieces for presentation to visiting dignitaries. His only surviving works are of this sort, two giant cups and one small cup presented by the towns of Wilster and Krempe to Christian IV of Denmark, and now in the Kremlin, Moscow. It is clear that, like many successful goldsmiths, Jacob Mores was also a merchant for jewels and goldsmiths' work and before his death he had amassed considerable wealth. He died some time before February 1612 when the guild records refer to him as deceased.

Archival evidence and the drawings in this and the Berlin group show that his patrons were the most distinguished in the North Sea area—the Danish royal family, the Dukes of Holstein-Gottorp, and the Counts zu Schauenburg, the old ruling family of Schleswig-Holstein. For example, there are two pendants on ff. 30 and 33 with the monogram C.H.Z.S.H. for Christine, daughter of Landgraf Philip of Hess (b. 1543, m. Adolf, Herzog zu Schleswig-Holstein 1564, d. 1605). One of her daughters, also called Christine, married Charles, Duke of Sweden, later Charles IX in 1592 (*see* their burial regalia, cat. no. 125). Their son, born in 1594 was the great Gustavus Adolphus (*see* a memorial pendant to him, cat. no. 124), and it is likely that the pendants on ff. 31 (*see* p.129) and 39 with GA are in celebration of his birth.

What were these drawings for? Are they after finished pieces or are they designs? It is certain that the crowns were only designs: Christian IV's crown does actually survive in Rosenborg castle, and it is not this one. Then, it is obvious that the more sketchy drawings are also designs, but with the other more detailed and representational ones it is impossible to be certain whether they were made to impress potential clients, or as a record of pieces actually executed by or for Mores.

For the most part, the designs share the same dense use of table-cut stones, mostly diamonds, surrounded by brightly coloured enamelled C-scrolls, pointed leaved rosettes, and often swags. There are more pendants than any other item (48) reflecting the importance of this piece of jewellery in the costume of the day. Although tending towards abstraction, many do still include small figures such as Perseus and Andromeda (fo. 23), and some are allusive, such as the ones with the winged heart and sandclock, which was probably an emblem of Duchess Christine zu Schleswig-Holstein. [A.SC.]

The illustration shows folio 31: three pendants from the Jacob Mores jewellery book. Pen, ink and body colour on vellum L. The sacred monogram IHS among grapes; C. probably the monogram of Gustavus Adolphus on the winged heart with sand clock of Duchess Christine zu Schleswig Holstein, his grandmother; the Pelican in her piety. Around 1594 when Gustavus Adolphus was born.

Provenance: sold in 1768 by A. C. Wolters, who had acquired it in Copenhagen, to the Johanneum in Hamburg.
Literature: P. Limmer, 'Die Regalien des dänischen Schatzes', *Hamburger lit. u. krit. Blätter* XXX (1857) pp. 255-6; Steingräber, *Alter Schmuck*, pp. 114, 118, 119, 122, 124; R. Stettiner, 'Das Kleinodienbuch des Jakob Mores in der Hamburgischen Stadtbibliothek', *Beiheft zum Jahrbuch der Hamburgischen Wissenschaftlichen Anstalten XXXIII* (1915); Evans (1970) p. 122; J. Hayward, *Virtuoso Goldsmiths*, pp. 256-7.
Collection: Staat- und Universitätsbibliothek Hamburg. Cod. 1a in scrin.

G36 Five Designs for ornament
Engraved copper plate and impression. Size: 4.4 cm × 5.4 cm.

Copper-plate engraved with five designs for ornament for enamellers, and a modern impression taken from it. A demonstration of the close similarity between the engraving techniques of the enamellers and the print-makers, which when printed produce a strong black and white effect. [M.S.]

Provenance: M. Rosenheim.
Collection: V&A.Inv. nos. E.1342, 1343— 1923.

G37 Six Jewellery designs
Artist unknown, French or German, c1600
Engravings cut to various sizes.

Designs on four plates for a jewelled belt-pendant, two ear-rings, two dress-clasps, and an aigrette. Numbered respectively *no. 13, no. 28, no. 38, no. 12*. The style of the aigrette, although not the engraving technique, recalls the prints of Pierre Marchant (active 1601-1623). [M.S.]

Provenance: Messrs. Heussner and Lauser; F. R. Meatyard.
Literature: Y. Hackenbroch, *Renaissance Jewellery*, fig. 517.
Collection: V&A. Inv. nos. E.1342, 1343—1923. 1921.

G38 Design for ornament
Esaias van Hulsen (c1570—before 1626)
Engraving. Size: 11.1 cm × 10.7 cm.

Design for grotesque ornament for enamellers. Plate from the set entitled: *Esaias van Hulsen Fecit in Studtgart 1617*. Signed EVH.

This sheet of ornament combines the classically derived grotesque framework with the sinuous lines of the arabesque. Like many of the

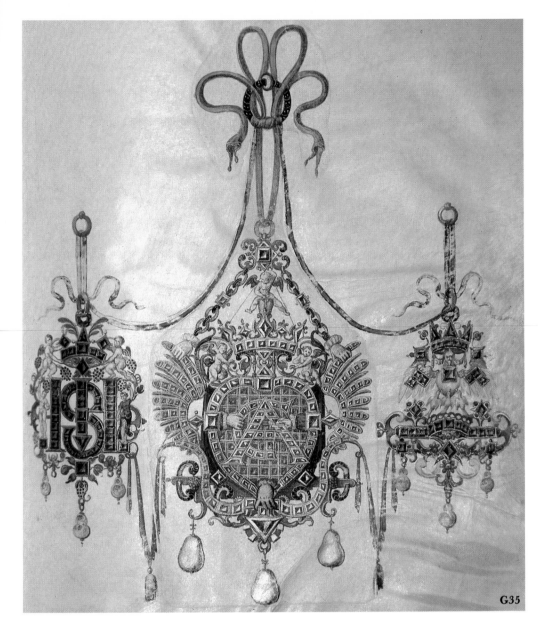

G35

enamellers' patterns of the period, it is an accomplished ornamental composition in its own right.

Provenance: sale at C. G. Boerner & Co., Leipzig, 15th-16th November 1928.
Literature: Guilmard, p. 391, no. 9; Berlin 656(4).
Collection: V&A. Inv. no. E.3352—1928.

G39 Design for pendant
Daniel Hailler (active 1604)
Engraving. Size: 9.9 cm × 6.8 cm.

Design for an enamelled pendant bearing the Sacred Monogram surrounded by eleven other patterns for enamelling. Plate from the set: *Hic Libellus aurifabris adeo commodus est e utilis eiusque usus necessarius Daniel Hailler syncero corte exsculpsit Anno Domini 1604 Augustae Vindelicorum* (i.e. Augsburg).

Signed D and HF in monogram.

Provenance: Kunstgewerbe Museum, Berlin.
Literature: Guilmard, p. 391, no. 8; Berlin, 654.
Collection: V&A. Inv. no. E.2196—1911.

G40 Design for enamel
Jean Toutin I (1578-1644)
Engraving. Size: 10 cm × 7.7 cm.

A circular design for enamel, held by a lion. Below are two men, one singing, the other playing a grid-iron as if it is a violin. Plate from a set. Dated 1619 and numbered III. For a miniature case closely related to this design *see* cat. no. 92. [M.S.]

Provenance: A. von Lanna.
Literature: Guilmard, p. 40, no. 18; Berlin, 792 (2); Evans, pl. 106 (6).
Collection: V&A. Inv. no. E.2894—1910.

G41 Designs for four aigrettes
Isaac Brun (b. c1590, active 1657) and Pierre Nolin, after Peter Symony (active 1604-1621). Engravings.

Designs for four aigrettes in the pea-pod style. Plates 21 to 24 of the set entitled: *Tabulae Gemniferae XXIV. Ad usum aurifabrorum accomodatae et Per P. Symony Invent, Isaac Brun Argentinae sculpsit 1621. Zu Strasburg bey Jacob von der Heyden Kupferstecher.* (a) signed *Isaac brun scul.* (b) signed PS and PN in monogram. (c) signed I.B. Each numbered in Roman and Arabic numerals. The goldsmith Peter Symony became a Master in Strasbourg in 1604.

Provenance: Stuttgart Sale, 2nd-8th May, 1913.
Literature: Guilmard, p. 396, no. 29; Berlin, 665; H. Meyer, *Die Strassburger Goldschmiedekunst* (1881) p. 219.
Collection: V&A. Inv. nos. E.2346-2349—1913.

G42 Designs for a pendent cross, two ear-rings and two other pieces
Giovanni Battista Costantini (active 1615-1625). Engraving cut to: 8 cm × 11 cm.

All designs decorated with ornament in black and white, the ear-rings held by two seated figures. From the set of six plates entitled: *Johannes Baptista Costanctinus Inventor et Fecit Romae 1622.* Costantini was both a goldsmith and an engraver. [M.S.]

Provenance: A. von Lanna.
Literature: Guilmard, p. 311, no. 11; Berlin, 875 (2).
Collection: V&A. Inv. no. E.2669—1910.

G43 Design for an aigrette
Unknown artist, after Jacques Caillardt
Pen and ink over pencil, oval. Size: 19.8 cm × 14 cm.

Design for an aigrette in the pea-pod style, a contemporary copy of plate 5 of the set of designs entitled *Livre de toutes sortes de feuilles pour servir a l'art d'orfeburie de l'invention de Jacques Caillart Marchant orfebure. A Paris . . . J. Briot sculpsit . . . 1627.* From a set of similar drawn copies, perhaps made by a jeweller for his own use. An engraved copy of Caillart's set was published in the Hague in 1628. [M.S.]

Literature: Guilmard, p. 44, no. 34; Berlin, 799.
Collection: V&A. Inv. no. D.1645—1908.

G44 Album of jewellery drawings
Arnold Lulls (active c1585-c1621)
Pencil, pen and ink, wash, body-colour and gold.
Volume size: 22 cm × 15.5 cm.
Album of drawings of jewellery, consisting of six preliminary leaves of contemporary laid paper and forty leaves of vellum, together with inserted sheets of paper and vellum, full-bound in contemporary gold-tooled calf.

The pieces of jewellery shown date from c1610 unless otherwise mentioned.

G41

G43

G42

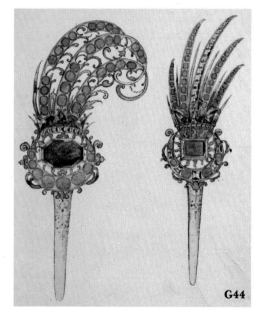

G44

p. 5 On a separate sheet of paper: a) a pendant formed as a dragon; b) a pendant formed as a sea-unicorn; c) a Garter George, on an attached slip of paper; d) a Garter Badge, on an attached slip of paper. The sheet inscribed *Schoon Esmaraude* (fine emerald) and (twice) *Granaat* (garnet).

p. 11 A pendant: twelve diamonds linked by enamelled leaves and florets, with a drop-pearl.

p. 15 A pendant: eight diamonds linked by enamelled scrolls, with three drop-pearls. (*See* Evans (1970) pl. 112).

p. 17 A pendant: an emerald surrounded by eight diamonds, within an oval of rubies or garnets entwined with enamelled serpents, with three drop-pearls.

p. 19 A pendant: the Sacred monogram in diamonds, with a gold crown of thorns, enamelled scrolling and a drop-pearl. The jewel dates from *c*1590 and is close to a piece in the Cabinet de Médailles, cat. no. 55.

p. 22 The stem of an aigrette.

p. 23 An aigrette: a ruby surrounded by numerous diamonds, all on an enamelled gold ground decorated with sunbursts, and with a diamond border.

p. 25 a) Three jewels; single large rubies in enamelled settings; b) a pendant composed of a diamond in an enamelled setting. All the pieces date from *c*1550-60.

p. 27 Two pairs of ear-rings: a) A green-enamelled snake from which hangs a ruby within a crescent of white enamel hung with three green drop-stones; b) a green-enamelled snake from which hangs a diamond within a crescent of diamonds, hung with a green drop-stone.

p. 29 A pair of pendants or ear-rings: eleven diamonds hung with drop-pearls and a green stone.

p. 31 a) A pair of ear-rings similar to p. 27 b) but with an enamelled crescent and a drop-pearl; b) a pendant of three emeralds flanked by green-enamelled palm branches, set with rubies and three drop-pearls.

p. 32 a) A pendant: a cabochon ruby surrounded by a diamond snake, and a drop-pearl; b) a large emerald in an enamelled setting. This jewel dates from *c*1550-60.

p. 33 a) A pendant identical to p. 32 a) but for its hanging loop; b) a pair of ear-rings in the form of an enamelled gold caduceus set with rubies.

p. 35 a) A pair of pendants or ear-rings: nine diamonds set in enamelled gold with a drop-pearl; b) A pendant; a rectangular emerald and four rubies set in enamelled gold, and a drop-pearl. These jewels date from *c*1560.

p. 37 Two aigrettes: a) three plumes of rubies and emeralds rising from a coronet of blue (?) stones surmounting a large octagonal blue (?) stone set within rubies; b) five plumes of diamonds, rubies and emeralds rising from a coronet of blue (?) stones surmounting a ruby set in an enamelled sun-burst, set within rubies and diamonds. Gold stems.

p. 39 A pendant: diamonds set in gold and enamelled scrolling, with a drop-pearl.

p. 41 a) A faint sketch of an aigrette; b) on a separate sheet of vellum a string of graduated pearls attached to an enamelled pendant set with a sapphire and a ruby. This jewel dates from *c*1550-60.

p. 43 An aigrette: five plumes set with emeralds and rubies rising from a coronet of diamonds (?) surmounting a large emerald set in rubies and diamonds. Gold stem.

p. 45 An aigrette: three plumes set with rubies and diamonds between crescents of gold rising from a gold circle surmounting a large diamond set within rubies, diamonds and crescents of gold. Gold stem.

p. 47 On a separate sheet of paper: a) A caduceus-shaped pin surmounted by a pearl, the snakes holding grapes (clustered amethysts) in their mouths; b) A pendant: a baroque pearl surmounted by an enamelled dragon and hung with amethysts imitating grapes.

p. 49 On a separate sheet of paper: a) an attached sheet bearing a drawing of a diamond(?) and ruby(?) pendant; b) An inscription in Dutch (translation: Picture of a large ruby and the fine pearl belonging to my brother Peter Lulls and the Company the which however not being of good colour I have been unable to sell here. I have sent it back to him. A.L.)

p. 51 On a separate sheet of paper: a brooch composed of a diamond and ruby branch bearing enamelled vine-leaves and hung with stones imitating fruit and grapes.

p. 53 On a separate sheet of vellum: a string of pearls.

p. 54 On a separate sheet of paper: two sketches of an aigrette.

p. 57 On a separate sheet of paper: a drawing of a jeweller's lens sent to Arnold Lulls by Francois

Pelgrim of Antwerp, with an inscription in Dutch by Lulls and another by another hand (Pelgrim?).

p. 59 On a separate sheet of paper: a pendant composed of enamelled foliage, an emerald and amethysts imitating grapes.

p. 60 A certified copy made by George Calvert (perhaps the 1st Lord Baltimore, 1580?-1632) of an exchequer warrant of 1605 concerning payment for jewels ordered by James I. Payments are authorised to Arnold Lulls and Sir William Herrick (1562-1653) in respect of jewels ordered by the King 'at this new year's tide now last past'. The jewels include a rope of round pearls and a 'great round pearl' for the Queen, a chain of stones and a George for Prince Henry, a jewel for Charles, Duke of York, and two 'pictures of gold set with stone (sic.)' given to the retiring French ambassador and his Lady, at a total cost of £3,029.

Arnold Lulls, a Dutch jeweller, is recorded between May 1605 and March 1607 in connection with the supply of jewellery to the royal family (*Calendar of State Papers, Domestic, 1603-1610*, 1857, pp. 217, 338, 352). In 1620 he was fined by the Court of Star Chamber for the unlawful transport of gold, silver and coins (ibid., *1619-1623*, 1858, p. 119). An Arnold Lulls appears in the lists of foreigners in the City of London and registers of the Dutch church between October 1585 and 1621. The church registers list him with his wife in 1594, and in 1617 as widower with five children. A certificate of the names of strangers of 1618 describes him as a '. . . merchant, born at Antwerp, . . . is of the Dutch Church, and a dweller here 30 years'. In 1625 he was living in Hoxton just outside the city (*see Return of Aliens dwelling in the City and suburbs of London*, II, III, Huguenot Society, 1902, 1907). The suggestion that Lulls was a *Marchand-Orfevre* as well as, or rather than, a working jeweller, cannot be discounted.

Most of the present drawings fall into one of three groups. 1) Drawings by a single hand on vellum. The cast shadows, perspective viewpoints and differing dates of the pieces shown, suggest that these are record drawings like those by Hans Mielich (*see* cat. no. G18). 2) Ink and water-colour drawings on vellum, by a single hand, of aigrettes (pp. 37, 43, 45). Although apparently by a different, freer hand than 1), they are placed within that series and are perhaps also record drawings. 3) Poor pencil, ink and water-colour drawings on paper, chiefly by a single hand, differing from 1) and 2). One (p. 49) is certainly a record drawing, the others could be designs. Outside these groups are the record drawings of the lens (p. 57), and the sketches of an aigrette (p. 54) which are probably designs. The purpose of this book and its connection with Lulls is unclear. Many of the pieces drawn on vellum are, however, similar to those seen in contemporary portraits of Anne of Denmark. It is reasonable to suggest that the book derived from his workshop, and that it may have been begun as a record. The pieces shown in the drawings on paper can be compared with those from the Cheapside Hoard (*see* cat. no. 120). [M.S.]

Provenance: John Blackwell (inscription on fly-leaf). A John Blackwell was admitted to Queen's College, Cambridge, *c*1594. Another John Blackwell was admitted to Emmanuel College in 1596. He died in 1630. G. Gregory.
Literature: Falk, *Edelsteinschliff*, pls. 66, 67; Y. Hackenbroch, *Renaissance Jewels*, figs. 801 A-C; Evans (1970) pl. 72.
Collection: V&A Museum. Inv. no. D.6(1-25)—1896.

G45 Portrait of Prince Khurram (Shah Jahan) holding a jewelled aigrette (*see* p. 5)
Painted by Abu'l Hasan, Mughal school, 1616/1617.
Opaque water-colour with gold details. Size: 20.6 cm × 11.5 cm (painting), 39 cm × 26.7 cm (page).

Inscribed, top: *Shah Jahan*; left: *The work of the inherited servant's offspring, Nadir al-Zaman (the Wonder of the Age)*; right: *Auspicious likeness of the Cynosure and Lord of Mankind*; lower border: *A good likeness of me in my twenty-fifth year and it is the fine work of Nadir al-Zaman.*

A note on the border in Shah Jahan's hand says that the portrait was painted in his twenty-fifth year, that is January 1616-January 1617. It is not unusual for the Mughal emperors to be shown holding a flower or jewel, but the ornament in the painting is particularly interesting. It resembles the designs of Arnold Lulls, who supplied Anne of Denmark and James I with jewels (*see* cat. no. G44). No jewelled aigrette of this kind and date was made in India before this date and it therefore seems probable it was a gift made to Shah Jahan by a European envoy or traveller. [R.S.]

Provenance: from an album belonging to Lord Minto, purchased in 1925.
Literature: Ivan Stchoukine, *La peinture Indienne à l'époque des Grands Moghols* (Paris, 1929) pl. XXXII; Bamber Gascoigne, *The Great Moghuls* (London, 1971) p. 186; Milo Beach, *The Grand Mogul: Imperial Painting in India 1600-1660* (Sterlin and Francine Clark Art Institute, Williamstown, Massachusetts, 1978), p. 90; *Paintings from the Muslim Courts of India* (British Museum, 1976) cat. 117 on p. 70 and ill. p. 71.
Collection: V&A. Inv. no. I.M. 14—1925.

G46 Copy drawing of the Liechtenstein ducal crown, 1756 (*see* p. 6)
Artist Unknown.
Pencil, pen and ink and gouache on vellum.

Prince Karl of Liechtenstein (1569-1627) was made Duke of Troppau in 1614, and Duke of Jagerndorf in 1623 by imperial concession. He wasted no time in ordering a ducal crown from Daniel de Briers, the Frankfurt jeweller and merchant. The choice of de Briers was no doubt because of his connection with the imperial court at Prague, where Karl would have come across him in his capacity as Viceroy of Bohemia. The standard of goldsmithing and of the jewellers' craft had been very high at the Prague Court ever since the days of Emperor Rudolph II who gathered to him craftsmen renowned all over Europe for their skill, and a collection which was legendary for its splendour (*see* cat. nos. 62-71).

As was frequently the case, Karl provided a great many of the stones himself, some loose, others set in pieces of jewellery which had become old fashioned, and de Briers supplies the rest. The princely exchequer books for 1626 and 1627 record how the payments for the crown were divided, with 4500 florins going to de Briers' brother-in-law, 'Jobst von Prussl, Jubilierer', 27 florins 30x going to the goldsmith 'Godtfridt Nieck' who polished and completed the crown, 8 florins to Hans Berckmann for work on the stones of the crown, and 9000 florins to Daniel de Briers. Apparently the crown was made and set with the stones bought by de Briers in Frankfurt, and then sent to Prague with Gottfried Nick where the remaining empty settings were filled with stones provided by the Prince. In using Jost of Brussels Karl was again drawing on a Prague imperial craftsman. Jost, who died in Prague in 1635, is recorded on his tombstone in the cloister of St Thomas as having served Emperors Rudolph II, Mathias, and Ferdinand II as 'Gemmarius', that is, cutter of precious stones, and in his role as Viceroy, Karl had made him repeated payments for supplying the court with pieces of jewellery.

It is not surprising, therefore, that the crown clearly derives from the imperial crown completed in 1602 (*see* p. 1): the double row of pearls, the large table-cut stones surrounded by smaller stones, alternating with vertically paired pearls on the circular are obviously the same.

The crown descended within the Liechtenstein family until, in 1756 Prince Josef Wenzel declared all the family jewels to be entailed. It was then that the crown together with the rest of the jewels, was depicted life size. Ironically, it was only after this declaration of entail that the crown disappeared: the precise date is unknown, but the 1781 inventory of the entailed jewellery records that the crown had gone. [A.SC.]

Provenance: executed for the Liechtenstein house archive where it has remained to this day.
Literature: G. Wilhelm, 'Der historische liechtensteinsche Herzogshut', *Jahrbuch des Historischen Vereins für das Fürstentum Liechtensteins* IX (1960) pp. 7ff; G. Wilhelm, *Die Fürsten von Liechtenstein und ihre Beziehungen zu Kunst und Wissenschaft* (Liechtenstein, 1976), p. 24, fig. 2.
Lent by: His Serene Highness, Franz Josef II the Reigning Prince of Liechtenstein.

G47 Design for a jewelled spray
Pierre De La Barre (active *c*1625)
Engraving. Size: 29.8 cm × 23.2 cm.

Lettered: *Avec Privilege du Roy*. A comic figure in a landscape, bearing on his back a large jewelled

spray. Plate from the set entitled: *Livre de Toutis sortes de feuilles Servant a L'orphevrerie Inventees Par P. De La Barre Me. Orphevre A Paris.* The introduction of figures and landscapes after Callot and Merian and the representation of jewels as plants (in this case uprooted), are characteristic of French jewellery prints of this date. [M.S.]

Provenance: J. Rimell and Son.
Literature: Guilmard, p. 49, no. 49; Berlin, 806.
Collection: V&A. Inv. no. E.7075—1908.

G48 Watercolour of a Pendant (*see* p. 4)
Paper, pasted into a letter dated 27th January 1546 from Stephen Vaughan, Henry VIII's agent in Antwerp, to William Paget in London; the pendant is shown actual size.

This letter recording an 'owche' on offer to the King, is one of many sent from Antwerp for Henry's consideration in the 1530s and 1540s. The diamond was exceptionally large and valued at 50,000 crowns; a week earlier Vaughan had sent a paper sample for size and commented on the 'great fair round orient pearl' but no mention was made of the enamelled setting.

At the time Henry's factor was desperately negotiating loans and there was a general European shortage of currency. The Fugger, or, in this case, John Carolo and his Affiati (Company), were often unable or unwilling to find cash for the King and offered to make up the value of the loan with outstanding jewels, which could then be used as security. 'If he could utter to the King the diamond . . . he would disburse therewith 100,000 crowns.' This deal apparently failed; another loan in March 1546, involved 'a great pointed diamond set about with pointed diamonds like a rose' priced at 100,000 *livres* along with copper and ready money on all of which interest was due at twelve per cent for twelve months. The Fugger offered to send 'the pattern of the jewel in lead and portraiture'.

Henry was known as a keen collector of jewels, but by the 1540s his agents were no longer passing offers on 'since (The King) hath already greater store than the most potant of all the prices of Christendom'. Apart from his Scottish campaigns, he was still building, at Nonsuch and elsewhere, and simply could not maintain all the facets of princely expenditure. He had in any case the pick of the fine stones from monastic shrines and treasures between 1536 and 1539 because of the dissolution and the monasteries. [P.G.]

Provenance: Paget correspondence, Public Record Office.
Literature: Evans (1970) p. 87, pl. 44d; Gairdner, *Calendar of State Papers Henry VIII*, vol. XXI, pl. 1, p. 55.
Lent by: Public Record Office. SP1/213.

G49 Manuscript inventory of the possessions of William Herbert, Earl of Pembroke, K.G., (1501(?)-1570)
Dated 1558-62. Folio book of 118 paper folios, of which a few are blank. The inventory is written in a standard professional hand of the period, but has many additions and annotations in other hands. Vellum binding reinforced with three hinge-like leather straps (incomplete), stitched to it with vellum laces, of which the centre one carries a simple brass buckle. This last can be used to secure a strap on the extension flap on the rear cover which wraps round the fore-edge. External dimensions: 30.2 cm × 39 cm.

Sir William Herbert, 1st Earl of Pembroke of the second creation in the Herbert line, was a major figure at the courts of Henry VIII and his three children and married Anne Parr, sister of Henry's last Queen, Catherine. This inventory, which apparently lists all his possessions but only some of those of his Countess, is dated in different parts 1558, 1561, 1562. The dates must refer to the original inventories of the parts of the collection in question copied into the present manuscript. The plate and jewellery, none of which appears to have survived, were of great richness and splendour and the latter, in particular, included many pieces decorated with enamel and precious stones, pearls, cameos and what was obviously a very remarkable group of Georges and garters of the Order of the Garter. The following extracts give some idea of the quality of the whole:

f.31 (Inventory of the Countess's jewels, 1562)
'ffirst a girdell of golde sett with pearle conteigning lvij knottes beinge Linked together, one knott with a pearle and the other with counterfect saphires and rubies havinge a knoppe at theinde accordingly and one of the peces broken pviz x vnces quarter farthinge golde weight.'
f.32v. (*ibid.* amongst collars)
'A Sabelles heade with xxjᵗⁱ diamondes and a ringe with a rubie in his mouthe and with xᵗⁱ sparkes of Diamondes with iiijᵛʳ clawes of golde and diamondes therein and a Cheine hanginge at it.' (? for a *Flohpelz*)
f.33 'A paire of brecelettes of flaggon facion with hoopes. A paire of bracelettes set with xxiiijᵗⁱ pearles ij Diamondes ij Turkasyes ij rubies ij Emerawdes ij Saphires one Topices (*sic*) and one Amathiste.'
f.34v (*ibid.* amongst 'Tablettes')
'A Tablett of king Philippes face on the one side and his fathers Charles Themperors on thother side.'
'A Tablett with ix great Diamondes on the one side and a P on thother side with viij diamondes and a greate platted chaine with it.'
'A Vnicornes bone sett in golde with one Turkus twoo Rubies and iij diamondes.'
'A booke of golde with a knotte enameled blacke and white of Gilbertes workinge.'
'A booke of golde with iiijᵛʳ Saphires havinge in it the History of David dauncinge before the arke.'
f.36v. 'A flower of golde with ij greate table diamondes and one great pointed diamonde enamelled with blewe white and redde with a peare facion pearle at it pendaunt.'
'A greate ballise with a pearle pendant sett with Snakes grene enamelled.'
f.75v. (Inventory of the Earl's apparel, jewels, etc., 1561, amongst 'Brooches')
'Item an Agatt of a woman morens hedde with a white Launde vpoon the hedde, set with iiijᵛʳ Rubies and iiijᵛʳ Diamondes enameled white and black with one hundred and xvj buttons black enameled.' [C.B.]

Provenance: The history of the manuscript is unknown before it entered the collection of the late H. L. Bradfer-Lawrence, apparently in the early 1950s.

Literature: J. F. Hayward, 'The armoury of the first Earl of Pembroke', *The Connoisseur* (April, 1964) pp. 225-30.

Lent by: P. L. Bradfer-Lawrence, Esq. (Fitzwilliam Museum, Bradfer-Lawrence Ms. 36.)

G50 Devices on a watch
Pen on paper, 1576

Document endorsed 'Janu. 23, 1575 Devices about a Diall of the Q. of Scottes.' Drawing of engraved panels headed folio I: 'Upon the cover of the boxe opening over the hours' a) polestar and lodestone, SA VERTU M'ATIRE (anagram of Marie Stuart); b) oaktree in graveyard, PIETAS REVOCABIT AB ORCO; 'About the sides of the Diall', eight ovals in pairs, one of each with the arms of France and Scotland (not copied); c) an appletree growing through a thorn, PER VINCULA CRESCET; d) a palm tree, PONDERIBUS VIRTUS INNATA RESISTET; e) a tree, a castle or walled town with two scythes, UT SUPERBIS VISUM; f) camomile in flower, FRUCTUS CALCATA DAT AMPLOS; f.3 'the botome of the Dial'; g) eclipses of the sun and moon, IPSA SIBI LUMEN QUOD INVIDET AUFERT; on the face: h) sun, moon and stars, QUE CECIDERE RESURGUNT.

All but two of these devices (e & h) are known to have been used elsewhere by Mary Queen of Scots, notably on sets of embroidered bedhangings, one now at Oxburgh Hall and the other recorded in 1619 (a, b, c, d, f), on the silver ryal issued in 1565 (d) and on her canopy of state.
The common theme is her capacity to endure adversity and flourish despite difficulties; the eclipse device refers to Queen Elizabeth and herself. This document was drawn up by a spy within Mary's household, suspicious of so rich a collection of devices; presumably the watch was a recent gift from someone at the French court and potentially concealed a message.

Mary's taste for devices, fostered at the French court, is clear from her letters; in the 1570s she ordered from France a small hanging mirror, to be engraved with devices drawn up by her Guise uncle, the Cardinal of Lorraine, and an emblematic jewel to her own design for her son James (later James I of England) and sent, fatally for the recipient, a cushion to the Duke of Norfolk worked with her favoured device of a vine and pruning hook. In 1571 the English government took this obscured message as contributory

evidence of a conspiracy, an indication of the significance sometimes attached to these enigmatic and necessarily limited vehicles of communication. While imprisoned at Lochleven in 1567 Mary had received secretly a ring engraved with Aesop's fable of the bound lion and the mouse, an encouraging although hardly practical gesture of support. An emblematic jewel sent to Queen Mary in 1570 aroused the suspicions of Randolph, the English ambassador, who sent an account of it to London (Fraser Tytler, p. 36-37).

Devices were peculiarly a French court fashion of the late 15th and 16th centuries although also used widely by the nobility of England and Italy. Combining a motto and a picture which reciprocally interpreted one another, they were intended to have an obscured but complementary significance for the individual choosing them. Many books on the language of devices and the related emblems appeared in the 16th and 17th centuries and specific rules applied as to the proper content of a device: it should not contain human figures but rather, objects pleasing to the eye (drawn from nature and not fabulous); the motto should not be in one's native language, it should express a true and noble thought in a form not immediately obvious, (Praz, p. 62). Emblems also combined words and pictures, but the text was regarded merely as a confirmatory title and there was no obligation to make the meaning deliberately obscure, nor as an integral part of the symbolic whole. The Lennox or Darnley Jewel (cat. no. 31) combines both emblems and devices. 'The emblem has only to feed the eye, the device the mind!' (Capaccio, *Delle Imprese*, p. 2-3.) [P.G.]

Literature: *Calendar of Scottish Papers*, vol. V (1907) p. 210; R. Strong and J. Trevelyan Oman, *Mary Queen of Scots* (1972) p. 38; F. de Zulueta, *Embroideries . . . at Oxburgh* (1923) p. 5-6; Palliser, *Historic Devices* (1870) p. 234-238; M. Praz, *Studies in seventeenth century imagery* (1939).
Lent by: Public Record Office, London.

G50

The 19th Century

H1 Mermaid pendant
Gold and silver, enamelled in opaque black, white, powder blue, dark blue, yellow, green, translucent green, red and blue; set with foiled diamonds, emeralds and pearls, including a large baroque pearl for the body; hung with three baroque pearls. Stones are table, rose and brilliant cut, all in closed collets. Height: 11 cm.

A brightly-coloured suspension loop and supports adapted from an old piece of jewellery, possibly a late 17th or early 18th century ear-ring. The remainder is almost entirely 19th century. The enamelled head is pegged straight into the baroque pearl body; a gold pin head in the pearl may indicate that an arm was intended. The scales on the tail are delineated with opaque black enamel, painted over translucent green. A jewelled cluster beneath the tail may have been taken from an earlier piece, but the goldwork elsewhere, such as the back of the tip of the tail, is matted in a fashion recalling silverwork of the 1820s and 1830s.

Queen Victoria described the set as 'a complete antique parure' in her Journal on 24th December 1842, but it was composed of disparate pieces, some of Transylvanian origin, spanning about a century and a half in date, the pendant being almost completely modern. At the time of the gift, the London Museum was under the impression that the set had been worn by Queen Victoria in the character of Philippa of Hainault at a costume ball at Buckingham Palace on 12th May 1842. This is clearly incorrect. [S.B.]

Provenance: purchased by Prince Albert with a necklace, ear-rings, girdle and eight gold pins from an unknown dealer and given to Queen Victoria at Christmas 1842; the set bequeathed by the Queen to her granddaughter, Princess Louis of Hesse (later Marchioness of Milford Haven) and given by the Marchioness (excepting the eight pins) to the Museum of London, 1920.
Literature: C. Gere, *Victorian Jewellery Design* (1972), p. 45, pl. 15 (accepted as the jewellery worn by Queen Victoria on 12th May 1842).
Collection: Museum of London. Inv. no. A.23327.

H2 Brooch (see p. 42)
A *commesso* cameo of Queen Victoria in a gold frame with the roses of Lancaster and York, enamelled in opaque white, translucent green, red, cream and black. It is set with table-cut and cabochon emeralds, and rose diamonds. Height: 6 cm.
Condition: slight loss of enamel.

The *commesso* made of shell (the Bull's mouth or

Cassis rufa), gold (mainly enamelled) and precious stones. The shell scratch-signed on the back: Paul Lebas/Graveur/1851/Paris. The tubular gold frame unmarked, but the pin and clasp struck with the maker's mark FD for Félix Dafrique of Paris, and a head of Mercury, an exportation mark in use from 1840 onwards.

The *commesso*, inspired by Renaissance pieces (*see* cat. no. 68), is a free adaptation of Thomas Sully's three-quarter length portrait of the Queen in Garter Robes, dated 1838 (Wallace Collection, London). The artist's original study is in the Metropolitan Museum, New York and a full-length canvas was executed on Sully's return to the United States of America in fulfilment of a commission from the Philadelphia Chapter of the Society of the Sons of St George. The portrait now in the Wallace Collection was engraved by C. E. Wagstaff and published by Hodson & Graves of London on 10th April 1839. Presumably Lebas used a copy of the print for the cameo, though for some reason he reversed the image of the Queen and portrayed her in a three quarter profile, whereas the painting shows her nearer full face. Her diadem (originally made for George IV in 1820) and the details of her Garter Collar, necklace and robe are much simplified.

Dafrique was awarded a Prize Medal for a variety of works shown at the Great Exhibition, but especially for 'polychromic cameos, with metal and enamel ornaments, a happy invention, well carried out.' See *Reports by the Juries* (1852) Class XXIII, p. 518. [S.B.]

Provenance: The brooch was almost certainly shown at the Great Exhibition of 1851 (France, no. 1575).
Literature: S. Bury, 'A commesso cameo of Queen Victoria' in Society of Jewellery Historians, *Newsletter*, No. 3 (April 1978).
Collection: V&A. Inv. no. M.340—1977.

H3 Parure (comprising necklace, brooch, ear-rings and bracelet) (see p. 42)
Silver-gilt with painted decoration imitating enamel in opaque black, white, red and green; set with garnets, emeralds and emerald pastes, pearls which are probably mainly imitations. The stones are mostly table-cut and foiled, in closed collets. Length of necklace: 33.5 cm.

Standardised components each of two convex openwork plates, one pinned above the other, to which are soldered tubes, the more elaborate of which have fleurets attached to their rims, supporting the collets which hold the stones and pearls. The ear pendants are identical to three of the components of the necklace, the brooch to the large square unit in the bracelet.

The parure is described as a 'trousseau' in the seventeenth century style in J. C. Robinson, *Inventory of the Objects forming the Collections of the Museum of Ornamental Art* (1856) p. 64, no. 9111. From the same source derives the information about the name of the manufacturer and the source of acquisition. Unfortunately Schlichtegroll's name does not appear in either the first or

the second edition of the official catalogue of the exhibition, nor in the list of those receiving medals. It is known, however, that the exhibition was far from complete when it was opened by Napoleon III and Eugénie, objects being unpacked and hastily assembled for the occasion, and then re-packed so that builders and decorators could resume their labours. In these circumstances, it is unlikely that a comprehensive list of the exhibitors was ever assembled.

Henry Cole conscientiously purchased examples of mass-produced wares from international exhibitions for the benefit of students of design using the Museum collections. [S.B.]

Provenance: The parure was said to have been shown by the manufacturing firm of Schlichtegroll of Vienna at the Paris Universal Exhibition of 1855. It was purchased from the Exhibition by the Museum of Ornamental Art, the precursor of the Victoria and Albert Museum.
Collection: V&A. Inv. no. 2664—1856.

H4 St George and the Dragon brooch pin
Gold enamelled in opaque blue, pink, black, red, white and grey, translucent green, orange, red and blue. Height: 3.3 cm. (*see* p. 43)
Condition: slight loss of enamel.

Modelled largely in the round, and cast with only the bodies of the horse and the dragon left concave at the back.

The provenance establishes the authorship of the piece, which was one of a group of works prepared for exhibition by François-Désiré Froment-Meurice (1802-1855) before his death in February 1855 and subsequently shown by his widow. It was designed as either a pin or a brooch and originally supplied with the appropriate fittings which presumably bore the maker's mark and Parisian warranty marks, but was stolen (with the Amazon pin below) in consequence of the dispersal of the V&A collections during the 1939-45 war. The fittings were removed by the thief though fortunately the piece was recovered in 1953. [S.B.]

Provenance: purchased with other pieces by the Museum of Ornamental Art, the ancestor of the Victoria & Albert Museum, direct from the Froment-Meurice display at the Paris Universal Exhibition of 1855 (see cat. nos. below).
Literature: *Reports on the Paris Universal Exhibition*, Part III (1856) pp. 394-5.
Collection: V&A. Inv. no. 2659—1856.

H5 Pendant and pair of brooches (*see* p. 43)
Coral cameos set in gold and pearls. The pendant is hung with three pearls and diamond sparks. Height of pendant: 10.5 cm, height of brooches: 5.6 cm.

All three cameos are unsigned. That in the pendant represents Bacchus wearing a wreath, a lion skin over one shoulder, and a thyrsus; those in the brooches are of Apollo and Venus. The

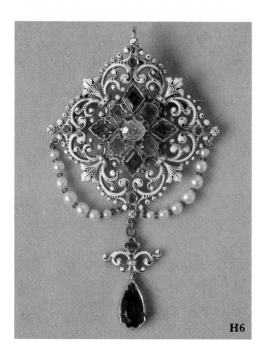

H6

wrought gold frame of the pendant incorporates two cast sirens with wings and double fish tails, while winged cherub terms flank the cameos in the two brooches. Loops for pendants are attached to the lower part of the brooch frames; the two pins are stamped F. MEURICE, together with the restricted warranty mark for gold wares produced in Paris from 1838 onwards. The frame of one brooch is also scratch-signed: F. Meurice. A catch on the back of the pendant indicates that it once had a brooch fitting, now missing. The catch is struck with an illegible maker's mark, perhaps beginning AX.

The sirens in the pendant are somewhat similar to the principal motif of a Renaissance jewel in the Green Vaults, Dresden, illustrated by Yvonne Hackenbroch in *Renaissance Jewellery* (1980), pl. 593A. Froment-Meurice was fond of the device; two sirens appeared on the centre of a bracelet shown by his widow at the Paris 1855 exhibition and illustrated in the *Art Journal* catalogue of the exhibition (p. 34). Two more figure on his 'Arethusa' brooch of the same year. *See*: Henri Vever, *La Bijouterie Française*, II, (1908), p. 121. If the pendant and two brooches shown here are dated to about 1855 by analogy, we can rule out a tradition that the set belonged to Hortense, Queen of Holland (1783-1837), passing from her to her son Louis-Napoleon (1808-1873), the future Napoleon III of France. Louis-Napoleon is said to have given the set to a member of the Standish family as security for financial assistance afforded him in England, presumably in the 1840s. It is of course possible that as Napoleon III he purchased the set and gave it to his English friends. It was supplied with a fitted case stamped: Froment-Meurice, orfèvre-joaillier de la Ville de Paris . . .' [S.B.]

Provenance: Dame Joan Evans, P.P.S.A.
Literature: C. Gere, *European and American*

Jewellery, 1830-1914 (1975) p. 182 (Venus brooch only).
Collection: V&A. Inv. no. M. 30-b-1962.

H6 Pendant with brooch fitting
Gold enamelled in opaque black, white and pink; set with diamonds, garnets, emeralds and rubies; hung with green glass beads and pearls. Pendant in three stages with an emerald and amethyst. Height: 7.8 cm.

The central diamond is brilliant-cut, in a claw setting. The other stones are table-cut and set in open-backed collets with indented edges. There is a diamond spark at the edge of each emerald.

The central lozenge-shaped group of stones stands proud of the openwork surround. Maker's mark, A & A . . .(?) struck on the clasp of the brooch fitting, which is presumably that of one of the outworkers employed by Froment-Meurice. [S.B.]

Provenance: purchased by the Museum of Ornamental Art from the Froment-Meurice display at the Paris 1855 exhibition.

Collection: V&A. Inv. no. 2660—1856.

H7 Amazon Pin
Gold with opaque black, white, grey, pink and orange, and translucent green enamel. Height: 10 cm.
Condition: slight loss of enamel.

The group of a mounted Amazon attacking a panther modelled in the round. The name and tail of the horse are chased, not enamelled.

See cat. no. H4 above. Froment-Meurice's signature has been expunged from the stem of the pin. [S.B.]

Provenance: purchased by the Museum of Ornamental Art from the Froment-Meurice display at the Paris 1855 exhibition (*see* cat. nos. 00 and 00).
Collection: V&A. Inv. no. 2660—1856.

H8 Pendant
Gold with opaque white, black, light blue and green painted enamel; dark blue cloisonné enamel; set with table-cut rubies, foil-backed in closed collets. Three pendent drops set with diamond chips and hung with river pearls. Height: 8 cm.

The vase body convex in front, flat at the back, the handles each made in two parts; the body and loop decorated with applied wires. Cast and enamelled cherub terms. Glass-fronted locket set in the back, below which is an applied oval plaque bearing the raised Roman initials C.G. (for Carlo Giuliano).

The jewel dates from 1867 or earlier; an almost identical piece was shown at the Paris Universal Exhibition of 1867 by Harry Emanuel of 18 New Bond Street and was reproduced in the *Art Journal Illustrated Catalogue* of the exhibition (p. 10). The only difference lies in the length of the pendent

drops. This piece is one of the instances which establish that Giuliano started to work for the London trade not long after he came to London. [S.B.]

Provenance: Carlo Giuliano; his sons C. & A. Giuliano, who presented the piece to the V&A in 1900.
Literature: M. Flower, *Victorian Jewellery* (1951, 2nd ed. 1967), fig. 78a; C. Gere, *European and American Jewellery, 1830-1914* (1975), p. 173; G. Munn, 'The Giuliano Family,' *Connoisseur*, CXC (1975) p. 156, figs. 2 & 3.
Collection: V&A. Inv. no. 164—1900.

H9 Pendant

Gold with opaque light and dark blue, black and white enamel; set with table-cut rubies, sapphires, pearls in closed collets, and an onyx cameo of Marie de Medicis (1573-1642). Also, a pendent drop with two pearls. Height: 10.4 cm.
Condition: slight loss of enamel.

The frame consists of gold strip scrolls, to which enamelled foliage is applied; the swags are rigid strips with enamelled pellets. The cameo is scratch-signed on the back 'Marie de Medicis/G. Bissinger/3204,' and forms the base of a locket with a table-cut crystal set in a gold rim. The back of the top pearl in the drop bears a shaped plaque with the mark of Carlo Giuliano of Frith Street, Soho, based on the crossed Cs mark of Castellani of Rome, who established Giuliano in business in London in about 1860.

This pendant cannot date from much later than 1865, for it bears the mark used by Giuliano in testimony to his association with the Castellani

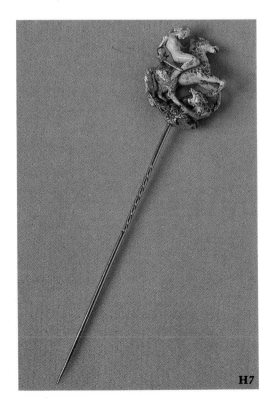

firm. Giuliano, a Neapolitan, almost certainly worked for Alessandro Castellani, the son of Fortunato Pio Castellani, who founded the firm in Rome. Alessandro was imprisoned for political activities after the fall of the short-lived Roman Republic in 1849 and lived in exile in Naples from about 1858. It was in the Neapolitan workshop that the firm's long struggle to reproduce the ancient technique of granulation at last met with a measure of success. In his years with Alessandro, Giuliano clearly had experience of the Renaissance style jewellery also made by the firm. On Giuliano's death in 1895, his business, based at 115 Piccadilly from 1874 onwards, passed to his sons Carlo and Arthur. Georges Bissinger (born in Hanau) spent most of his working life in France. He distinguished himself at the Paris Universal Exhibition of 1867 (*Art Journal*, 1868, p. 38) and again at the Paris Exhibition of 1878 (E. Babelon, *Histoire de la Gravure sur Gemmes* (1902), pp. 235-6. [S.B.]

Provenance: Carlo Giuliano. His sons, C. and A. Giuliano, presented the piece to the V&A in 1900.
Literature: M. Flower, *Victorian Jewellery* (1951) pl. VII; C. Gere, *Victorian Jewellery Design* (1972) pl. 61a.
Collection: V&A. Inv. no. 165—1900.

H10 Pendant with brooch fitting

Gold with opaque black, white, green, translucent green and red enamel; set with a large sapphire intaglio of a contemporary battle scene, a diamond, rubies; hung with three pearls. Height: 8.5 cm.

Heart-shaped sapphire intaglio, bevelled diamond, cabochon and point-cut rubies, the intaglio open-backed, the remaining stones set in closed collets. One spherical pearl forms a crest; two pink, one grey pear-shaped pearl drops. Cast

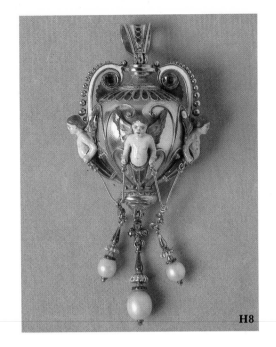

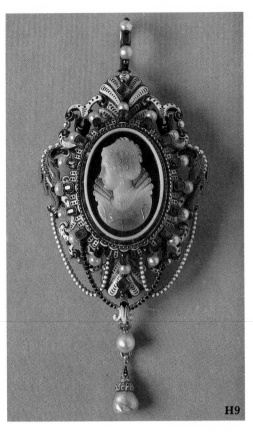

and wrought components assembled into one thick plate, the back chased with panels, scrolls and scallops on a partly-matted ground. An applied plaque with an indented border bears the crossed Cs mark of the firm of Castellani of Rome.

The overall construction of this piece, and most of the detailing, is identical to that of the pendant described below. Though paying homage to Renaissance jewellery, the structure is quite uncharacteristic of late sixteenth and early seventeenth century pieces assembled from two or more plates. The pendant probably dates from about 1865. The Castellani family, especially Alessandro (1802-1883), supported the Risorgimento, and the battle scene may well represent one of the campaigns undertaken in the cause (an impression of the cameo is shown with the jewel). [S.B.]

Provenance: H. L. Florence, Esq.
Literature: M. Flower, *Victorian Jewellery* (1951) pl. VII.
Collection: V&A. Inv. no. M.22—1917.

H11 Pendant (*see* p. 44)

Gold with opaque black, white and blue, translucent green and red enamel; set with table-cut rubies and emeralds. Height: 8.4 cm.
Condition: slight loss of enamel.

Cast and wrought components assembled into one thick plate as in cat. no. H10 above, the chief difference being that two rubies set proud on individual scalloped frames are substituted for the

single sapphire intaglio. The overall size is also smaller. The back, partly flat, partly convex, with the remains of an attachment for a brooch fitting, is chased with panels of scrolling foliage.

The late Dame Joan Evans acquired this piece as an example of early seventeenth century German work. The close parallel with the signed Castellani pendant, however, is evidence of a nineteenth century date. [S.B.]

Provenance: Dame Joan Evans, P.P.S.A.
Collection: V&A. Inv. no. M64—1975.

H12 Pendant (*see* p. 43)
Gold with opaque blue, translucent red and green enamel; set with a garnet and chrysoberyls, chrysoberyl pendant. Height: 6.9 cm.

Cabochon garnet, table-cut chrysoberyls. The simple oval frame engraved on the back with a shell, a flower and acanthus scrolls, surrounding a glass-fronted locket, the base of which is formed by the cabochon garnet.

A characteristic example of the High Victorian 'Holbein style' which first appeared in the mid 1850s, remaining fashionable until 1880 or later. It was a peculiarly English phenomenon, exemplifying the English taste for non-figurative design. The pendant is reminiscent of jewellery shown at the International Exhibition of 1862 by Howell, James & Company of Regent Street (*Illustrated Catalogue of the Industrial Department*, II, Class XXXIII, figs. 12, 13) and by other London firms such as London & Ryder (*Art Journal* catalogue, p. 92) and Hancock (*id.*, p. 3). [S.B.]

Literature: similar pieces illustrated in C. Gere, *European and American Jewellery, 1830-1914* (1975) fig. 82; P. Hinks, *Nineteenth Century Jewellery* (1975), colour pl. F (c) and G (b).
Collection: V&A. Inv. no. Circ. 95—1961.

H13 Chatelaine
Iron. The hook attached by a ring to the plate, which is embossed and chased; on the back of the plate, chased scales, foliate scrolls and foliage. Signed: T. SPALL. INV & FECIT. Height: 25.5 cm.

Thomas Spall studied at the Birmingham School of Art from 1869 to 1873, probably attending evening classes while working during the day for Elkington & Company of Birmingham. The firm's chief artist-craftsman at the time was a Frenchman, Leonard Morel-Ladeuil (1820-1888), whose Milton Shield, in silver and embossed iron, was shown at the Paris Universal Exhibition of 1867 and was acquired by the South Kensington Museum. The head of their design studio was another Frenchman, a designer and sculptor named Auguste Willms (1827-1899), who was active in training the firm's apprentices. Spall seems to have been among them: his style was greatly influenced by Willms. This piece probably dates from about 1875. [S.B.]

Provenance: the artist.
Collection: V&A. Inv. no. 533—1903.

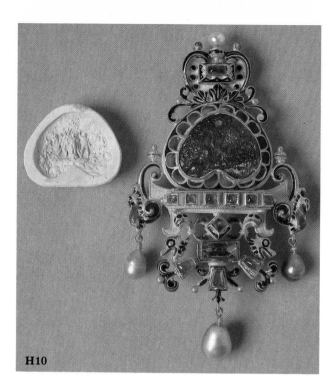

H10

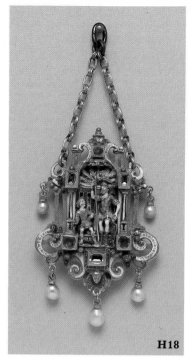

H18

H14 Brooch with buckle fittings
Silver enamelled in opaque blue, purple, black, white, green and turquoise enamel and translucent orange; set with step-cut rubies and table-cut emeralds. Height: 6.3 cm.

Convex plate, the pierced borders decorated with cornucopiae, monsters, masks and scrolls; group of St George and the Dragon cast and applied in front of a round-headed arch and scrolls in enamel. Two vertical slides at the back stamped with the quality mark (800) and the crown and crescent stamped on German silver from 1888 onwards, together with a maker's name, largely obliterated by solder and the bar of the brooch fitting, the further initials M.I. or M.T., and a fir tree device.

This is a more than usually elaborate example of commercial jewellery in the Renaissance taste manufactured in Germany in the late nineteenth century and popular both in that country and elsewhere. Quantities of German jewellery were imported into England, especially the cheaper varieties of stamped and cast work. [S.B.]

Provenance: unknown before c1940, when it was purchased in Italy by a member of the Agnelli family as a gift to a friend.
Collection: private collection, Surrey.

H15 Ship pendant (*see* p. 45)
Gold, silver with green and blue translucent enamel. Australian opal, diamonds sparks, hung with pink tourmalines. Height: 8.5 cm.
Condition: slight loss of enamel.

The opal forming the mainsail irregular on the surface and on the edges, diamond sparks at the ends of the spar, the tourmalines in the form of beads. Wrought, the ship is rigged with gold wire

and the polished gold hull has an enamelled setting representing waves. Plain gold back, slightly convex, in two parts.

Made by the Guild of Handicraft Ltd., at Chipping Campden, Gloucestershire, about 1903 and almost certainly designed by C. R. Ashbee (1863-1942), who founded the Guild in Whitechapel, in the East End of London, in 1888. The design relates to the ship pendants of the Renaissance (*see* the pendant in the portrait of Lady Cobham, cat. no. P9). But the 'craft of the Guild' was also one of Ashbee's favourite devices, appearing on copper plaques, furniture and other items made by the Guild.

The claim that the pendant was shown at the Arts and Crafts exhibition of 1903 is unproven. On page 48 of the catalogue is an entry for a 'Pendant ship in gold and silver with pearls and

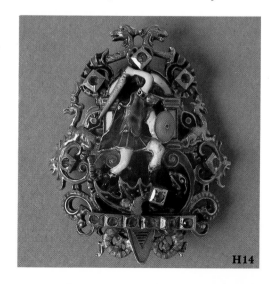

H14

136

one opal.' This was designed by Ashbee, executed by E. Daniels, and enamelled by Arthur Cameron. The pendant with tourmalines may have been a repeat order of the piece exhibited in 1903. [S.B.]

Provenance: Said to have been acquired from the Arts and Crafts Exhibition of 1903 by the father of the last owner, Miss Mary Annesley.
Literature: *Catalogue of the Exhibition of Victorian and Edwardian Decorative Arts* (Victoria and Albert Museum, 1952) p. 27.
Collection: V&A. Inv. no. M.4—1964.

H16 Ring (*see* p. 44)
Gold with blue, white, black and green enamel. Set with a cabochon garnet. Diameter: 1.8 cm.
Condition: enamel heavily damaged.

German (?) second half of the 19th century. The downward curved leaf ornament on the setting and exaggerated strapwork volutes are both 19th century inventions. The gold bands used to mount the stone, and the stone itself, (garnet was very much in vogue in the second half of the 19th century)—are further indications that it is a fake. [I.H.]

Collection: Bayerisches Nationalmuseum. Inv. no. T4267.

H17 Pendant (*see* p. 44)
Gold with opaque black, white and blue, translucent red, blue and green enamel; with table-cut rubies and diamonds and hung with a pearl. Height: 7.1 cm.
Condition: some enamel missing, particularly from the figure of Charity.

In an alcove of columns and brickwork with scrolling cartouches above and below and flanked by couchant lions stands a group emblematic of Charity. The female figure holds one child while two more clutch at her skirts. On either side figures of Faith and Prudence are mounted on plinths set with rubies. On the reverse the architectural setting is mounted on a plinth engraved as brickwork and enamelled green. Two white enamelled pilasters flank a central panel surmounted by a shell and enamelled with a blue cartouche and two pole arms, reversed, in saltire, on a matted ground. The whole is supported by a single ring. The figures and stones are secured to the backplate by square nuts.

Reinhold Vasters is recorded as a goldsmith working in Aachen between 1853 until 1890 by Marc Rosenberg—*Der Goldschmiede Merkzeichen*, (Berlin, 1922-28), III, no. 42. In 1870 he was employed, with August Witte and Martin Vogeno, as a restorer in the cathedral treasury of that city and a cross in the collection which bears his signature is mentioned by Rosenberg. It is also evident that he worked for the dealer/collector Frederic Spitzer, and some 25 pieces from the Spitzer Collection appear in the 1,079 drawings by Vasters kept in the Victoria and Albert Museum. Of these over half are for mounted rock-crystals or hardstones. Drawings

for jewellery and silver make up the remainder with a miscellany which includes some imitations of medieval *champlevé* enamels. Well over half are carefully painted in body-colours, white and gold to indicate enamels. Several bear annotations which leave little doubt that the drawings were designs for goldsmiths' work rather than records of existing pieces.

In 1912, Marks sent the drawing which he had purchased at Vasters' sale in 1909, to the Museum for examination and in his report, Edward Strange, Keeper of the Department of Engraving, Illustration and Design noted that they were 'executed with remarkable skill as designs for goldsmiths' work, many pieces of which, I understand, have been placed on the market as old work'.

There are four drawings by Vasters which relate to this pendant, (*see* cat. no. HG1.) One shows the jewel as it is today, whilst another substitutes the figure of Charity for a diamond cross flanked by figures of Sts John and Mary. A third shows the reverse of the pendant and the fourth is a study of the figures of Charity, Faith and Hope (?). The central group is noticeably more damaged than the rest of the jewel and there are traces of decoration under the base of the group. It is possible, therefore, that the Charity group is of an earlier date than the rest, and was associated with the jewel by Vasters. [C.T.]

Provenance: Collection Frederic Spitzer, (sale, Paris, P. Chevalier, 17th-16th June 1893), Lot 1813. George Salting Collection.
Literature: *Catalogue of the Collection Spitzer*, P. Chevallier (Paris, 1893) Charles Truman, 'Reinhold Vasters—the last of the goldsmiths,' *Connoisseur*, Vol. 201, no. 805, March 1979.
Collection: V&A. Inv. no. M.534—1910.

H18 Pendant
Gold enamelled with opaque white, blue and translucent blue, green and red; set with table-cut diamonds and rubies and hung with pearls. Height: 5.3 cm.
Condition: some loss of enamel.

Double sided pendant comprising on both sides a shell-headed alcove flanked by columns and adorned above and below by scrolls. In the centre of the obverse is a group *en ronde bosse* of David and Goliath: on the reverse, Judith and her maid with the head of Holofernes. The obverse is set with three rubies and three diamonds set in raised box collets. The pendant is supported by a chain of flattened gold links and loop.

Double-sided pendants seem to be rare. The Metropolitan Museum in New York possesses one with marine deities on both sides. A drawing in the Victoria and Albert Museum (E.2847—1919) by Reinhold Vasters illustrates the present example accompanied by annotations as to enamel colours (cat. no. HG2). The difference in slight details, for example in the enamel colours, stones and in the suspension loop, between the drawing and the pendant suggest that it is a

design for the jewel rather than a record of its existence. [C.T.]

Provenance: Formerly in the collection of Frederic Spitzer, (sale, Paris, P. Chevallier, 17th April-16th June, 1893), lot 1840.
Literature: *Catalogue of the Collection Spitzer*, P. Chevallier (Paris, 1893); *Catalogue of a Collection of European Enamels*, Burlington Fine Arts Club, (London, 1897), no. 244, pl. LXVI, (Mrs J. E. Taylor); *Jewellery Ancient to Modern*, Walters Art Gallery, Baltimore, 1979, no. 517.
Collection: Walters Art Gallery, Baltimore, Inv. no. 44.424.

H19 Pendant (*see* p. 44)
Gold with opaque blue, black and white, translucent red and green enamel; set with table-cut diamonds, a cabochon ruby and pearls. Height: 13.7 cm.
Condition: an antler of the stag and two pearls missing, some enamel lost.

From a cartouche set with a cabochon ruby and hung with a pearl, the two chains embellished with red and white enamel beads support a pendant of open scroll-work incorporating flowers, leaves and shells and set with a large diamond in a box collet decorated with black and blue enamel flanked by two smaller diamonds in box collets. A semi-naked female clasping a column and mounted on a stag surmounts the jewel.

There are two drawings by Reinhold Vasters in the Victoria and Albert Museum for this pendant, one shows the pendant (E.2801—1919) and another the chain (E.2855—1919), (*see* cat. no. HG3). [C.T.]

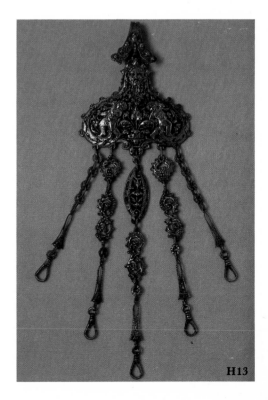

H13

137

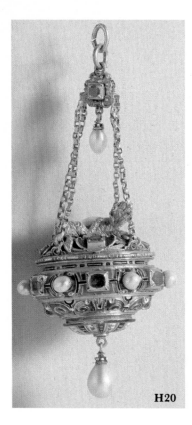

H20

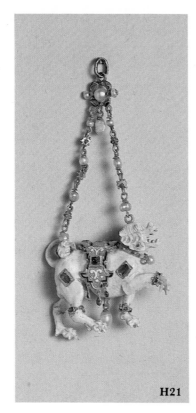

H21

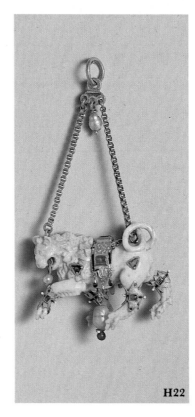

H22

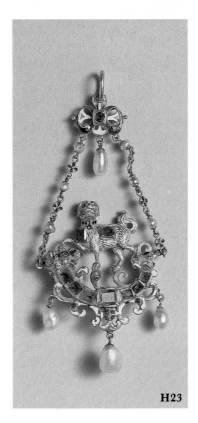

H23

Provenance: Collection of Frederic Spitzer (sale, Paris, P. Chevallier, 17th April-16th June, 1893), Lot 1819. Belle da Costa Greene Collection, and presented in her memory by the Trustees of the Pierpoint Morgan Library, 1951.
Literature: *Catalogue of the Collection Spitzer*, P. Chevallier (Paris, 1893); *Enamel, An Historic Survey to the Present Day* (Cooper Union Museum, New York, 1954) no. 79; *Enamel* (Museum of Contemporary Crafts, New York, 1959) no. 54; *Jewellery, Ancient to Modern*, (Walters Art Gallery, Baltimore, 1979) no. 518.
Collection: Walters Art Gallery, Baltimore. Inv. no. 44.622.

H20 Pendant

Gold with opaque black, white, blue and translucent red enamel. Set with table-cut rubies and emeralds and pearls. Height: 9 cm.
Condition: some enamel loss.

The circular jewel has at the centre of the domed base a pearl hanging from a loop from which radiates panels of red, white and blue enamel, above which are similarly-coloured scrolls and a band of strapwork around pearls, rubies and emeralds. The pierced top of the jewel is mounted with a seated hound whose body is formed with a baroque pearl. The four simple chains meet at a ruby-set cartouche from which hangs another pearl.

The lower section of the pendant is illustrated in a drawing by Reinhold Vasters (cat. no. HG4). The drawing shows a comparable jewel with a base identical to the present example which is

illustrated in Y. Hackenbroch, *Renaissance Jewellery* (London, 1979) no. 908. [C.T.]

Provenance: From the collection of Frederic Spitzer (sale, Paris, P. Chevallier, 17th April-16th June, 1893), Lot 1841.
Literature: *Catalogue of the Collection Spitzer*, P. Chevallier, (Paris, 1893); *Exhibition of Gemstones and Jewellery*, City of Birmingham Museum and Art Gallery, 17th February-16th March, 1860, no. 292; Christie's, London, 27th November 1979, Lot 170.
Collection: Lord Astor of Hever.

H21 Pendant

Ivory mounted in gold with opaque white and translucent green and red enamel; set with table-cut rubies, emeralds and pearls. Height: 7 cm.
Condition: one garter from left hind leg missing.

Ivory beast with raised foreleg, with a collar and trappings of gold edged with green enamel and decorated with emeralds and scrolls of opaque white enamel. The flanks of the beast are set with rubies and the legs are gartered in enamelled gold. The two chains are set at intervals with pearls and join at a link in the form of a flower.

A drawing for this pendant marked 'no. 3,' and in a complete state, by Reinhold Vasters is preserved in the Victoria and Albert Museum (E.2844—1919), (cat. no. HG5). It is probable that the ivory fabulous beast predates the gold mounts. [C.T.]

Provenance: Collection Frederic Spitzer, (Sale, Paris, P. Chevallier, 17th April to 16th June, 1893), lot 1865.

Literature: *Catalogue of the Collection Spitzer*, P. Chevallier (Paris, 1893); Christie's, London, 27th November 1979, Lot 168.
Collection: Lord Astor of Hever.

H22 Pendant

Ivory, mounted in gold with translucent red and green enamel. Set with table-cut rubies, emeralds and a sapphire, and hung with pearls. Height: 7 cm.

Ivory lion passant, with enamelled gold trappings. Set with rubies and a sapphire and with enamelled gold garters. The beast holds a pearl in his mouth, another hangs from his belly and his flanks are set with diamonds. The simple gold chains joins at a pearl-hung enamelled gold loop.

A drawing by Reinhold Vasters in the Victoria and Albert Museum (E.2845—1919) shows this jewel with a more elaborate chain set with pearls and quatrefoils *en suite* with the pendant of an ivory beast from the same collections (cat. no. HG6). As with the latter example, it is probable that the ivory figure is of an earlier date than the mounts. A comparable piece appeared in the collection of Baron de Redé and Baron Guy de Rothschild, Sotheby, Monte Carlo, 25th-26th May, 1975, Lot 146. [C.T.]

Provenance: Collection Frederic Spitzer; sale, Paris, P. Chevallier, 17th April-16th June, 1893, lot 1864. Lord Astor of Hever Collection.
Literature: Christie's Sale Catalogue, London, 27th November, 1979, lot 169.
Collection: Breede Juwelier, Kiel, West Germany.

H23 Pendant

Gold with opaque white, blue and black, with translucent red and green enamel; set with table-cut emeralds and rubies and hung with pearls. Height: 8.3 cm.

From an elaborate ruby-set cartouche, suspension chains of pearls and quatrefoils in green enamel support a flower filled horn set with a ruby and six emeralds and decorated above and below with scrolls. The reverse of the horn is decorated with polychrome enamel. On the horn is set a hound in opaque white *champlevé* enamel, wearing a black collar, with an emerald on its chest and a ruby on the flank.

A drawing by Rheinhold Vasters in the Victoria and Albert Museum depicts this pendant with two alternative *cartouches* for the suspension (E.2843—1919) (cat. no. HG7). This form of pendant appears to have been the stock-in-trade of the Barcelona goldsmiths; P. Muller illustrates a drawing by Gabriel Ramon, dated 1603, in an album used by apprentice goldsmiths of that city. The Victoria and Albert Museum possesses two similar pieces (334—1870 and 336—1870) (*see* cat. no. 109) which were purchased at the sale of the Treasury of the Virgin of the Pillar in Saragossa. Frederic Spitzer possessed a further example (Spitzer, 1893, Lot 1843) and additional examples have appeared in the London salerooms. [C.T.]

Provenance: Collection Frederic Spitzer (sale, Paris, P. Chevalier, 17th April-16th June, 1893), Lot 1842. Lord Astor of Hever Collection.
Literature: P. Chevallier, *Catalogue of the Collection Spitzer* (Paris, 1893); Muller, *Jewels in Spain*, Hispanic Society of America, 1972; Christies Sale Catalogue, London, 27th November 1979, lot 167.
Collection: Breede Juwelier, Kiel, West Germany.

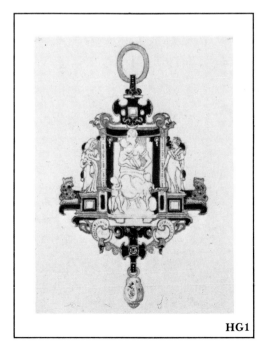

HG1

Vasters Graphics

REINHOLD VASTERS (active 1853-1890)
HG1 Four designs for a pendant
Body-colours, with white and gold and pencil under drawing. Dimensions: a) 7 cm × 4 cm. b) 7 cm × 4 cm. d) 2.5 cm × 7 cm.

A figure of Charity stands in an alcove flanked by figures of Vanity(?) and Faith, and by couchant lions. One drawing (c) inscribed: *Rückseite*.

There are 1,079 drawings by Reinhold Vasters in the Victoria and Albert Museum. Of these over half are for mounted rock crystals or hardstones. Drawings for jewellery and silver roughly divide the remainder with the total made up with a miscellany which includes some imitations of medieval *champlevé* enamels. Well over half are carefully painted in body-colours, white and gold to indicate enamels. Several bear annotations which leave little doubt that the drawings are designs for goldsmiths' work rather than records of existing pieces. [C.T.]

Provenance: the drawings were sold at Vasters' sale in 1909 and appear to have been bought by Murray Marks, the celebrated London dealer. They were then bought by Lazare Lowenstein for £37.16s.0d (Christie's, London, 5th July 1918, lot 17), and presented to the museum in 1909.
Literature: Charles Truman, 'Reinhold Vasters —the last of the goldsmiths', *Connoisseur*, Vol. 200, no. 805 (March 1979).
Collection: V&A. Inv. nos. E.2845—1919, E.2841 —1919, E.2813—1919, E.3278—1919.

HG2 Design for a double-sided pendant
Body-colour, with white and gold and pencil under drawing. Height: 5.8 cm.

Figures of David and Goliath and of Judith and her maid with the head of Holofernes, in an architectural setting.

This design is for a pendant now in the Walters Art Gallery, Baltimore, (cat. no. H18). The goldsmith has made slight variations in executing the jewel, for example, in omitting the suspension ring at the top. [C.T.]

Provenance: Murray Marks, Christie's, London, 5th July 1918, lot 17; Lazare Lowenstein.
Literature: Charles Truman, 'Reinhold Vasters —the last of the goldsmiths', *Connoisseur*, vol. 200, no. 805 (March 1979).
Collection: V&A. Inv. no. E.2847—1919.

HG3 Designs for a pendant
Body-colours, white and gold with pencil under-drawing. Size: 12 cm × 6 cm.

On a scrollwork cartouche a figure riding a stag

and holding a column is set above a stone in a square collet.

The designs appear to be for a pendant now in the Walters Art Gallery, Baltimore, (Inv. no. 44.622. cat. no. H19). The subject of the allegorical figure is confusing, and is probably a misunderstanding of an illustration of Diana riding a stag, in which her bow and arrow has been transformed into a column. It is interesting that Vasters rejected the simple design of the chain for a more elaborate one. [C.T.]

Provenance: Murray Marks, Christie's, London, 5th July 1918, Lot 17. Lazare Lowenstein.
Literature: Charles Truman, 'Reinhold Vasters —the last of the goldsmiths', *Connoisseur*, Vol. 200, no. 805, March 1979.
Collection: V&A. Inv. nos. E.2801—1919, E.2855—1919.

HG4 Design for a pendant
Body-colours, white and gold with pencil under-drawing and the ground washed in black. Size: 10.5 cm × 5.4 cm.

A triton rides a sea creature whose body is formed of a baroque pearl. The group is set on a vase-shaped base and hung by chains.

It is interesting to note how Vasters has produced the design for a complete pendant by joining three different elements, the base, the

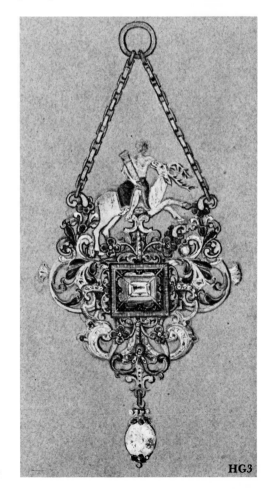

HG3

139

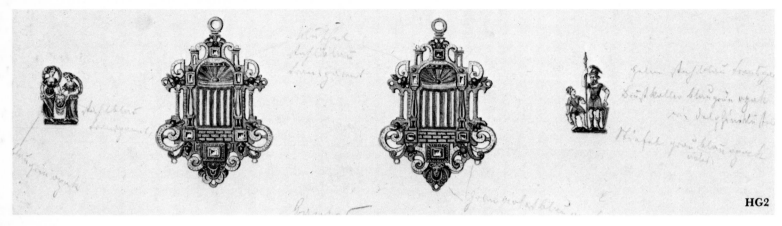

HG2

figure group and central band of strapwork. The pendant made to this design is illustrated by Yvonne Hackenbroch, *Renaissance Jewellery,* (London, 1979) no. 908. An additional pendant which is of comparable form and identical in the lower section, is in the collection of Lord Astor of Hever (cat. no. H20). [C.T.]

Provenance: Murray Marks, Christie's, London, 5th July 1918, lot 17; Lazare Lowenstein.
Literature: Charles Truman, 'Reinhold Vasters —the last of the goldsmiths,' *Connoisseur*, Vol. 200, no. 805 (March 1979).
Collection: V&A. Inv. no. E.2818—1919.

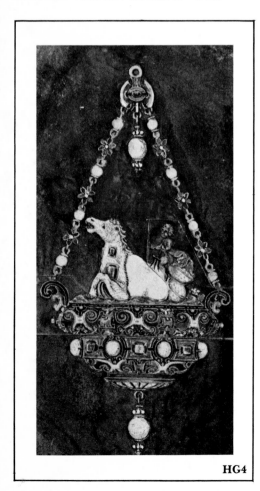

HG4

HG5 Design for a pendant
Body-colour with gold and white pencil under-drawing. Size: 7 cm × 3.8 cm.

Inscribed 'no. 3', 'a' and 'b'. This drawing appears to be the design for the pendant, cat. no. H21, in the collection of Lord Astor of Hever. [C.T.]

Provenance: Murray Marks, Christie's, London, 5th July 1918, lot 17; Lazare Lowenstein.

Literature: Charles Truman, 'Reinhold Vasters —the last of the goldsmiths', *Connoisseur*, Vol. 200, no. 805, (March 1979).

Collection: V&A. Inv. no. C.2842—1919.

HG6 Design for a pendant
Body-colour, with white and gold and pencil under-drawing. Size: 7.5 cm × 4.3 cm.

A lion passant, mounted with jewels and enamelled trappings. Inscribed 'No. 4,' 'a' and 'b'. Apparently a design for the pendant, cat. no. H22, formerly in the Spitzer Collection. The elaborate chains have been exchanged for simpler pieces on the actual jewel. [C.T.]

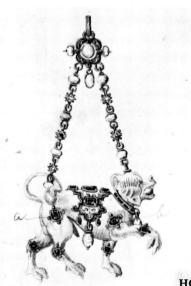

HG5

Provenance: Murray Marks, Christie's, London, 5th July 1918, lot 17; Lazare Lowenstein.
Literature: Charles Truman, 'Reinhold Vasters —the last of the goldsmiths', *Connoisseur*, Vol. 200, no. 805 (March 1979).
Collection: V&A. Inv. no. E.2845—1919.

HG7 Design for a pendant and two additional elements
Body-colour with gold and white, with pencil under-drawing. Size: 10 cm × 9.9 cm.

A scrolled flower-filled horn supports a hound between two chains. Pendants in this style were the stock-in-trade of the Barcelona goldsmiths and a design by Gabriel Ramon dated 1603 is preserved in the album of apprentices' designs of that city (cat. no. G1). A pendant from the Spitzer Collection (cat. no. H23) is made to this design. [C.T.]

Provenance: Murray Marks, Christie's, London, 5th July 1918, lot 17; Lazare Lowenstein.
Literature: Charles Truman, 'Reinhold Vasters —the last of the goldsmiths', *Connoisseur*, Vol. 200, no. 805 (March 1979).
Collection: V&A. Inv. no. E.2843—1919.

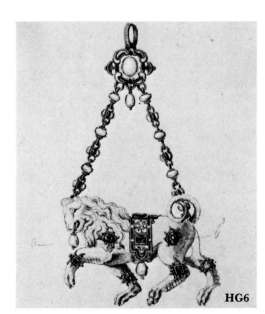

HG6